Islands in the Salish Sea

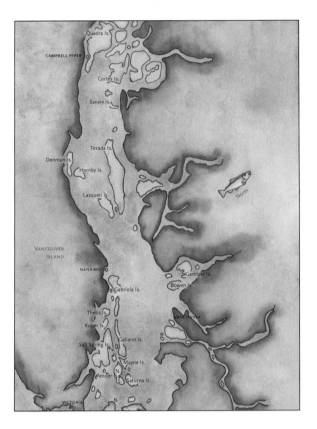

Islands in the Salish Sea

A Community Atlas

Edited by Sheila Harrington and Judi Stevenson

History by Kathy Dunster

Preface by Robert Bateman • *Foreword by Briony Penn*

TouchWood
EDITIONS

VICTORIA • VANCOUVER • CALGARY

TouchWood Editions
#108 – 17665 66A Avenue
Surrey, BC V3S 2A7
www.touchwoodeditions.com

LIBRARY AND ARCHIVES CANADA CATALOGUING IN PUBLICATION
 Islands in the Salish Sea [cartographic material]: a community
atlas / edited by Sheila Harrington and Judi Stevenson.

Includes bibliographical references.
ISBN 1-894898-32-X

 1. Islands—Georgia, Strait of (B.C. and Wash.)—Maps. 2. Biotic
communities—Georgia, Strait of, Region (B.C. and Wash.)—Maps. 3. Islands
in the Salish Sea Community Mapping Project. 4. Georgia, Strait of, Region
(B.C. and Wash.)—Maps. 5. Islands—Georgia, Strait of (B.C. and
Wash.)—History. 6. Georgia, Strait of, Region (B.C. and Wash.)—History.
7. Georgia, Strait of, Region (B.C. and Wash.)—Description and travel.
I. Stevenson, Judi II. Harrington, Sheila

G3512.G4S1 2005 912.711'28 C2005-905420-4

Edited by Marlyn Horsdal
Cover design by Stacey Noyes/LuzForm
Interior design by Roberta Batchelor/R-house
Overview map by Darlynda Bunce

PRINTED IN CANADA

TouchWood Editions acknowledges the financial support for its publishing
program from the Government of Canada through the Book Publishing Industry
Development Program (BPIDP), Canada Council for the Arts, and the British
Columbia Arts Council.

Contents

Overview Map of the Islands .. *6*

Preface .. *7*

Foreword .. *8*

Introduction .. *11*

Mapping Our Past, Our Present, Our Future .. 14

The Community Mapping Process: Mobilizing Information, Art and Love of Place 24

Unravelling a Few Threads of History .. 37

The Island Maps

 Gambier .. 53

 Bowen .. 57

 Galiano .. 63

 Mayne .. 67

 Saturna .. 71

 North and South Pender .. 75

 Salt Spring .. 81

 Kuper .. 89

 Thetis .. 92

 Gabriola .. 95

 Denman .. 101

 Hornby .. 105

 Lasqueti .. 108

 Texada .. 111

 Savary .. 115

 Cortes .. 119

 Quadra .. 123

The Regional Maps

 Wsanec (Saanich) .. 130

 Marine Life in the Salish Sea .. 132

 Economic Map of the Islands .. 138

 Major Energy and Transportation Systems .. 142

 Islands Trust Protected Sites .. 146

 Endangered Ecosystems .. 150

Endnotes .. *154*

Bibliography and Resources of Interest .. *154*

Acknowledgments and Thanks .. *159*

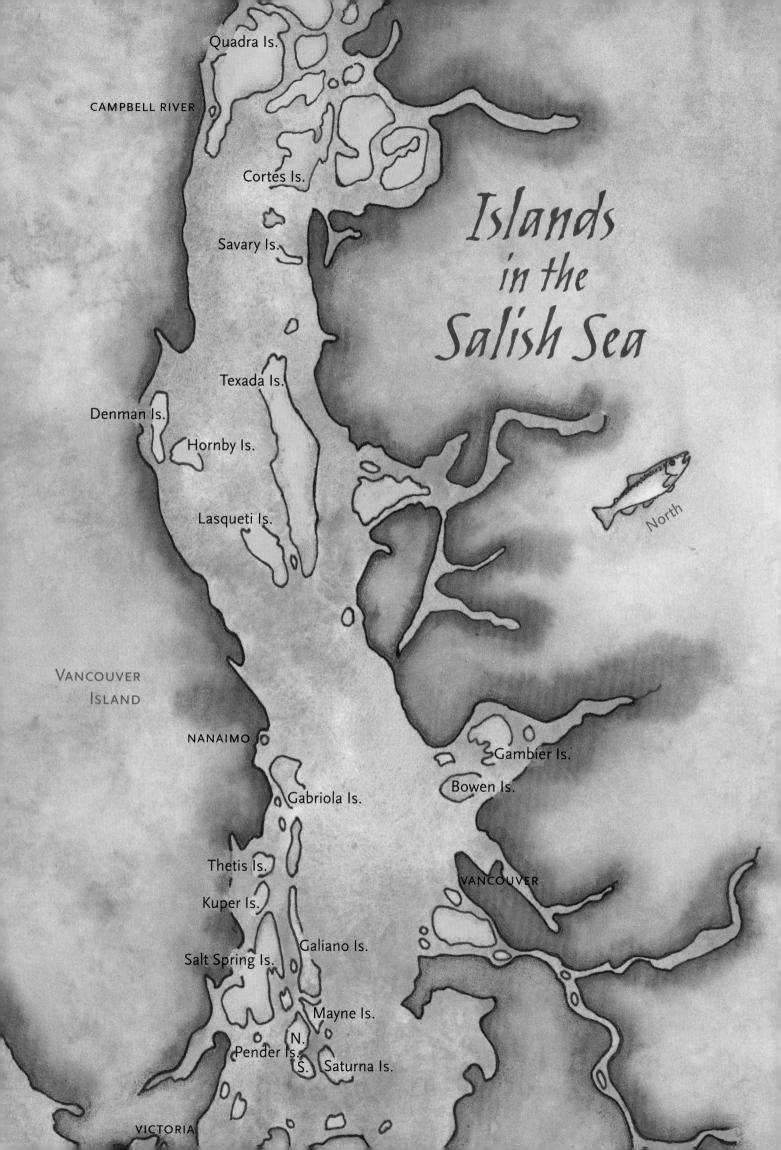

Islands in the Salish Sea

Quadra Is.

CAMPBELL RIVER

Cortes Is.

Savary Is.

Texada Is.

Denman Is.

Hornby Is.

Lasqueti Is.

North

VANCOUVER ISLAND

NANAIMO

Gambier Is.

Bowen Is.

Gabriola Is.

VANCOUVER

Thetis Is.

Kuper Is.

Galiano Is.

Salt Spring Is.

Mayne Is.

N.
Pender Is.
S. Saturna Is.

VICTORIA

Preface

EVER SINCE I WAS A TODDLER, I have been absorbed by art and nature. In university, I studied geography. These three aspects of my life have come together in this atlas of the islands in the Salish Sea.

In our global, packaged world we are losing a sense of our place. This is a philosophical tragedy. It results in a lack of caring, a lack of sense of community and a neglect of civil responsibility. It is also an environmental and human tragedy. For with this loss of knowledge of and intimacy with our home place, we are also losing our sense of spirit.

The Islands in the Salish Sea Community Mapping Project, which produced this book, is a wonderful antidote to this poisoning of our spirit. If we pay attention to the particularity of the world around us, in all of its overlapping aspects, not only will we derive the joy of discovery, we will care. And caring is what really matters.

Robert Bateman

Geographer, Naturalist and Artist, Salt Spring Island

Foreword

Briony Penn

How does one express love for places that are under threat and need to be cherished—a swamp pulsating with the rap tunes of tree frogs, a Garry oak meadow in full psychedelic bloom, a berry patch oozing with luscious salmonberries or an estuary hopping with spawning salmon? I've tried singing about these places to unsuspecting audiences—realtors, politicians and stockbrokers—but this form of expression is probably best left to someone with superior musical skills. I've also tried dance, but strange choreography that mimics the migration of a rough-skinned newt through the forest or the landing of a bufflehead in a quiet bay has a limited audience.

My reasoning is that if I can express my feelings strongly enough, those who are chopping and bulldozing these places down will be moved to change their ways—a deluded but desperate and well-intentioned strategy. Artists have expressed their sense of loss since the first cave painters plunged their hands into red ochre and painted the animals that were disappearing as the deserts swept in. They painted their savannah to remember when they could drink deeply at the waterhole and feast on warthog at leisure. Poets have been expressing their sadness since Homer wrote his two epics about the golden age of Greece at a time when the Elysian Fields were being subdivided into bourgeois stucco villas. While Queen Elizabeth I was busy converting forests into clear-cuts, bards were writing about the olde days when red squirrels could travel across the country without touching the ground.

Art has an advantage in that it touches the heart. Science touches the mind. I have never found purely scientific arguments for conservation very successful. Most people's eyes glaze over at the mere whisper of a "biogeoclimatic zone" or the hint of an "ecosystem-based management approach." In other words, the microscope is a suitable instrument to express concerns to other scientists, but it is a clumsy object with no emotional appeal to the rest of the world. But even the cave painters, Homer and Shakespeare weren't entirely successful in persuading the developers of their day to have an artistic, ecological sensibility. This brings the question: when did science and art, nature and culture meet on equal terms? Isn't the integration of mind and heart the most powerful medium of all?

You only have to look at the first people to inhabit this land—the Coast Salish—to find the answer. A culture evolved here that celebrated these places to such an extent in science and art that they named their months of the year after tree frogs, camas and salmon instead of dead Roman emperors, Viking war gods and numbers. Their economic well-being depended on these places; so subsequently did their spiritual well-being. But now we are an urban-industrial society with our cultural roots in those Euro-empires. What was our high point in western civilization for recognizing the importance of the natural world in both science and art?

I took my cue from the Renaissance where, for a brief while, they married the microscope with the mandolin. Through the Renaissance came an outpouring of celebration of place. One medium in which these two instruments came together in sublime perfection was the map. The map locates accurately on land those places we value, while providing some space on the paper to wax and paint poetically what those values are. In this age of increasing land-use conflicts,

there is a renaissance of mapping to mark places of exquisite value in the hopes of saving them. We can make illustrated maps of special places—indeed, everyone can.

Maps somehow seem to fit into our socio-political needs, because they hold power. It has to do with our obsession with property lines and ownership of scarce resources, and the way we plan our communities with zones telling us where we can and cannot carry on certain activities. From Indonesia to Italy, there are groups of people who have used maps to set down the exact locations of special places whose values are not necessarily congruent with commercial importance. The maps might be the landing stages of the brant geese along the Pacific flyway, ancient village sites or a favourite walk recording the spiderwebs and pubs along the way. The urge to map comes from the same base as the urge to sing, dance or write. If you put things down on a map, it is an expression of both knowledge (microscope) and art (mandolin). If someone has taken the time and effort to record it, then it has value. People become aware of and sensitized to these values, and they can then become advocates for them. Look at the power of political boundaries that are visible only on a map; they can lead to wars. How much better to use a map for peace.

Community maps provide a geographical as well as historical record of what makes a place unique and liveable. They record the special information that isn't included on the maps that tell us where to drive, locate mines or build shopping malls. Instead, they record the places where our children's imaginations learn to soar and where we feel at home. Community maps are a reflection of all the love and positive power in a community.

I was inspired to do community mapping while working on a Ph.D. in Geography at Edinburgh University. The inspiration had nothing to do with my formal education —that was full of cartographic instruments like theodolites, cadastral maps and Geographic Information Systems. Instead, it arose from my informal education—information I gleaned at the breakfast table every Sunday morning. I'd open up the *Sunday Times Magazine* to find a beautifully

WHAT IS THE SALISH SEA?

In the 1970s, Canadian/American biologist Bert Webber was working on oil-spill issues in the fragile inland sea that stretches from Campbell River on eastern Vancouver Island to Seattle, Washington, in the United States and west to Juan de Fuca Strait. Canadian scientists called their area of responsibility the Strait of Georgia while Americans called theirs Puget Sound. But using both names was clumsy when they were trying to describe the entire shared water body. Oil knows no boundaries, nor do fish and marine mammals, and the scientists could see the problem of not identifying this water body as a single entity. Webber thought that if they created a name for this distinct inland sea, like the Mediterranean, people would think about their shared responsibility to the health of the region. He coined the name the Salish Sea, in recognition of the Salish-speaking people who lived around and on it. In many of the dialects of Salish people, the sea is referred to simply as "saltwater" and the people themselves as "saltwater people." Today, First Nations in both countries have formed a Salish Sea Council to tackle joint issues; tour operators use the name; it appears in several books; and Parks Canada embraced the name with an educational package for children, including a song called "Salish Sea." This book, *Islands in the Salish Sea: A Community Atlas*, follows on in the tradition to create an awareness of our shared responsibility of this wonderful sea. Not often in the 21st century is there an opportunity to name a sea, but the time has come to give a single name to one of the world's most abundant and diverse marine ecosystems.

illustrated map of a small area or parish somewhere in Britain. Local residents and artists had collaborated to map and record many things they loved about their place, from badger sets to heritage apple orchards and from historic pubs to newt habitat. It was called the "Parish Maps Project." Started in 1987 by an organization called Common Ground, it continues to this day. The clippings provided a rich image of Britain, and I dreamed about spreading the idea to my home place around the Salish Sea.

When I came back from Scotland in 1993, Sheila Harrington approached me about raising awareness of local places on the Gulf Islands, and I showed her the Parish Maps clippings. A year later, we held an artists' show on the islands called "Mapping Cherished Places"—an exhibition of 20 maps that local artists made of their own cherished home places. Islanders loved the maps, and mapping caught on. The handbook *Giving the Land a Voice: Mapping Our Home Places* evolved out of the shows and preceding workshops. In 1999, Judi Stevenson encouraged us to launch a mapping project for the millennium. Four years later, hundreds of community members from 17 islands had brought their mandolins, microscopes, paintbrushes, computers, compasses, pastels, binoculars, fabric, clay, plaster, plant books, hiking boots, water samples, heritage registrars, theodolites, traditional knowledge and stories to the task of mapping the rich natural and cultural history of the islands at the turn of the millennium.

It has been a significant decade, when we realize just how many people care about the same things and are crazy enough to spend thousands of hours to express that love with whatever instruments they have at hand. This book celebrates the regional community that participated in this project—from poets to plumbers and newts to nudibranchs.

One thing I have learned as a professional geographer is that whoever has the maps in their hands controls the fate of the land. Cartographers have been at the forefront

From Briony Penn's map of her home place, Fulford Harbour on Salt Spring Island.

of turning land and nature into polygons of commodities. Our clients have rarely been citizens of a place anxious to recognize all the values that make life diverse and rich; the majority have been companies or agencies intent on extracting resources or delineating property. The profession has not been devoid of, to quote Wendell Berry, "professional vandals," rarely pausing to question our oversimplification of a landscape of which we have little knowledge or love.

With this book, I hope young aspiring geographers can take heart that making maps can indeed be a noble profession, as I did when I first saw the Parish Maps. Even more importantly, I hope that everyone who is inspired will make a map of somewhere they love.

Mapping is a great excuse to talk to the neighbours, old-timers and local kids, and listen to tree frogs and barred owls, even in the city. You can map where rivers used to run and believe that they may run once again. Learn the names of your favourite trees and sniff the delicate aroma of skunk cabbages in March. Stick in all those important bits of information like the First Nations' place names, a heritage building, an outcrop of ancient granite, some secret trail or the hedge where a song sparrow is singing. You don't need to be an expert, and it doesn't have to be done on a computer. Maps can be made with red earth on a cave wall. In the future, who is to say which maps will survive the test of time and which spoke the greatest truth?

Introduction

Sheila Harrington

"I haven't been so moved since I visited the Louvre in 1972. These maps and the story they tell must be shared as much as possible."

From the guest book at the first exhibition of the map collection on Salt Spring Island, March 2001

THE BOOK YOU ARE NOW holding is the culmination of over five years of work by over 3,000 people who live in a region we call the Salish Sea, also known as the Strait of Georgia. These beautiful and innovative maps encompass many fields: cartography, science, history, art and community planning. Their initial creation, exhibition and now their publication have been three stages of a single undertaking—the Islands in the Salish Sea Community Mapping Project.

The 500-plus islands in the Salish Sea are widely recognized as a region of international ecological and cultural significance; the Georgia Basin is considered one of the three most threatened ecoregions in Canada. This project focusses on 17 islands, from Saturna in the south to Quadra in the north. Approximately 28,000 people live and work on these, the largest and most populated islands. Thirteen of these islands, in the central and southern portion, are protected by a special Act of the British Columbia government and administered as a Trust Area for all the people of Canada.

The project began in 1999 on the eve of the millennium. Judi Stevenson and Briony Penn, of Salt Spring Island, were discussing the pace of development and loss of natural areas they cherished. They thought it would be valuable for local people to inventory and map their land as a way to celebrate and mark the millennium and to come to a deeper knowledge and understanding of this home place.

Briony suggested broadening the scope of the project beyond Salt Spring and asked me to get involved. Deciding to focus on the more populated islands on the Canadian side of the Salish Sea, we invited local coordinators to work with us on a bioregional community-mapping project.

Judi, Briony and I, the overall coordinators, believed that it was important to take stock of what is here and who we are and, most significantly, what is of essential value. Once these features were identified and mapped, we hoped people would be better able to care for their home places. With artistic community maps, island residents might be more willing to protect and sustain the ecosystems, culture and heritage that support our communities and economies.

When we all came together at the first workshop in January 2000, we discovered that we share not only a region but also similar values: independence, a firm sense of community and an overriding love of the natural and relatively wild environment in which our islands are located. At this meeting we recognized each other as neighbours within a wider bioregion. Significantly, we also realized that communicating the needs of our island communities was up to us. We held the local knowledge of our home places that governments may not have or consider when making decisions about planning and development.

We were reminded that there are numerous political bodies with overlapping jurisdiction within our region: the First Nations bands who call the territory home; the five regional districts (none of which are situated on the islands themselves) that regulate building, schools, highways, health care, waste, recycling and many other aspects of life; the Islands Trust, which is responsible for land-use planning

on the 13 large islands and hundreds of little islands in its jurisdiction; and the municipal government that exists on just one of those large islands. In addition, the provincial and federal governments have significant control over the use of public lands, mining, forestry and agriculture on private lands, and aquaculture and mining in the sea itself.

We chose to call the project area "the Salish Sea" to recognize and honour First Nations' original territories. Other people have also started using the name. We hope governments, other projects and people in general will increasingly recognize Salish and other First Nations place names, thus including everyone in discussions and decisions about our shared home places. In fact, since the 1980s, formal renaming of many of Canada's place names is being accepted through the Canadian Board on Geographical Names. As Alan Morantz aptly says, "a place name reveals the past and puts a stamp on the future."[1]

This collection contains three original Salish maps. The Kuper Island carved cedar-panel map and the Wsanec Map are both compelling, telling a story that connects the past to the present and calls the islands "our relatives." Herb Rice, the Kuper Island artist, reminds us that "our life's blood came from our mother the earth, and for many generations we cared for this." John Elliot, coordinator for the Wsanec map, expands on this further by explaining that "the word for 'island' in the Saanich language is TETACES (Tlu-Tla-Chus), meaning 'relatives of the deep.'" Several of the other maps give the Coast Salish names for island places, revealing past land use. In addition, the Hul'qumi'num Treaty Group has provided a map showing the location of modern settlements of First Nations communities in this region and the traditional territorial boundaries that have been defined in "Statements of Intent" as part of modern-day treaty negotiations with British Columbia and Canada.

These islands have held on to their rural identities for the past hundred years. However, they are now under enormous pressure as more and more people arrive from cities and suburbs, seeking a different kind of life. At the same time, hundreds of thousands of people from across the country and around the world visit the islands each year in search of recreation and to experience their natural beauty. Like many other regions, they have now reached a critical threshold. Rapid development threatens not only to devour the last remaining wild or natural areas, but also to alter significantly the way of life of the people who call the area home.

The Islands in the Salish Sea Community Mapping Project was designed to encourage people living on the most populated islands to research, record and communicate their distinct natural, economic and cultural heritage. Formally, our goals were:

- to unite a group of isolated island communities in a project that celebrates our commonalities and unique rural identities;
- to help people discover and learn how to document and record what they value about their island communities through locally created collaborative maps;
- to share these maps in a touring exhibition, encouraging broader public interest and understanding of the distinct rural character, special traditions and rich Aboriginal, cultural and natural heritage of the islands;
- to create a lasting resource that can be used as a catalyst for sensitive and sustainable rural planning and community economic development initiatives;
- to present the final 30 maps rendered by local professional artists in a community atlas, to motivate people everywhere to cherish, respect and care for these special islands and their own home places;
- and to capture in words, for inclusion in the book, the personal and collective visions and experiences that gave birth to the maps, and thus contribute to community mapping and sustainability in other parts of Canada and beyond.

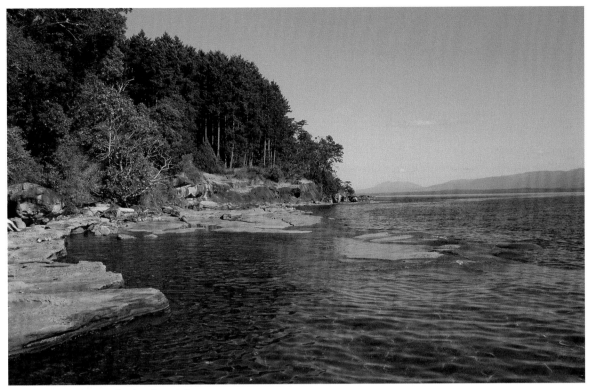

Coming to shore on an island in the Salish Sea. PHOTO BY GORDON SCOTT

In this book, we are offering a blend of views of individuals who have attempted to provide as accurate a picture as possible of selected aspects of the islands at a particular time. As facts change over time, and some are disputable, these maps and their stories show only a moment in our history. They are a millennium portrait, lovingly rendered by local artists, after considerable research, discussion, meetings and workshops with local coordinators and their island communities between 2000 and 2003.

Also included are three chapters that provide different perspectives on the project. I give an overview of the development of this new genre—artistic community mapping—and explain how it can be a useful tool to help local communities sustain themselves as we move into the 21st century. Judi Stevenson describes how the project progressed, as both a moving story and a guide for other communities. Kathy Dunster provides a concise and insightful overview of the human history of the region.

Thus we will begin our journey to the islands through the maps and the stories of their creation, navigating from the eastern side, closest to the mainland (Gambier and Bowen), west to the southern islands (Galiano, Mayne, Saturna and the Penders). Then we will travel north, visiting the islands that lie closest to Vancouver Island (Salt Spring, Kuper, Thetis, Gabriola, Denman and Hornby). Next, we will cross over, mid-channel, to those islands that stand out in the windswept, salty waters (Lasqueti and Texada). In the last leg of the journey, we will voyage up to the islands at the north end of the Salish Sea (Savary, Cortes and Quadra). Here, as the more rugged northern islands and the high mountains of the mainland form a border for our bioregion, our journey to the individual islands ends. To complete the picture, six maps give an overview of the region, focussing on the themes of the Wsanec (Saanich), Marine Life, the Economy, Energy and Transportation, Protected Sites and Endangered Ecosystems.

We hope that these collaborative artistic maps will prove a powerful voice for island residents and many other communities, as we present locally gathered significant knowledge while celebrating some of what we treasure here on the edge of coastal Canada.

Mapping Our Past, Our Present, Our Future

Sheila Harrington

If we could look objectively at this world, this wonderful planet that is so delicate here on the edge of a vast universe, we would see that all is sacred. Nature is inexplicably woven together to create an incredibly diverse and inherently connected whole Earth. How do we understand that this intricate web of life is the very source of our water, our air, our food? Through an intimate love for our own home places we will find a link, to each other and to the Earth. For we are part of nature.

AS A SAILOR AND FORMER set designer, I am thoroughly connected to maps, charts and graphic metaphors, convinced of their power and importance. Maps are useful for exploring and finding our way in the world. As the last remote areas of the Earth are charted, increasing human populations with an avid hunger for resources, farmlands and urban culture are significantly altering the fabric of the planet. The essential links between natural areas are only now being glimpsed, let alone recognized as necessary for the health and survival of us all.

Through science and other avenues of knowledge, we are learning that the diversity of both our natural and our human communities fits into a larger whole, and the whole is greater than the sum of its parts. We can only judge the value of any one part when we come to know it intimately, in all its dimensions, with awareness and openness. And words alone tell only a small part of the story.

A map is a picture that speaks a thousand words. It can connect things, places and complex concepts together into a graphic image full of information and beauty. Maps reveal what connects us and what divides us. Creating and sharing local and regional community maps can help us find our way through the challenges of this century as we seek to balance our escalating human needs with those of a finite planet. Within the Georgia Basin, which includes the lands surrounding the Salish Sea, the human population is projected to increase by 50 percent over the next 20 years. In our rush to measure, divide up and make a home for ourselves, we risk destroying the very elements that attracted us initially and that sustain our home places.

A March 2005 United Nations report, *The Millennium Ecosystem Assessment*, drawn up by 1,300 researchers from 95 nations over four years, concludes that human activities threaten the Earth's ability to sustain future generations. The authors say that the pressure for resources has resulted in a substantial and largely irreversible loss in the diversity of life on Earth, with some 10 to 30 percent of the mammal, bird and amphibian species currently threatened with extinction, and fisheries and fresh water now well below levels that can sustain current, much less future, demands. The study goes on to state that humans have changed ecosystems more rapidly and extensively in the last 50 years than in any other period. Some 60 percent of the elements that support life on Earth, such as fresh water, clean air and a relatively stable climate, are being degraded or used unsustainably.

The UN Millennium Assessment board of directors does offer some hope: "The overriding conclusion of this assessment is that it lies within the power of human societies to ease the strains we are putting on the nature services of the planet, while continuing to use them to bring better living standards to all ... Achieving this, however, will require radical changes in the way nature is treated at every level

of decision-making and new ways of cooperation between government, business and civil society. The warning signs are there for all of us to see. The future now lies in our hands."[2]

As we started our community-mapping project here on the islands in the Salish Sea, we too felt that the future was in our own hands. As Roger Deakin suggests in *from place to PLACE*, islands offer both limitations and opportunities: "An island is contained by the sea or by ancient boundaries, natural and supernatural; what might seem limiting and defining to one state of mind can be at once to another liberating. "[3]

Although these islands are in some ways separated from the larger world, they also share commonalities of place that give them a regional association. How can we live sustainably and care for our own territory yet be linked to the larger world? It is clear from the individual island maps and the stories of their creation, and from the regional maps, that these communities are dependent on many other places, and they are becoming even more so. Yet, in their semi-isolation, they do point to alternative ways of living, revealing routes that may lead to a more balanced future.

I feel privileged to have moved, in my teens, to the west coast of Canada. But like many new residents, it has taken me years to learn about my new home and to recognize the exotic plants and foreign practices that can take over the lifestyles and habitats native to an area. Through finding out about the history and natural features of a place, mapping them and then bringing these beautiful maps full of local knowledge to a larger audience, perhaps we can help create a future where nature and humans can all live together in sustainable community.

Maps as Instruments of Power

A map is a representation of selected and limited observations about a specific place, at a specific time. Because what is mapped is selective and how it is mapped is also a human choice, it is actually a statement about relationships and values.

When we travel to new places, we look for maps to help us get a basic sense of direction and locate major features. Tourist maps show roads, buildings, boundaries of parks, heights of mountains or depth of waters, sometimes with cultural or historical information scattered around the edges or interspersed in the "blank spaces." But in order to know a place more thoroughly, in a way that makes living there more sustainable, we need additional information, such as the history of the preceding 100, 200 or 500 years; details of the ecology, climate and geology; and descriptions of the economy, culture and social traditions of the residents. All of these qualities form the character of any one region. Although we have extensive technical knowledge and creativity, we are only now understanding how to put together a whole picture of our home places.

How do we compose this holistic picture? Community archives and oral histories gathered from elders can provide some information. In many cases, we may have only a brief window of time to gather this local knowledge from the people who have lived in these places for a long time. We also need to gather ecological data, such as the paths of cougar, deer and elk or the eelgrass beds that are home to herring. Maps are an influential way of recording, portraying and sharing this knowledge of complex features and their relationships: they show what we value and what we may lose if we fail to conserve it.

Maps have considerable power. When people were more nomadic, they drew maps in the sand or on animal hides, or carved them in wood. In Canada, the Inuit used both songs and stone markers as descriptors of their home places, and much of their oral cartography formed the basis of European explorers' maps. "Inuit place naming sought to portray the physical, biological, or ecological significance of the land. Inuit rarely named places in honour of persons, and only occasionally to commemorate events. Many of these place names are disappearing, signifying the destruction of libraries of maps."[4] In some Aboriginal cultures, a map was considered the property of its creator. Rather than being published or shared, it would be destroyed or buried with its owner. These maps were personal power objects.

In contrast, European cartography was developed through technical, seemingly objective methods; often the published maps were actually drawn by different hands than those that visited the land. In the 17th, 18th and 19th centuries, North American maps were primarily assertions of exploration, expropriation and control. These maps were not personal to the mapmakers; instead, they were public assertions of ownership, laying claim to a place. The coast of B.C. was mapped by Russian, Spanish, British and American explorers seeking to colonize these lands. In the 1790s, Captain George Vancouver charted the west coast of North America, particularly Vancouver Island and the "Gulphe of Georgia," largely to determine if there was a navigable passage inland between the coast and Hudson Bay. He was also mapping and naming areas specifically to establish the authority of King George III.

Today, Geographic Information Systems (GIS) are the norm in this continuum of objective, technical mapping. These computer-generated maps use a wide array of biological, physical, historical, cultural, archaeological and economic data to produce maps. The data are based on a set of geographical coordinates and encoded in digital format so that they can be sorted, selectively retrieved, and statistically and spatially analyzed. For many purposes they are very useful. The data can be overlain in virtually any order, revealing specific relationships upon which decisions can be made. Many of the islands in the project area have used GIS maps to help document species and habitat locations and a multitude of other features. These too are useful, but any map is only as accurate as the data, with features selected according to the values or purposes of the person who made it. Yet if an "expert" has created it, most people will assume it is a complete and inclusive representation. Thus, the Denman Apple Map is as accurate a statement about a place as a GIS map.

Formerly, local knowledge was communicated by word of mouth or carefully rendered onto a single medium. Today, computer-generated maps are commonly provided on demand, from a distant location, frequently claiming ownership of resources in someone else's home place. We have moved from mapping as craft to mapping as an instrument of commerce—a commodity. Artistic community

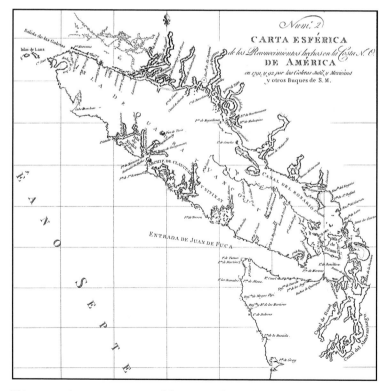

This engraved map is a summary of the voyage of Spanish explorers Dionisio Galiano and Cayetano Valdez in 1792. It was not published until 1802, after British explorer George Vancouver's book of maps was released. (Reprinted with permission from Derek Hayes, *Historical Atlas of British Columbia*.)

maps, such as those in this atlas, are crafted with an intimate selection of features, which elicit powerful responses. This question of what is the most effective mapping tool, and what has the most impact on people and their decisions, is one that not only our island mappers but also scientists and artists have been disputing for decades. But no matter where or on what a map is drawn, it can be an instrument of power, asserting authority; the person who makes the map has decided what, where and who are included and what, where and who are not. Through these artistic community maps, local islanders are reclaiming power from distant technicians, resource managers and politicians, describing for themselves, and for others, their own cultures and home places.

The Bioregional Perspective

From the time of European colonial expansion in the 1600s, the social and political foundations of the western world have changed dramatically, and our relationship to both the land and our communities has undergone a fundamental shift. In feudal society, as in many Aboriginal societies, there was generally more of an overall sense of responsibility towards the land and its ecosystems; property was often held in common. As the political climate moved away from traditional lines of authority, the individual became the focus, more lands were enclosed, and more public resources were privatized.

In the 20th century, increasing awareness of industrial exploitation and other environmental pressures has led to an alternative quest to "reinhabit" community and help conserve natural functioning ecosystems. In the early 1970s, when Allen Van Newkirk was studying the science of biogeography—the geography of nature—he reasoned that nature seemed to organize itself into communities that shared continuities of physical and ecological association. These areas, which he called "bioregions" (from *bio,* life, and *regia,* territory), could become the territorial units within which humans protected and restored natural ecosystems.

The concept of a bioregion was expanded by Peter Berg, a San Franciso-based cultural activist, and Raymond Dasmann, an ecologist, to include both a geographical terrain and a terrain of consciousness—living-in-place, people living within the natural ecological capacity of a particular region. The underlying premise is that human cultures thrive best when rooted in relatively small bioregions.

Bioregional mapping, developed from the pioneering work of Berg and Ian McHarg, brings the science of cartography and inventory together with the concept of a bioregion as the basis for sustainable communities. McHarg, a professor of landscape architecture and regional planning, introduced the concept of layering information on separate transparent maps; this resulted in a new visual image that could show where sustainable human developments could best be located.

When computer technology became more accessible in the early 1980s, Jack Dangermond, a graduate student in landscape architecture at Harvard, designed a system that could collect and sort the geographic data and information layers more quickly than before; the system became known as GIS. Dangermond went on to found the Environmental Systems Research Institute (ESRI) and create ArcInfo, ArcView and many supporting suites of software used by individuals, developers and governments.

In 1993, a local mapping approach was added to the bioregional concepts and presented by Doug Aberley in *Boundaries of Home, Mapping for Local Empowerment.* A Vancouver-based professor of community and regional planning, Aberley promoted the concept of local people, rather than outside experts, layering levels of thematic information important to a community onto maps in an atlas. Since then, Aberley has helped many indigenous communities use GIS maps in a locally developed atlas to identify and map their own territories.

Artistic Community Mapping: Weaving Maps, Bioregions and Art

In the early 1990s an innovative project in England, Common Ground, presented local artistic renderings of small regions called parishes. Inspiring many people around the world, these maps were expressions of community values portrayed creatively to help people define and communicate what made their parish special, what they wanted to keep and what they might change for the better. Sue Clifford, one of the founding directors of Common Ground, explains, "So much surveying, measuring, fact gathering, analysis and policymaking leaves out the very things which make a place significant to the people who know it well."[5]

In 1994 these many strands were connected when Doug Aberley, Briony Penn, Michael Dunn and I worked on a southern Gulf Islands project, Mapping Cherished Places. Bringing the bioregional planner, the artist, the scientist and the designer together, we gave workshops teaching people how to map their own properties. These resulted in some exquisite artistic maps, made by landowners of their homes. *Giving the Land a Voice, Mapping Our Home Places* (*GLAV*), produced in 1995, was based on the workshops. It provided easy-to-follow basic mapping techniques and an explanation and list of subjects that a bioregional community atlas could include, and it displayed some of the innovative maps that islanders had created of individual places they loved. The idea was so popular that in 1999 a revised edition was published, adding descriptions of a few tools for the conservation of people's own properties. This manual was the base resource for the Islands in the Salish Sea Community Mapping Project.

Giving the Land a Voice mapping manual

Since then, numerous books and projects have used these ideas for their own purposes. *La Terra Racconta,* published in Italy in 1996, includes some original maps done by Peter Berg's Planet Drum Foundation, a few from the 1995 version of *GLAV* and many brilliant new Italian maps. Green Mapping, which is now an international network of urban community-mapping groups, also drew inspiration from the concepts. Green maps generally highlight green spaces, parks and natural and organic restaurants or stores in urban areas, and suggest energy-efficient transportation routes. More recently *Landscapes, Wildlife, and People: A Community Workbook for Habitat Conservation,* from the Sonoran Institute in the United States, states in its introduction that part of its inspiration came from *GLAV.* In fact, more and more communities are now mapping their watersheds, species and habitat locations and other biological features for themselves in order to find sustainable solutions for living in a place and conserving what is valued.

This "new" idea of bringing an artistic approach to mapping one's own land or a larger community helps to bring local knowledge to a wider audience. Art touches us emotionally, at a much deeper level than lists, graphs or computer-generated data could ever do, presenting information in a more accessible way to more people. Beautiful, hand-drawn maps help us feel and recognize our links to nature and each other, in a personal, moving way. Artistic community mapping is a powerful way of bringing local knowledge and values into the offices and hearts of local planners, the larger community and the corporations and politicians who are making decisions about the future of our home places.

The maps in this atlas display styles, scales and subjects as diverse as the people who made them. Yet their

ultimate power is in revealing what local people consider valuable—why they live here, and what they want to protect as we move into the next millennium.

These maps point to a new type of exploration and a different course from the one we have been on; they emphasize values other than those that have been separating us from each other and from the natural world. Whereas conventional maps seek to impose boundaries on a landscape, these maps seek to infer them. Maps like these express the interior of a place, rather than the exterior boundaries of territoriality, surveillance and control.[6] They offer an outward portrait of a local intimacy, providing an opportunity to share, to empathize, to know and to care. They are a collective portrait of a community—a face—expressed beautifully and lovingly, with all the lines and marks of experience and age.

Mapping—A Community Portrait

The Islands in the Salish Sea Community Mapping Project has brought together knowledge of past and current realities that were formerly hidden from view. Of equal significance is the joining of separate islands into a broad bioregional community.

In Phase One, at the first workshop for the project, as we told each other about our fears and hopes, we saw clearly that, like virtually all places in our western world, these islands are connected to and affected by larger political and economic global systems. This economic infrastructure has brought great abundance to many people here and throughout the developed world, but it has brought considerable loss to others who live in areas where resources have been extracted and ecosystems degraded. As the participants in this project discovered each other and our shared bioregion, we also discovered a larger cooperative community that has compelled us to seek solutions.

Once this initial bioregional community was forged,

the local coordinators went back home and started making links within their island communities: organizing events and workshops, and talking with elders, children, historians and everyone who was interested. The coordinators were free to determine what method of inventory would be most effective for gathering knowledge about their particular island. We asked them to focus on the year 2000 and suggested comparisons to 100 years ago, in order to reveal changes from the last millennium.

In March 2001, we held a preliminary exhibition and workshop at Artspring on Salt Spring Island. We invited both coordinators and artists to attend, asking them to bring their maps and tell us their stories of the community-mapping process. The local Salt Spring community added a few extra maps to the weekend display, bringing in a local school's project on mapping their own home places, and some islands also brought additional maps. As we viewed the amazing display and listened to the artists telling each other their stories about the challenges and joys of their relationship with their islands during the previous year, a portrait of a larger bioregional community began to take shape.

We opened the exhibition to the public on the final day and discovered that these maps meant more to others than we had ever imagined. The gallery requested that the show stay another week, later commenting that it brought in more people than any other exhibition held there.

Phase Two of the project included the creation of six regional thematic maps for the area and a travelling exhibition that made its way around the islands, to acclaim and astonishment at all stops. We held these exhibitions on 14 of the 17 islands, as well as in Vancouver, Sidney and Victoria. The guest book contains over 125 pages of positive and encouraging remarks from viewers, expressing how important the maps are for future community planning and as an important development in the fields of community collaboration and cartography.

Invitations to speak about the project came from numerous academic and scientific gatherings, including a national conference put on by the Simon Fraser University Centre for Coastal Studies, "Linking Science and Local Knowledge," the First International Conference for the Georgia Basin, and the International Conference on Geography and the Stewardship and Conservation in Canada Conference, both held in 2003. In 2004 we presented the project at an International Conference on Environmental History and, most recently, in 2005 at a conference in Seattle, Washington: "Science for the Salish Sea, A Sense of Place, A Sense of Change." We hope that the interdisciplinary nature of the project will help lead to a more holistic view of our world and, with it, increased regard and care for our islands and other home places.

Iona Campagnolo, the lieutenant-governor of B.C., at the Stewardship and Conservation Conference in July 2003. PHOTO BY MARION MARKUS

Stewardship—Care and Conservation

Artistic Community Mapping is a collaboration between science, art and the community. These maps help us to understand and protect significant natural and cultural features. It's almost as though it's not the final product, the map, that saves the place; it's the actual process of working together. The final art is a visual statement of the collaboration.

Today we are losing many important species and habitats, and altering important ecological processes, because we don't know that they exist, we don't understand their relationships or we just don't know how to present their significance to our communities or to the larger world. The power of artistic maps to protect both our communities and natural and cultural areas is uncanny. Michelle Marsden's map of Medicine Beach, on Pender Island, drawn for the Mapping Cherished Places project, helped raise the level of community awareness and involvement in a campaign that protected the area. Several of the maps created for this project have also been instrumental in helping our Salish Sea island communities protect threatened areas.

As many of the people involved in this project have said, it is both personally satisfying and beneficial for our local communities to take the time to learn about our home places, and then present these features in a way that reveals the connections between the social, economic and ecological characteristics of the area; it is even better to do so in a way that gets attention and moves the viewer to take action or resolve to learn more. As the international scientific community raises alarms about the state of the world, and particularly its marine life, it is the people in our own communities who have the ability to help protect and sustain our home places. An artistically rendered community map is just the tool to encourage this awareness.

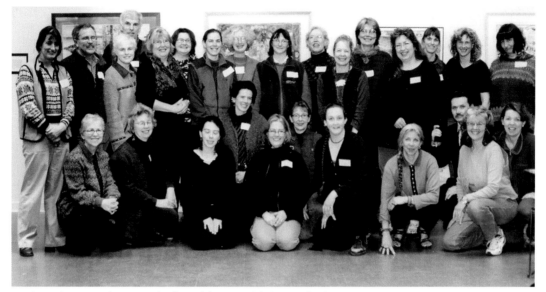

Local coordinators and artists at the first exhibition on Salt Spring Island in 2001. PHOTO BY SHEILA HARRINGTON

As the individuals involved in this project took stock of who we are and what we have here, an overarching view of the bioregion was revealed. Few of the natural and cultural features from just a hundred years ago still remain, and an even more determined call came forward to protect and conserve them: on Denman the maps were made to show and celebrate what they still have, in spite of immense loss over the last decade; on Gabriola, the makers of one map became aware of how little they had protected, and the need to do so; on Bowen, the maps helped to protect amphibians and preserve cultural and historical knowledge; on Hornby and Thetis, people didn't want to reveal too much and instead chose to use the maps to demonstrate how vulnerable they are; on the Penders, they wished to foster discovery, increased education and the conservation of specific areas; on Saturna, they hope the map will assist in protecting local people and places once they are the hub of a new national park; on Savary, their map directly helped to save their precious dunes; on Salt Spring, one map was effective in preserving Canada's largest Garry oak woodlands, and the other maps showed foundations—First Nations place names, precious watersheds and an agricultural heritage; on Lasqueti and Mayne, the maps inspired pride in their communities and led to more and more maps; on Kuper, an ancient community was revealed; and on Galiano and Gambier the maps helped to build bridges in a divided community, encouraging both natural and cultural preservation; on Texada, the most industrial island, the artist exclaims, "We simply must protect them!"

These islands are so dedicated to stewardship of their lands that 12 of the 17 islands have their own land trust or conservancy organizations, and new ones were forged during the project. As we look at the overall picture these maps have exposed, it shows that we are beyond sustaining our individual homes and communities. We need to restore and conserve nature—to protect the web of life that binds us all together. Through community we can help each other and expand our circle of knowledge and support. It is in our own self-interest to include the whole Earth in our greater community; the world is one connected system.

"Universal responsibility is the best foundation both for our personal happiness and for world peace, the equitable use of our natural resources, and, through a concern for future generations, the proper care for the environment."

—Tenzin Gyatso, the 14th Dalai Lama

Maps as Tools for Self Discovery

Mapping has many uses for education and conservation, but it is also a tool for personal exploration of our identity in kinship with our community. Mental mapping is common in business and psychology; people simply put ideas and themes they have brainstormed onto blank paper and then connect these concepts and relationships in a network of lines. Mental mapping is the geography of perception, and as a field of study it was first articulated in 1974 by Peter Gould of Penn State and Rod White of the University of Toronto, in their book *Mental Maps.*

In Canada, Marlene Creates has published two books on personal memory mapping: *Places of Presence: Newfoundland Kin and Ancestral Land, Newfoundland 1989–1991* and *The Distance Between Two Points is Measured in Memories.* Creates was seeking a route to her own identity. Brought up in Montreal, she moved to Newfoundland, where she had maternal roots. Once there, she explored her surroundings and history artistically, through maps. She asked other people to map their memories of home and discovered that women and men almost always drew their maps from a different perspective: women tended to draw the immediate vicinity, while men would draw a broader area; women would render a shoreline at the top of a map whereas men would place it at the bottom. These and other personal and psychological discoveries were revealed in this artist's search for her home and her place within it. For Creates, the artist is both the illustrator and the subject of the map.

Another type of mapping that follows this route of self-discovery is presented in *You Are Here, Personal Geographies and Other Maps of the Imagination,* by Katharine Harmon. This remarkable collection of personal maps displays artistic images ranging from the Topography of a Face by Gerald Fremlin to a visual poem-map by Scottish poet Edwin Morgan, depicting the geographic range of the chaffinch. Thus, maps are useful for the geographer, the psychologist, the conservationist and all of us who care about our relationships to nature, place and each other.

Many Aboriginal societies, including the Coast Salish, teach that we are part of the world, and it is our destiny to cooperate with all other beings. The perception that we are separate from the world and other creatures, and that we are born to dominate it, is probably a psychological and linguistic "miss take": the Christian Bible's statement that humans should have "dominion" over the Earth may have been a call for stewardship, one definition of dominion in earlier days.

As the artistic community maps in this collection reveal, we are not separate from each other, the world or other species. We are all connected by watersheds and oceans, energy and food sources from afar, and animal and plant systems that provide our air, water, soil and food. This perception of separation is understandable, given that we hadn't mapped our kinship with our communities.

Medicine Beach Map on Pender Island BY MICHELLE MARSDEN

Mapping The Future: Guideposts from the Islands

This project's exploration of our communities and the development of these new maps have brought us a deeper understanding of both the past and current relationships between ourselves and other creatures. People who have seen

the maps, and those who participated in making them, have come to understand more about our dependence on the land and waters, the wealth that we have here and of the communities far away that enable us to thrive. Some of the information that these maps have uncovered shows clearly that we have very little left of the resources that are the basis of our abundance. Historically, like much of North America, these islands were once teeming with marine life, huge and diverse trees and plants, and wildlife.

"There was no way you could starve in this country. We had so much of everything. It would be impossible to starve. There was so much food, it was everywhere. This is why I say our people were so rich." [7]

—Dave Elliot Sr., Tsartlip band, Wsanec

As Dave Elliot's son John explains in the text that accompanies the Wsanec map in this collection, all creatures are our relations. Perhaps if we understood this, we would be more thoughtful about the future. The idea of unlimited growth as the basis of success is another "miss take" that has led us down a dangerous path. Everything in nature cycles: it is born, grows and in its death provides renewal for the next generation.

Today's successful economies have been based primarily on an abundance of resources and large energy and transportation systems; because we are islands, the limits of the resources, and of the systems that allow us to import and export goods and services, are more obvious. In a small community one knows the people whose hardware store depends on local rather than off-island shoppers, or the people who are laid off when the organic cooperative doesn't get the support it needs to survive, or the local fishermen and -women whose livelihoods have been affected because there are hardly any wild fish left. The feedback loop is closer, and we realize that our own choice to go off island or travel farther

to buy that cheaper toolbox, loaf of bread or farmed salmon has led to these difficulties.

On some of the islands, people are living off the electric grid, using wind, solar and water systems that they have created independently or in cooperation with their neighbours. The islands are known for their barter, trade and sale of local produce, animals, goods and crafts; many have free stores and continue their exchange of heritage and non-hybrid seeds at fairs. It is essential to identify and maintain both the natural ecosystems and these rural systems of cooperative living.

Does part of the route to sustainability lie in recognizing seemingly complex relationships, rather than denying or ignoring current reality? One guidepost is to reinhabit our communities, educating ourselves about their histories and their natural and cultural diversity. Thus we may come to know and have compassion for the beauty, importance and values of the people and creatures with whom we share our home places. All are sacred. Let's respect and honour our differences and stop denying the problems we face. Overpopulation is real; deforestation is real; we are running out of the oil that is the basis of our modern world. Rather than increasing mining for new sources of oil, gas or coal, polluting our water and destroying the habitats and livelihoods of locals, let's look to greener energy alternatives. We are part of nature. We can think and act beyond our own needs, and care for and consider the requirements of other creatures and our children.

Today, we tend to mistake the globe for the planet—the symbol for the reality—the abstract for the concrete. Rather than generalities that tend to ignore the people, creatures and habitats of a region, artistic community maps impart specific, intimate knowledge that is easily absorbed, often eliciting regard and care for a place. The Islands in the Salish Sea maps celebrate the interwoven communities of plants and animals and people, revealing a living tapestry that is our home place, planet Earth.

The Community Mapping Process: Mobilizing Information, Art and Love of Place

Judi Stevenson

Starting with a Sense of Place

My own sense of place was implanted in childhood. I grew up on the edges of Nanaimo when it was still a small town and its footprint on the land less ruinous than it is now. A solitary kid by choice and circumstance, I rambled freely through a marvellous world of water and woods and small wild things. Sometimes on Saturdays, I would go with my dad to the Pacific Biological Station when he went in to check his experiments or catch up on paperwork. He would leave me to study the spiny and scaly creatures in the tanks or, like Alice down the rabbit hole, disappear into a microscope and enter an alternate reality. Those experiences taught me wonder at the complexity of life and respect for the "right to be" of all living things.

Painted tealia and giant red urchin at Tilly Rocks, South Pender. PHOTO BY DEREK HOLZAPFEL

After 25 years of living far away from the Pacific coast, I came to Salt Spring for the first time in 1989. Quite unexpectedly, the mossy damp of the air, the particular shades of green in the forest, the scramble of small crabs on the beach, the racket and plummet of a kingfisher, caught me by the heart and held on. It was like a return to my childhood. Without ever having been exactly here before, I had rediscovered home place. A few years later, I came to stay.

The amount and rate of change to the fabric of the island that I saw every day was troubling. I began to wonder, how could this place be kept the way it was when I found it —yes, already transformed from its pristine state by the axe, the plough, the chainsaw and a growing number of monster homes, but still hanging on to remnants of its functioning ecosystems and human vitality? A thought flashed into my mind, pretty much out of the blue: *everything that's important here should be captured on a map.* I am no geographer, so I wasn't even sure what that meant, let alone how to go about it. The thought lay dormant for almost a decade, until I met first Briony Penn, then Sheila Harrington, and together we hatched the Islands in the Salish Sea Community Mapping Project.

The Heart of the Project: Education

Community mapping (once I began to understand it) seemed like the answer to a search I'd been on for years to find a new and engaging means of environmental education. It has the elusive power I'd been looking for, to connect people more deeply with their particular place—the shape of it, the details and features that define it, the processes and relationships that are its life force—and, via that exploration, to *feel* their way towards more resolute action in defence of the irreplaceable Earth.

Artistic community mapping is a mechanism that takes "education" far beyond the familiar round of workshops and lectures and nature shows on TV. Those learning tools appeal primarily to the mind; they are essentially passive. Mapping done by the people who live in a particular place offers a more active, visceral and multi-faceted experience of that place. The process brings people closer, I think, to the state of mind that Stan Rowe, one of Canada's first ecologists and the man who established the phrase "home place," wanted us to attain.

Rowe wanted us to understand ourselves as one small part of a living system much bigger than we are—the Earth—and to develop an attitude of profound empathy with the workings and beings of its component ecosystems. He came to his insights, in part, through his explorations of the grasslands of southern Alberta where he grew up. Even then, in the 1930s and '40s, Canada's native grasslands were a disappearing ecosystem. As a scientist, Rowe studied these places; as a citizen, he used his knowledge to champion their protection. We can't all be scientists, but as citizens we can all get to know our home places a little better and perhaps become their champions.

Community mapping is a good way to do that. It entices people to explore hands-on what's around them, noting what's significant and making a record of it for others to learn from. To my mind, that is definitely a recipe for effective environmental education and, just maybe, for more and better champions.

"Not only are we in the Earth-envelope, we are parts of it, participants in it, born from it, sustained and reproduced by it. To really grasp this symbiosis is to change radically our appreciation of humanity in the world ... And what we [appreciate], not superficially but in our hearts and imaginations, has great power over how we act."[8]

—Stan Rowe

Who Is "We"?

Bringing our interlocking ideas and complementary skills and passions together in the summer of 1999, Briony, Sheila and I constituted ourselves as the overall coordinators of the Islands in the Salish Sea Community Mapping Project, under the sponsorship of the Land Trust Alliance of BC with support from the West Coast Islands Conservancy. The idea of a bioregional community mapping project, involving as many as possible of the major islands in the Strait of Georgia, seemed like the perfect millennium undertaking: it would be a celebration of the glories of the islands and at the same time a record of what is fragile, endangered and disappearing as a point of reference for the future.

The first challenge was to define the region for our purposes and then negotiate the participation of other islands in the project. We wanted to discover and show the commonalities among the smaller populated islands, excluding Vancouver Island, which is so large a land mass that it seems to us on the little islands almost like another mainland, another continent on our western flank. There are about 20 of these smaller populated islands in the Canadian half of the Salish Sea, along with literally hundreds of even smaller islands and islets, many of them unpopulated. The Islands Trust, an innovative regional planning agency with a mandate to "preserve and protect" the natural and rural character of the islands in its jurisdiction, includes roughly two thirds of the total.[9] We could have limited the scope of the project to the Trust area, but since one of our purposes was to link up the bioregion as a whole, we included four key populated islands that lie outside its present boundaries: Texada, Savary, Cortes and Quadra.

Reaching out to them all was not straightforward: there are surprisingly few links between the islands, and no one network that connects them all. Most residents of one island have little familiarity with the others, except perhaps as occasional visitors, and only a minority have working knowledge

of those neighbouring places. Briony and Sheila are among the few: they have good connections on the other islands in the environmental, conservancy and land trust movements. Starting with lists they prepared, we set about contacting likely participants.

Our goal to start with was to find just one person from each of the islands on our list willing to come to a weekend workshop on Salt Spring, to hear and talk about mapping generally and the project specifically. We were hoping that they would take on the role of local coordinator for the project on their islands—the critical link between the overall project and each community. We were committed to the idea that the most vital maps are those made by people who live in and love the places mapped. Only if we could enable people to work together on each island to record what mattered most to them would the maps be true expressions of community ideas and values.

Liftoff: Engaging the Islands

To our delight, representatives from all over the Salish Sea agreed to come to the first workshop in January 2000. They came from as far away as Gambier and Quadra, taking as many as three ferries to get to Salt Spring. They came, in fact, from all of the islands that ultimately participated in the project, except Texada and Kuper, with which we made connections later. Some were keen on the idea of mapping their islands right from the first phone call; others came because we'd piqued their curiosity and because it was a rare opportunity to meet like-minded people from other islands.

In order to tantalize and excite people with the breadth of possibilities that community mapping opens up, the workshop included presentations by:

- Briony Penn, on the depth and richness of interpretation that local knowledge and artistic interpretation can bring to mapping, using her own map of Fulford Harbour on Salt Spring as the example;

- Sheila Harrington, on bioregional mapping, overlaying information to reveal relationships among human and natural communities in a locally defined bioregion;
- Judi Stevenson, on the opportunity to engage in hands-on environmental education and community-building;
- Briony, along with landscape architect Kathy Dunster (from Bowen), on basic mapping techniques;
- Jan Kirkby, a biologist then with the Conservation Data Centre and a resident of North Pender, on sensitive ecosystem inventories;
- John Munro, a land and resource planner for the Kwakiutl Laich-Kwil-Tach Nations Treaty Society, on First Nations' perspectives on mapping;
- Jacky Booth, an oceanographer from Salt Spring, on Geographic Information System (GIS) mapping;
- Maeve Lydon, an activist from Common Ground in Victoria, on mapping as a tool of community development and empowerment.

Our main purpose was to test the basic project ideas and see if they would catch fire. We were perhaps a little anxious. Would other islanders find what we were proposing interesting or valuable in any way? Would they see the huge potential that we saw in community mapping? Would at least some of those who came take on the challenge of activating their own islands in the role of local coordinator?

In hindsight, the pivotal part of the weekend was the afternoon we set aside for participants from all the islands to address each other. One by one, they walked up to the front of the cozy meeting room in Salt Spring's venerable Beaver Point Hall and spoke of their love for their islands, their fears for the future and their desire to find ways to stop the worst excesses of resource extraction, suburbanization, gentrification and what might be called Whistlerization—the transformation of living communities into "destination resorts." Quite visibly, each person's tale of change and loss on his or her island touched chords in the others. At times, the whole room sighed

and murmured in response. Although in their daily lives they were most often focussed on their individual islands, our guests on that afternoon were recognizing one another as members of a larger community: the islands in the Salish Sea. The winter light was fading on their faces as the session ended, but excitement about the project idea was building. MARILYN JENSEN, from Denman, described a painful, three-year clear-cut logging operation covering one-third

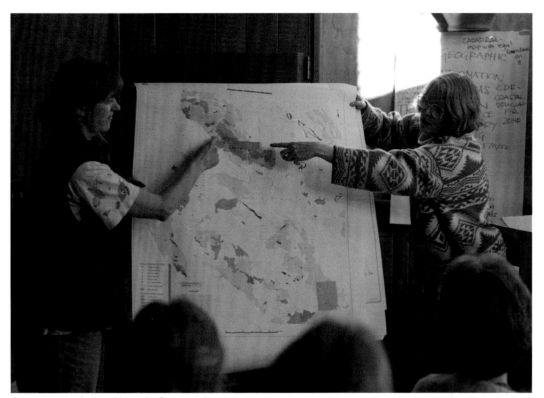

Briony Penn and Jan Kirkby at the first workshop in 2000. PHOTO BY JUDI STEVENSON

of the island and producing a great sense of powerlessness among islanders unable to stop its ravages. They were trying to turn their attention to the remaining two-thirds, she said, and to intensify their stewardship efforts there. She thought that the mapping project could be a positive, healing experience for her island.

SABINA LEADER MENSE, from Cortes, talked about the perspective she had gained on these islands from having travelled widely around the world. They *are* special, she said, both the places and the people. She welcomed artistic community maps as a way to celebrate who and what we are.

PAUL PETRIE described a mapping project he was involved with on South Pender, making a record of a very special open headland with children from Grades 3 to 6. The children, he told us, have become self-appointed caretakers of this land as a result of their hands-on experience of mapping it.

PRISCILLA EWBANK, from Saturna, talked about the demographic changes on her small island, including the fact that they were in danger of losing their school for lack of children. At the same time, the island was becoming an increasing focus for tourism. She feared that the old intimacy, slow pace and sense of community were in jeopardy. The kind of mapping we proposed, she thought, could be a way of preserving community spirit and engendering a sense of responsibility for the land in all who live in or visit the islands.

In the following weeks, commitment to the project solidified. By early spring, we had lined up a local coordinator and a host organization on almost every island. (The idea of the latter was twofold: the coordinators needed home-based support, and the overall project needed an established group in each community to provide sponsorship and formal financial records.) We had secured early-stage funding from local, provincial and federal sources, and continued to fundraise until we had a small stipend for coordinators and artists, and some basic resources for training workshops, exhibitions and project administration. We prepared a simple agreement, setting down our commitments and everyone's responsibilities. By summer, the project was well underway on just about every island.

The Active Mapping Stage

The local coordinators were the driving force of the project on every island: the complex tasks of mobilizing the communities and ensuring that interesting and relevant research got done were theirs. Although a few were already knowledgeable about mapping, most were not. No matter: technical know-how was not a prerequisite for the job. What we were looking for in local coordinators was an instinctive grasp of the potential of the project, strong commitment to and insight into their communities, the capacity to engage and inspire others, imagination and creativity, organizational and research ability, the courage to work at the edge of their expertise and an unquenchable love for these islands. We found all that in every one.

To help them get going, we provided the local coordinators with a number of tools:

- the "launch" workshop described above, which featured keynote speakers with lots of ideas about what can be mapped and a display illustrating some of the possibilities in non-traditional mapping;
- a copy of *Giving the Land a Voice: Mapping Our Home Places*, a manual that lays out many of the themes and techniques of local and bioregional mapping;
- the promise of more support to come, including "how to" mapping workshops on their islands, led by Briony, as well as other events that we encouraged them to arrange to meet their own needs.

The amount of structure or definition that we, as the overall project directors, should give to each island was a matter of extended debate among ourselves. In the end, we asked for only three major things: some reference to special or endangered features of the natural world; some reference to First Nations' interests and past occupancy; and some reference to more recent human settlement and activity. As well, we requested a "key" or legend to explain each map, clear calligraphy of a certain size and vertical orientation for all maps.

Briony Penn arrives on Savary to lead a "barefoot" mapping workshop.
PHOTO BY JUDI STEVENSON

But mostly, we handed local coordinators one of the scariest things on Earth—a blank piece of paper—and said: it's your island, get people together and figure out the maps you and your community want to make. The "sweet muddle" (as the coordinator from Mayne called it) of finding their way to what they wanted to show and say about their islands was something they had to do for themselves. Getting lost, getting excited, getting frustrated, solving problems, making discoveries—it was all part of the process, and, of necessity, it was *their* process.

One of the earliest and most universal challenges was deciding precisely what to map on each island. The possible subjects for community mapping are unlimited. When we first discussed mapping just Salt Spring, we thought we might go about it by inviting every community group and organization to make a map of the island from their point of view. There could have been dozens—from an eelgrass map by the Waterbird Watch Collective to a floral map by the Garden Club to a map of sacred places by an all-faith gathering of the spiritually inclined to a map of crimes and accidents by the Community Crime Prevention Association. Each one would have told us something we didn't know about our island as home place.

This wide range of possibilities is perhaps a hard message to take in at first, given that we've all grown up with more traditional maps: school atlases, road maps, trail maps, navigational charts, neighbourhood lot layout maps (cadastrals), computer-generated GIS maps made by scientists and resource-extraction companies, etc. It bends the mind into new shapes to think in terms of maps made by children, by elders, by poets and storytellers, maps charting political struggles—maps that ignore or defy convention.

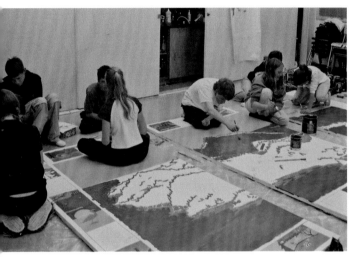

Students from Island Pacific School making their map of Bowen Island.
PHOTO BY KATHY DUNSTER

In the face of almost unlimited choice, each island had to go through a period of consideration: weighing the alternatives, listing the possibilities, deciding how to decide. In some places, there was at first a kind of hesitancy or holding back as coordinators and local project participants worked through a variety of concerns that surfaced.

1. DEFERENCE. At a workshop on Galiano to get the project going there, a huge, bare map of the island was mounted at the front of the room; the people who came were asked to mark on it a place they had a special feeling for and tell the story. It was surprisingly hard! People stood back from the paper, making faces, trying to get up their courage. Most put tiny, faint marks, as if fearful of "doing it wrong," and then quite comfortably told wonderful stories about their special places.

Our answer: demystify the process. Make informal maps and fill them full of provisional information by hand without preconceptions about what it should look like; scribble on base maps; get people to sit there until they can screw up their courage; loosen things up by getting kids involved; remember that the artists will be coming along to turn all that basic material into gold.

2. FEAR OF LOSS. On Cortes, Thetis and elsewhere, people were extremely wary of mapping anything vulnerable, for fear that vandals—or even well-meaning hikers or kayakers —would go there in numbers great enough to destroy the ambience of their special places and the living things that survived there. Somebody on Cortes suggested that they create a map of the most sensitive places on the island in the form of an elaborate cake—and then, in a big community celebration, eat it all up.

Our answer: if there are things you don't want to show, don't show them. Or at least, don't locate them so precisely that they can be found by anyone who looks at the map. Place things in the general vicinity of their real location. Or, create a border around the map, where you can illustrate any number of precious things without giving away their exact location. Several islands, including Texada, Mayne and Savary, adopted and adapted the border idea.

3. FEAR OF DISCOVERY. Residents on islands that were already struggling with big influxes of visitors every summer, like Hornby, didn't want to attract still more by developing "a pretty tourist map." And a few residents on the less-travelled islands weren't sure they wanted to make a map at all—to guard against being "found out" by the rest of the world. For at least one coordinator, this sentiment almost swamped the project.

Our answer: it is too late to avoid "discovery." We're in more danger of being loved to death than bypassed. One of the goals of the project is to convey to newcomers and visitors how vulnerable these islands are, in order to help

Salt Spring's MapFest 2000 appealed to all ages.
PHOTO BY JUDI STEVENSON

inspire respect and good stewardship: if other people see the reverence and love we put into these maps, perhaps they will be influenced to join us in protecting them. At the very least, these "millennium portraits" will serve as a baseline against which we can measure change in the coming decades and rally islanders to hold on to what we had in the years 2000–01.

On some islands, the problem was never one of deciding what to map: it was deciding what *not* to map. I sat in on meetings of the community-mapping group on Salt Spring at the beginning, and the wealth of good ideas seemed inexhaustible—to the point where many of us began to wonder if the group would ever actually make a map. (They did: that group produced the wonderful Fulford Valley map.) On most of the islands, as time went on, ideas for maps flew thick and fast.

Coordinators and their communities and/or mapping groups dived into the information-gathering stage with gusto and imagination. They made good use of conventional sources and mapping methods including:

- existing maps, both contemporary and historical, delving into university and government as well as local collections;
- aerial photos;
- field surveys and inventories of such things as buildings (e.g., old barns), land types (e.g., sensitive ecosystems) and species' occurrence or abundance;
- written information in local and provincial archives and libraries;
- interviews with long-time residents and local experts.

They also came up with great ideas that reflected island ways and culture: setting up a table or booth at the Saturday market (or a community fair) and asking people to mark various things on a base map of the island; having an exchange with local community groups about what should be mapped; boating around to have tea and discuss the land with long-time residents on isolated properties with no road access; collecting information at the general store; involving the schools. These activities were more than simply alternative methods of gathering information: they were mechanisms for involving a broad range of people in their communities both in the development of the maps and in getting to know their home places a little better. In the end, on most islands there was so much information that the challenge became one of selection and reduction, a process often carried out with or by the artists as part of designing the final image.

The Microscope and the Mandolin: Working with the Artists

The artists could be called the "magic ingredient" of a community mapping project—certainly of this one. Their ability to translate the facts and stories that resulted from the research process into vivid and engaging images is what enables these maps to speak so powerfully to so many people. Their work adds beauty, humour and emotion to the facts.

There's no hard and fast rule about when to bring the artists into a community mapping project. In this one, a variety of approaches was used. Some of the coordinators were artists and were thinking in images from the start, whether or not they created their island's map themselves. Some decided to work on content first and choose an artist to interpret it later. In other cases, artists were consulted at the outset of the community process, to build in a perspective from the arts in the planning and development process. Elsewhere, the artists were selected right at the beginning, on the basis of proposals solicited by the local coordinator, then reviewed and approved by the overall coordinators; the artists then did the research themselves, or compiled it in consultation with local coordinators and others.

The artists worked from the heart. They got involved because the project caught their imaginations and because they felt an affinity for its goals. At the same time, being selected as "the artist" was something of a plum. The project offered several benefits: a small cash honorarium, the promise of exhibition at multiple showings and publication of their work in this book. In a small community, making this kind of selection can be tricky, and coordinators were careful to go about it fairly. Most often, they advertised the project and asked interested artists to submit a proposal and samples of their work to a committee of some kind to assist in making the decision. The committee usually comprised members of the host organization and others with wide respect in the community.

Denman took a unique approach, inviting as many local artists as were interested to make a map, using the funding support supplied by the project to pay for all materials. The result was 16 maps, from which the overall project coordinators chose one to represent Denman in the atlas. (Galiano did something similar, producing fewer maps; the local coordinator set up a committee of community leaders to make the choice.) Sometimes, these being small islands, it was all a little more informal. But in every case, the "central committee" (as the local coordinators sometimes called Sheila, Briony and me) was sent a sample of their chosen artist's past work for final approval. We tried to do this with a light touch, respecting the autonomy of the islands and their selection process, but keeping in mind the goals of the overall project, as well as commitments to funders and long-term plans to publish the collection.

Artists made their maps in several different media (not including cake, to the best of my knowledge). The majority were rendered in watercolour, the medium most amenable to text, but there are quite a few in the collection that deviate from this norm. For example:

- Herb Rice carved and painted a cedar panel to make the map of Kuper;
- Leanne Hodges used recycled pulped paper to make a three-dimensional, bas-relief image of "The Shorelines of Quadra," which she built on a navigational chart of the area;
- on Salt Spring, Caffyn Kelley made a fabric map, "Cloak for a Watershed Guardian," in silks;
- on Denman, the array of maps included a video, a felted image, a photo collage, a three-dimensional topographical map built out of plywood, a map with sound effects and more;
- on Galiano, one of the maps was rendered in beadwork.

To me, a purveyor of words, it was interesting to discover that for many of the artists, incorporating text was

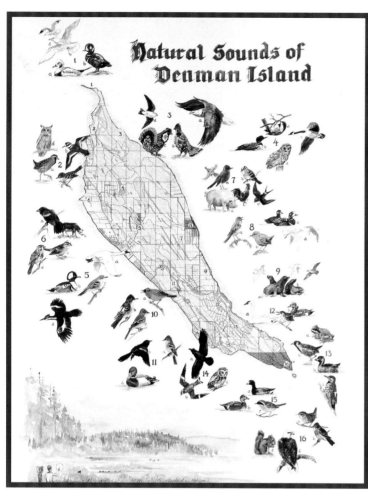

Sounds of Denman, by Peter Karsten, was accompanied by an audiotape of birdsong and other island sounds.

the end, so many of the maps were horizontal or "landscape" in orientation that we had to rethink the layout—probably a good thing, as it turned out. But take a look at the Bowen section for a demonstration that north really doesn't have to be at the top.

The contributions of the artists are essential to the kind of community mapping we are now recommending to other communities. Their strengths ranged from exquisite illustration to passionate vision; everything they brought to the project enriched it. Maria Van Dyk, coordinator for Gambier, summed it up this way:

> The power of this project stems from the emotional impact it has. The artist brings heart and soul to raw data and pure information. He or she is freed to capture the spirit of the data rather than its absolute accuracy. Our artist, Gloria Massé, brought the smell, the feel, the sense of Gambier to life by capturing aspects of its great natural beauty and its essential 'islandness.' So what we initially perceived as the biggest challenge in creating our map, working with an artist, turned out to be no problem at all. We learned the value of what the project coordinator advised: "Trust the artist."

a huge challenge. A couple simply didn't do it, which came as a bit of a shock to us as project organizers. We had not issued detailed instructions to "include place names" or "supply written information on your map." We took the role of text for granted—and we were caught with our assumptions showing.

Assumptions and conventions about maps and mapping were always under challenge during the process —that was intentional—but some simply wouldn't budge. For example, we had originally planned for all of the maps to be vertical or "portrait" in orientation: to be taller than they were wide, so they would fit onto a single page in an upright volume. We imagined an orderly layout with supporting text on each facing page. Several of the artists (and/or coordinators) just couldn't bring themselves to do it. "The island doesn't go that way," they said. "People here won't recognize their island if it's standing on its head." In

From Seventeen Islands Comes One Vision

With the benefit of hindsight, I can see a certain unplanned but wonderful rhythm to the Islands in the Salish Sea Community Mapping Project. From its starting point as a holistic bioregional portrait with goals and principles in common (at least in the minds of project organizers), it disassembled into 17 dynamic and intense local projects, with separate and distinct collaborations among the coordinators, mapping groups and artists on each island. Then in the end (with the exhibitions and this atlas), it reconstituted itself as the holistic portrait we'd hoped for—an eclectic and enchanting

collection of 30 maps of the Salish Sea region and its many facets, no one of which could tell the whole story by itself.

This dynamic between the whole and the parts became clear at the second all-islands workshop held on Salt Spring in March 2001, 14 months after our initial gathering. The maps were all supposed to be finished by then, ready for display, although we knew some would not be. Sheila, Briony and I waited in considerable suspense for them to arrive. We were about to see a series of works of art and research that we had indirectly brought into being but not directly overseen. And since one of the essential qualities of islanders is their independence and idiosyncrasy, inevitably some of the maps were going to confound our spoken and unspoken expectations.

Sure enough, some maps did take us by surprise: Cortes—an unexpectedly abstract image that arrived without a key or legend, which meant at first we were unable to decipher it; Hornby—a map rendered digitally by its artists, an option we had not fully considered; Gabriola #1—a map that originally included no outline of the island at all. These three maps in particular forced us (as they now force everyone who looks at them) to examine our assumptions about maps yet again. We had seen only a few before coordinators and artists from all the islands started arriving that Friday night, large bulky packages in hand. What were the rest going to look like?

As more and more maps were extracted from layers of packing, we could hardly contain our growing excitement. The maps were so beautiful, so stuffed full of good information, so different from one another, so rich. The coordinators and artists were excitedly exclaiming over one another's work as we laid them all out, getting them ready for their first collective showing. We were all a little dazzled. At one point in the evening Sheila dashed up to me and said, "Every one is perfect!" Exactly so.

Over the next two days, coordinators and artists filled the gallery at Artspring, on Salt Spring, with the stories of the individual community mapping processes on each island. Many of these stories are told, at least in part, in the pages of this book. But the "we" who were listening in rapt attention had changed. We were not just representatives of 17 separate islands anymore. Our home place had expanded: we were residents of the Salish Sea.

It was a profound shift in consciousness, like finding out all of a sudden that you're not an only child—you have siblings, you have a family. In the process of doing the project, we had built bonds among the islands that we would all be able to draw on in the coming years. But we had also made and set down on paper, so to speak, the connections that define a bioregion, a community of communities: commonalities of geography and ecology and history and economy, commonalities of challenge and struggle and celebration. In the exhibitions of the maps that followed in the next two years on almost every participating island, this fact became more and more clear. As splendid as each map is, the collection is more powerful still.

Those who came to see the shows on the islands seemed to feel this way too. They went from one map to another, comparing details, commenting on similarities and differences, seeing the region as a whole, sometimes for the first time. People who knew each other and perfect strangers talked to one another about what they saw, what they hadn't known about this island or that one. People came back— once, twice, several times—to pore over the maps, unable to drink in all that information at one go. They wrote over and over again in the guest book, "You must publish these, to keep the collection together." We hope the atlas that you are now holding in your hands will have something of the original impact.

The maps did quite a lot of travelling during the next 18 months or so, stopping for a weekend or a week on almost every participating island (a couple simply didn't have a venue for them), as well as Vancouver, Sidney and Victoria. They

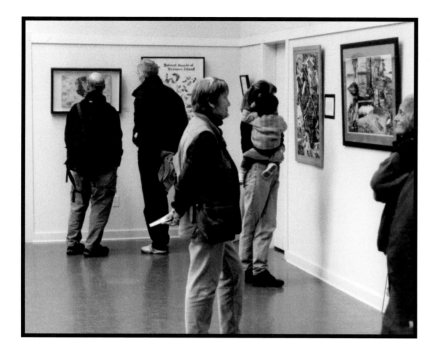

travelled informally, in vans and the backs of trucks, packed carefully in bubble wrap and cardboard, and unpacked with loving hands. They were always a hit, drawing steady crowds. Sometimes we regretted that we hadn't set up educational events to explore their meaning and "the future of the islands" in each location, but we were running out of energy and money. And maybe it was better for the maps to speak for themselves.

The first exhibition of Salish Sea maps, Salt Spring, March 2001. PHOTO BY JUDI STEVENSON

This is a real surprise! I had no idea how mapping and art are so complementary and could be so broad in concept, vision and execution. [Mayne]

What a great way to bring all the island communities together. [Cortes]

A project like this should be happening everywhere. It's profound. [Courtenay]

An outstanding blend of art, history and science. Most impressive! [Gabriola]

We should have copies of all of these on display permanently on all the islands to remind ourselves! Thank you to the coordinators and the devoted artists. [Salt Spring]

Thank you. You've got the soul of these places down for future generations. [Saturna]

Words fail me. Long may these maps continue to remind people of the fragility of our precious Earth. [Sidney]

I wish everyone could see this show at least four times! [Bowen]

Extraordinary! Would love to have them in book form in order to spend more time with them. [Galiano]

Two hundred years from now, this collection will still be of historic interest and precious. [Sidney]

Such beautiful and creative maps. Really brings home how unique each island is and yet how much we have in common. [North Pender]

Delightful to study and very thought-provoking. I am inspired to try to do something similar in my community. Thanks! [Mayne]

Impacts and Legacy

Although dozens of those who saw the exhibitions said, "All the maps should be kept together, on permanent display," there is no place connected to the islands that is big enough or accessible enough for 30 large maps to hang for all time. More importantly, they needed to go back to their home communities, where so many people have a sense of pride and ownership in them—as well they should, having participated in their creation. Besides, the maps have a job to do there: reminding people who we were as islands and as islanders in the millennial year 2000–01, and issuing a call to "stand on guard" (as the Canadian national anthem says) for what we love and cherish.

For the most part, the maps are contributing to their communities still. Many were donated outright by the artists (with whom copyright resides unless they assigned it elsewhere) and hang in community halls or other public places. Some are also in wider circulation: they have been reproduced in the form of cards, placemats, posters and high-end prints. Separately and together they have been used to raise the standard of everyday knowledge about the islands, send messages to politicians, rally support for stewardship initiatives, raise money for land acquisition and protection, and inspire more maps.

Priscilla Ewbank, the local coordinator on Saturna, has eloquently described the power of her island's map to support sensitive community development. She sees it as evidence of two essential truths about Saturna: first, that the community includes flora and fauna as well as people, living interdependently on a finite rocky extrusion from the sea; second, that ordinary people on a little island on the edge of Canada can create a valuable self-portrait, pulling it together out of their own expertise and creativity. Its beauty and "uncommon way of being a map," she has written, is the basis of its reminder to politicians, bureaucrats and all outsiders to think carefully about any new development there, such as

the new national park now dotted over several of the southern Gulf Islands.

Liz Webster, the coordinator on Savary, arranged for their map to be reproduced as a poster and in a small placemat size. Both were bought up avidly by islanders, few of whom are year-round residents. According to Liz, they have been very effective in raising the general level of awareness about Savary's unique features, natural history, ecologically sensitive areas, erosion problems, water issues—all the information on the map. They have also helped in critical land-preservation work. The flip side of the placemat makes the case for protecting "the dunes": now, about a third of the island is protected. Liz credits the map as having "played an important role in this achievement."

Lynda Poirier, the coordinator on Thetis, found that the idea of mapping her island raised some opposition among a small but vocal minority. As a result, people who were interested in the project drew back for fear of offending their neighbours by gathering information that would somehow "reveal" Thetis to the world. But the old maps and reports and data and stories about the island that she discovered when she began working, mostly by herself, on the research for the map inspired her to form the Thetis Island History and Conservancy Group. Two years later, when the exhibition of all the maps was presented on Thetis, she was pleased to hear from some of the people who had opposed the project that they could now see its value. Reproductions of the map of Thetis are selling well and the money raised will support future projects undertaken by the History and Conservancy Group.

Not the End

The project is over but the maps, of course, live on. Perhaps even more importantly, the core ideas of community mapping are being taken up by people throughout the Salish Sea and elsewhere, and given new shapes and meanings to fit

the needs and dreams of their home places. These ideas have endless potential to be embraced by other communities and regions, used by the people who live there to record what matters and extend awareness of the necessity to protect all the natural and cultural features of all the home places in our suffering world.

Beautiful, ecologically sensitive Walker Hook (*Syuhe'mun*) on Salt Spring, now the site of an onshore sablefish hatchery. PHOTO BY BART TERWEIL

Somewhere along the way in our multi-year process, one of the local artist/coordinators, Caffyn Kelley from Salt Spring, used the word "subversive" in something she wrote about the project. We all liked that word very much as a way of describing what we were doing. The essence of community mapping is to be subversive of "normal" or official mapping. We hope that those who establish community-mapping projects elsewhere will continue to be subversive in all the ways we tried to be:

- Maps have traditionally been made as a means of charting the unknown, a means of documenting new information resulting from exploration. We wanted to chart what is known: the old and disappearing knowledge of our islands that community members possess or is mouldering in historical and scientific documents in distant, disparate agencies.

- Maps have often been made to communicate pathways, to show how to get from point A to point B. We wanted to preserve pathways that are being paved over, whether they are deer trails or hiking trails or country roads or paths more metaphorical.

- Maps have long been used to help people get farther and farther from home. We wanted to reverse that impetus: to help people see home more clearly and be more rooted there, by making pictures of the land as a home place for all the creatures who dwell there.

- Maps have also been used as tools of separation and domination: legal documents showing the boundaries around private property and nation states, establishing the relations of ownership and rulership. We wanted to portray another reality, the reality of shared lands and waters, of the history and everyday experience that connects us: in essence, the heartfelt bonds of community.

The Islands in the Salish Sea Community Mapping Project got its energy from several very BIG ideas—some explicit, some more dimly sensed. The swirl of ideas grew to encompass many of those that lie at the heart of living responsibly on the planet:

Earth-bioregion-neighbourhood-home place

plant-animal-human

story-science-art

love-loss-resistance-conservation.

To some extent, these ideas touched everyone who participated in the project: those who gazed at the maps and absorbed their embedded messages of awe, enchantment, humility and love, and those who made each map as an expression of our collective commitment to safeguard our home place—the islands in the Salish Sea. If these ideas touch the readers of this book in a similar way, our work will have been not an end, but a beginning.

Unravelling a Few Threads of History

Kathy Dunster

SINCE 1859, THREE DISTINCT, BUT deeply intertwined threads of history have evolved on the islands in the Salish Sea, and their effects appear as themes for the maps in this book. The first is the slowly unfolding natural history of the landscape that shapes, and has been shaped, by ecological processes and the countless activities of people. Another has survived in the oral, pictographic and archaeological accounts of First Nations communities and the third is a record of the more recent stories of non-Aboriginal immigrants. None of the three histories provides a stand-alone account of this bioregion's past, nor does any particular combination of the three tell the whole story. Sometimes the threads are loose and easy to unravel; at other times they are tightly wound and impossible to separate. We do not claim to be the last word on the islands and hope the maps will trigger many more. Whose history is recounted depends on whose stories are heard, understood and interpreted. Edward Chamberlain describes the importance of stories to the Gitksan First Nation:

"It happened at a meeting between an Indian community in northwest British Columbia and some government officials. The officials claimed the land for the government. The natives were astonished by the claim. They couldn't understand what these relative newcomers were talking about. Finally one of the elders put what was bothering them in the form of a question. "If this is your land," he asked, "where are your stories?"[10]

Through the process of their creation, the maps and narratives in this volume have become histories. They reveal the personal involvement of a handful of artists and coordinators and their passionate relationships with the islands. They also represent the shared experiences of the many hundreds of people who participated in the project. The maps are their stories. The relationships between islands form the common threads that weave together into the beginnings of a bioregional history.

Like other histories, this atlas doesn't tell all, in part because the creators of some maps do not want to reveal the most secret of their island's secrets and in part because no set of maps can tell all the stories. "Whose history?" is an important question, and the reader must be mindful that there are many stories and voices that contribute to the histories of the islands in the Salish Sea; some of them are tucked into the maps and text, while countless others are left untold for future projects. Because we can't provide a detailed account of all the islands within the covers of this book and some local histories are still waiting to be researched, we have provided a list of resources and references that you can turn to for more information.

The maps are rich with hints and glimpses of the islands, and of the people who lived here at the turn of the millennium. Many natural and cultural events and phenomena have influenced human settlement on the islands, and helped islanders develop community and identity. Because the islands share ecological origins that are depicted on several of the maps, many events and activities related to the land evolved in similar fashion from one island to another. Just as tools, boats, livestock, teachers, police, postal services, preachers and doctors were shared between islands, so too was essential knowledge about how to survive and thrive

during periods of adversity such as drought and economic recession. Other shared features include lapping tidal waters, overlapping traditional territories between Coast Salish tribes, and in more recent times, inter-island marriages that bond island communities together at the familial level. All this is rooted in a sense of place that shapes the distinct island cultures we are concerned about protecting today. And all are inextricably linked to the past.

Aboriginal History

Prior to European contact, the Native population of what became British Columbia has been estimated at 300,000 to 400,000, though there is considerable variation in the numbers proposed by scholars. Wilson Duff notes that by 1835, Native peoples had already been interacting with non-Aboriginal settlers for around 60 years, and that by 1865 the dwindling population was all that remained after almost a century of exposure to diseases, firearms and alcohol.

During the pre-colonial and early post-colonial periods, disease was the primary cause of catastrophic population losses amongst the native population. Of the many deadly diseases recorded, smallpox was the most devastating. The first contact between native persons and smallpox was in the 1780s, and a later epidemic in 1862 drastically reduced the population. As explained in the map narratives for Denman and Lasqueti islands, the impact of smallpox was direct and permanent, resulting in the extirpation of the Pentlatch tribe from those islands. Both the Hudson's Bay Company and colonial governments believed that absence meant abandonment, and declared unoccupied lands on the islands available for invasion and colonization by Europeans.

In the view of the colonial government of Vancouver Island, "whose land?" was settled when the Surveyor General of the colony of Vancouver Island began to demarcate reserves for "Indians" in the 1850s. When the united colonies joined Canada and became a province in 1871, a Joint Federal-Provincial Indian Reserve Commission further refined the reserves, always reducing the acreage previously set aside, and ignoring the appeals and requests of the First Nations to keep their traditional lands.

On the Gulf Islands the slowly evolving relationship between humans and ecosystems has created a culturally modified landscape. While food is necessary for human survival, some foods were cultivated, harvested and preserved in quantities that could be used for spiritual, ceremonial, social and trade purposes. The most significant First Nations influence on the islands is a consequence of the periodic use of fire for hunting and for maintaining the open meadows beneath Garry oak and Douglas-fir/arbutus woodlands. Important food and medicinal plants such as camas, wild onion, springbank clover, Pacific silverweed and Indian consumption plant grow, and were cultivated, in the meadows. After First Nations were displaced from the islands, settlers chose to protect their property from wildfires, and substantial areas of meadows and Garry oak woodlands were soon replaced with Douglas-fir forests. Across the islands, these forests represent a different viewpoint, the result of cultural decisions about how to manage the land.

Another enduring landscape modification was the shell middens created by Native peoples where shellfish was harvested along coastal shorelines and at inland and upland sites. "Midden" is a Scandinavian term meaning refuse heap. While the word has been used to help describe Coast Salish shell middens and burial middens, the Coast Salish peoples

OPPOSITE PAGE:

This map includes all First Nations reserve settlements on the map (including the five Sencoten-speaking First Nations in the Saanich Peninsula area—Tseycum, Tsawout, Tsartlip, Pauchaquin and Malahat). The legend provides a description of the First Nations who are not participating in the B.C. Treaty Process (hence no Statement of Intent), including four of the Saanich First Nations (the Malahat are part of the Temexw Treaty Association), in addition to the Semiahmoo, Esquimalt, Hwulitsum, Qayqayt, Qualicum and Kwikwetlem.

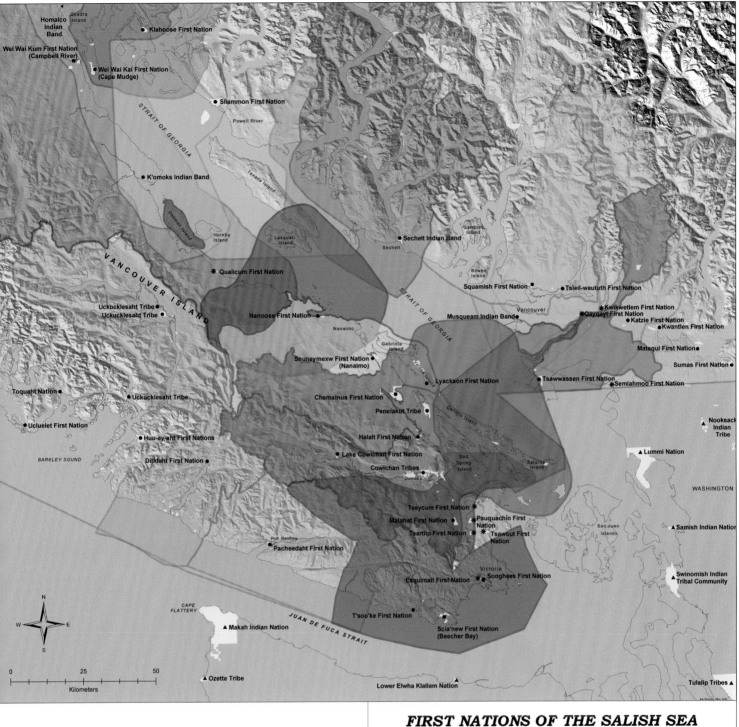

FIRST NATIONS OF THE SALISH SEA

- **Indian Reserves and Resevations**
- ● **Modern Settlements of British Columbia First Nations Participating in the BC Treaty Process**
- ✳ **Modern Settlements of BC First Nations _not_ Participating in the BC Treaty Process**
- ▲ **Modern Settlements of Washington State First Nations**

Core Traditional Territory (Statement of Intent) of First Nations of the Salish Sea

Hamalta Treaty Society
K'omoks Indian Band
Kwiakah First Nation
Tlowitsis First Nation
Wei Wai Kai First Nation
Wei Wai Kum First Nation

Homalco Indian Band

Klahoose First Nation

Hul'qumi'num Treaty Group
Chemainus First Nation
Cowichan Tribes
Halalt First Nation
Lake Cowichan First Nation
Lyackson First Nation
Penelakut Tribe

Sechelt Indian Band

Sliammon First Nation

Snuneymuxw First Nation

Squamish First Nation

Te'mexw Treaty Association
Malahat Indian Band
Nanoose First Nation
Scia'new First Nation
Songhees First Nation
T'sou'ke Nation

Tsawwassen First Nation

First Nations not currently participating in the BC treaty process have not made a Statement of Intent line publicly available and so do not have their Core Traditional Territory represented on this map.

Saanich First Nations
Pauquachin Tsawout
Tsartlip Tseycum

Esquimalt
Kwikwetlem
Qayqayt

Qualicam
Semiahmoo

Although the modern settlements of some of these First Nations communities are not on an 'Island in the Salish Sea', these Islands are an extremely important part of these First Nations' cultures.

Core Traditional Territory (Statement of Intent) of West Coast and Fraser Valley First Nations Participating in the BC Treaty Process

Nuu-chah-nulth Tribal Council
Ahousaht
Ehattesaht First Nation
Hesquiaht First Nation
Mowachaht/Muchalaht
Nuchatlaht First Nation
Tla-o-qui-aht First Nation
Tseshaht

Maa-nulth First Nations
Huu-ay-aht First Nations
Uckucklesaht Tribe
Ka':yu't'h'/Chek:t'les7et'h' Nation
Toquaht Nation
Ucluelet First Nation

Ditidaht First Nation

Pacheedaht First Nation

Hupacasath First Nation

Sto:lo Nation
Aitchelitz Band
Chawathil First Nation
Kwantlen First Nation
Kwaw-kwaw-a-pilt First Nation
Leq'a:mel First Nation
Matsqui First Nation
Popkum Band
Scowlitz First Nation
Seabird Island

Show'ow'hamel First Nation
Skawahlook First Nation
Skowkale First Nation
Soowahlie First Nation
Squiala First Nation
Sumas First Nation
Tzeacheten First Nation
Yakweakwioose

Tsleil-waututh First Nation

Katzie First Nation

Musqueam Indian Band

The Cheam First Nation and Shxwaha:y Village are affiliated with the Sto:lo Nation, but are not negotiating a treaty.

The Hupacasath, Ditidaht and Maa-nulth First Nations are affiliated with the Nuu-chah-nulth Tribal Council but are negotiating indepenty of the Tribal Council.
Not all members of the Nuu-chah-nulth Tribal Council, Maa-nulth First Nations and Sto:lo Nation appear within the extent of this map.

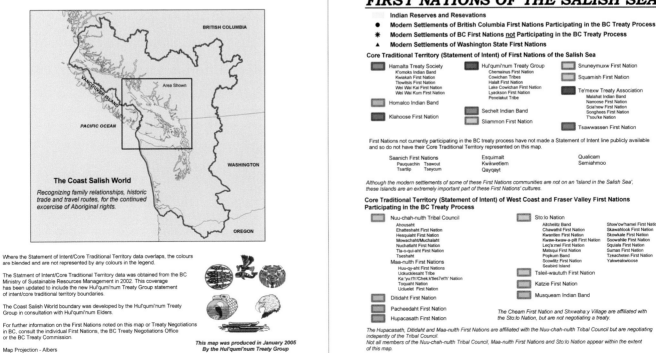

The Coast Salish World

Recognizing family relationships, historic trade and travel routes, for the continued excercise of Aboriginal rights.

Where the Statement of Intent/Core Traditional Territory data overlaps, the colours are blended and are not represented by any colours in the legend.

The Statment of Intent/Core Traditional Territory data was obtained from the BC Ministry of Sustainable Resources Management in 2002. This coverage has been updated to include the new Hul'qumi'num Treaty Group statement of intent/core traditional territory boundaries.

The Coast Salish World boundary was developed by the Hul'qumi'num Treaty Group in consultation with Hul'qumi'num Elders.

For further information on the First Nations noted on this map or Treaty Negotiations in BC, consult the individual First Nations, the BC Treaty Negotiations Office or the BC Treaty Commission.

Map Projection - Albers

This map was produced in January 2005 By the Hul'qumi'num Treaty Group

do not consider them simply refuse heaps. When edible parts of animals were consumed or preserved, the non-edible shells and bones were respectfully returned to the land. When other household items were no longer needed, they too were placed in the midden. Over centuries the shells became mixed with other organic materials, resulting in deep layers that helped raise shorelines above sea level. Kimberly Kornbacher, an archaeologist from Salt Spring, tells us that Coast Salish midden sites are very complex in structure and composition and can vary in use through time; a site could change in use from a seasonal village site to a permanent village site, burial midden or shell midden. Or, it could have several uses at the same time, such as seasonal village site *and* shell midden. Because of the gaps in First Nations histories, this complexity can be difficult to interpret and understand. As tangible connections to the human history of the islands, these archaeological sites are now recognized, appreciated and respected through the protective mechanisms of the Heritage Conservation Act and the federal Constitution Act.

During the last period of glaciation, coastal areas were compressed by the weight of the ice, and were often flooded as the glaciers retreated and melted. As lands emerged and sea levels stabilized, permanent villages were established near productive intertidal areas linked to salmon streams flowing into the Salish Sea. The Coast Salish people thrived on a variety of plants and animals that provided food, medicine and other household goods from the sea, estuaries and interior forest. Seven species of salmon were the primary catch, and they were so abundant that they could be easily guided into fish traps or scooped from the water with nets. Several hundred other kinds of wildlife and plants were also caught or harvested and consumed. Depending on the season, game of all types was hunted for food and other domestic uses. This diversity and profusion of foods are reflected in the various Coast Salish language dialects, which

are richly endowed with words for many different plants, animals and fish.

Current thinking and cultural decorum suggest that Aboriginal peoples should make their own maps and write their own histories; there is now an emerging and exciting Aboriginal mapping network in British Columbia that links technical mapping with traditional ecological knowledge and community information through the Aboriginal Mapping Network. The three First Nations maps in this book depict a world view that, in describing creation myths and traditional territories, extends back to time immemorial. Many of the other maps respectfully acknowledge the ongoing presence of the Coast Salish peoples on the islands; you will see some Salish language place names and listings of dates and events connected to the maps. These maps speak *of* Aboriginal peoples, but it is not our right to speak *for* them. Just because there are no Aboriginal place names on a map does not mean Aboriginal peoples never occupied particular islands. Loss of knowledge and the delicate matter of treaty negotiations mean that the First Nations maps are as complete as they can be at this moment.

The Wsanec, Kuper and Mayne island maps reveal the intimate relationship between the Coast Salish peoples and their environment. As well as sustaining families through the seasons and providing surpluses for economic security, the landscape has special spiritual values: throughout the Salish Sea there are many places where myths and legends originated, where supernatural powers are sought and received, and where the bones of ancestors rest. Coast Salish place names are closely tied to the rich experiences that ancestors first had with the land.

Recent traditional-use mapping projects by First Nations throughout the Salish Sea have sparked the imaginations of both Native and non-Native communities on the islands. Discoveries of archaeological sites inland challenge our assumptions that the Coast Salish peoples were tied

only to the coastlines. Some Aboriginal place names have vanished and others have lost their meaning. What was lost cannot be reclaimed; our hopes are vested in a future that respects First Nations' rights to reclaim their own historical ties to the islands in the Salish Sea, through new maps and language about places. This is clearly articulated in the United Nations Draft Declaration on the Rights of Indigenous Peoples:

"Indigenous peoples have the right to revitalize, use, develop and transmit to future generations their histories, languages, oral traditions, philosophies, writing systems and literatures, and to designate and retain their own names for communities, places and persons."[11]

Non-Aboriginal (European) Settlement

Although Great Britain colonized the region, the term "European" is generally used to describe the four waves of non-Aboriginal settlers that arrived on the islands from many other parts of the world. The first two waves of settlement were small and lasted only a few years, while the second two could be considered tidal waves that resulted in major landscape changes. The Royal Charter creating the Colony of Vancouver Island in 1849 first granted settlement rights to the Hudson's Bay Company and required that land title be acquired from First Nations before it was sold to settlers. Initially, Governor James Douglas negotiated treaties, now known as the "Douglas Treaties," with the extant First Nations in and around Victoria, Nanaimo, the Saanich Peninsula and farther north at Fort Rupert. At the time of the Douglas Treaties, the Colonial Office in London required that all effort be given to settling Vancouver Island first. In 1859 the Fraser River gold rush was rapidly winding down and the Colony of Vancouver Island was flooded with miners and recently arrived immigrants wanting to farm, but unable to because all the land around Victoria had been acquired by employees and friends of the HBC. Douglas was pressured to release new lands in the Cowichan District for settlement. Well aware that the Cowichan lands had not been relinquished by the Hul'qumi'num people native to the region, Douglas gave permission for the unsurveyed Chemainus District to be opened for pre-emption and settlement (ignoring the fact that these lands had not been surrendered either).

In a global sense, until a place is named and becomes permanently stuck on a map, it doesn't officially exist. This notion partially explains the pattern of occupation and settlement on the islands. In 1859, only rough maps and charts were available for the area we now know as the Salish Sea, and many islands were not depicted on any map. Most of the islands were a long way from the safety blanket of Victoria, where mail and supplies could be obtained and the Royal Navy could be called upon for military support when there were problems. For these reasons, islands close to Victoria were the first to be settled by non-Aboriginals. The others were left alone until they were mapped.

A group of potential farmers set sail on Edward Walker's *Nanaimo Packet* on July 18, 1859, to investigate the Chemainus District lands being offered and to report back to Douglas a week later. The returning men enthused about the potential for settlement on an island known then as Chuan, which they had passed on their way to Chemainus District. Chuan, also called Tuan and Tuam, was the name for Salt Spring Island that Douglas heard in 1852 when he took a canoe trip to Nanaimo. The name Salt Spring Island came after the springs were "discovered" at the north end, but the island also led a double identity for a time, when the Royal Navy charted the area and decided to rename it "Admiralty Island." Not wasting time, 29 settlers applied for permission to take up land on Chuan. By July 26, 1859, the first group had landed on the northeast shore of Salt Spring at Syuhe'mun, which was given the new name of Walker Hook.

Twenty lots were surveyed and the pioneers gave their new home place the name of Begg's Settlement after Jonathan Begg, who established a fruit tree nursery, general store and post office.

Figure 1. Adapted from B.C. Government base map. Begg's Settlement, Salt Spring Island

Two important events triggered the second wave of settlement. First, the HBC relinquished its rights to Vancouver Island and adjacent islands, and then the Colony of Vancouver Island created the Land Registry Act in 1860. The rush to settle land in this wave began in 1861 and continued through November 1866, when Vancouver Island was annexed to the mainland British Columbia colony. While most of the pre-emptions took place on Salt Spring Island, other outlying islands that captured the interest of a few settlers included James and Moresby in 1861, Mayne and Galiano in 1862, and Pender and Piers in 1864. With each passing year, more islands appeared on maps and were noticed and claimed by new settlers. During the Fraser River gold rush of the 1850s, Miners Bay on Mayne Island became a stopping

point along the way from Victoria to the goldfields. A few men remained on Mayne and Galiano, but land was quickly abandoned when it was discovered that Active Pass was also a main thoroughfare for First Nations; isolated settlers were unable to cope with surprise raids on their crops. The Cariboo gold rush in the 1860s again triggered the movement of men and supplies from Victoria to the Fraser River by way of Active Pass; some returned to become permanent settlers. During this period it was common for islanders to move around, looking for the best land to farm. For example, Theodore Trage and Henry Spikerman initially tested the farming capability of Galiano in 1862, moved to Pender in 1864, and then to Salt Spring in 1868, where they established large and successful orchards around Beaver Point and became key figures in the development of agriculture on the southern Gulf Islands.

Impacts on the landscape in the first two waves were relatively small scale and slow paced. Most farmers cleared and fenced very small acreages for orchards and crops. They chose the best soils and flattest parcels first, preferably close to a creek, spring or lake. These early settlers typically grew root crops such as potatoes, turnips and cabbages that stored well and could be eaten through the winter months. Like the Coast Salish peoples, early settlers relied on hunting and gathering. Collecting wild food was an important survival skill throughout the 19th century because it was free and available when needed. The Salish Sea was famed for its abundance of oysters, clams, mussels, crabs and other shellfish, which inspired expressions such as "When the tide is out, the table is set."[12]

Once log or pole houses were constructed, using small trees from the property, there was no immediate need to clear more land. Many settlers chose the open woodland meadows for their farms because there were few trees to chop down and the soils were deep; they supported pastures of native grasses that could be grazed by livestock, and crops

and fruit trees that could be planted by the farmers. Any remaining forests were generally left undisturbed because firewood was abundant and trees were often too big to cut down with a single-bit axe. Wetlands were also left intact; enough good farmland was available that it wasn't worth the effort to ditch and drain swamps and marshes.

The third wave of settlement followed the union of the two colonies and lasted from 1866 to 1871 when British Columbia joined Canada as a province. The first pre-emptions by widowed women were recorded during this period; Charlotte Foord of Salt Spring being the first in 1867. Some of the early subdivisions of the first land grants also occurred, providing the precedent for real estate sales and land speculation on the islands. The first permanent settlers landed on Gabriola Island in 1865, Saturna and Thetis in 1869, and Kuper and Hornby in 1870. A second wave of settlers arrived on Pender in 1867, bringing sheep and cattle for their ranches. Settlement was spreading across the Salish Sea.

In 1870, an omnibus Lands Act was approved by the legislative council, providing a comprehensive system for the orderly disposal of Crown lands, as well as rudimentary policies regarding the rights to fresh water. This set the ground rules for the fourth wave of settlement that occurred after Confederation with Canada in 1871 and lasted up to World War I. During these years land was granted to veterans returning from the Boer War, and further work delineating reserves was completed by the Joint Commission on Indian Reserves. Towards the end of the 1800s many new settlers arrived on the islands, including some with considerable wealth; they took over land cleared and abandoned by previous settlers. Others moved from one island to another in search of quieter lifestyles. With their savings, some islanders pre-empted or purchased small islands and islets located near their farms on the larger islands. As the Salish Sea became better known, interest expanded to the more distant islands; settlement reached Texada in 1871, Mudge, Jedediah and

Lasqueti in 1872, Samuel and Denman in 1873, Prevost and Bowen in 1874, Portland in 1875, Quadra in 1880 and finally Gambier in 1886.

This was a British colony, so it is not surprising that new immigrants from the British Isles dominated the settlement period. However, as early as 1858 Governor James Douglas developed open immigration and land ownership policies that allowed people from a variety of countries to settle on the Gulf Islands in the 1860s and '70s. Anyone could own land as soon as they became British subjects. These colonial policies encouraged a variety of ethnic groups, including Hawaiians, African Americans and Caribbean blacks, to immigrate and settle on the islands. Following Confederation with Canada, federal immigration policies increasingly favoured citizens of the British Empire and later the Commonwealth. The outcome was that new settlers in the third and fourth waves were mostly English, Scottish, Irish or Welsh, though the occasional continental European arrived from time to time to add cultural diversity.

The construction of the Canadian Pacific Railway sparked mass Chinese immigration to British Columbia; more than 15,000 men arrived on the west coast between 1881 and 1885, seeking short-term employment on the railway. By late in the century, Chinese Canadians remaining in B.C. had become part of the rapidly growing urban areas, although there were enclaves working on the Gulf Islands as woodcutters, farm labourers, fish packers, domestic servants and cooks. Chinese immigrants also established a commercial laundry on Salt Spring.

Canadian immigration policies influenced the cultural composition of the islands up to and beyond World War II, including the removal of Japanese Canadian farmers and fishermen from the coast. This had a devastating effect on the local and regional agricultural economies and on the social structure of the islands, as described in the text accompanying the Mayne Island map.

The Sea

From 1869 to the early 1900s, whaling was an industry that touched most parts of the Salish Sea, resulting in the extirpation of humpback whales for nearly a century, as discussed in the text accompanying the regional Marine Map. Whaletown on Cortes Island became home port for a few whaling companies, and several place names on other islands also mark this period of industrial activity: Whalers Bay, Whaling Station Bay and Whalebone Point. Stepping back further in time, Worlcombe Island, west of Bowen Island, was known to the Coast Salish as Swus-pus-Tak-Kwin-Ace, meaning "that's where they catch the whales." At some time in their histories, nearly all the islands were home place for people employed in the fishing industry: on the boats and in the fish-oil reduction plants, salteries and canneries located on Galiano, Quadra, Lasqueti and Pender. Every island had a fishing fleet, and the local fishery around the Salish Sea was highly productive and prosperous throughout the settlement period. Many people, often women, children and First Nations, earned extra money handlining for lingcod and salmon, and selling fish, crabs and bait to travelling buyers or local stores. Today, people still fish, but there are few commercial fisherman left. Between Denman and Vancouver islands, oyster aquaculture dominates the marine environment of Baynes Sound. Most boating is for pleasure or transportation, and sea kayaking has become a popular way to travel and explore around the islands.

Mining the Islands

Between 1866 and 1914, interest in mining the islands was sparked by the discovery of base metals and other minerals on Texada. Various attempts were made to open mines on Texada, Bowen, Lasqueti, Salt Spring and Saturna with limited success, except on Texada, as described in the text accompanying the Texada map. The presence of gold, silver and copper in the bedrock maintained interest in mining for decades. Limestone, sandstone and granite were quarried for many uses, including building stones, paving stones and millstones for grinding pulp for paper. Gravel pits were established on islands covered with glacial deposits, and the sand and gravel were used for road construction and concrete. The discovery of coal near Nanaimo, Ladysmith and Comox captured the imagination of many speculators. While the coal mines on Vancouver Island had long productive histories, coal-mining attempts on the islands were unsuccessful. Through the 1890s most of the islands of the Nanaimo Group bedrock (see Figure 2) were extensively prospected for coal. While attention was mainly given to Newcastle, Tumbo and Saturna, Canadian Collieries also owned huge tracts of land on Denman that it eventually sold to logging interests rather than develop into mines. After 1900, geologists turned their attention from coal to oil and gas, and exploratory drilling occurred on Salt Spring, Pender, Galiano, Mayne and Saturna. Financial backing for mineral exploration dwindled when World War I began in 1914, but for many years islanders shovelled coal from outcropping surface seams and used it to heat their homes. Brickyards were opened on nearly every large island and several smaller ones, first exploiting small clay seams and later shale beds. The bricks were used locally for fireplaces and chimneys, and millions were exported to Vancouver, Nanaimo, Victoria and beyond. Brickmaking on the islands ended around 1950 when the island brickyards could no longer compete with the superior bricks made at Clayburn in the Fraser Valley. Except on Texada, mining on the islands dwindled and ended during the Great Depression. Place names that reflect the mining history of various islands include Stonecutter's Bay, Quarry Bay, Bricky Bay, Brickyard Hill and Brickyard Bay.

Agricultural Roots

Many of the community maps acknowledge the important agricultural history of the islands. Beginning in 1859,

top not exposed

FORMATION

Gabriola
Spray
Geoffrey
Northumberland
De Courcy
Cedar District
Protection
Pender
Extension
Haslam
Comox
(Sidney Island)

Conglomerate Sandstone

Mudstone Coal

Figure 2. General stratigraphy of the Upper Cretaceous Nanaimo Group.
SOURCE: KATNICK & MUSTARD 2001

farming was the driving economic activity of the islands for around 100 years. In the early years, the government required settlers to farm in order to obtain land titles. Producing food was also a basic necessity to support a family; any surpluses were bartered at the general store for other household goods. By the late 1800s, agriculture was shifting from subsistence levels to more substantial mixed farms capable of producing surpluses that could be sold to wholesale and retail markets. Farmers on most of the islands produced grain such as oats, barley and wheat. They also grew hay, cultivated vegetables, supported small cooperative dairying initiatives, and raised cattle, pigs, sheep and poultry. As explained in the narrative about the Denman Island map, several islands took advantage of the mild climate and planted soft fruits, such as strawberries, raspberries and tomatoes, that ripened several weeks ahead of the larger farms on Vancouver Island and the mainland. This strategy allowed farmers to gain a competitive advantage and claim a much higher price. After this period of initial experimentation, during the 1890s farmers

came to the conclusion that island environments were best suited to sheep ranching and fruit growing.

Little husbandry was required to raise sheep that could thrive independently during the summer droughts. On islands that had no wild predators, sheep were generally allowed to range freely, and were only rounded up when it was time to shear them or sell the lambs. On Salt Spring, high-quality wool used to knit Cowichan sweaters was often traded for salmon caught by the Hul'qumi'num people.

In the early orchards, the varieties of fruit that best thrived here were selected by trial and error. Some dual-purpose (cooking and eating) apples were planted for family use while other varieties were planted in greater numbers for commercial purposes. Mayne Island folklore lays claim to the King apple, or more correctly King of Tompkins County; the variety was available from local nurseries in the early 1870s. The King was indeed the dominant apple grown on the islands, and was planted in orchards from one end of the Salish Sea to the other. Besides using local suppliers, farmers often imported young trees from New York, Ontario and England in their search for the newest and best varieties. The old orchards that still survive are a living testament to the agricultural heritage of the islands, honoured on several of the maps, especially Denman's. The kinds of apples you might find today in a typical island heritage orchard are depicted in Figure 3.

Until Confederation, the provincial economy was dependent on Vancouver Island and the islands for locally grown food because farming was late to develop on the mainland. After Confederation, the completion of the transcontinental Canadian Pacific Railway provided a rapid shipping and distribution system through the interior of the province. There, acreages were vast and farms could produce large volumes of fruit, grain and produce. The large agribusinesses quickly exceeded the productivity of small island family farms. While the larger island farms remained

Figure 3. A typical island heritage orchard. ILLUSTRATION BY KATHY DUNSTER

competitive and were able to export surpluses, the smaller farms focussed on provisioning local stores and establishing farm stands for direct sales to growing island populations. In 1894, the Farmers' Institute Act provided an impetus for the formation of institutes on the islands with the goals of encouraging and improving agriculture, and sharing equipment and other resources. Fall Fairs were introduced and sponsored by the Farmers' Institutes; they have remained grand annual traditions that celebrate the agricultural heritage of the islands. In 1896, the Cooperative Act enabled people to achieve better local economic success by working together. On the islands, this legislation inspired the formation of cooperative dairies that produced milk and butter sold locally and exported to nearby urban centres.

Farming has never completely disappeared from the islands. In the 1960s, some islands became infamous for their production of cannabis. Today, as island communities are searching for ways to develop sustainable local economies, farming is once more receiving interest and community support. Vineyards, new orchards and olive groves are being planted on hillsides formerly thought to have unproductive soils. Specialty crops such as tomatoes, garlic, salad greens and herbs are available in local markets, while meat and dairy products can again be purchased on some islands. For many new (and well-established) farmers, agriculture is guided by the principles of sustainable, responsible practices: many are certified organic producers. The potential to create an economically viable agricultural economy on the islands was recognized in the 1890s, but it took over a hundred years for the necessary technology, population growth, transportation and financial support to be achieved.

Logging

Logging was closely connected to agriculture because heavily forested lands had to be cleared before the land could be converted to pastures, orchards and cultivated fields. By 1901, commercial logging operations had begun on most of the islands. Shingle- and shake-cutters worked independently in small teams, needing little equipment to get the job done. Most islands had small sawmills cutting dimension lumber,

railway ties, mining pit props and other items both for local use and export. Cordwood was sold as fuel to stoke steam engines and fish canneries. Japanese charcoal-making crews worked throughout the southern islands; some cut alder and cleared farm fields, while others tended the charcoal pits. The alder charcoal sold as fuel to the canneries was superior to and more efficient than cordwood. It was also used to supply the Canadian Explosives dynamite factory on Bowen Island, which was moved by barge to James Island in 1910.

Major forestry companies arrived on the Gulf Islands in the 1950s. By then, most of the old-growth, "virgin" forests had been cleared, leaving a patchwork of mixed-age forests interspersed with just a few old trees. With the exception of Bowen, Gambier, Quadra and Cortes, nearly all the Crown lands on the islands had been pre-empted or purchased by early settlers, and were held in private ownership. Major logging companies acquired title or logging rights to large acreages of second-growth timber on Quadra, Cortes, Gabriola, Bowen, Gambier, Salt Spring, Galiano and Valdes. Trees were cut, yarded to log dumps and towed in booms to mills on the mainland and Vancouver Island. For many decades, the coastlines of these islands were covered with log-booming grounds; intertidal areas were badly affected. By the 1990s, all the big companies had completed logging the most lucrative stands, and either sold out to smaller companies that continue to work right up to the present, or sold off individual parcels for rural residential development. Today, logging mostly occurs when land is cleared for development. The lands that are permanently replaced by subdivisions and commercial enterprises will never grow trees again in any numbers.

Post-War

After World War II, most urban centres of British Columbia grew exponentially in area and population while the islands remained slow, quiet places. Cottagers and recreational visitors supplemented the agricultural economy during the summer months, and a few small resorts were opened. By the early 1960s the population began to increase with new part-time residents seeking recreational respite from the cities. Many city dwellers moved to the islands in the 1960s and '70s in search of alternative lifestyles, spiritual fulfillment, creative inspiration, rural community and a slower pace of life; this has remained a hallmark until very recently. Since 1859, newcomers have added new layers of cultural richness to each island, slowly helping shape and define the unique island communities depicted on the maps. The maps also show that together, the islands share many delightful qualities; it is these that many islanders have developed a fierce determination to protect.

As long-time landowners began to die in the 1960s, development pressures increased and large acreages were subdivided into smaller parcels. The potential for unsustainable population growth became a fear in 1967, when 1,450 small lots were created around Magic Lake on Pender Island. By 1969, land speculation was driving up property values on all the islands, and old working farms were being carved into small parcels without zoning or planning controls. There were grave concerns about the general lack of drinking water, ferry service and other infrastructure necessary for growing populations. A study undertaken at the University of British Columbia in 1969 predicted that without immediate action, most of the land in the Gulf Islands would be intensively developed within a decade. In November 1969, the provincial government recognized the importance of protecting the islands and imposed a 10-acre freeze on all development to slow the pace down until community plans and zoning regulations could be developed.

A legislative committee was struck in April 1973 to examine all laws that might be changed to ensure future development on the islands was appropriate. Reporting back in September, the committee recommended that the

"Provincial Government establish an 'Islands Trust' (or commission), as the most appropriate body to be responsible for and to co-ordinate the future of each island including land use, future growth patterns, control of development, industrial, recreational, and commercial activity, as well as parks and open space designations."[13] In 1974, the legislature created the Islands Trust to oversee land-use planning in a Trust Area encompassing the hundreds of islands and their surrounding waters from Hornby and Denman south to the international border. Excluded until further studies were initiated—and still excluded—were Texada, Nelson, Savary, Hernando, Quadra, Cortes and the other smaller islands and islets to the north of Hornby and Denman. Some of the history of the Islands Trust, and its conservation initiatives, are discussed in the text accompanying the Islands Trust Protected Sites map.

The Island Way of Life

"... islands are much more than a writer's inspiration, a scientist's laboratory. They are home to islanders, who are both the same yet different to everyone else ..."[14]

Island living is full of paradoxes; things that make life infuriating, inconvenient and logistically complicated can be the same things that make life intensely rich, satisfying and remarkably interesting. Boat travel, for instance, is an inescapable part of island life. During the late 1800s publicly owned wharves and docks were built to meet the transportation needs of islanders. In most cases community-minded landowners donated both land and road access to the waterfront where the dock was to be sited. Because funding for construction and maintenance came from the provincial government, the docks were known as "the government docks" and became collection points for mail, livestock, supplies and people heading to or from the islands. Steamer

service was infrequent, and often occurred on alternating days and weeks, depending on where you lived and what was happening with the weather. Boat Day, which often turned into Boat Night when the steamer was late, was an opportunity to visit with friends; waiting patiently for "the boat" is still an essential quality of being an islander. Inconvenient ferry schedules are something most of us choose to live with rather than fight against. The idea that a person could build a rowboat capable of travelling independently from one island to another was also important, and many islands had at least one shipwright listed on the census forms; most still do. Owning or having access to a rowboat allowed islanders to get around, without relying on steamships or ferries, depending on the island and time period. While the larger islands have regular car ferry service, most small islands and some of the larger ones (Lasqueti, Gambier, Keats and Savary) are only accessible today by passenger ferries, water taxis or private boats.

Communication and cultural activities evolved between nearby islands from the very earliest days of settlement. For a long time, the only post office on the outer southern islands was located at Miners Bay on Mayne Island: everyone had to get there to collect their mail. This led to a lot of visiting before people headed for home. The first organized social gathering was the communal picnic, which has evolved over time into marvellous potluck dinners that celebrate community at its richest and fullest. People would walk or row to a beach for a day or weekend of food, music, conversation and games at special places such as Fiddlers' Cove on Saturna, Walker Hook on Salt Spring, Snug Cove on Bowen and Tribune Bay on Hornby Island. Today, potlucks range in scale from small, friendly group occasions to large community events such as the annual lamb barbecue on Saturna.

When farm work became more mechanized in the late 1800s, islanders volunteered time and materials to build

churches, schools and community halls that became the focal point for decades of social events such as potlucks. From the initial settlement years to today, the tradition of neighbours helping neighbours has been an important part of island living. Islanders have always relied upon each other's particular skills, tools, technology or time to make things happen. Volunteerism is a way of life, sometimes consuming more hours in the day than paid work does. Anyone who lives on an island is expected to help out, or little of community importance will be accomplished. All the islands are proud of their volunteer fire departments, library boards, festival and fair committees, community arts councils, as well as countless environmental, local government, service, sporting, theatrical and musical groups that enrich our lives or make them more secure.

Island life is not for everyone; many early settlers learned this quickly and left for the cities. Isolation is still a reality. Every island is affected in some way by insular barriers, including size, distance and lack of resources. Cooperation with neighbours is essential and this creates an unquestionable sense of community that can be very reassuring in times of need, but somewhat overwhelming when not. While escaping to big cities or towns is the typical antidote for beleaguered islanders, the character of the islands is increasingly attractive to tourists, who are seeking funky rural holiday experiences as the cure for fast city living. Becoming too popular, too dependent on tourism for economic survival to the detriment of rural qualities, is the paradox we now fear.

We are an inter-island community that is joined together, island to island, by intertwined threads of history, nature and culture. However tenuous those threads have become in recent years, we still share the common bond and responsibility for the preservation of our islands and the irreplaceable lifestyles we cherish. One of the reasons the mapping project began five years ago was because people

Bridgeman Road Barn, Salt Spring Island. ARTIST: MARGARET THRELFALL.

were concerned that these traditional connections between and within the islands were being lost. People involved in making the maps expressed distress that we were losing our sense of what it means to be an "islander," and just why each island *is* unique and in need of protection through legislation such as the Islands Trust Act.

In the autumn of 2004 concerned islanders again joined together, this time to raise the alarm that change was happening too fast, and without regard for the cumulative impacts each land development brings to the islands. They asked decision-makers to find a way to slow down and remember what the islands, and island living, were about. From protest and petitioning came the birth of the Slow Islands Movement, an inter-island collective of islanders willing to stand up and speak for the island, and for island lifestyles. We treasure our "island way of life" and lose sleep worrying about those who don't. Besides being a noun describing the physical geography of home place, to be an islander is a state of mind and spirit, as well as a way of existence.

The maps in this book lay out some of what we, the residents, feel could be lost or destroyed through over-development, unsustainable tourism and ignorance: a rural way of life, irreplaceable ecosystems and the unique relationship between people and the hundreds of other species they co-exist with around the Salish Sea. History takes time. It has taken millions of years for the islands to reach their

current state of natural and cultural evolution. Mahatma Gandhi once said, "There is more to life than increasing its speed." Slowing down is all about island time. We are beginning to understand that what we hold dear about our islands has something, and everything, to do with the notion of slow island time. As you absorb the maps you will learn about some of the exceptional things on each island. Here are a few closing thoughts about some of the ordinary and common things found in our histories that we feel should remain in our future:

The bleating of newborn lambs; the dawn chorus of crowing roosters; frogs and toads calling at night; waiting for banana slugs; sharing the roads with newts, frogs and toads; the rustle of leaves; the stillness of a mid-summer day; the dripping of rain onto the ground; the deep hush of settling snow; walking everywhere; horses on roads; fog-muffled sounds; howling gale winds; murmuring breezes; children playing in the woods or on a beach; the mating calls of hundreds of different bird species; heronries; the imperceptible sound of ferns and skunk cabbages unfolding on a spring day; a dark sky full of stars; power outages; picking blackberries; digging clams; farmers' markets, apple festivals and fall fairs; music, art and theatrical performances; rural post offices; potlucks, beach picnics and general stores; public schools; waiting for ferries; island time ...

The Island Maps

The tide turns.
After a little while
One sees.

—Sheila Weaver, *Gambier Island*

Gambier Island

Coordinator Maria Van Dyk
Artist Gloria Massé

DESPITE ITS PROXIMITY TO VANCOUVER, tucked into Howe Sound, Gambier remains an isolated island. It has no car-ferry service, just a water taxi. Most of the island is accessible only by private boat. Sixty-nine percent of the island is Crown land, unavailable for residential development. The permanent population is about 120.

When we were approached to host the Salish Sea mapping project, the small Gambier Island Conservancy had already put a lot of time and energy into technical mapping of the ecosystems on the island. It concerned us deeply that planning decisions affecting the beauty, diversity and natural integrity of the island were being made every day, without adequate information. The idea of maps made by artists, using community stories, sounded strange to us at first. But the more we found out, the more we realized that such a map might be able to communicate something different from what we were doing—something very special.

The project also sounded like something Gambier needed. The work of the conservancy was viewed with suspicion and hostility in some quarters. Understandably so: there is a lot at stake. Decisions about timber licences and forest management on the Crown land, and about private property development on the rest of our rugged landscape, are typically based on profitability. The conservancy believes that those decisions should take account of natural ecosystems. We believe that there should be places on the planet, like Gambier, where the "highest and best use" of the land is something other than human gain.

The idea of bringing people from all perspectives together to make a map of Gambier as it is today seemed like a way to help us think, as a community, about our future. In the conservancy, we came to see this project as an extension of the scientific mapping already underway and a chance to heal rifts in our community.

In order to de-politicize the project as much as possible, I set up a process that involved other groups, starting with the composition of the coordinating committee. We planned activities that were interesting and fun and allowed us to gather information about the island that hadn't been pulled together before.

We started with a backyard-mapping workshop led by Briony Penn. She took the mystery out of basic techniques and encouraged us to map our own land. One family started in right away. They researched the history of the property back to its first settlers, locating and interviewing relatives of the original owners. We also set up a mapping booth at the annual summer Family Fair. In exchange for a raffle ticket, we asked visitors to the booth to mark significant unmapped features on a big blank map of Gambier. Lots of interesting stories came out, and people who didn't usually talk were smiling and laughing together.

Still, we felt we weren't reaching enough people. We decided to pay a visit to some of the long-time resident families in remote locations who probably weren't going to come to us. So while the GPS technicians were out marking coordinates for streams, tributaries and wetlands, others in the project group were sipping tea on sunny decks with people we might never otherwise have met, learning old family histories, walking new parts of the island and discovering more reasons to protect it. This experience was proof positive that it may be difficult to get people excited about the technical side of mapping, but they love to talk about their own land.

Making this an inclusive community project and involving as many islanders as possible in the process did help to bring together a rather divided and isolated population. The Gambier map and its spin-offs have added to the heart and soul of a community.

—Maria Van Dyk

GAMBIER ISLAND AT A GLANCE*

POPULATION	SIZE	AREA OF FARMLAND	PROTECTED AREAS	AREA OF GREEN SPACE
2001: 274 1991: 115	24,874 acres/99.5 sq km	299 acres/121 hectares	785 hectares/7.8%	4,829 hectares/70%

Mapping Gambier: A Venture into Unknown Territory

FOR ME, AS A VISUAL artist, map-making was a venture into unknown territory. Because I paint with emotion, in an expressionistic way, the idea of producing art and information at the same time was a very big challenge.

The biggest task was to pare down the vast number of things to be shown to those that could fit on the map without making it difficult to read. For instance, island bird observers produced the names of up to 160 species they had sighted. Not all of these could be illustrated. I decided that portrayals of human activity had to be limited to what was happening in the year 2000. So it was a case of honing down, honing down, honing down, until I got to what I could actually fit. It was a comfort to realize that mine was just a first community map: there could be others.

I started at the top with large portraits of two of the birds most talked about by Gambier residents. The bald eagle and barred owl naturally came to represent day and night on the island—the energy of sun, moon and stars. When the island outline was drawn below them, it looked disturbingly like a rather fragile organ. Yet that also seemed right, as it is both rugged and vulnerable.

Government dock at West Bay. PHOTO COURTESY OF GAMBIER ISLAND CONSERVANCY

I used a grid pattern of 10 blocks depicting many of the life forms found here, plants and animals, including humans, to build a strong visual base for the map. Trees, a dominating presence on the island, form a frieze at the bottom edge, and this relates back to the cedar branches framing the birds at the top.

Since water defines an island, I painted it boldly with strong colour and waves. Streams were widened to allow for miniature images of the fish found there: coho and chum salmon, rainbow and cutthroat trout.

Previously published maps provided guides for marking wetlands, watersheds, old-growth forest and areas under development. An aerial photo showed me the locations of the log-booming grounds.

Just before Christmas, Mother Nature reminded me to mark the prevailing winds on the map by blowing two trees down on my studio, taking the hydro out for a week. The roof was punctured in many places; there was mud inside everywhere, but tarps kept out sleet and rain. My drawing table became an island surrounded by chaos. I hope the map took on a reflection of this often-wild nature on the islands in the Salish Sea.

Introducing the idea of community mapping to Gambier felt like a big responsibility, so I tried not to be too overtly political. I thought the first map done this way should be attractive to people and have something in it for everybody. I tried to point out a few things, like the size of the clear-cuts in some places, softly not harshly, in muted colours. I want everyone to feel comfortable with this map, to feel represented, not alienated, no matter who they are.

I am extremely grateful for the chance to have made this map because of the positive response from others who love the island as I do. A map such as this shows what we have and what we could lose.

—Gloria Massé

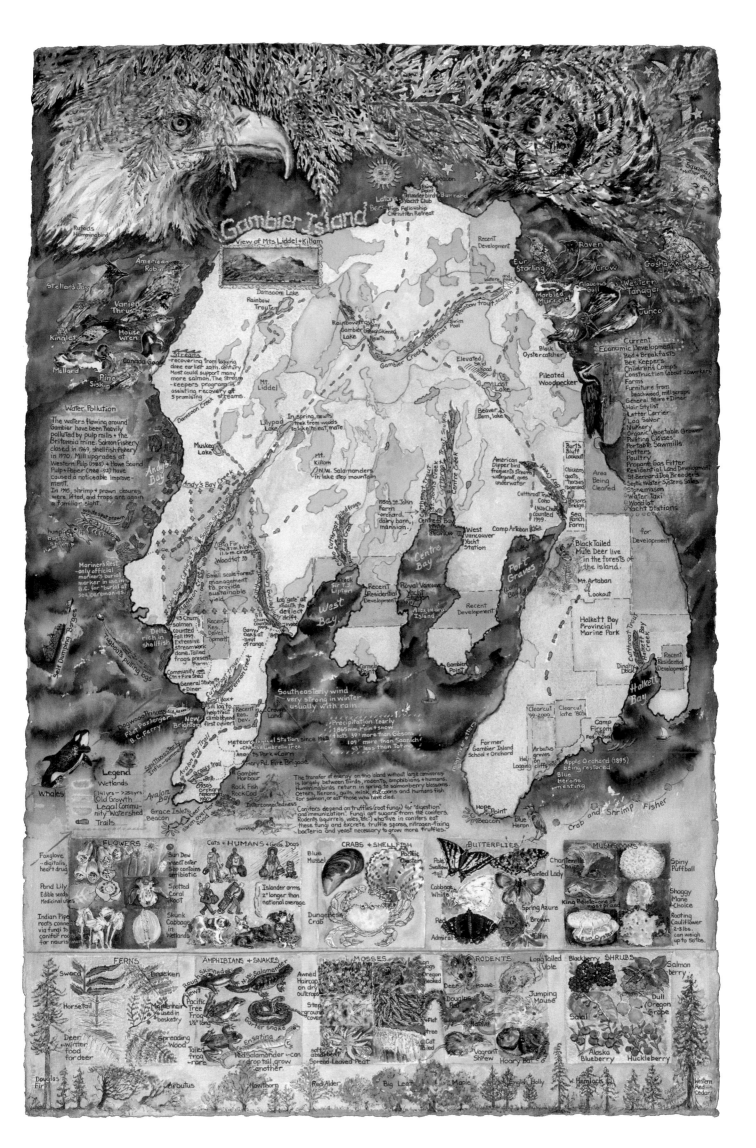

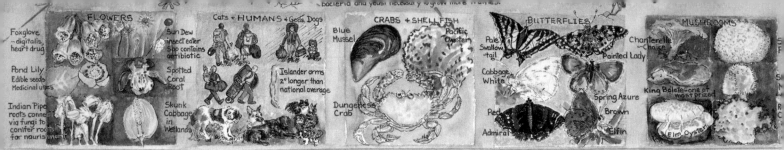

Flowers

On Gambier, there are wildflowers to inspire, amaze and heal. Skunk cabbage can generate their own heat to protect their flowers in the snow. Indian pipes, ghostly saprophytes in the heart of the forest, can heal wounds. Sundews ensnare insects in their sticky tendrils, but they can cure infections with their sap.

Cats, Humans, Dogs

With no car ferry, getting things to Gambier is a big challenge. On weekends, the *Stormaway III* (foot passengers only) looks like Noah's Ark with its motley cargo of cats, dogs, people and stuff—all needing to be schlepped to the cabin by wagon, buggy, dolly or extra-long arms.

Crabs and Shellfish

Food security in the Salish Sea comes from an abundance of healthy, fresh food packaged in hard, shiny shells in the intertidal supermarket, from Dungeness crab to mussels, clams and oysters. If we protect them, it will always be true that "when the tide goes out, the table is set."

Butterflies

In the world of corporate design, butterflies have become generic decorations used to sell clothes, jewellery and sexy holidays. But when you see a spring azure, a pale swallowtail or a Lorquin's admiral along Gambier's coastal bluffs, the last thing most people want to do is head off to the city and buy more stuff.

Mushrooms

Ah, mushrooms, the forest's little helpers. If it weren't for these fungi, island trees wouldn't grow: they build an all-important network between tree roots and nutrients in the soil. They accelerate the decay process by breaking down wood fibre with their mycelia. And happily, they give slugs an alternative to our vegetable gardens.

Ferns and Horsetails

To encourage young naturalists to get to know ferns, a great teacher once conjured a medieval scene with Sir *Licorice Bracken* the knight, a *Sword* and *Shield* by his side, riding his *Horsetail* through the wood in search of *Deer*, *Lady* or *Maidens*. She missed a few rare ones hanging precariously on the bluffs, but so did the knight.

Amphibians and Snakes

One little rough-skinned newt went to the swamp, and one little red-legged frog stayed home. One little Northwestern salamander ate larvae, and one little *Ensatina* got none. And one little Pacific treefrog chirped, "ribbet ribbet ribbet" until the garter snake ate him up.

Mosses

For the neophyte naturalist, mosses are the best group of organisms to start studying. They grow everywhere, in every season, and they stay still. They create soft edges in a hard world and, over time, mute the worst damages inflicted by humans. The sight of a junked car covered in haircap moss, slowly reverting to the soil, is a sight to lift the soul.

Rodents

Rodents should not be taken for granted. They feed our owls and raptors, make intricate tunnels through the meadows, share our cabins on cold winter days, chatter away at us while they shuck fir cones and build up piles of bracts on the forest floor. Bats, of course, are not flying mice; they are themselves—beautiful, beleaguered, bug-eating bats.

Shrubs

The Gardens of Eden on the Pacific coast are our berry patches. All by themselves or with help from gardeners, they creep and scramble their way into lush, tangled, chaotic communities that newcomers may want to rip up. But from May to September, pause and savour.

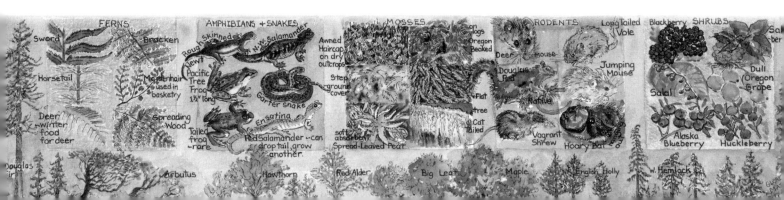

Bowen Island

Coordinator and artist Kathy Dunster

THE TWO MAPS OF BOWEN depicted in this atlas are not the original contributions to the mapping project from our island. In November 1999, the Bowen Island Conservancy sponsored an afternoon with David Suzuki at the Community School. The gym walls were covered with maps, and Mayor Lisa Barrett gave an introductory speech, mentioning community mapping at least 10 times. At my request, she asked the audience of 400-plus to help with the Islands in the Salish Sea Community Mapping Project by adding their thoughts to the clipboards being circulated. We asked just one question: "In a word or two, what does Bowen Island mean to you?" And we got words, lots of them—so many words, in fact, that I realized our map had to be about the words.

With the enthusiastic help of Andrea McKay, a teacher at the school, I held mapping workshops with many classes. An after-school "map and compass club" was set up for the keeners. The sharing worked both ways: I learned about many places and things that defined Bowen Island for the children, and we had a lot of fun learning together how to use a compass and make maps of the places important to them. From their maps, I gathered another collection of both delightful and sobering words that only children would associate with Bowen.

By the end of 1999, the Lane 20 Artists' Collective (Sarah Haxby, Wendy Merkley and I) had begun work on an interactive, three-dimensional map we called "Fast Drumming Ground," or *Xwlil'xhwm*. This has been the Squamish name for the island since time immemorial. We decided that the map should tell the story of Bowen from the beginning of time. The base and frame were built of Douglas-fir and copper as a reminder that our industrial legacy was based on logging and mining. We turned two large water containers into the movable centre of the map, a huge hourglass. Mother Earth goddesses wearing multi-layered map skirts that depict the past and future of the island were attached to the frame. The whole structure was adorned with cedar boughs and strands of English ivy, representing the struggle between native and non-native species.

The heart and soul of the map, however, was inside the hourglass. All the words we had collected were sorted and divided into two categories. Those that described the beauty, goodness and fine qualities of our island were written onto stones we had collected from creeks and beaches around the island. Those that dealt with "bad karma," insensitivity and anything else people thought was terrible about the island we inscribed onto shells and bits of pulpwood chips. The idea was that when the hourglass was turned, the stones (representing the good) would eventually pound into dust the shells and wood chips (representing the bad), just as natural processes weather a wave-pounded shore.

As a community map, "Fast Drumming Ground" really worked. But it weighed a lot, did not fit into a box that could travel, and took a fair bit of effort to assemble, even with an instruction sheet. So in the summer of 2001, it fell to me to transform the ideas into a more conventional, two-dimensional map that could fit into a box and sail around the Salish Sea. While I may be the one who finally put ink and chalk to paper, the text of *Be Own Island,* our second map, was assembled with the help of over a thousand islanders who contributed words, ideas, concerns, history and, most importantly, deep love for this place known as Bowen Island.

—Kathy Dunster

Bowen's first map, "Fast Drumming Ground," or *Xwlil'xhwm*.
PHOTO BY KATHY DUNSTER

Amphibian Migratory Routes Across the Roads of Bowen Island

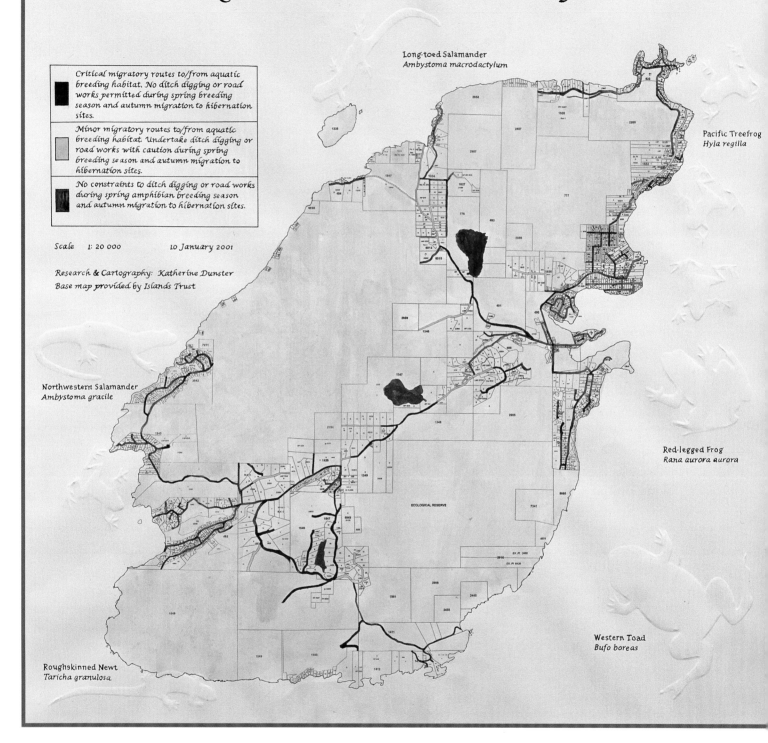

Critical migratory routes to/from aquatic breeding habitat. No ditch digging or road works permitted during spring breeding season and autumn migration to hibernation sites.

Minor migratory routes to/from aquatic breeding habitat. Undertake ditch digging or road works with caution during spring breeding season and autumn migration to hibernation sites.

No constraints to ditch digging or road works during spring amphibian breeding season and autumn migration to hibernation sites.

Scale 1: 20 000 10 January 2001

Research & Cartography: Katherine Dunster
Base map provided by Islands Trust

Long-toed Salamander
Ambystoma macrodactylum

Pacific Treefrog
Hyla regilla

Northwestern Salamander
Ambystoma gracile

Red-legged Frog
Rana aurora aurora

Roughskinned Newt
Taricha granulosa

Western Toad
Bufo boreas

ECOLOGICAL RESERVE

Protecting Amphibians with a Map

There are many ways for people in a community to help officials see local problems more clearly. Some people protest, nag, write letters and sign petitions. Street theatre is effective and fun, but ephemeral. When it comes to issues of land use, there is nothing better than creating a map to make your point. A good map can change political opinions and influence decisions. An artistically seductive map can captivate and then engage people into loving and caring for a place more than they already do. Here's a case in point.

Amphibians often follow migratory routes that cross major roads to reach breeding grounds in wetlands and lakes. Annual road and ditch maintenance during migration periods has been devastating to both amphibian populations and wetland habitat. On Bowen, a small group volunteered their professional expertise to devise a plan that would allow the municipality to direct the local roads-maintenance contractor to develop work schedules that meet the needs of amphibians first when working on ditches.

The first step was to create a map with a simple, three-colour key (red, yellow and green) for the road system on the island. Red, for example, means the road is located in a critical migration corridor. The final step was for the contractor to incorporate the data into road-maintenance plans, and this has largely happened. Thanks to a map, Bowen Islanders will continue to enjoy the springtime chorus of frogs and toads intent on their own seductions, we hope. The Bowen Municipal Council is currently reviewing a road design standard for the island that, with lobbying from caring citizens, should take into account the needs of amphibians. On "slow islands" you pay attention to the slowest inhabitants.

Most often, the frogs we hear in the Salish Sea area are either Pacific tree frogs or red-legged frogs. Pacific tree frogs lay their eggs in warm shallow water such as vernal pools. When young, the froglets live in grass or brush next to their birthplaces; adults are found in wet meadows and on trees. Red-legged frogs prefer to lay their eggs in cool, shady bodies of fresh water such as ponds, lakes and streams. Once hatched, they spend their lives in and out of their home wetlands. Like most frogs, they are prodigious eaters, devouring large quantities of insects, spiders, earthworms and other creatures, depending on their size and palate.

ILLUSTRATIONS BY DONALD GUNN

Salamanders fall into two groups: those that are fully terrestrial and never venture near water, and those that live at least part of their life cycles in freshwater. Both types are silent. Mole salamanders breed exclusively in vernal pools that dry up during the summer droughts—risky if the hatchlings haven't completely transformed into adults before the water disappears, but a good strategy for avoiding fish and other predators. Areas near vernal pools also provide these salamander species with important non-breeding habitat functions such as feeding, cover and over-wintering sites.

The World's Disappearing Amphibians

One of the most cheerful sounds on a grey winter's day on any of the islands of the Salish Sea is the sudden peeping of a tiny Pacific treefrog from a damp corner of the woods. Then in the spring, the frantic croaking and beeping and honking of the red-legged frogs rolls over us in bursts of competitive self-advertising from ponds and wetlands.

But just as Rachel Carson warned us 50 years ago about the danger of a "silent spring" without birdsong if we allowed toxic chemicals in the environment to build up unchecked, now we must worry about the possibility, some day, of a future without frog song. A global survey by more than 500 scientists in 60 countries, released in 2004, shows that amphibians around the world are in precipitous decline. Of the known species, almost one-third meet international criteria for being in danger of extinction.

The wetlands they inhabit are often dismissed as "useless swamps" by the unknowing and drained without thought for what might be living there. Wetlands have been treated this way for many decades. And that's not the only problem. The skins of amphibians are porous, leaving them vulnerable to chemical pollutants and acid rain. A deadly fungal disease is spreading among some species, possibly as a result of global warming. Others are harvested for food and medicinal use. Yet scientists say the full explanation for their alarming rate of disappearance remains a mystery.

In the Salish Sea, there is still hope. Most of the islands have adopted community plans that "address means to prevent further loss or degradation of freshwater bodies or watercourses, wetlands and riparian zones and to protect aquatic wildlife."[15] If we want to listen to frogs, we must protect our wetlands and surround them with forested buffers; even small seasonal wetlands and ditches can be critical habitat. We don't want to risk a silent spring here.

Isla de Apodaca 1791

Origins: The ancient island known as Wrangellia was formed in the South Pacific about 250 million years ago (mya). Islands began drifting north through time and space and collided with the West Coast around 130 mya. Three fragments were stitched together into a larger island by molten plutons squeezed up from the basement of the planet. The island continued to move northwards and reached its present location about 60 mya. Since then it has been splattered with volcanic debris, rattled by earthquakes, smeared by glaciation, rebounded from glacial compression, and sluiced by the tides. It is the year 2001 and we are in an interglacial period, wondering when the big earthquake will happen and thinking about what global climate change has in store for us, and for the Salish Sea.

Wrangellian Greenstone Plutonic biotite-hornblende & quartz-diorite

Cougar

Snug Cove – 2001

Museum & Archives
Miller Road
Dorman Road
"Alderwood"
Upper Pub
RCMP
General Store
Pileated Woodpeckers
Black-tailed Deer
Seabreeze Building
Heronry
Davies Creek
Baseball Field
The Lagoon
Memorial Garden
BIHPA
BowMart
Heronry
Kingfishers herons and salmon
The Orchard
Bakery
Old General Store (U.S.S. 1924)
Boulevard Cottage
Seaside Cottage
Birdwatching
Salmon & Cutthroat Trout
Fill Put
Sunday Market
The Causeway
Trail
War Memorial
USS Manna
Water Taxi
Ferry Dock
Dallas Marina
Snug Point Subdivision (1962)
Sandy Beach
Great Blue Heron
CNIB
Bowen Field
Coastal Bluffs

Union Steamships 1919–1957
Black Ball Ferries 1956–1962
BC Ferries 1962 – ?

Killarney Creek
Bridal Falls
Cymac Launch Service from New Westminster to Bowen Bay 1929–1972
Cape Roger Curtis
Green Rain Islet
Falls Bay
Aka Cr.
Retreat Cr.
Burke Creek
Huszar Creek
Gnome Br.
Bobs K.
Gobs Knob
Fairy
BANG Brook
Cosmos Cr.
Whine Creek
Radar Hill 500 m
Fairweather Bay (Winnipeg Bay)
Library Cr.
West Bay
Hungry Deer Cr.
Josephine Creek
Echo Bay
Napoleon Cr.
No-Name Creek
Lee Creek
Arbutus Bay (Wilson Bay)
Konishi Bay
Alder Cove
Pt. Cowan
Union Cove
Trinity Bay
Josephine Lake
Eco Cr.
Warnock Creek
Humpback Islet
Seymour Bay
Plenderson Br.
Drifting
Apodaca Cove

Tree Frog
Scale 1: 5 000 100 metres

We are: a rural island community of about 3,000. About half of the population is under 18. Our elementary school is a community school – the hub of learning and recreation on the island. We are heavy on local politics, meetings and potlucks. Anything can become an island political issue. We sing a lot, write, play music and stage concerts and shows so that we can see our friends and neighbours perform.

We live in nature, surrounded by rainforest. According to Squamish legend, the black-tailed deer was created on Bowen. Many islanders include the resident deer as part of their extended family. If you garden, you think of them as the black sheep of the family.

Up until 1957, the Union Steamship Company controlled the docks, ferry, taxi, telephone (just one), store, post office, and hydro-electric power supply. Not everyone liked this state of affairs and community activism began in earnest. There is a strong undercurrent of anarchy on the island. We fight to protect land and people from what we think are the wrong decisions (they usually are), and battlegrounds are scattered across the island.

Our local newspaper is The Undercurrent, which kind of sums up the state of everything: nothing is obvious on Bowen Island. We write lots of letters to the editor, who doesn't even live on Bowen. We argue a lot, and usually agree to disagree. We always question authority and became the first island municipality in 1999. Rush moments occur as hourly pulses of traffic, allowing people to ebb and flow from the island.

We volunteer, pick up hitchhikers and honour our elders. We wave when we pass a friend on the road. If you are on the island, you do not miss the Remembrance Day service. We have many customs and traditions that include the Library Book Sale, Haunted House, and fireworks on the Causeway at Hallowe'en, Midsummer in the Orchard, Muriel Neilson Day, Bowfest and the shortest parade in the world, recycling, spring and fall cleanup, Christmas carolling, Dog of the Year, Citizen for the Year, blackberry picking, the Mummers and Morris Dancers, Run for the Ferry, Round Bowen Race, Word Jam, The Strawberry Tea, Honour a Life, Bake Sales, Cannabis Canada Day, GrandFriends Volunteers Tea, Friday dinners at the Legion, the Fireman's Dock Dance, the PPP tour (people, places and plants), walks around the lake, and the Christmas bird count. "Endangered Species" is the mid-winter music event, and the Tir-na-nOg Youth Theatre School wraps its year with the Spring Festival of Plays in May and June. Summer is baseball.

NORTH →

Scale 1: 15 000 1 kilometre

Legend ✝ Church ♻ B.I.R.D. Recycling 🐟 Salmon Stream

Black-tailed Deer

2001

OWN ISLAND

BOWEN ISLAND 1860

"Vacant" Crown lands remaining on Bowen in the year 2001

Crown lands pre-empted on Bowen 1872-1914

Bowen as charted by Vancouver in 1792

Bowen as charted by Narvaez in 1791

Over ½ the island remains undeveloped and has a diversity of ecosystems and habitats that sustain hundreds of species of plants, birds, fish, insects and animals. Many of them are endangered elsewhere. Wetlands of all sizes and types are home to the Blue Dasher and several dozen other species of dragonflies, red-legged frogs, salamanders, newts, and toads. We have rainforests and rain shadow forests. We know that large areas of undeveloped land, and a relatively undisturbed coastal zone are the reasons why species such as the great blue heron, bald eagle, turkey vulture, band-tailed pigeon, cormorant, blue grouse, surf scoter, marbled murrelet, harlequin duck, short-eared owl, hairy woodpecker, cougar and western screech owl spend time on Bowen Island.

"Our 'Crown-land' forests are the commons, and are not for sale, ever. Potable water is precious on Bowen, and much of the drinking water that lands on the commons and runs down hill to the wells, lakes and reservoirs that supply our water."

Bowen Bay
King Edward Bay
Bluewater
Crayola Beach

Hutt Rock
Hutt Island (wahk-woak)
Galbraith Bay
Ethel's Islet
Hutt Islet

Little Rock 1940-1955 Ethel & Wallace Wilson Given to UBC, owned by the McIntosh's as Endswell Farm since 1964, sheep & eggs

Mt. Gardner
600 m
500 m
400 m
300 m
200 m
Trout Lake (Grafton Lake)
Camp Bow-Isle
Conical Hill
100 m

Endswell Farm
Grafton Bay
Xenia Retreat

Fern Falls
Killarney Lake (Sucker Lake)
Crippen Park
Cates Hill
BICS

Honeymoon Lake

Meadowhawk Marsh (Mud Lake)
Mt. Collins
DL 2260 The Hood Point Buffer "we have rules and mores..."

We call them the Squamish winds. The Squamish call the big winds alyum-spaiyum.

September Morn Beach
Snug Cove
Sandy Beach
Deep Bay
Snug Point
Pebbly Beach

Dorman Bay
Dorman Point

Scarborough Bite
Miller's Landing

Columbine Bay
Hood Point
Enchanta Bay
Montevista Bay
Cates Bay
The Gap
Finisterre Island (kwum'shnam)

BC Telephone came to Bowen in 1957, and we had party lines up until the mid-1980s

Lieben: Work/Play/Think/Create Living legacy of Muriel & Einar Neilson Artists Colony 1946 - 1965

The Sannie's water taxi & grocery boat 1921-1954

Vineyard Park Wetland Crown Lands Battlegrounds for Social & Environmental Justice

Red-legged Frog

"Be Own Island"—A Landscape Reading

On most maps, Bowen Island is displayed in a north–south orientation, the cartographical convention. But our island world is actually centred on Snug Cove, which harbours the ferry dock and is the connecting point to the continent and the rest of the world beyond. The ferry to Bowen leaves from Horseshoe Bay and heads in a westerly direction towards Snug Cove. It is from this floating vantage point that newcomers first see the island, and the rest of us breathe more easily because we are nearly home. So, on this map of our home place, west is at the top to signify that Snug Cove is the front door and welcome mat to the island. The title, *Be Own Island,* transforms the place name "Bowen Island" into a new construct that recognizes its identity as our special island-place in the Salish Sea.

Making this image was one way to capture the spine-tingling process of remembering, discovering and recording the rich collective knowledge about the island that community members share. Every encounter with the natural world, every happenstance conversation, every community event is part of this; the process creates memories, transforms knowledge, expands minds and sometimes triggers the urge to put things down on a map.

One of the themes of this map is "the commons," those places that we collectively depend on and cherish because without them we would have no identity. We cross paths daily with frogs, salamanders, dragonflies, a few precious herons and many other creatures. We rely on over 175 creeks and 107 different kinds of rain to fill our wells and reservoirs with drinking water. We are only beginning to understand how nature and culture are synergistically involved in the process of social and economic transformation on our island.

Nearly half of our island's landscape remains in a natural or semi-natural, undeveloped state. Its greenness inspires prolific creativity and a deep passion for the place. It is both ecologically fragile and highly vulnerable to insensitive developers. Defending rural values from distortion by invading urbanites is a difficult task when you are located just west of the largest city on Canada's west coast. Over the years, we have had to rally together to fight for a variety of social and environmental causes, and the island is scarred with battlegrounds that are shown on the map.

Many members of our community make their livings by crafting words into songs, letters, stories, poems, articles, books, plays, film scripts, lessons, reports and judgments. It has been this way for a long time. Bowen is a small island that cannot sustain many traditional jobs, and the pull of the city is as strong as a spring tide. Island culture encourages people never to be in a hurry: the speed limit is 40 kph, and the ferry is always late or overloaded, sometimes both. This is a good thing; we're practising to be a slow island.

—Kathy Dunster

The students at Island Pacific School created the map shown here, which hangs on a wall next to the ferry dock. It is about 8 feet tall and 12 feet wide.
PHOTO BY KATHY DUNSTER

BOWEN ISLAND AT A GLANCE

POPULATION	SIZE	AREA OF FARMLAND	PROTECTED AREAS	AREA OF GREEN SPACE
2001: 2,957 1991: 1,833	12,071 acres/48.28 sq km	450 acres/182 hectares	687 hectares/14.1%	3,561 hectares/71%

Galiano Island

Coordinators Kate Hennessy; Krista Casey
Artist Krista Casey

THE GALIANO COMMUNITY'S relationship to its lands has often been fraught with conflict. The Islands in the Salish Sea Community Mapping Project came at a time when discussions over land use, density and development had made us acutely aware of the political and economic power of mapping. We were used to seeing maps of our island that divided it into pieces—maps that spoke more to politics and profits than to people. As the coordinator who took on the task of eliciting community participation in the project, I saw it as an opportunity to imagine our island defined by community history and knowledge, rather than by politics.

Throughout the spring and summer of 2000, I set up mapping workshops at all of Galiano's public events. With large map-outlines of the island as their starting point, people used art, narrative and poetry to mark places that were important to them. Students from Galiano Elementary School created a map of our beloved Pebble Beach, and many other residents were inspired to make more detailed maps of their own properties and favourite places. Maps of our gardens, deer paths, beaches, trees, wildflowers, our historical roots and more reminded us that a focus on official boundaries and numbers can overshadow what we all have in common—our love for this island.

As the coordinator who came after me, Krista Casey encouraged as many Galiano artists as possible to make maps. To create her own map, she drew on the information from my workshops, contributions from lots of individuals and her own research and memories. But, as important as the final map is, the *process* of community mapping—in which people of diverse ages, interests and political orientations embraced this way to define their relationship to the land—was more important. The stories that I heard about people's connections to particular places on Galiano gave those places new meaning for me. Maybe the maps from this project will have the power to reconnect all of us: to these places, and to each other.

—Kate Hennessy

DETAIL OF MAP BY DIANNE LARONDE

A HISTORICAL MAP OF GALIANO ISLAND

When Dianne Laronde was deciding what sort of map to make as part of this project, her experience growing up in the interior of B.C. led her to focus on history. She went to school with Japanese–Canadian children whose presence there, as a result of the internment of their parents during the Second World War, was rarely discussed. Dianne was struck by the loss of local history that takes place in the silence between generations.

On Galiano, it was the economic history that interested her. When she arrived in the 1970s, the resource-based economy (fishing, logging) was still thriving. In the years since, jobs in those industries on Galiano have greatly decreased. Low wages in the service-sector jobs that have replaced them and soaring land prices make it difficult for young families to get a toehold. Yet the evidence from old buildings, still standing or in photographs, showed her that Galiano once provided a variety of options for making a living: farms, a dairy, a cannery, more than one saltery, a sawmill, several small schools, etc. Dianne hopes that by telling some of the stories from the past, her map may serve as a reminder that small communities have options and encourage islanders to find new ways of building vital and self-sufficient economies in the places we live.

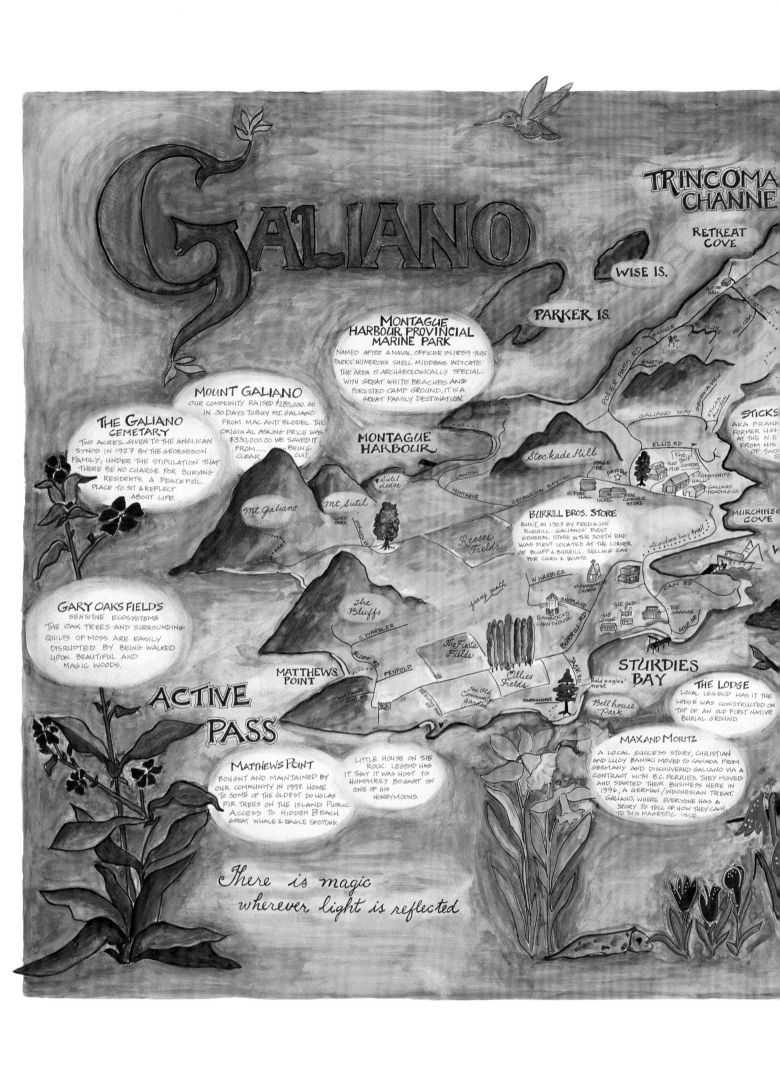

GALIANO

TRINCOMA
CHANNE

RETREAT
COVE

WISE IS.

PARKER IS.

**MONTAGUE
HARBOUR PROVINCIAL
MARINE PARK**
NAMED AFTER A NAVAL OFFICER IN 1859 THIS
PARKS' NUMEROUS SHELL MIDDENS INDICATE
THE AREA IS ARCHAEOLOGICALLY SPECIAL.
WITH GREAT WHITE BEACHES AND
FORESTED CAMP GROUND, IT IS A
GREAT FAMILY DESTINATION.

MOUNT GALIANO
OUR COMMUNITY RAISED $285,000.00
IN 30 DAYS TO BUY MT. GALIANO
FROM MAC AND BLODEL. THE
ORIGINAL ASKING PRICE WAS
$330,000.00 WE SAVED IT
FROM..... BEING
CLEAR CUT.

**THE GALIANO
CEMETARY**
TWO ACRES GIVEN TO THE ANGLICAN
SYNOD IN 1927 BY THE GEORGESON
FAMILY, UNDER THE STIPULATION THAT
THERE BE NO CHARGE FOR BURYING
RESIDENTS. A PEACEFUL
PLACE TO SIT & REFLECT
ABOUT LIFE.

**MONTAGUE
HARBOUR**

Stockade Hill

STICKS
AKA FRANK
FORMER UGH
AT THE N.E
FROM HIS
OF TWO

BURRILL BROS. STORE
BUILT IN 1903 BY FRED & JOE
BURRILL. GALIANOS' FIRST
GENERAL STORE IN THE SOUTH END
WAS FIRST LOCATED AT THE CORNER
OF BLUFF & BURRILL. SELLING GAS
FOR CARS & BOATS.

MURCHINSON
COVE

*Sutil
Lodge*

mt.galiano

Mt.Sutil

*Reeses
Fields*

GARY OAKS FIELDS
SENSITIVE ECOSYSTEMS
THE OAK TREES AND SURROUNDING
QUILTS OF MOSS ARE EASILY
DISRUPTED BY BEING WALKED
UPON. BEAUTIFUL AND
MAGIC WOODS.

*The
Bluffs*

*The Fiesta
Fields*

*Ollies
Fields*

**STURDIES
BAY**

THE LODGE
LOCAL LEGEND HAS IT THE
LODGE WAS CONSTRUCTED ON
TOP OF AN OLD FIRST NATIVE
BURIAL GROUND

MATTHEWS
POINT

ACTIVE
PASS

Matthews Point
BOUGHT AND MAINTAINED BY
OUR COMMUNITY IN 1998. HOME
TO SOME OF THE OLDEST DOUGLAS
FIR TREES ON THE ISLAND PUBLIC
ACCESS TO HIDDEN BEACH.
GREAT WHALE & EAGLE SPOTTING.

LITTLE HOUSE ON THE
ROCK. LEGEND HAS
IT THAT IT WAS HOST TO
HUMPHREY BOGART ON
ONE OF HIS
HONEYMOONS.

MAX AND MORITZ
A LOCAL SUCCESS STORY; CHRISTIAN
AND LUCY BANSKI MOVED TO CANADA FROM
GERMANY AND DISCOVERED GALIANO VIA A
CONTRACT WITH B.C. FERRIES THEY MOVED
AND STARTED THEIR BUSINESS HERE IN
1996, A GERMAN / INDONESIAN TREAT.
GALIANO, WHERE EVERYONE HAS A
STORY TO TELL OF HOW THEY CAME
TO THIS MAGESTIC ISLE.

*There is magic
wherever light is reflected.*

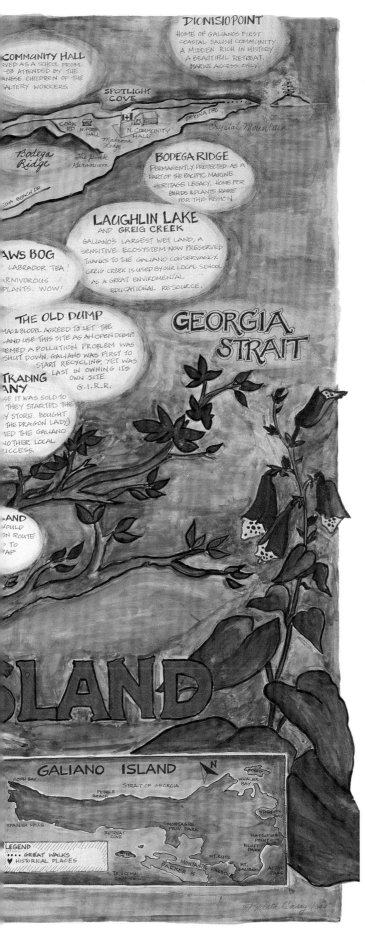

DIONISIO POINT
HOME OF GALIANOS FIRST
COASTAL SALISH COMMUNITY
A MIDDEN RICH IN HISTORY
A BEAUTIFUL RETREAT.
MARINE ACCESS ONLY.

COMMUNITY HALL
VED AS A SCHOOL FROM
-53 ATTENDED BY THE
ANESE CHILDREN OF THE
SALTERY WORKERS

SPOTLIGHT
COVE

COOK
RD N FIRE
HALL
N. COMMUNITY
HALL
DEVINA DR.

Crystal Mountain

*Bodega
Ridge*

the Pink
Geranium

Madrona
Lodge

EGA BEACH DR.

BODEGA RIDGE
PERMANENTLY PROTECTED AS A
PART OF THE PACIFIC MARINE
HERITAGE LEGACY. HOME FOR
BIRDS & PLANTS RARE
FOR THIS REGION

LAUGHLIN LAKE
AND GREIG CREEK
GALIANO'S LARGEST WET LAND, A
SENSITIVE ECOSYSTEM NOW PRESERVED
THANKS TO THE GALIANO CONSERVANCY.
GREIG CREEK IS USED BY OUR LOCAL SCHOOL
AS A GREAT ENVIRONMENTAL
EDUCATIONAL RESOURCE.

WS BOG
LABRADOR TEA
RNIVOROUS
PLANTS. WOW!

THE OLD DUMP
MAC & BLODEL AGREED TO LET THE
AND USE THIS SITE AS AN OPEN DUMP
EMED A POLLUTION PROBLEM WAS
SHUT DOWN. GALIANO WAS FIRST TO
START RECYCLING, YET WAS
LAST IN OWNING ITS
OWN SITE.
G.I.R.R.

TRADING
ANY
SE IT WAS SOLD TO
THEY STARTED THE
Y STORE. BOUGHT
THE DRAGON LADY)
ED THE GALIANO
OTHER LOCAL
UCCESS.

**GEORGIA
STRAIT**

AND
OULD
ON ROUTE
TO
AP

LAND

GALIANO ISLAND

COON BAY

STRAIT OF GEORGIA

PEBBLE
BEACH

WHALER
BAY

SPANISH HILLS

RETREAT
COVE

MONTAGUE
PROV. PARK

STURDIES
BAY

MATTHEWS
POINT
BLUFF
PARK

MT. SUTIL

MONTAGUE HARBOUR

PARKER IS

MT
GALIANO

ACTIVE
PASS

TRINCOMALI
CHANNEL

LEGEND
GREAT WALKS
♥ HISTORICAL PLACES

Krista Casey '04

Memories of Galiano

I was eight years old when I arrived on Galiano from St. John's, Newfoundland. I remember being shocked at how sweet the air smelled. For the next five years, my childhood was spent outdoors. Play was filled with magical forest creatures that left evidence of their existence everywhere. Drops of dew collecting in the vanilla leaves were fairy water receptacles. Deer paths were well-travelled fairy highways. And mushrooms were totally sacred. So when I decided to create a map of Galiano, what I most wanted to capture were all the magical outdoor places of my childhood.

The map-making process for me was a trip down memory lane, which I was delighted to share with my daughter, then three years old. She too knows the "Fairy Trail" that leads down to Bambricks Lighthouse, nestled in the woods. We are sure it is a secret doorway to a magical underworld. When I got started on the map, one place I remembered fondly was the old dump that was one of my family's favourite adventure spots. Going there was like being let loose on a giant mountain of hidden treasure. We all remember it that way. How we treat garbage on Galiano has really changed since then. On the map, it was great to acknowledge the hard work and commitment that have been invested in creating Galiano's own recycling centre, which now, at long last, owns its own site. Congratulations!

Creating this map helped me see just how much impact this little island has had on me. When you connect with a place and spend time there, you grow and change just as the land and the community grow and change around you. Living on Galiano, I feel a part of something great. It was an honour to landmark some of my favourite places that no longer exist. I feel I've played a part in preserving their memory. Take, for example, the old community garden that was behind my house as a child. Shared by a number of families, it was a common meeting place. Everything that grew there was delicious. And Ruby had the best raspberries ever.

Galiano, after all these years, has maintained its beauty and magic for me. I am still captivated by the natural perfume that fills the air, the deer that graze in my garden, the people who with their stories add to the island's character and charm, and the way I feel having a share in it all. If my map can accomplish just one thing, I hope it encourages us to stand still for a moment—to breathe in the air, and feel the magic that is Galiano.

—Krista Casey

The Galiano Conservancy's UP-CLOSE Community Values Project

While the Islands in the Salish Sea mapping project was under way, Galiano was engaged in another community project that centred around mapping. At first, organizers tried to figure out how to bring the two together, but they were sufficiently different in purpose and process that each proceeded (quite amicably) down its own path. Galiano's landscape classification and UP-CLOSE workshop project was "community mapping" without the artistic dimension: it was developed by the Galiano Conservancy Association, and it involved the community every step of the way.

Galiano is located about halfway between Tsawwassen on the mainland and Swartz Bay on Vancouver Island. It's the first land mass encountered by the outpour of silty fresh water from the Fraser River when it empties into the Salish Sea. Although subject to the same pressures from timber harvesting and residential development that challenge all of the islands to one degree or another, Galiano has largely retained its rural character and a significant proportion of its natural ecosystems.

In 2000, the conservancy began an ambitious project to develop a landscape classifi-cation information data-base and use it to generate a series of maps of the ecosystems on Galiano at the beginning of the new millennium. The classi-fication was based on data from aerial photographs, satellite images, the B.C. Sensitive Ecosystem Inventory, many different resource-management plans and even road maps. About 25 percent of the area was "ground-truthed" (examined at first hand) to verify the data. Preliminary classification maps were presented at a series of three open houses for residents and property owners in November 2003, providing all islanders with the chance to point out errors based on their own intimate knowledge of the land. The sessions were lively, with much discussion about the specific locations of streams, pocket wetlands and the biggest dogwood tree. As many of the notes and comments as possible were ground-truthed, and corrections were made to the database.

The next phase of the public process was called "Galiano Island UP-CLOSE." It featured workshops on the four key ecosystems that dominate Galiano's landscape: the forest, the remnant Garry oak meadows, the marine and foreshore ecosystem and the freshwater ecosystem. A fifth workshop explored the connections among them. About 125 participants made recommendations about stewardship, community education, responsible resource use and land-use planning.

With this comprehensive information base in hand, people and organizations have begun to work together on Galiano to improve conservation plans and outcomes. Now, if only they would get the artists involved!

- Mature forest (forest over 80 years of age)
- Young forest (forests between 30 and 80 years old)
- Recently harvested (regenerating forest less than 30 years old)
- Wetlands, lakes and riparian areas
- Garry oak meadows, cliffs and bluffs
- Beaches and mudflats
- Developed areas (residences, roads, agriculture etc.)
- Protected Area
- Proposed Marine Protected Area

GALIANO ISLAND AT A GLANCE

POPULATION	SIZE	AREA OF FARMLAND	PROTECTED AREAS	AREA OF GREEN SPACE
2001: 1,071 1991: 909	14,543 acres/58.17 sq km	931 acres/377 hectares	826 hectares/14%	4,733 hectares/81%

Mayne Island

Coordinator Tina Farmilo
Artists Tania Godoroja with Sarah Sexsmith and Glenda Goodman

ON MAYNE, WE WANTED TO map *everything*: water-sheds, First Nations, early colonial and Japanese settlement patterns, precious remnant ecosystems, beachheads of the iniquitous Scotch broom and other invader species. We visualized a series of layers of transparencies that would peel back to reveal different points in the island's history. Our ambitions rapidly outgrew our capacities.

Early on we encountered local concern that through the mapping process, we would lay the island open to ma-rauders—disrespectful persons who would carelessly pick flowers, destroy habitat and interrupt the residents in their peaceful pursuits. We joked that we should create a map of an imaginary Mayne, to forestall all anxieties.

I was eager to get the schoolchildren involved, especially after the first classroom workshop "Mapping Your Heart Places," in which one lad did a beautifully detailed map—of his computer. We organized several events to help the children find themselves on the map, including a "Walk Through Time" in Miners Bay. Local residents came out and told stories of their own youth on Mayne. Writer Terry Glavin spoke eloquently of the days when First Nations people made their homes here, and the very different land and seascape they would have known. We explored artifacts on a local beach and visited the graveyard.

Local naturalist and technical mapper *par excellence* Michael Dunn was, as always, generous with his time. He led one workshop to teach basic skills to the mapping group and document the remnant arbutus and Douglas-fir ecosystem on a neighbour's land, and another when we took the school-children up Mount Parke on a nature hike. Palaeontologist David Spalding came over from Pender and took the map-pers up the mountain, metaphorically back through time, to explore the geological history of the island.

The final selection of an artist was difficult. Eventu-ally, several agreed to collaborate under the able direction of Tania Godoroja, with assistance from the local coordinator. Much discussion arose about what we knew and felt about Mayne and how to capture it in the map: what to leave out,

what to put in? In response to concerns about the fragility of local species and habitat, privacy and the "secret Mayne," we decided to use indirect ways to share some information: hence the decorative floral border of local native and invader species, with no specific locations shown.

Building from an idiosyncratic topographical render-ing, we layered information to show property boundaries, sensitive ecosystems, parks and other notable features. The Coast Salish calendar in the border of the map honours First Nations' presence and traditions on Mayne. We wanted to acknowledge how much intimacy with and respect for the island and its seasonal variety we all share. Tania managed to incorporate everyone's contributions and create an informa-tive yet poetic map, striking in its delicacy and beauty.

There is great interest in continued community map-ping on Mayne, a legacy of the Islands in the Salish Sea proj-ect. We've been collecting data on heritage fruit trees, hoping to explore our rural heritage more deeply and tie it into the history of settlement over the last 200 years. An oral history project is well underway, and we hope to produce many more maps in the future.

—Tina Farmilo

SLUGS

These fascinating members of the phylum Mollusca are a ubiquitous feature of island gardeners' lives. Our native species, which include the familiar and impressively large banana slug, are for the most part forest dwellers that help disperse seeds

ILLUSTRATION BY SARAH SEXSMITH

and spores, break down decaying plant material and keep small pests in check. It's the black ones among the several invasive species from Europe and Asia that are really in competition with humans for the tender lettuce and ripening strawberries in our gardens.

MAYNE ISLAND AT A GLANCE

POPULATION	SIZE	AREA OF FARMLAND	PROTECTED AREAS	AREA OF GREEN SPACE
2001: 880 1991: 739	5,568 acres/22.27 sq km	808 acres/327 hectares	91 hectares/4%	1,440 hectares/62%

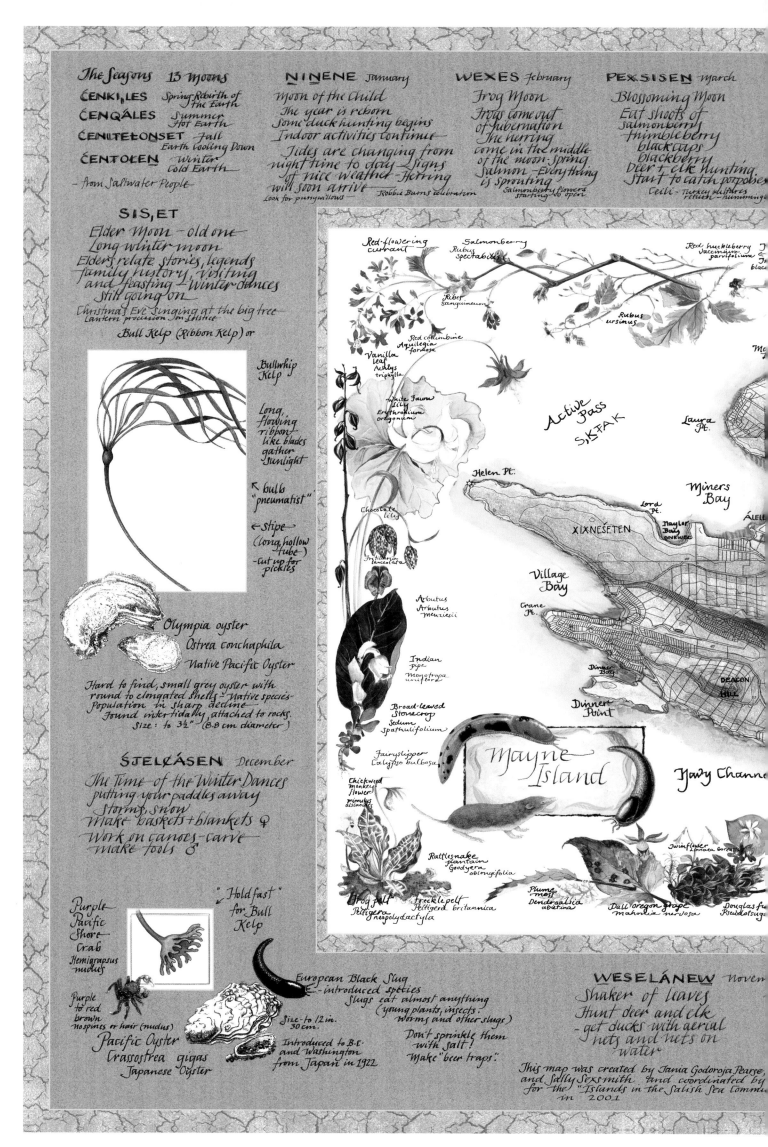

The Seasons — 13 Moons

ĆENKI,LES — Spring Rebirth of the Earth
ĆENQÁLES — Summer Hot Earth
ĆENIŁEŁONSET — Fall Earth Cooling Down
ĆENTOŁEN — Winter Cold Earth

– from Saltwater People

NINENE — January

Moon of the Child
The year is reborn
Some duck hunting begins
Indoor activities continue
Tides are changing from
night time to day – Signs
of nice weather – Herring
will soon arrive — Robbie Burns celebration
Look for pussywillows

WEXES — February

Frog Moon
Frogs come out
of hibernation
The herring
come in the middle
of the moon – Spring
Salmon – Everything
is sprouting
Salmonberry flowers
starting to open

PEXSISEN — March

Blossoming Moon
Eat shoots of
salmonberry
thimbleberry
blackcaps
blackberry
Deer + elk hunting
Start to catch porpoises
Ceili – Turkey wildfires
return – hummings

SIS,ET

Elder Moon – old one
Long winter moon
Elders relate stories, legends
family history, visiting
and feasting – Winter dances
still going on
Christmas Eve singing at the big tree
Lantern procession on Solstice

Bull Kelp (Ribbon Kelp) or

Bullwhip Kelp

Long, flowing ribbon like blades gather sunlight

← bulb "pneumatist"

← stipe (long, hollow tube)
- cut up for pickles

Olympia oyster
Ostrea conchaphila
Native Pacific Oyster

Hard to find, small grey oyster with
round to elongated shells – native species
Population in sharp decline
Found intertidally, attached to rocks.
Size: to 3½" (8.8 cm diameter)

ŞJELĆÁSEN — December

The Time of the Winter Dances
putting your paddles away
Storms, snow
Make baskets + blankets ♀
Work on canoes - carve
make tools ♂

"Hold fast" for Bull Kelp

Purple Pacific Shore Crab
Hemigrapsus nudus

Purple to red brown
no spines or hair (nudus)

Pacific Oyster
Crassostrea gigas
Japanese Oyster

European Black Slug
- introduced species
Size - to 12 in. 30 cm.
slugs eat almost anything
(young plants, insects,
worms and other slugs)

Introduced to B.C.
and Washington
from Japan in 1922

Don't sprinkle them
with salt!
Make "beer traps"

WESELÁNEW — November

Shaker of leaves
Hunt deer and elk
- get ducks with aerial
nets and nets on
water

This map was created by Tania Godoroja Pearse,
and Sally Sexsmith, and coordinated by
for the "Islands in the Salish Sea Committee"
in 2001

Map labels (Mayne Island)

Red-flowering currant

Salmonberry
Rubus spectabilis

Ribes sanguineum

Red huckleberry
Vaccinium parvifolium

Rubus ursinus

Red columbine
Aquilegia formosa

Vanilla leaf
Achlys triphylla

White Fawn Lily
Erythronium oreganum

Chocolate lily
Fritillaria lanceolata

Arbutus
Arbutus menziesii

Indian pipe
Monotropa uniflora

Broad-leaved Stonecrop
Sedum spathulifolium

Fairyslipper
Calypso bulbosa

Chickweed monkey flower
mimulus alsinoides

Rattlesnake plantain
Goodyera oblongifolia

Frog pelt
Peltigera neopolydactyla

Freckle pelt
Peltigera britannica

Plume moss
Dendroalsia abietina

Dull Oregon grape
Mahonia nervosa

Douglas fir
Pseudotsuga

Twinflower
Linnaea borealis

Active Pass
S,KTAK

Laura Pt.

Helen Pt.

Miners Bay

Lord Pt.

Naylor Bay
ONEWET

XIXNESETEN

ÁLELE

Village Bay

Crane Pt.

Dinner Bay

DEACON HILL

Dinner Point

Mayne Island

Navy Channel

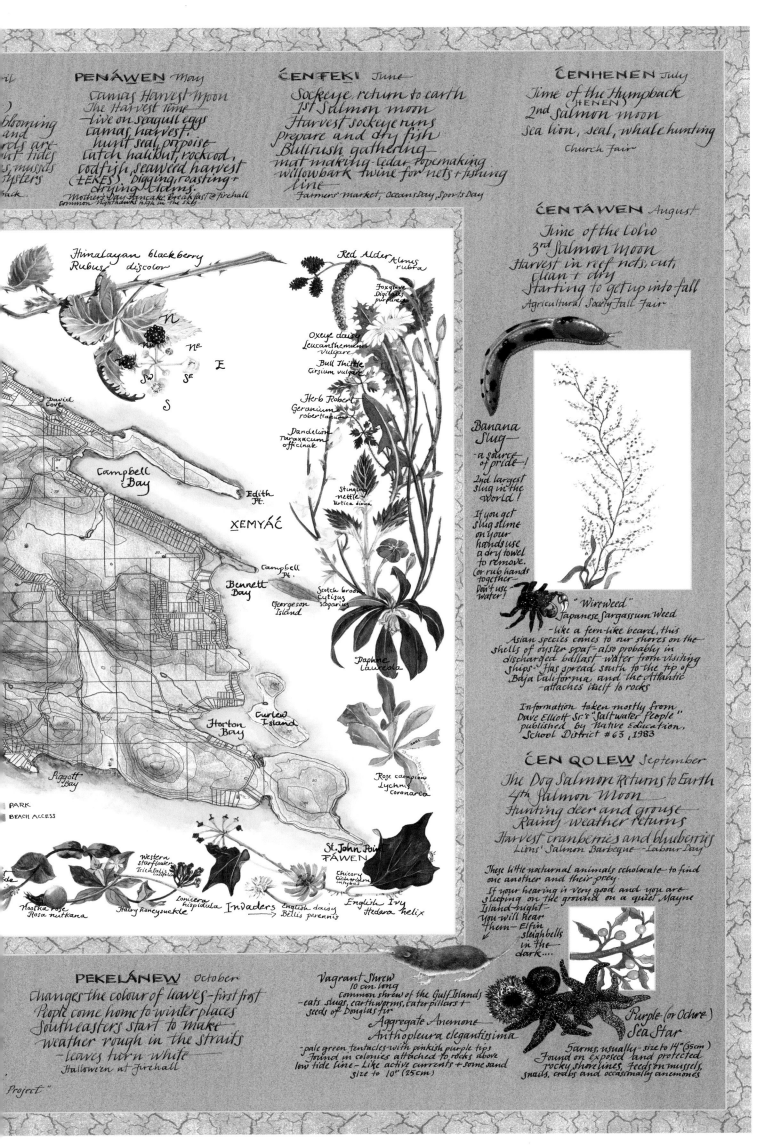

PENÁWEN May

Camas Harvest Moon
The Harvest time
—live on seagull eggs
camas harvest
hunt seal, porpoise
catch halibut, rockcod,
codfish, seaweed harvest
(ŁEKES) digging, roasting +
drying clams.
Mothers Day Pancake Breakfast @ Firehall
common nighthawks high in the sky

(left margin) ...il
...blooming
...and
...rds are
...ut tides
...s, mussels
...ysters
...ack.

ĆENŦEKI June

Sockeye return to earth
1st Salmon moon
Harvest sockeye runs
prepare and dry fish
Bullrush gathering
mat making—cedar ropemaking
willowbark twine for nets + fishing
line
Farmers Market, Oceans Day, Sports Day

ĆENHENEN July

Time of the Humpback
(HENEN)
2nd Salmon moon
sea lion, seal, whale hunting
Church Fair

ĆENTÁWEN August

Time of the Coho
3rd Salmon Moon
Harvest in reef nets, cut,
clean + dry
Starting to get up into fall
Agricultural Society Fall Fair

Himalayan blackberry
Rubus discolor

N
NE
NW
E
SW SE
S

David Cove
Campbell Bay
Edith Pt.
XEMYÁĆ
Campbell Pt.
Bennett Bay
Georgeson Island
Horton Bay
Curlew Island
Piggott Bay
PARK
BEACH ACCESS
St. John Point
ȾÁWEN

Red Alder
Alnus rubra

Foxglove
Digitalis purpurea

Oxeye daisy
Leucanthemum vulgare

Bull Thistle
Cirsium vulgare

Herb Robert
Geranium robertianum

Dandelion
Taraxacum officinale

Stinging nettle
Urtica dioica

Scotch broom
Cytisus scoparius

Daphne
Laureola

Rose campion
Lychnis coronaria

Western starflower
Trientalis latifolia

Nootka rose
Rosa nutkana

Hairy honeysuckle
Lonicera hispidula

Invaders

English daisy
Bellis perennis

English Ivy
Hedera helix

Chicory
Cichorium intybus

Banana Slug
—a source of pride—!
2nd largest slug in the world!
If you get slug slime on your hands use a dry towel to remove. (or rub hands together—Don't use water!

"Wireweed"
Japanese Sargassum Weed
—like a fern-like beard, this Asian species comes to our shores on the shells of oyster spat—also probably in discharged ballast water from visiting ships—Has spread south to the tip of Baja California and the Atlantic—attaches itself to rocks

Information taken mostly from Dave Elliott Sr.'s "Saltwater People" published by Native Education, School District #63, 1983

ĆEN QOLEW September

The Dog Salmon Returns to Earth
4th Salmon Moon
Hunting deer and grouse
Rainy weather returns
Harvest cranberries and blueberries
Lions' Salmon Barbeque—Labour Day

These little nocturnal animals echolocate to find one another and their prey.
If your hearing is very good and you are sleeping on the ground on a quiet Mayne Island night you will hear them—Elfin sleighbells in the dark....

PEKELÁNEW October

Changes the colour of leaves—first frost
People come home to winter places
Southeasters start to make weather rough in the straits
—leaves turn white
Hallowe'en at Firehall

(left margin) ...tle
...Project"

Vagrant Shrew
10 cm. long
common shrew of the Gulf Islands
—eats slugs, earthworms, caterpillars + seeds of Douglas fir

Aggregate Anemone
Anthopleura elegantissima
—pale green tentacles with pinkish purple tips
Found in colonies attached to rocks above low tide line—Like active currents + some sand
size to 10" (25cm)

Purple (or Ochre) Sea Star
5 arms, usually—size to 14" (35cm)
Found on exposed and protected rocky shorelines, feeds on mussels, snails, crabs and occasionally anemones

Japanese Canadians on Mayne

Mayne Island has always been within the house of the Tsawout (pronounced "say out") people, who are part of the Wsanec (Saanich) Nation. Cowichans from farther north in the Salish Sea sometimes married in to Tsawout families, and occasionally they settled on Mayne. An archaeological site on the Helen Point Reserve shows 5,000 years of continuous use and occupation.

The Hiashi or Zig Zag Bridge in the Japanese Memorial Garden, completed in 2002. PHOTO BY BRIAN HALLER

community spirit towards their fellow citizens." In a later letter, he reiterated his pro-Japanese views and expressed the hope that confiscated fishing boats would soon be returned to their owners. But to no avail. The Canadian government would not reconsider its policy.

The Japanese Canadian greenhouse operators did convince the British Columbia Securities Commission to allow their greenhouses to keep running for a time under the management of their former employees. "These persons, though not Japanese, have been our assistants for many years," wrote Kumazo Nagata, one of the owners.[16] Meanwhile, many islanders secretly hid away the Japanese families' household possessions, awaiting their return.

The Enemy Aliens Property Board, working through a prominent Salt Spring realtor, seized and eventually auctioned off Japanese lands and possessions. Anti-Japanese settlement laws remained in place until years after the war ended, preventing their return to the coast. Veterans arriving back in B.C. couldn't resist the fire-sale prices of former Japanese farms.

Most of the first non-Aboriginal people—those men commonly described as Mayne's first settlers—were the husbands of local Native women. The island settlers' origins were thoroughly cosmopolitan: German, Portuguese, Scots, English, New Brunswickers and, of course, Japanese.

By the 1920s, at least 60 first- and second-generation Japanese Canadians lived on Mayne, making a successful living as fishermen and farmers. They were the force behind a thriving greenhouse tomato industry. By the 1930s, the island boasted 3½ hectares of tomatoes under glass, and the growers were shipping out 50 tonnes a year.

But the Second World War and racial prejudice intervened. On April 21, 1942, the CPR steamship *Princess Mary* arrived to take away a third of Mayne's population. The rest of the island turned out at the Miners Bay dock to wish their Japanese neighbours a tearful farewell. Internment was a tragedy for those who remained as well as those who were forced to leave. It broke up friendships, removed the island's major employers and closed the local school for two years because there were no longer enough children to keep it going.

Internment was protested by non-Japanese islanders, notably the well-known First World War veteran Lieutenant-Colonel Charles Flick. In a letter to the Victoria *Colonist* on January 25, 1938, he wrote that the Japanese Canadians on Mayne were "courteous, civil, hospitable, and of excellent

On Mayne today there are fields still full of shards of glass from the shattered remains of the greenhouses. And what of memory? In 2002 the Mayne Island Parks Commission completed construction of the Japanese Memorial Garden on the site of the former Adachi family farm at Dinner Bay Park. Full of rhododendrons, Katsura trees, Japanese cherries and flowering plums, it also has a Shinto-inspired zigzag bridge across the pond, a meditation shelter and a classic Japanese-style archway at the entrance. Built by volunteers from the community in honour of the island's Japanese Canadian settlers, the garden is growing in beauty daily, a true labour of love and respect.

Saturna Island

Coordinator Priscilla Ewbank
Artist Rosalinde Compton

WHEN I WAS APPROACHED ABOUT this project, I could hardly believe my ears. "You want to give us funding to help the community create a map that tells our story to the world, and then we can have it for ourselves to use to raise more money for other island projects?!" From the start, I liked everything I heard about the Islands in the Salish Sea Community Mapping Project:

- the philosophy: portraying our island through our own eyes, noting who we share it with, what we have created together and where we came from—a map from the people;
- the vision: seeing these islands as vital communities that could benefit by defining ourselves individually and collectively, to further articulate who we are and what we need to survive;
- the process: getting a recognized island sponsor, then getting out in the community to record cultural history, natural history, present community functions and the buildings that hold them, then rendering this information into a map like no other map before it.

AND we'd have a little financial support to compensate worn-out volunteers for their time and effort. I said "Yes" emphatically and with great excitement.

I ran a café that year in one of the general stores, and the café provided a venue for people to talk about the map. As I babbled on enthusiastically about the possibilities, people came to see themselves in the project—it started to belong to the community. Over a period of months, it gradually gained momentum, recognition and acceptability, attracting a broad base of participants. We gathered research data for over a year. We used some of our funds to pay a small honorarium to several local artists who were eager to produce work that represented what Saturna means to them. Their work became part of the mother lode of information and imagery that helped artist Rosalinde Compton create the final map, which has won such universal praise and appreciation.

Saturna is proud of its map. We give framed prints as gifts to honour departing islanders: teachers and others who have made a contribution to the good of us all. We have presented it to various officials to let them know—in an elegant way—that we need them to be mindful of our home place and to make plans *with* us, not *for* us. We are pleased to think that our map, and all the others in the collection, will help the Islands Trust to interpret and fulfill its mandate to "preserve and protect" these islands.

Framed and unframed prints are for sale. A portion of each sale goes to our broadly based Community Club, the local sponsor of the project, to help with other initiatives. The success of the project and the pride it has engendered have inspired many people in the community, including our local Parks and Recreation Commission, to take on other creative mapping ideas. Thanks to everyone who contributed to our map.

—Priscilla Ewbank

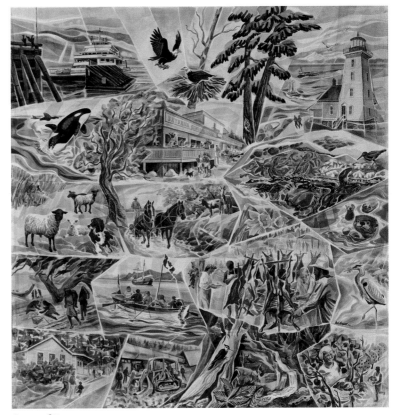

Facets of Saturna MURAL BY JACK CAMPBELL

SATURNA ISLAND AT A GLANCE

POPULATION	SIZE	AREA OF FARMLAND	PROTECTED AREAS	AREA OF GREEN SPACE
2001: 319 1991: 267	8,679 acres/34.72 sq km	7,397 acres/2,993 hectares	1,554 hectares/44.2%	2,494 hectares/77%

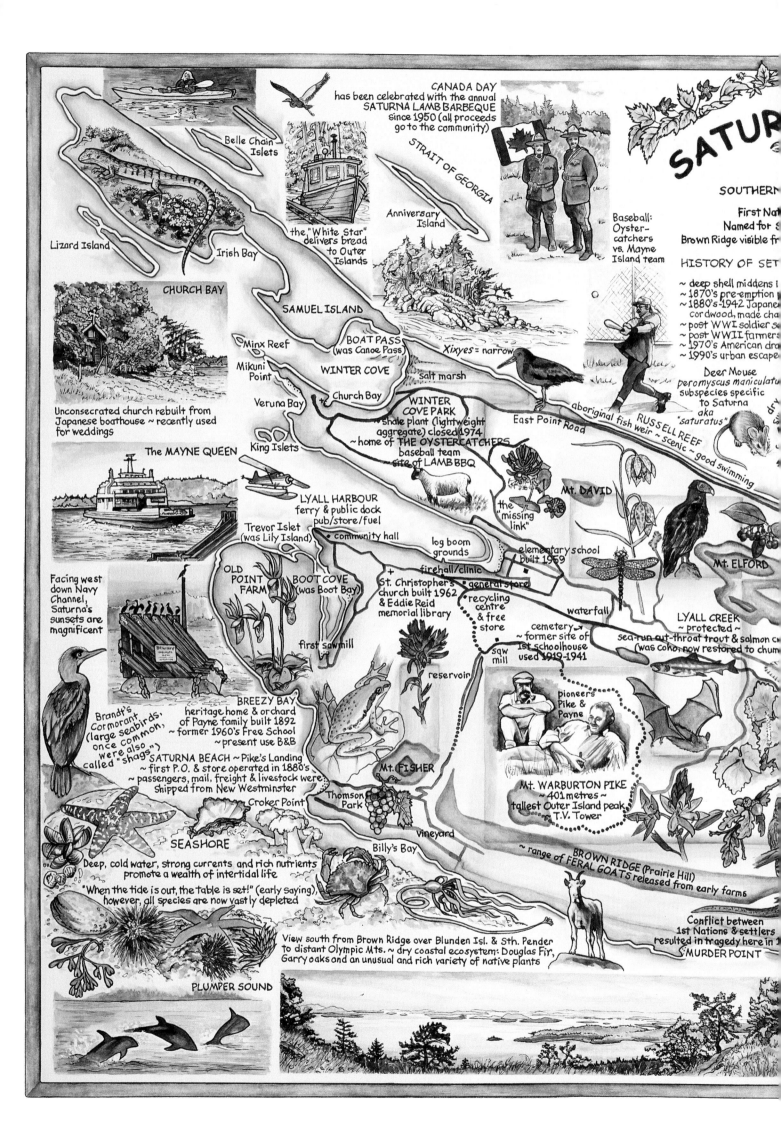

Belle Chain Islets

Lizard Island

Irish Bay

the "White Star" delivers bread to Outer Islands

CANADA DAY has been celebrated with the annual SATURNA LAMB BARBEQUE since 1950 (all proceeds go to the community)

STRAIT OF GEORGIA

Anniversary Island

Baseball: Oyster-catchers vs. Mayne Island team

SATUR...

SOUTHERN

First Nat...
Named for S...
Brown Ridge visible fr...

HISTORY OF SET...

~ deep shell middens i...
~ 1870's pre-emption...
~ 1880's-1942 Japane... cordwood, made cha...
~ post WWI soldier s...
~ post WWII farmers...
~ 1970's American dra...
~ 1990's urban escape...

Deer Mouse peromyscus maniculat... subspecies specific to Saturna aka "saturatus"

CHURCH BAY

SAMUEL ISLAND

Minx Reef

Mikuni Point

BOAT PASS (was Canoe Pass)

WINTER COVE

Xixyes = narrow

salt marsh

Church Bay

Veruna Bay

Unconsecrated church rebuilt from Japanese boathouse ~ recently used for weddings

WINTER COVE PARK ~ shale plant (lightweight aggregate) closed 1974 ~ home of THE OYSTERCATCHERS baseball team site of LAMB BBQ

East Point Road

aboriginal fish weir ~ scenic ~ good swimming

RUSSELL REEF

The MAYNE QUEEN

King Islets

LYALL HARBOUR ferry & public dock pub/store/fuel

Trevor Islet (was Lily Island)

community hall

log boom grounds

Mt. DAVID

the "missing link"

elementary school built 1959

Mt. ELFORD

Facing west down Navy Channel, Saturna's sunsets are magnificent

OLD POINT FARM

BOOT COVE (was Boot Bay)

St. Christopher's church built 1962 & Eddie Reid memorial library

firehall/clinic

general store

recycling centre & free store

waterfall

cemetery ~ former site of 1st schoolhouse used 1919-1941

LYALL CREEK ~ protected ~ sea-run cut-throat trout & salmon c... (was coho, now restored to chum...

first sawmill

Brandt's Cormorant (large seabirds, once common, were also called "shags")

Beware

sqw mill

reservoir

pioneers Pike & Payne

BREEZY BAY heritage home & orchard of Payne family built 1892 ~ former 1960's Free School ~ present use B&B

SATURNA BEACH ~ Pike's Landing ~ first P.O. & store operated in 1880's ~ passengers, mail, freight & livestock were shipped from New Westminster

Croker Point

Mt. FISHER

Thomson Park

MT. WARBURTON PIKE ~ 401 metres ~ tallest Outer Island peak ~ T.V. Tower

vineyard

SEASHORE

Billy's Bay

Deep, cold water, strong currents and rich nutrients promote a wealth of intertidal life

"When the tide is out, the table is set!" (early saying), however, all species are now vastly depleted

~ range of FERAL GOATS released from early farms

BROWN RIDGE (Prairie Hill)

Conflict between 1st Nations & settlers resulted in tragedy here in 1... MURDER POINT

View south from Brown Ridge over Blunden Isl. & Sth. Pender to distant Olympic Mts. ~ dry coastal ecosystem: Douglas Fir, Garry oaks and an unusual and rich variety of native plants

PLUMPER SOUND

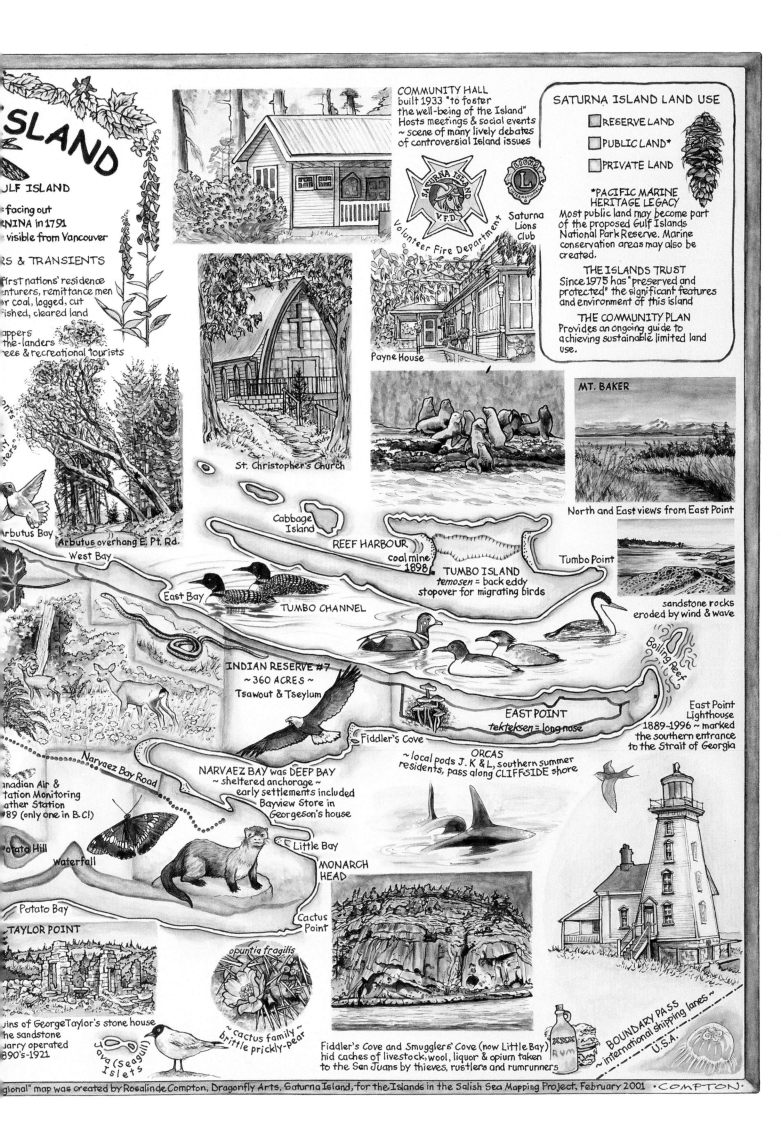

ISLAND

...ULF ISLAND
...facing out
...NINA in 1791
...visible from Vancouver

...RS & TRANSIENTS
...first nations' residence
...enturers, remittance men
...r coal, logged, cut
...ished, cleared land
...appers
...the-landers
...es & recreational tourists

...rbutus Bay
Arbutus overhang E. Pt. Rd.

COMMUNITY HALL
built 1933 "to foster
the well-being of the Island"
Hosts meetings & social events
~ scene of many lively debates
of controversial Island issues

Saturna Island V.F.D.
Volunteer Fire Department

Saturna Lions Club

St. Christopher's Church

Payne House

SATURNA ISLAND LAND USE

☐ RESERVE LAND
☐ PUBLIC LAND*
☐ PRIVATE LAND

*PACIFIC MARINE HERITAGE LEGACY
Most public land may become part
of the proposed Gulf Islands
National Park Reserve. Marine
conservation areas may also be
created.

THE ISLANDS TRUST
Since 1975 has "preserved and
protected" the significant features
and environment of this island

THE COMMUNITY PLAN
Provides an ongoing guide to
achieving sustainable limited land
use.

MT. BAKER

North and East views from East Point

Cabbage Island

REEF HARBOUR
coal mine 1898

TUMBO ISLAND
temosen = back eddy
stopover for migrating birds

Tumbo Point

sandstone rocks
eroded by wind & wave

West Bay

East Bay

TUMBO CHANNEL

INDIAN RESERVE #7
~ 360 ACRES ~
Tsawout & Tseylum

Boiling Reef

East Point
Lighthouse
1889-1996 ~ marked
the southern entrance
to the Strait of Georgia

EAST POINT
tekteksen = long nose

Fiddler's Cove

ORCAS
~ local pods J, K & L, southern summer
residents, pass along CLIFFSIDE shore

...nadian Air &
...tation Monitoring
...ather Station
...89 (only one in B.C!)

Narvaez Bay Road

NARVAEZ BAY was DEEP BAY
~ sheltered anchorage ~
early settlements included
Bayview Store in
Georgeson's house

...otato Hill

waterfall

Little Bay

MONARCH
HEAD

Potato Bay

Cactus Point

...TAYLOR POINT

opuntia fragilis

...ins of George Taylor's stone house
...he sandstone
...uarry operated
...890's-1921

Java (seagull) Islets

~ cactus family ~
brittle prickly-pear

Fiddler's Cove and Smugglers' Cove (now Little Bay)
hid caches of livestock, wool, liquor & opium taken
to the San Juans by thieves, rustlers and rumrunners

XXX RUM

BOUNDARY PASS
~ international shipping lanes ~
U.S.A.

...gional" map was created by Rosalinde Compton, Dragonfly Arts, Saturna Island, for the Islands in the Salish Sea Mapping Project, February 2001 • COMPTON •

Summer Memories of Narvaez Bay

Sounds of seagulls announcing morning's arrival ... A pair of kingfishers machine-gunning the air with their calls ... Dragonflies shimmering in the heat of the sun ... Swallows sitting on the power line, waiting for what? ... Hummingbirds buzzing like bees and sitting on our fingers at Mom's feeders on the deck ... Eagles circling lazily above in the blue blue cloudless sky ... The delicious sweet smell of the dry golden grasses baking in the sun ... Solitude. Low tide, clams squirting ... Raccoons fishing on the beach ... Drifting in the rowboat over the shallows to watch crabs and perch and sea stars and iridescent seaweeds ... Fetching pails of delicious water from the spring's pool at the base of the huge cedar tree ... A tub of bathwater warming in the sun ... Picking wild gooseberries and baking pies in the woodstove oven ... Quiet. Children creating art for the outhouse gallery ... Helping build a raft from driftwood ... Swimming and running naked on the beach ... All of us eating like kings—feasts of clams and oysters and crab and salmon and cod and, of course, anything the kids caught ... Dad thrilled with the first harvest of asparagus, just before the deer discover it ... Stillness. Evening walks up Monarch Head and up top of Taylor Bay ... The thrill of glimpsing the wild goats ... Nighthawks beeping as they dive through the darkening sky ... Kids in their jammies brushing their teeth outside over the grease pit ... Lying on blankets on the beach at night and watching for falling stars ... Phosphorescence magically appearing in the night waters when stirred up by the oars ... Blessed, blessed island ... Saturna.

—Jody Bavis

Forty-Four Percent National Park

Almost half of Saturna is part of a park: the new Gulf Islands National Park Reserve. The GINPR is a patchwork of land on 15 islands and more than 30 smaller islets and reefs, plus an undersea area. Nine former provincial and marine park sites have been rolled into the total, which stretches over about 33 square kilometres.

The park lies in the heart of the Georgia Lowlands, the smallest of Canada's 39 distinct terrestrial regions and probably the one most at risk of change beyond recognition or restoration. Just a short boat ride from the millions who live in the Lower Mainland of B.C. and on Vancouver Island, it has become an almost-too-attractive place for people to live and play.

In recognition of the singular abundance and diversity of species and ecosystems here, in May 2003 the GINPR was declared a reality by Parks Canada and the province of B.C. The goal is to safeguard a small portion of this beautiful archipelago, both its natural and cultural features, for all time. The population of the Georgia Basin grew by 21 percent between 1991 and 2002; it is expected to grow by a further 35 percent by 2020, to reach 2 million. You might say that this sample of the Vancouver Island rain shadow was protected just in time.

But parks are themselves subject to great pressures. Many suffer from small size, fragmentation of ecosystems, overuse, resort and residential development on their borders, water pollution, increased risk of fire—in other words, the stresses of human use and abuse. Among the residents of tiny Saturna, anxiety has swirled around those issues, plus two others: how will the community get along with the large bureaucratic agency that suddenly "owns" so much of their home place? How will residents cope with the influx of visitors, uninitiated in island ways, that the widely advertised national park will attract?

So far, most people on Saturna seem to agree that Parks Canada has been careful, cooperative and willing to listen. They are hoping for the same respect from new visitors.

North and
South Pender Islands

Coordinators Lisa Fleming and
Don Harrison
Artists Susan Taylor; S.L. Wilde

ANY JOURNEY IS BEST STARTED with a good map and a plotted course. In 1999, when Lisa and I moved into the house we built on North Pender Island, we had neither. We just knew we wanted to live here. Revealing ourselves as curious and eager full-time newcomers to the islands, we were immediately seized on by active Penderites and asked to get involved in some of the things going on in the community. The Islands in the Salish Sea mapping project was placed in our laps by the Pender Islands Conservancy Association with the hope that we would agree to be the local project coordinators.

As biologist and geologist respectively, Lisa and I had technical experience with mapping, but the concept of "barefoot mapping" and the creation of artistically rendered maps was both an interest and a challenge to us. Seeing the project as an opportunity to learn more about the islands and to meet new people on the Penders and from all around the Salish Sea, we embarked on a journey of discovery.

In the spring of 2000, we set about hosting workshops and meetings to inform members of the community about the project, and to bring people with various backgrounds and knowledge of their islands together to express what they knew and loved about the Penders. We met with individuals and experts from many local organizations to discover the secrets of the islands. We contacted the Pender School to learn about previous mapping projects. We looked up information in the Conservation Data Centre's Sensitive Ecosystem Inventory, and uncovered aerial photos of the Penders that dated back to the middle of the last century.

Each new insight, new "find" of information, went onto the big compilation maps we used like notebooks. It was especially enjoyable to display these evolving maps at the Saturday Farmers' Market at the Pender Community Hall over that summer. Residents and visitors alike put pencil to paper and helped to create the map of the Penders by sharing their special knowledge and memories of the islands.

We were fortunate to meet South Pender resident and artist Susan Taylor, who was involved with the campaign to preserve and protect Brooks Point, a splendid piece of land near her home. Her artwork is inspired by the beauty and

Lion's mane jelly at Tilly Rocks, South Pender. PHOTO BY DEREK HOLZAPFEL

species diversity of Brooks Point, and it was her passion for the area that led to the creation of our first map.

We were equally fortunate to receive a proposal for our second map from S.L. Wilde, a North Pender resident and artist with a deep love for and connection with all of the natural world. Her concern for the islands' fragility and threatened ecological diversity was the driving force and inspiration for our second map, a depiction of both islands.

Participating in this project has instilled in us a deep appreciation of our home islands: how they've evolved with ancient and more recent human settlement, and how they will continue to evolve. Through the process of gathering information from many sources and working with others to survey and take inventory of our islands, we hope we have helped to create a millennium portrait of the Pender Islands that will remain a legacy for future residents, visitors and planners.

The project has reminded us that maps are not just graphic representations: they shape our perceptions of place. They open the door to understanding, awareness and appreciation. Perhaps our greatest hope is that the maps and this book will instill in others a sense of discovery and a thirst to learn more about the places we call home. As more people come to the islands, we need these maps to make us all more aware of our connections with the land, and to the larger region in which we live.

—Don Harrison and Lisa Fleming

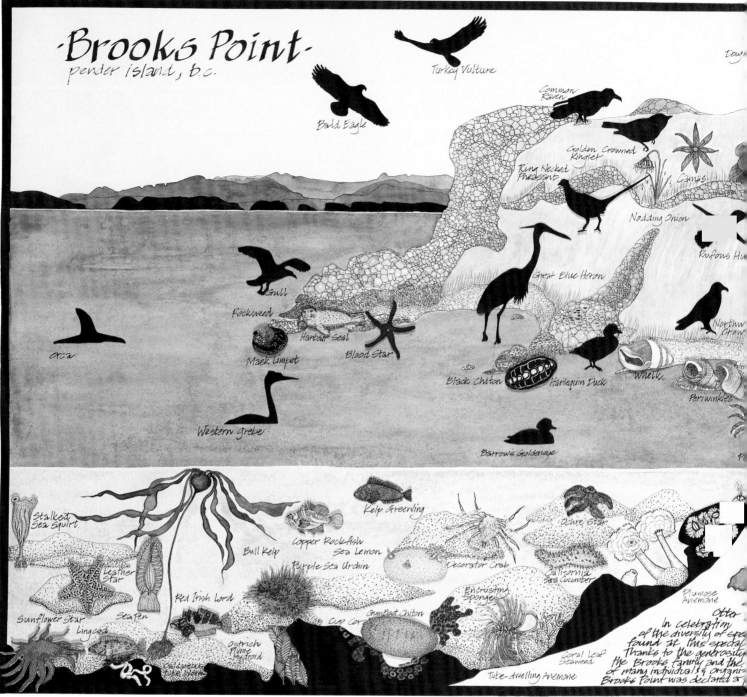

Brooks Point
pender island, b.c.

(Map labels, clockwise/as shown:)

Turkey Vulture
Bald Eagle
Common Raven
Golden Crowned Kinglet
Ring Necked Pheasant
Camas
Nodding Onion
Rufous Hu[...]
Great Blue Heron
Northw[...] Craw[...]
Gull
Rockweed
Harbour Seal
Mask Limpet
Blood Star
Black Chiton
Harlequin Duck
Whelk
Periwinkles
Orca
Western Grebe
Barrow's Goldeneye
Stalked Sea Squirt
Kelp Greenling
Ochre Star
Bull Kelp
Copper Rockfish
Sea Lemon
Purple Sea Urchin
Decorator Crab
California Sea Cucumber
Plumose Anemone
Leather Star
Red Irish Lord
Encrusting Sponge
Sunflower Star
Lingcod
Seafen
Cup Cor[...]
GumBoot Chiton
Otter
Ostrich Plume Hydroid
Coral Leaf Seaweed
Tube-dwelling Anemone

In celebration of the diversity of spe[...] found at this special [...] Thanks to the generosity [...] the Brooks family and the [...] of many individuals & organiz[...] Brooks Point was declared a [...]

MAP BY SUSAN TAYLOR

The "Disappearing Line" Map

One of the most treasured places on the Penders when the Islands in the Salish Sea mapping project began was a rare, undeveloped, four-hectare coastal headland of spectacular beauty known as Brooks Point. Former residents and ardent conservationists Allan and Betty Brooks were eager to have their property preserved for future generations. After nearly four years of intense community fundraising, this unique and sensitive marine foreshore habitat on South Pender was acquired as a conservation area in 2000.

Just as a photograph cannot depict a person's soul, traditional maps can never truly capture the essence of a place. Pender's project coordinators and artist Susan Taylor realized that to capture Brooks Point, they would have to venture beyond those limits. After much brainstorming, the idea of the "disappearing line" map was born. The idea was to illustrate the continuum of native species from ocean bottom through intertidal zone to terrestrial zone and on up to treetop. Drawing on research from projects by the Pender School and the local Straitkeepers, and numerous deep dives by Parks Canada, Canadian Parks and Wilderness Society (CPAWS) and artist Susan Taylor herself, the innovative concept was brought to life in this map.

The Ecology of Brooks Point

Brooks Point is one of the very few natural coastal headlands in the southern Salish Sea that is free of human development. Rare too is the stretch of native grasses, where the

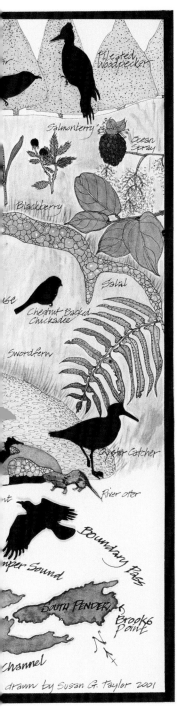

drawn by Susan G. Taylor 2001

meadow of the bluff adjoins dense thickets of salmonberry, leading to a tall mixed forest of Douglas-fir and grand fir. The open grasslands host delicate native wildflowers in the spring and are habitat for several species of endangered birds. The point provides valuable habitat for migratory birds on their way to their breeding or wintering grounds: up to 105 bird species have been recorded there, including five provincially endangered and nine threatened species. In addition, many marine mammals can be observed from Brooks Point, including otters, seals, porpoises and sea lions. Orcas often frequent the area to rest in the nearby shallows.

At the water's edge, wave-eroded conglomerate rock forms pockets, crevices, tide pools and overhanging ledges where marine organisms thrive: eight species of starfish, two of sea urchin, four of sea cucumber, five of anemone, four of chiton, and many species of snail, bivalve and seaweed. The rich diversity of life found on all sides of the elusive disappearing line at Brooks Point makes it a community treasure well worth protecting.

The Brooks Family Legacy

The owners of Brooks Point, Allan and Betty Brooks, were accomplished naturalists, fully aware of the immense ecological value of the area. Through the 1990s, they tried in vain to get various levels of government to purchase the land so it could be protected in perpetuity. In 1996, a dedicated group of islanders formed the Friends of Brooks Point. With the support of the Pender Islands Conservancy Association and many others in the community, they worked tirelessly to purchase the point. Fundraising for the acquisition of Brooks Point became a feature of the Pender community throughout the late 1990s, and there is probably no one on the island who has not purchased a T-shirt, poster or raffle ticket, or attended a dance, art auction or garage sale in support of this effort. Allan and Betty generously donated one of the three lots that make up the 10-acre site, and other agencies and individuals made up the purchase price. As a result of all these efforts, Brooks Point became a protected area in January 2000. Shortly thereafter, in February 2000, Allan passed away, with the knowledge that his dream of protecting Brooks Point as a conservation area had been achieved.

Brooks Point in Context

Protected, Brooks Point helps provide a link between the high rocky ridge atop Greenburn Lake in the recently established Gulf Islands National Park Reserve lands on South Pender Island and the rich yet fragile marine environment of Boundary Pass. This link, along with stewardship efforts on private lands in the neighbourhood, will help maintain the ecological integrity of a unique, sensitive and disappearing habitat.

Boundary Pass is itself a prime candidate for some form of ecosystem protection. A regional coalition of environmental groups is working with Parks Canada and others to establish a National Marine Conservation Area (NMCA) for the southern waters of the Salish Sea. A legislated NMCA, which would include Brooks Point, would help to protect the extensive marine biodiversity of this region. It would also help re-establish a once-lucrative fishery.

In 2002, a small group of Pender SCUBA divers initiated a project to identify, photograph and document marine species and habitat in the sub-tidal area around Brooks Point, among other sites. Perhaps, if we are lucky, this unusual inventory work will lead to another unusual map.

NORTH PENDER ISLAND AT A GLANCE

POPULATION	SIZE	AREA OF FARMLAND	PROTECTED AREAS	AREA OF GREEN SPACE
2001: 1,776 1996: 1,655	12,532 acres/50.13 sq km	2,667 acres/1,079 hectares	938 hectares/18.5%	1,685 hectares/62%

North and South Pender Islands

We share these islands in the Salish Sea with a vast and varied host of life. Slow down, walk gently; how many will you see?

The 171 species represented on this map are a mere fraction of the many who live here with us. Most of those I've shown are common, native residents of the Pender Islands. Some, like foxglove and blackberry, are introduced species which have become a part of the web of life here. Others, like elephant seal, gray whale, luna moth and sharp-tailed snake, are rare, transient or endangered. Peaceable, playful sea otter, once hunted to the brink of extinction, was believed to be gone from these waters forever. In recent years, there have been several reported sightings of sea otters off the coast of the Penders: some say they must simply be river otters a long way from shore, but others believe they are lone adolescents from sea otter colonies re-established far to the north and south of our islands, exploring their ancestral territories. I say, "Welcome home, young explorers!"

All of these species are vulnerable to human impact. How can we protect them and these magical islands? We can work together to safeguard habitats and create new parklands. We can practise good stewardship by enjoying native plants instead of striving for monoculture lawns and city-type yards. We can seek conscious options in daily living, reduce consumption, reuse and recycle whenever possible. We can support local organic farms and low-impact businesses. Most importantly, we can examine the products we use in our homes and gardens and make educated choices, refusing to pollute our lands and waters.

Fresh water is the heart of all life, especially on an island. We live in our watersheds. If we use pesticides, herbicides, toxic household-cleaning or laundry or body-care products and other unnecessary chemicals, they enter the aquifer, endangering plants, animals, human health and the future of our island home. Our everyday choices can protect or destroy. We share these lands and seas—please, let's take care!

—S.L. Wilde

With invaluable research and secretarial help from her children, Nicholas and Naomi, the artist prepared a list of the 171 species illustrated on her map. The list is framed and hangs beside the map in the Pender Community Hall. Feedback from visitors and residents indicates that the list has added greatly to the educational impact of the map. Many have made a game of seeing how many of the species listed they can locate on the map and then identify later in their hikes around the islands.

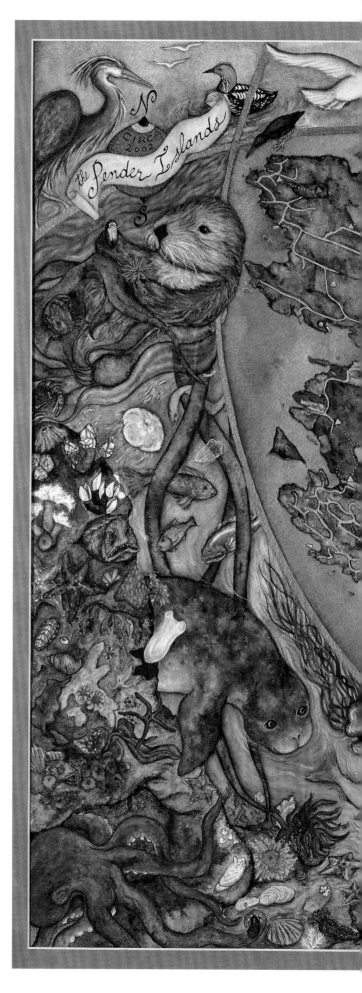

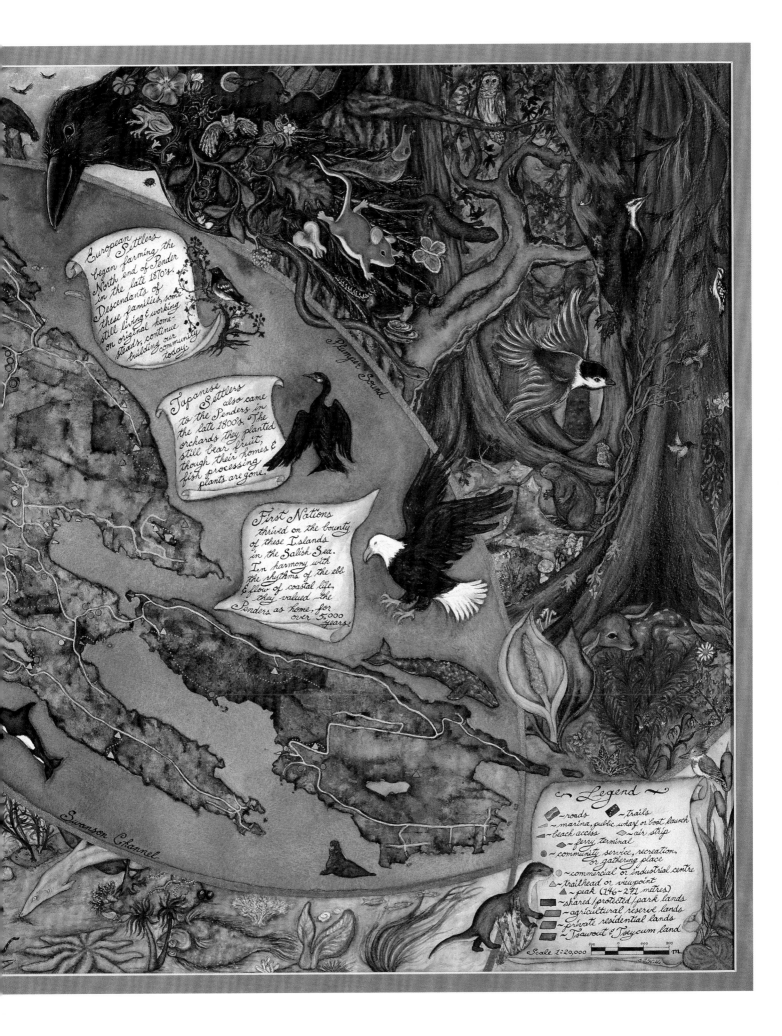

European Settlers began farming the North end of Pender in the late 1870's. Descendants of these families, some still living & working on original home-steads, continue building our community today.

Japanese Settlers also came to the Penders in the late 1800's. The orchards they planted still bear fruit, though their homes & fish processing plants are gone.

First Nations thrived on the bounty of these Islands in the Salish Sea. In harmony with the rhythms of the ebb & flow of coastal life, they valued the Penders as home, for over 5,000 years.

Plumper Sound

Swanson Channel

~ Legend ~

⬛ ~ roads ⬦ ~ trails
△ ~ marina, public wharf or boat launch
⬟ ~ beach access ⬦ ~ air strip
⬟ ~ ferry terminal
● ~ community service, recreation, or gathering place
◉ ~ commercial or industrial centre
△ ~ trailhead or viewpoint
▲ ~ peak (146 ~ 272 metres)
⬛ ~ shared / protected / park lands
⬛ ~ agricultural reserve lands
⬛ ~ private residential lands
⬛ ~ Tsawout & Tseycum land

Scale 1:20,000

First Nations

The many shell middens on the Penders are testament to the fact that our islands were well used by Aboriginal peoples on a year-round and seasonal basis for upwards of 5,000 years. Most local residents are probably familiar with the archaeological dig at the Pender Canal site, but every stretch of waterfront hospitable to a canoe haul-out and encampment is probably a First Nations' heritage site, protected by law.

Even so, in many instances features of First Nations' presence on and occupation of the islands have been destroyed and lost forever. The construction of the Pender Canal in 1903 resulted in the loss of countless invaluable artifacts. Resort development at Bedwell Harbour from 1960 to the present has disturbed ancient cultural sites. Construction at Poets Cove Resort on South Pender in 2004 was stopped when the remains of at least 52 people and more than 2,000 artifacts were found. Elders and community members from the Tsawout, Tsartlip, Pauquachin and Tseycum First Nations later conducted a burning ceremony on their reserve, adjacent to the site. Their purpose was to settle unrest caused by the desecration of their ancestral burial grounds, to honour those who have passed on and to bring healing to those who remain.

The archaeological record on the Penders is a valuable link to the past. It may be lost forever unless adequate care is taken and First Nations' traditions are respected. The responsibility rests with all of us to protect these richly informative and sometimes sacred sites, and to consult with today's descendants about their use.

Japanese Canadians

In a mostly forgotten chapter of the Penders' history, a large number of Japanese settlers arrived in the late 1800s and early 1900s. There were few employment opportunities open to Japanese people on the coast so they made work for themselves. They fished, especially for herring and lingcod; they harvested *nori* (seaweed) to sell in Japanese communities around B.C.; they made and sold charcoal using technology they brought from Japan; they cut cordwood. Their families built houses and planted orchards. Both Japanese and European Canadians found seasonal work at the saltery at Hyashi Cove, where many tons of fish were preserved.

During the Depression years, the wages earned at the saltery and on the herring boats were essential to many Pender Island families.

When the Second World War brought prejudice and fear to the surface of Canadian society, the Japanese were treated as enemy aliens. In 1941, the government seized their fishing boats on the grounds that they could be used to create a navy and attack coastal communities. Japanese Canadians on the Penders, as elsewhere, were deprived of their homes, their businesses and their personal possessions, and forcibly relocated to internment camps far from the coast. This unhappy period of island history was, of course, extremely painful to Japanese Canadians and after the war, few returned to the Pender Islands.

European Settlement

Permanent European settlers arrived on Pender in the 1870s, most from the British Isles but some from Australia and Eastern Canada. Pender was a single island then, its northern and southern sections connected by a sandy neck of land. In 1903, following a petition by islanders for a safer shipping route to Victoria, a navigable canal was dug through it, separating North and South Pender until 1955, when a bridge reconnected the two.

Although agriculture was the main industry for most of the islands' history, the land supported little but fruit trees and grazing for sheep and cattle. Small industries survived for periods of time, including a fish-reduction plant at Shingle Bay, a brick factory at Bricky Bay, a saltery at Hyashi Cove and a number of small sawmills.

The islands had a relatively small population until the 1960s, when construction began on Gulf Garden Estates (now Magic Lake Estates). With 1,200 lots, it was the largest planned subdivision in Canada at that time. Recognizing the potential for uncontrolled, suburban-style development to spread throughout the Gulf Islands, in 1969 the B.C. government imposed a moratorium on the subdivision of lots under 10 acres. The moratorium remained in force until the Islands Trust was established in 1974. Now, at the beginning of the 21st century, the Penders are experiencing renewed pressure for residential development—an ongoing challenge to the "preserve and protect" mandate of the Islands Trust.

SOUTH PENDER ISLAND AT A GLANCE

POPULATION	SIZE	AREA OF FARMLAND	PROTECTED AREAS	AREA OF GREEN SPACE
2001: 159 1996: 165	2,149 acres/8.59 sq km	384 acres/155 hectares	244 hectares/28%	590 hectares/65%

Salt Spring Island

Coordinators Nora Layard; Caffyn Kelley
Artists Susan Pratt; Margaret Threlfall;
Caffyn Kelley; Chris Arnett

HOW OFTEN IN OUR BUSY lives do we stop and reflect on two of life's important questions: What do we stand on? And what do we stand for? We did not set out to examine life's mysteries, but the end result of Salt Spring Island's contribution to the Islands in the Salish Sea mapping project contains important answers to these questions.

Literally, what do we stand on? Early on, Tom Wright, retired geologist and keen community mapper, enthusiastically shared his maps of the geological history of our island. It was astonishing to learn that the South Enders live on some of the Earth's oldest bedrock.

We started to collect other maps about our island. We soon discovered maps that show the Earth's fault lines, sobering information for some of us when we realized how close they are. Other maps, showing different soil distributions, helped us to see the surface layers and how some of our settlement patterns grew from good farming sites. We began to understand what we stand on here.

The maps just kept coming, and we needed to find a way to share them with our fellow islanders. MapFest, a weekend mapping extravaganza, was held in May 2000, and it became a catalyst for the four Salt Spring Island maps in this atlas.

The Burgoyne Bay Map explodes from the depths of the Earth. First Nations' names for landforms and special places remind us of those who have stood here before. The Agricultural Land Map traces the stories of those who found the good soils. And wearing it on our shoulders, the Cloak for a Watershed Guardian reminds us what we must stand up for. We have a sacred trust to protect our water along with the incredible biodiversity that surrounds us, now and into the future.

—Nora Layard

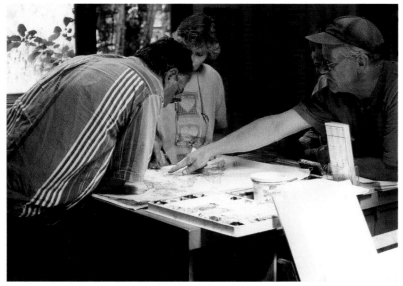

MapFest, May 2000 PHOTO BY DERRICK LUNDY

Work on the Agricultural Land Map began before the Fall Fair in 2000. Historian and archivist Usha Rautenbech researched historic farms. Visitors to the fair were invited to put their farm and garden on the map with coloured pins and entry forms and to tell stories about their land. Early in 2001, artist and farmer Margaret Threlfall agreed to create a map on the theme of agriculture for the project. Throughout the summer of 2001, farmers came to Threlfall's Serendipity Studio to put their farm on the map. The frame is made by Tony Threlfall out of wood from the still-standing Bridgman Road barn shown on the map.

SALT SPRING ISLAND AT A GLANCE

POPULATION	SIZE	AREA OF FARMLAND	PROTECTED AREAS	AREA OF GREEN SPACE
2001: 9,381 1996: 9,249 1991: 7,871	46,536 acres/182.27 sq km	7,396 acres/2,993 hectares	3,094 hectares/16.4%	12,384 hectares/67%

Agricultural Land, Salt Spring Island

Artist: Margaret Threlfall

PAINTING BY MARGARET THRELFALL

The landscape of salt spring Island is shaped by a history of agriculture. Today's Garry oak ecosystems evolved through First Nations' agricultural practices. Native people cultivated camas, using fire to prepare seed beds and keep meadows free of brush and tree seedlings, creating the perfect environment for our now-rare groves of Garry oak.

The first non-Native settlers arrived in 1859, and small subsistence farms were painstakingly cleared from the old-growth forest. By 1880 many of the best-located farms were well established. The barns shown on the map, along with others from this period, are still standing today. The Ruckle farm, established in 1872 and now a provincial park, is the oldest family farm still in operation in B.C. Orchards that grew many different kinds of apples from the turn of the century are now considered "heritage" and are being nursed back to health by current farmers.

Settlers used the mountainous areas for sheep farming and cattle ranching. In the 1890s more than 1,100 sheep ran wild on Mount Bruce and Mount Tuam. John Maxwell raised Texas Longhorns. These grazing animals changed the mountain ecosystems. In 1862 Maxwell and his partner, James Lunney, scattered imported grass seed at the head of Burgoyne Bay to feed their cattle. Since then, many kinds of plants originally sowed by early farmers have become firmly established across the island.

Farmers hunted the wildlife that threatened their stock. By 1901 wolves and bears were extirpated from the island. Cougars occasionally killed sheep, raccoons stole chickens, and deer enjoyed feeding on garden produce as they still do today.

Apples and other fruit were the island's first specialty, and in 1901 fruit from Salt Spring orchards was shipped by boat and rail to markets in Eastern Canada. Dairy farming was another specialty of Salt Spring. The building that housed the island's first creamery in 1896 still stands on Upper Ganges Road. Nursery farming has long been a fea-ture. In 1860 Jonathan Begg cultivated ornamental shrubs and fruit trees at his Fernwood Nursery, which later became Berrow's Nursery, and then the very successful James Seed Company from 1917 to 1930. Salt Spring's first greenhouse was built in1930 by the Okano family at their Booth Canal farm.

In 1901 the island was serviced by steamships that would stop six times a week at wharves around the island, picking up farm products for shipment to mainland markets. By the 1920s transportation methods had changed, and Salt Spring fruit farmers, previously so successful, could no longer compete with orchards in the United States and the Okanagan.

Today, much of what islanders eat is grown on farms far from Salt Spring, imported in refrigerated trucks by ferry. A local grocery reports that they sell approximately 50,000 chickens a year, of which only 1 percent are local, free-range. The 125,000 pounds of apples they sell each year come from B.C.'s Okanagan, New Zealand, Washington, California, Nova Scotia, Ontario, New York and Chile as well as Salt Spring. However, Salt Spring farms still export lamb, wool, cheeses and other products to Vancouver Island and the mainland.

Statistics Canada reports that there were 205 farms on Salt Spring Island in 2002. Many more properties that are not official farms are cultivated by islanders. Approxi-mately 7,240 acres of the island are in the Agricultural Land Reserve. The Farmers' Institute, well established by 1901, recently published a catalogue listing 40 farms that sell food and other products directly to islanders. The Fall Fair, an agricultural exhibition held at the Farmers' Institute, is the most important festival on the island. The taste of real food, fresh from island farms, connects islanders with their home place.

—Margaret Threlfall with assistance from Caffyn Kelley, Usha Rautenbach and Fiona Flook

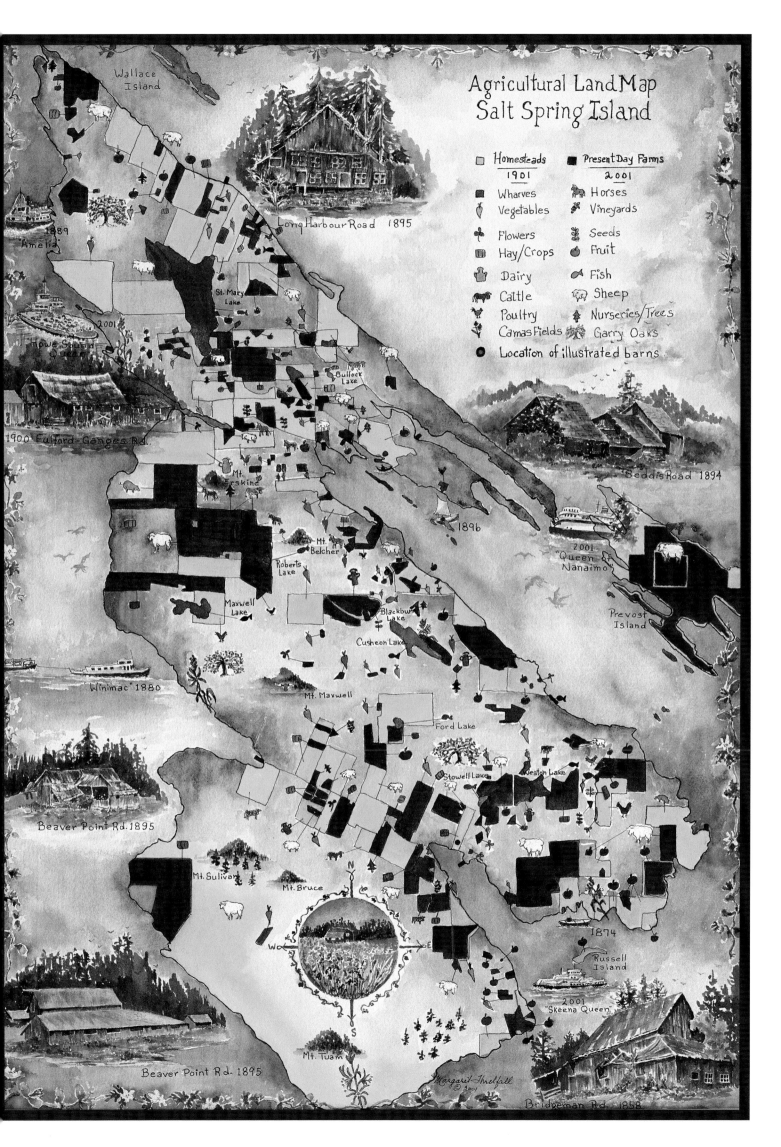

Agricultural Land Map
Salt Spring Island

Long Harbour Road 1895

1889 "Amelia"

2001 "Howe Sound Queen"

1900 Fulford-Ganges Rd.

Wallace Island

St. Mary Lake

Bullock Lake

Beddis Road 1894

2001 "Queen of Nanaimo"

Prevost Island

Mt. Erskine

Mt. Belcher

Roberts Lake

Maxwell Lake

Blackburn Lake

Cusheon Lake

"Winimac" 1880

Mt. Maxwell

Ford Lake

Stowell Lake

Weston Lake

Beaver Point Rd. 1895

Mt. Sulivan

Mt. Bruce

1874

Russell Island

2001 "Skeena Queen"

N

W E

S

Mt. Tuam

Beaver Point Rd. 1895

Margaret Threlfall © 2001

Bridgeman Rd. 1858

Legend

Homesteads 1901	Present Day Farms 2001
Wharves	Horses
Vegetables	Vineyards
Flowers	Seeds
Hay/Crops	Fruit
Dairy	Fish
Cattle	Sheep
Poultry	Nurseries/Trees
Camas Fields	Garry Oaks

● Location of illustrated barns

Cloak for a Watershed Guardian

Artist: Caffyn Kelley

It seemed important for the Salish Sea Community Mapping Project to create a map of water cycles on Salt Spring Island. Water quality is an urgent issue, here as elsewhere on the Gulf Islands. Nutrient loading, erosion, sensitive-ecosystem destruction, development pressures, pollution and gradual habitat deterioration have brought Salt Spring Island's water to a place of crisis and danger.

Tom Wright showed us many different maps of the watersheds of Salt Spring Island and his articles about water. His map of 24 island watersheds, shown here, is an interpretation that gives a sense of watershed as home and neighbourhood. By locating ourselves on the map, we can get some sense of how we all flow into the water. Water surrounds us and flows through us. Rainwater, creeks, lakes, tap water,

groundwater, sweat, sea—water is everywhere present, finite, necessary and sustaining.

In the circle of creatures that depend on the flow of water, how do human beings fit in? It sometimes seems as if all people do is injure the natural world and interrupt the flow of elements. But on Salt Spring we have many people who model a different relationship with nature, creating opportunities for restoration, healing and empowerment. They are the watershed guardians.

OPPOSITE PAGE: This fabric appliqué by Caffyn Kelley is based on the map of Salt Spring Island watersheds by Tom Wright and a map of creeks and wetlands by Kathy Reimer and the Salt Spring Island Salmon Enhancement Society.

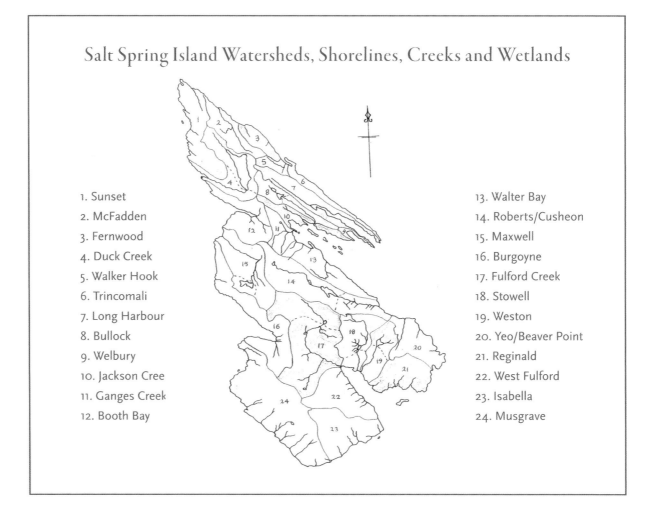

Salt Spring Island Watersheds, Shorelines, Creeks and Wetlands

1. Sunset
2. McFadden
3. Fernwood
4. Duck Creek
5. Walker Hook
6. Trincomali
7. Long Harbour
8. Bullock
9. Welbury
10. Jackson Cree
11. Ganges Creek
12. Booth Bay

13. Walter Bay
14. Roberts/Cusheon
15. Maxwell
16. Burgoyne
17. Fulford Creek
18. Stowell
19. Weston
20. Yeo/Beaver Point
21. Reginald
22. West Fulford
23. Isabella
24. Musgrave

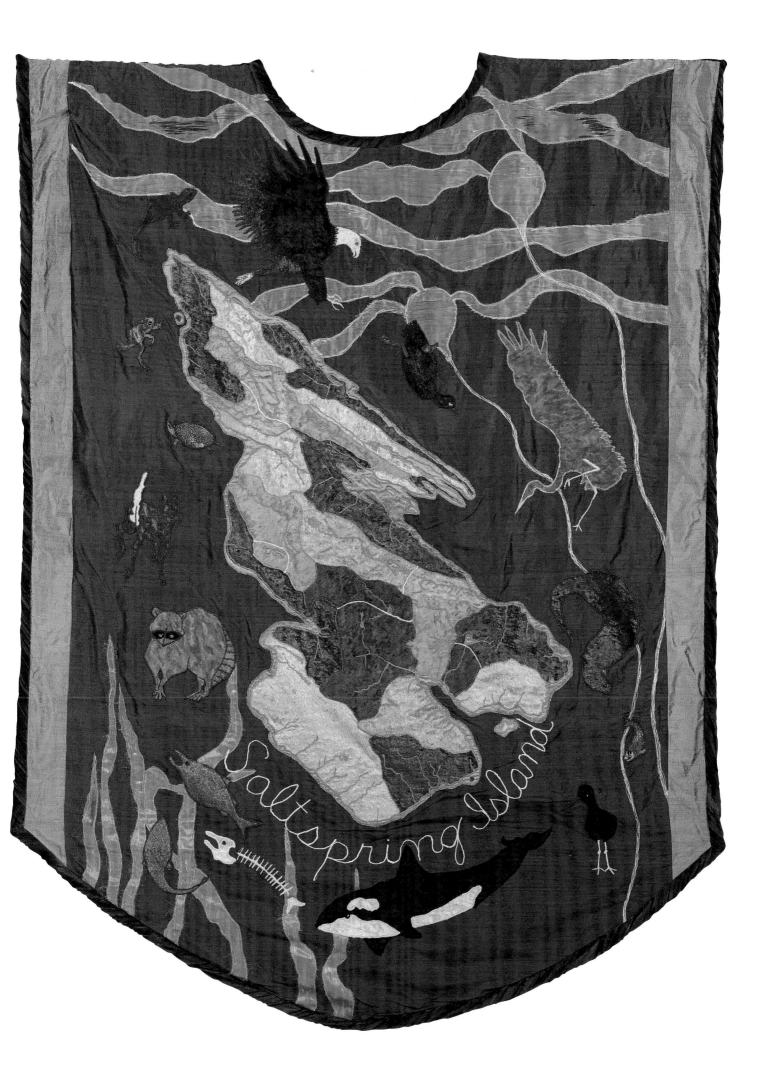

Saltspring Island

The Burgoyne Valley

Artist: Susan Pratt

Stories of the land and those who came here are highlighted in The Burgoyne Valley map. From the geological cross-section of the original boundary creek that delineated First Nations' use of the area to the first white settlers, the map reminds us to honour the past.

Burgoyne's Garry oaks PHOTO BY TAMAR GRIGGS

The north shore of Burgoyne Bay has Canada's largest Garry oak woodlands. The south is dominated by second-growth Douglas-fir. These forests are home to over a dozen rare and endangered species, and more than that are vulnerable.

The origins and shapes of Mount Maxwell are described in a Cowichan legend: a cannibal monster, Sheshuq'um'("wide open mouth"), lived beneath the ocean waters at Octopus Point in Sansum Narrows between Vancouver Island and Salt Spring. This creature swallowed passing canoes and ate the passengers. Smuqw'uts, a powerful man who lived at Tsawwassen, asked Mount Maxwell to bend over and allow him a clear throw of a giant rock; Mount Maxwell complied. Sheshuq'um's lower jaw was shattered and the monster never again bothered canoes travelling through Sansum Narrows and around Octopus Point.

The Coast Salish have actively harvested from the rich bays at both ends of the valley for generations. To the Cowichan, Burgoyne Bay is called Hwaaqwum, "place of the sawbill duck" (merganser), a name that described its most important resource. Sawbill ducks were harvested by the hundreds with large aerial nets during the summer and autumn, speared, singed and dried for winter use. Herring was raked and sea mammals were hunted. The shoreline harboured rich oyster beds and a stream with coho and chum salmon. The Cowichan people who used these and other resources occupied several nearby camps, including a very large site at the head of the bay.

Burgoyne Bay is the largest undeveloped bay and estuary in the Gulf Islands. Two salmon streams run into it, and its two kilometres of sensitive tidal flats include extensive healthy eelgrass beds. Killer whales, seals and harbour porpoise have been seen there, along with flocks of western grebes, cormorants and diving ducks. Bald eagles, peregrine falcons and great blue herons nest along the shorelines.

Only a few areas on Salt Spring Island preserve the sense of place found today in Burgoyne Bay. The five 100-acre lots at the head of the bay date from the original settlement of 1859–60, a Cowichan–European community created when immigrant men married the daughters of the *si'em* (chiefs) of the families who owned and managed the resources of the area. During the 19th century, one branch of this family moved to Burgoyne Bay, where, according to descendant Bob Akerman, they lived year round. Their "village" sat between the mouths of the two creeks that flow into the head of the bay. A large granite boulder with a bowl carved into it stood nearby. It was owned by the family and used to process dried camas in late spring and salal berries in the fall. Tuwa'h'wiye' (Bob Akerman's grandmother) married Michael Gyves, a friend of early settler John Maxwell, and members of the Akerman and Gyves families farm in the Fulford Valley to this day.

In 1866 Maxwell was the first settler to pre-empt land in the Burgoyne Valley. Eventually, he ranched and logged over 1,000 acres in the area. In the 1930s and '40s a large portion of this holding was acquired by the Larson family of Seattle. It and other properties on Salt Spring were bought by Texada Logging in 1960 and managed according to European sustainable-forestry principles. In 1999 a Vancouver developer purchased the lands, and the pace of logging increased dramatically. This map has become part of the story of saving Burgoyne Bay. It continues to be shown at celebratory events and stands as a reminder to all that this is indeed a very special area.

—Research by Daphne Taylor and Mike Meyer with special thanks to Bob Akerman and Chris Arnett

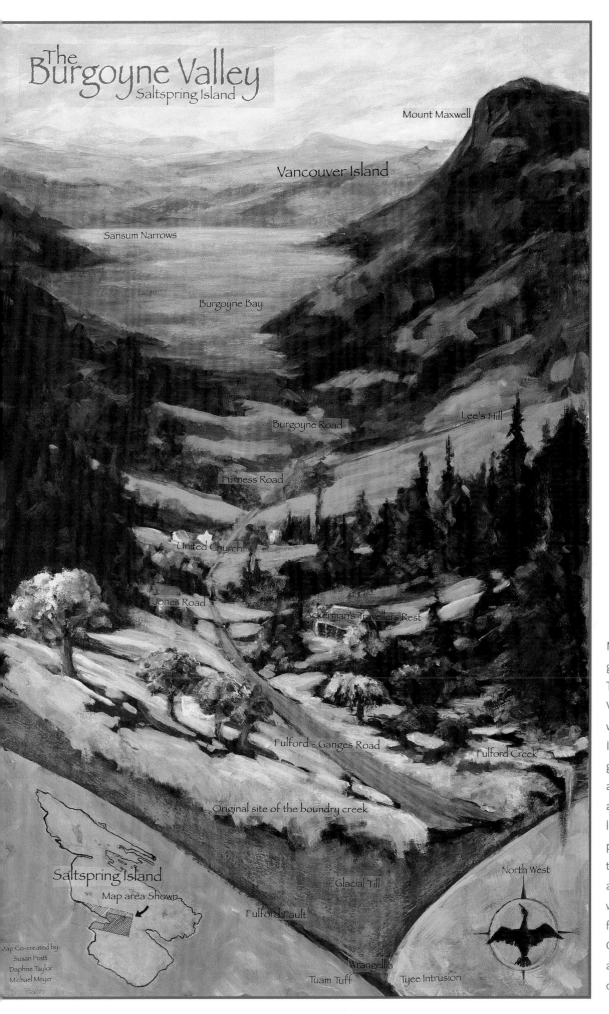

The Burgoyne Valley
Saltspring Island

Mount Maxwell

Vancouver Island

Sansum Narrows

Burgoyne Bay

Burgoyne Road

Lee's Hill

Furness Road

United Church

Jones Road

Ackerman's Travellers Rest

Fulford – Ganges Road

Fulford Creek

Original site of the boundry creek

Saltspring Island

Map area Shown

North West

Glacial Till

Fulford Fault

Map Co-created by:
Susan Pratt
Daphne Taylor
Michael Meyer

Wrangellia

Tuam Tuff

Tyee Intrusion

Maps can embody tears, grief and ultimately triumph. The Burgoyne–Fulford Valley, located in the southwest corner of Salt Spring Island, became the testing ground for community spirit and tenacity in the face of a Vancouver company's logging and development plans. This area is now protected as a provincial park and an ecological reserve, with additional lands held for future parks by the Capital Regional District and The Land Conservancy of British Columbia.

Tumuhw/The Land

Artist: Chris Arnett

The European tradition of mapping on the northwest coast has been used historically as a tool by colonizers to delegitimize the territories of cultural groups while legitimizing the occupation of these territories by newcomers. Throughout the Gulf Islands, ancient place names, in use for thousands of years, were replaced by foreign place names that had no connection to the land. The names familiar to the prevailing culture of today are as foreign to First Nations as the place names shown here are foreign to most viewers.

First Nations mapping was cognitive and gained by intimate knowledge of the ecology and history of the landscape. Place names described resources, physical features and history. You learn the name and you learn the place. Here are some place names of Salt Spring Island, common to most fluent speakers of Sencoten and Hul'qumi'num, superimposed over the natural landscape, to challenge the viewer to learn more about them, to seek information from informed persons, in the traditional manner of oral cultures, and to ask why these place names and the ancient knowledge they contain are not more familiar.

PQUNUP: "white shell ground." The beaches and estuaries here were favoured places to harvest and process clams. The white shells that cover the foreshore are the remains of thousands of years of sustainable resource extraction.

HWTL'ELUM: "place of salt." Named after the numerous salt springs found in this area.

SYUHE'MUN: "to go ahead and make camp." Known as Walker's Hook today, in former times this area was a shellfish-harvesting place, campground and burial site.

STSA'TX: "halibut." Named for the fish formerly caught in what is now Long Harbour.

SHIYAHWT: An ancient name; its exact meaning is not known. It may refer to the canoe portage that existed between Booth Canal and Ganges Harbour.

TS'ESNO'OM: "to be hit straight on." A reference to the action of the tides in the vicinity of what is now called Beaver Point.

HWNE'NUTS: "move your butt over."

TS'WEEN: "straight down to the water's edge." A descriptive reference to the land above Cape Keppel as seen from a canoe.

SHELUQUN: place near the peak of Mount Tuam named for a man who received power from the Thunderbird and abused it, causing his downfall.

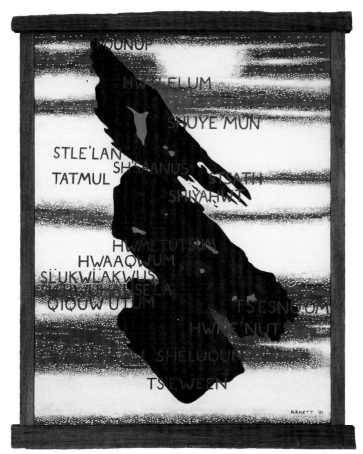

The place names on the map are spelled as they were prior to official changes by the Cowichan Tribes in 2004.

QWATTHAQW: "shit head." Descriptive name for the guano-covered appearance of Musgrave Rock.

QIQUW'UTUM: "little drummer place." The action of waves inside a cove here produces a drumming sound.

SH'HWUHA'USE'LA: "cave of the Thunderbird." A cave believed to be home of the Thunderbird.

SLUKWLAKWUS: "lots lying down." Referring to a spiritual practice involving the capture of eagles.

HWAAQWUM: "place of the sawbill duck (merganser)." The name for Burgoyne Bay described an important resource harvested here.

HWMETUTSUM: "bent over place." A name describing the shape of Mount Maxwell in reference to a creation story.

TATMUL: "warm water." A descriptive term for the warm waters of this area.

SH'SAANUS: "dries at low tide." A descriptive term for the head of Booth Inlet.

STLE'LAN: This term may connote paddling a canoe towards the shore and then stopping to let the canoe drift in.

Kuper Island

Coordinator and Artist Herb Rice

IT IS DIFFICULT TODAY TO obtain or present original information on First Nations' lands or interests because so much is held within sensitive current treaty negotiations. The Penelukut of Kuper Island retain most of the island as a reserve, and the majority of people living here still depend on the natural environment for their survival. However, as most of these resources have been depleted over the last hundred years, life for the Penelukut is a struggle. Most of the residents have not completed extensive educational programs and are not employed. There have been some discussions about setting up a commercial campground on Tent Island, directly south of Kuper, commonly used freely by Salt Spring and Vancouver islanders for recreation. Other economic initiatives under consideration include charging for crabs and other resources taken from the nearby sea.

The history of white settlement in the area has been filled with conflict. As Chris Arnett details in his book *The Terror of the Coast: Land Alienation and Colonial War on Vancouver Island and the Gulf Islands*, Kuper Islanders have endured some particularly traumatic experiences. Gold miners and settlers were encouraged to pre-empt land that was still part of Salish territory. Often while Penelukut men were away fishing, usually on the Fraser for sockeye, settlers would move in. This caused understandable conflict. The people at Lamalchi Bay on Kuper Island set up a fort to counter attacks from the northern peoples en route to Victoria. There was a direct attack in Lamalchi Bay on April 20, 1863, when the gunboat *Forward* came into the bay to search for individuals charged with the murders of a couple of men on Saturna and Pender islands. The gunboat was defeated, but subsequent expeditions ended the Penelukuts' resistance, and seven men were eventually hanged. The newspapers in Victoria responded negatively to these actions. According to a census at that time, the Lamalchi village contained 100 people, over half of them children. The village was removed from the "reserve lands" after that summer, but, according to Arnett, its return is currently being negotiated.

Kuper Island also holds another tale of oppression. For almost a century, Salish children from all around the area were sent to the Kuper Island Residential School. These schools operated in B.C. between 1863 and 1984. Children were forced to learn European and Christian traditions and were often brutally abused. For some, attempted escape or even suicide seemed the only answer.[17]

Until 1905, Kuper and Thetis islands were joined by mudflats. A passage, now known as Canoe Pass, was dredged to enable boats to travel through at high tide. Today, they are separate islands, linked only by the ferry that travels from Vancouver Island to both Kuper and Thetis. The Penelukut are part of the Hul'qumi'num Treaty Group, currently negotiating treaties. It is hoped that this will begin a journey back from devastation to a caring society that enables cultures to co-exist with distinctive independence and mutual respect.

Tent Island, off the southern tip of Kuper. PHOTO BY GORDON SCOTT

KUPER ISLAND AT A GLANCE

POPULATION	SIZE	AREA OF FARMLAND	PROTECTED AREAS	AREA OF GREEN SPACE
2001: 302 1996: 185	8.70 sq km	n/a	n/a	extensive

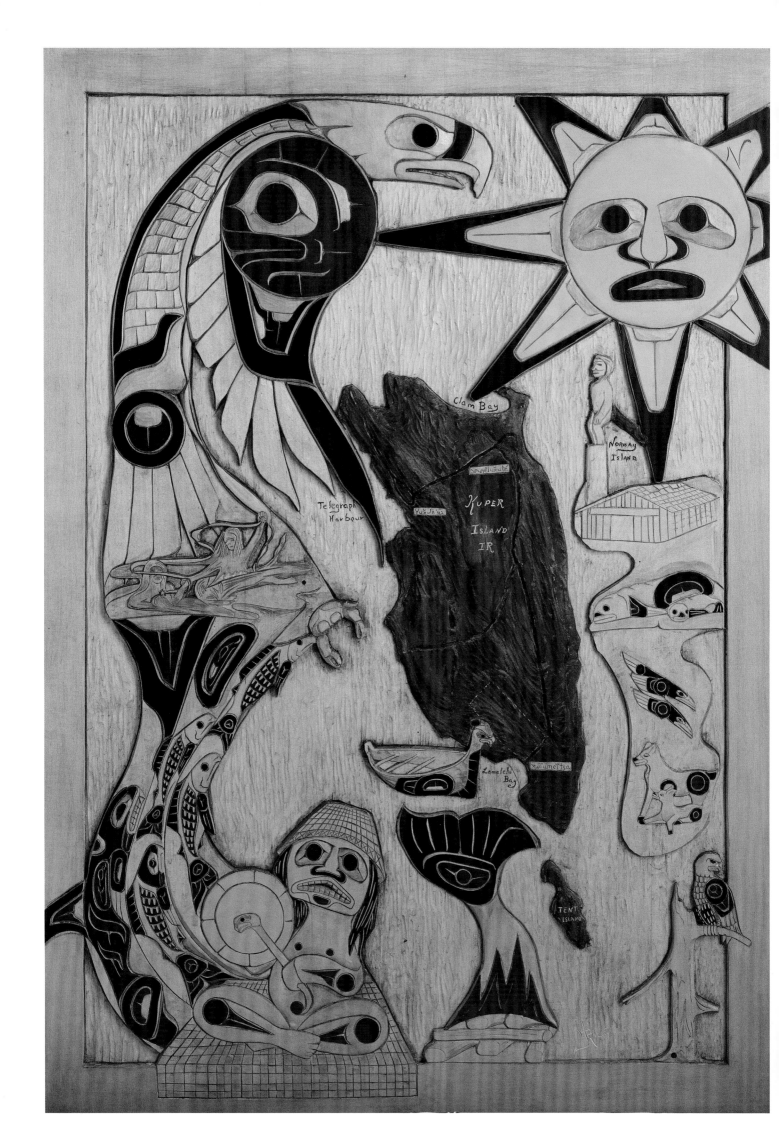

Clam Bay

Spuné'luxutl

Kuper
Island
IR

Yuxula'as

Telegraph
Harbour

Norway
Island

Lamalchi
Bay

Xwlumel'tsa

TENT
ISLAND

The Myths of Kuper Island

Let me tell you a story, from where the sun rises to where the sun sets. The place your people call the east and the west. My home is called Kuper Island. Our people have three villages here, on Kuper Island:

1. SPUNE'LUXU TZ' (Clam Bay—also Penelukut)
2. XWLUMEL TSA (Lamalchi Bay)
3. YUXULA'US (Ferry Landing)

Two of these villages (Spune'luxu Tz' and Yuxula'us) are populated with approximately 450 people. These people are still dependent on salmon and clams for their staple diet.

Our people lived on the shore in longhouses marked by a welcome figure. They hunted on the rocks of the small islands, Tent and Norway, for sea lions and seals. Deer were abundant in the forests of Kuper Island. The canoe was the main form of transportation. Even to the present day, our people fish off the shores of Kuper Island for crabs, salmon, clams and cod.

The sandy shore of Kuper Island is called Spune'luxu Tz' (Penelukut). This is the beginning of our people, where Heels the transformer brought life, on the wings of an eagle, to a single log and man was created. The pure white sands of the shore became woman, the legend tells itself. My vision has been the vision of the countless generations that have survived through the natural and the unnatural changes in our times. Yuxula'us, the place where eagles roost, Xwlumel Tsa, where the sands recede from the shores—these are all places named by our ancestors, places we know in their natural state.

The vision of the Shaman was related to us before the coming of your canoes that glide on the wind. Our life's blood came from our mother the earth, and for many generations we cared for this. Past and present we lived within our boundaries, marked by the still waters. These times are marked not as written legend, but as oft-repeated stories passed on by the memories of our people and remembered in the dreams of life. These stories are forever on the drums that call our people to the fire to hear the legends again and again.

The little deer, Smii, taught our children how to care for this land and what we must do to care for ourselves. The supernatural strength we searched for in our visions brought our love for the gifts that were given by each creature that in turn gave each one of us life through its own death. The multitudes of salmon that each year came home through our waters fed the great numbers of our people but still thrived. It is said that, "As long as we put the bones of the salmon back in the waters, the salmon shall return the next season."

The clams that were piled high over successive generations mingled with the bones of our ancestors to form the high shores with white beaches at Clam Bay and Lamalchi Bay. These clams were savoured all year round, as fresh food.

Today, the people of Kuper Island are working to maintain their traditional rights of food gathering and can be reached through the Penelukut Band Office.

—as told by Herb Rice

This story and artistic design are the interpretations of Herb Rice, a Native Indian artisan with roots on Kuper and Norway islands. This traditionally carved cedar panel is three by four feet in size.

Thetis Island

Coordinator Lynda Poirier
Artists Mary Forbes and Bill Dickie

I FEEL LUCKY TO HAVE been contacted by the Islands in the Salish Sea mapping project coordinators, asking for participation from Thetis Island. I attended the two-day workshop about mapping on Salt Spring in January 2000 and was completely drawn in. It was one of the most interesting projects I had ever encountered, and I made a commitment to participate wholeheartedly.

Back home, I wrote articles in the *Thetis Island Quarterly* and hosted two information workshops in an effort to gain community involvement. My enthusiasm did not get the reaction I expected. In fact, I was taken aback by negative feedback, fears of "revealing too much" and a general unwillingness to commit any time.

COLLAGE MAP BY LYNDA POIRIER

But interestingly enough, many of the other coordinators had faced similar challenges and found ways to overcome them. They told me they really related to my crazy map.

The top of the collage reflects my vision for the project: a community effort, learning from each other, growing together in knowledge of our island, encouraging stewardship. The left side represents the opposition: fears of inviting more tourists and uncertainty about First Nations' land claims. The right side is what's happening: increased tourism and a community that is changing too fast. The rip in the island represents the excuses we make for not protecting our home.

In frustration, I considered dropping the whole project. But despite the controversy, I still felt that it was important to the future of Thetis. I decided to go ahead quietly, doing the research on my own. I am thankful that I found two local artists who were interested in the project, although both had busy lives and little time to spare for it. Result? Our map was not going to be ready in time for the first showing of the maps on Salt Spring in 2001.

In desperation, the night before the opening, I created a collage-map of Thetis for that first exhibition. The collage expresses my hopes for the project, my initial excitement, the challenges I encountered and my frustrations. There were so many wonderful maps on display there that I was a little embarrassed about my last-minute outpouring.

We completed our "real" map a few months later. Pressures from tourism were already underway. When the project began, Thetis had three bed-and-breakfasts and one resort. By 2004, there were no fewer than 20 places offering accommodations. The tourists are here, and we are hidden from view and protected from change no longer. We *need* our map to share our knowledge of Thetis and help people understand how fragile and sacred our home place is.

I hope that this project will inspire Thetis Islanders to get involved in active land stewardship and record some of our history before it is lost. We've made a start. The Salish Sea map-ping project brought the Thetis Island History and Conservancy Group into being, and sales of prints of the map are helping to raise funds for historical and conservation projects.

—Lynda Poirier

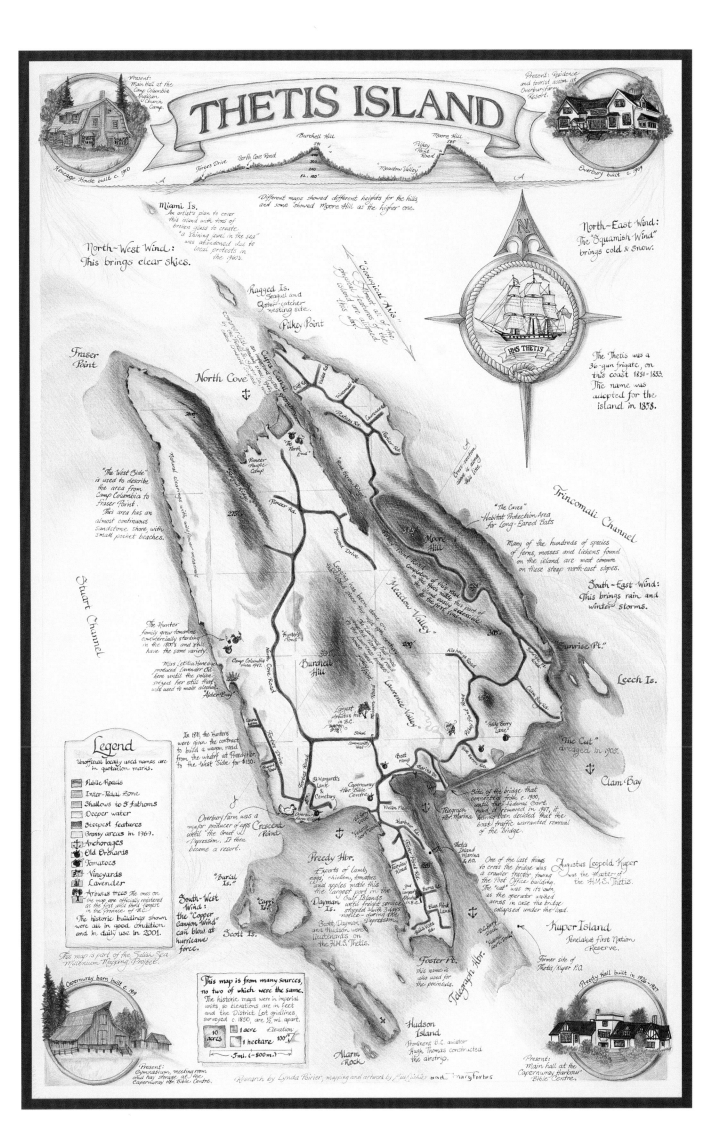

Townsend's bat PHOTO BY TRUDY CHATWIN

The Caves

The Caves are a sensitive site on Thetis. They are located in a dangerously rugged area, accessible only through private property. Serious accidents have befallen curious trespassers.

Surprisingly, The Caves are not really caves at all. Part of the height of land where the formation is located broke away centuries ago, possibly as a result of an earthquake. The so-called caves are actually a series of crevices and passages between randomly strewn boulders and chunks of broken sedimentary rock.

The Caves are a rare hibernating site for Townsend's big-eared bats. If the bats are disturbed, they are likely to abandon the site, which is now designated as an ecological land reserve to protect them. All the more reason for the curious to stay away.

The Largest Arbutus Tree in B.C.?

Community mapping can be an opportunity for ground-truthing. This simply means assessing directly something that you have only had general knowledge about before, from old records or maps based on imprecise aerial photographs or just word of mouth. When the mapping project began, it was believed that the largest arbutus tree in B.C. was on Thetis,

near the Department of Highways maintenance yard; it was recorded as such in the official provincial database of large trees. The discovery—in another part of B.C.—of an even larger arbutus brought a slight feeling of loss to islanders. But then, two long-time residents said they knew of a "damn big tree" in the forested southwest part of Thetis. With the help of the Conservation Data Centre, they measured this new contender for the title. Sure enough, it was officially declared the "top arbutus" in the province, at 35.5 metres in height.

Overbury

The question of increasing tourist accommodation is a hot one on Thetis these days, but of course visitors have been coming to the islands for decades. The story of Overbury is a good example of the way guest facilities of some kinds can help to sustain the community.

In 1907, Geraldine Hoffman and her son, Rupert, of Worcestershire, England, stopped by Thetis to visit their relatives, the Burchells, who had been among the earliest settlers. Geraldine and Rupert fell in love with the island and bought a 265-acre site next to the Burchells', which they called "Overbury" after their home village in England. Henry Burchell built them a grand home, where they took up residence in 1910. For most of the next 20 years, they ran a successful poultry farm, shipping chickens and eggs off the island by means of the weekly Canadian Pacific Railway steamer. The stock market crash of 1929 and subsequent cancellation of the CPR service put an end to the farm operation, so Rupert dismantled the outbuildings and used the lumber to build four guest cabins.

These cabins still stand today, having served four generations of guests. Rupert's grandson, Norm Kasting, and his wife, Arlene, now run the business. They have restored some of the original features and added four new cabins and other facilities. Overbury is an elegant reminder of times past, but it is also a graceful contributor to the current way of life on Thetis.

Overbury built c. 1909

THETIS ISLAND AT A GLANCE

POPULATION	SIZE	AREA OF FARMLAND	PROTECTED AREAS	AREA OF GREEN SPACE
2001: 344 1991: 236	11,984 acres/47.94 sq km	373 acres/151 hectares	148 hectares/3.1%	835 hectares/74%

Gabriola Island

Coordinators Leigh Ann Milman; E.J. Hurst
Artists Victor Anonsen; Melinda Wilde

I FIRST ENCOUNTERED THE IDEA of ordinary citizens laying claim (in a way) to local landscapes by making maps of them in England, in a project called Common Ground. I loved the idea of identifying what was important to the people living there rather than just what was scientifically important. I was delighted to get the chance to help highlight what is special to people living on Gabriola, as the second coordinator of something similar here, the Islands in the Salish Sea Community Mapping Project.

I followed gratefully in the footsteps of the first coordinator, Leigh Ann Milman, who compiled the research she had done onto a hand-sketched map of the island. It was simply teeming with all the information she had gathered. Victor Anonsen, the artist she worked with, used the information in his way to produce the first image of Gabriola—unconventional, perhaps, but much loved by islanders for its beauty.

For the second map, artist Melinda Wilde and I used the research in another way, combining it with information from the Regional District of Nanaimo and bringing in more historical information. We also held mapping workshops with the two Grades Four/Five and Five/Six classes at the local elementary school. Each student made a map, and they were all displayed at the school. The students' work was an important source of inspiration to Melinda as she worked on the final design.

Since the research had already been done, Melinda and I worked very much as a team of two. We had regular meetings, at which my four-year-old was a frequent attendant. Thanks to Melinda's mothering skills and a great wooden train set, we spent many happy afternoons selecting and condensing information from our accumulated maps. I would draft lists of what I felt was significant from our resources, and we would compare notes, discussing our choices with others who were involved in a kind of "advisory capacity." Then Melinda would take the lists and start overlaying the information onto our base map. Establishing the accuracy of the information we were working with was sometimes a problem for us. We would have loved to ground-truth our base maps but time did not permit. Sometimes we just made our best educated guesses.

Boots PAINTING BY MELINDA WILDE

Once we had established the basic design and contents of our map, I wanted to defer to Melinda's artistic judgment in developing the visual presentation. This was sometimes stressful for her as she was grappling with the notion of it being a "real map." I tried to be a support to her by just being there to offer advice and encouragement. I think we both found this collaborative way of creating the map very satisfying. I know I did.

When the map was finished, what really struck us was how little of our island is protected: a mere handful of small regional and provincial parks. Fortunately, since the map was completed, we've gained a new 33-acre regional park in Descanso Bay and a 158-acre nature reserve now in the hands of the Islands Trust Fund. Even so, the total under protection is minimal: 3.1 percent of our land base, the smallest percentage in the Islands Trust area.

Creating the map also made us aware of the mounting pressure for residential development on private land and the demand for our very scarce water that goes with it. This, combined with the lack of protected areas, made us realize how easily we could become just a suburb of Nanaimo. But I do believe that our map has been instrumental in a recent shift in attitude on the island towards more protection and local control of decision-making on Gabriola.

—E.J. Hurst

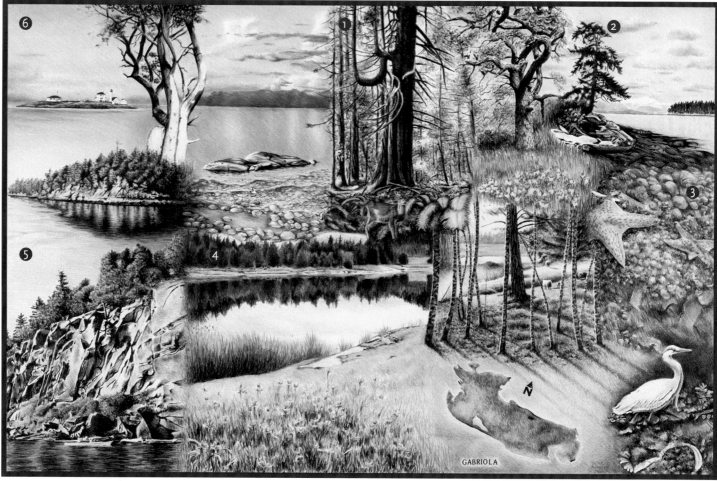

MAP BY VICTOR ANONSEN

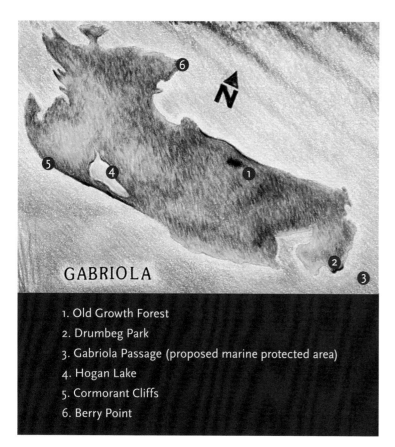

GABRIOLA

1. Old Growth Forest
2. Drumbeg Park
3. Gabriola Passage (proposed marine protected area)
4. Hogan Lake
5. Cormorant Cliffs
6. Berry Point

1. Old-Growth Forest

The largest remaining intact forest on Gabriola covers about 450 acres—on an island of more than 12,000 acres that was once almost entirely covered by trees. Of this intact forest, slightly over 15 percent is old growth: cedar, fir, hemlock, Pacific yew and other trees that may be 200 years old or older; all are now protected in a brand-new nature reserve. Featured at the top centre of Victor Anonsen's map is a much-loved, great-great-grandmother cedar tree, 24.5 feet around, which is part of that stand.

In an undisturbed forest ecosystem, the standing trees are connected by an underground fungal web. The fungi spread a mantle around the finer roots and root hairs of the trees, and it is this matted fungal web that reaches out into the soil, gathering nutrients and bringing them back to the trees' roots. In return, the trees reach up into the light and send down to the fungi the nutrients they make through photosynthesis. This system of interdependence helps protect the trees from disease, pests and extremes of climate. Clear-cutting and all that goes with it—compaction and erosion of soils, slash burning—puts the health of the forest at risk.

2. Drumbeg Park

At the far eastern end of the island, Drumbeg Provincial Park comes alive in the spring with an amazing array of short-lived wildflowers: tiny pink fairy slippers, chocolate lilies, golden masses of broad-leafed stonecrop trailing over the sandstone cliffs. If you look closely, you can find a miniature jungle among the mossy mats draining on the sandstone, and see the unusual Least Mousetail with its strange flower spikes. Where the old homestead still stands, many introduced species can be found: giant cow parsnip, periwinkle, Scotch broom. Beyond them, a Garry oak meadow survives because human hands pluck out the invaders. The meadow rewards them with a brilliant show of blue and gold in May, when the camas, Spring Gold and Western buttercup put on their annual display. Tread softly, and only on the paths!

3. Gabriola Passage

Between the shores of Gabriola and Valdes islands, the tide creates strong currents that reach dizzying speeds up to nine knots. The fast-moving water is rich in oxygen, and in plankton and other micro-organisms that begin the underwater food chain. The diversity below the surface is exceptional: waving kelp beds, sandstone cliffs, eelgrass mats and rocky caves. All the colours of marine life are on show: red sea urchins, pink scallops, orange-red sponges, purple sea stars, white sea cucumbers, green anemones, yellow sea slugs. Lingcod and rockfish hide in the kelp while octopus and wolf eels peek from the crevices. Slender blades of eelgrass provide valuable shelter and food for young salmon and herring. The richness of life below the water supports large numbers of seabirds above it, as well as seals, otters, porpoise and sometimes orcas.

First Nations, Gabriola Islanders and governments have worked together to have Gabriola Passage named a candidate to be one of Canada's first Marine Protected Areas. Fingers are crossed for formal designation in the near future.

4. Hogan Lake

The endangered red-legged frog lives on the marshy edges of shallow Hogan Lake, the only lake on Gabriola. On a summer's day, she is probably waiting for Blue Darner dragonflies, perhaps seeking revenge but certainly seeking lunch. Earlier in the spring, the Blue Darner's huge larvae dined on her own small tadpoles, but now the tables are going to turn.

As an adult, the red-legged frog has few natural enemies other than the great blue heron. She may, however, need to dodge golf balls and perhaps chemicals from the golf course surrounding most of Hogan Lake. A hundred years from now, if she were to return, she would probably find the whole lake turned to marsh, the result of relentless eutrophication, the overgrowth of algae that chokes out other species.

5. The Cormorant Cliffs

Gabriola is marked by dramatically sculpted sandstone cliffs along much of its coastline, the product of frost action, wind and waves. For many years, the cliffs along the southwest shore were an important nesting site for pelagic cormorants, one of the three species of cormorant found in the region. In 1968, almost 400 nests were counted; in 1987, none. Extensive blasting at nearby Duke Point, a major ferry terminal, is thought to have been the immediate cause of their departure. Since then, a few have come back to the cliffs: 62 nests were counted in 2000. Even so, research confirms that these cormorants are in serious decline in the Strait of Georgia (double-crested cormorants even more so) due to eagle predation, disappearing food stocks and human disturbance.[18]

6. Berry Point

On official maps it's called Orlebar Point, but islanders call it Berry Point. At the end of a road of the same name, it looks out on a spectacular view of the Salish Sea. No matter the season, it's a good spot for birdwatching. Winter is an especially busy time, when the protected waters around the point provide shelter and sustenance for overwintering seabirds. Surf scoters can be seen in rafts of hundreds, accompanied on some days by smaller numbers of common goldeneye, American widgeon, bufflehead, mallard or colourful harlequin ducks.

Entrance Island Lighthouse, just to the northeast, is the human addition to this seascape. After several shipwrecks in the area in the mid-1800s, the beacon was built to guide marine traffic in and out of Nanaimo. Entrance Island was chosen because when the light blinked into service, it would form a triangle with a second light at Point Atkinson and a third on the Coal Company Wharf at the mouth of the Fraser River. The lighthouse was completed and manned in May 1876. It remains one of the very few staffed to this day.

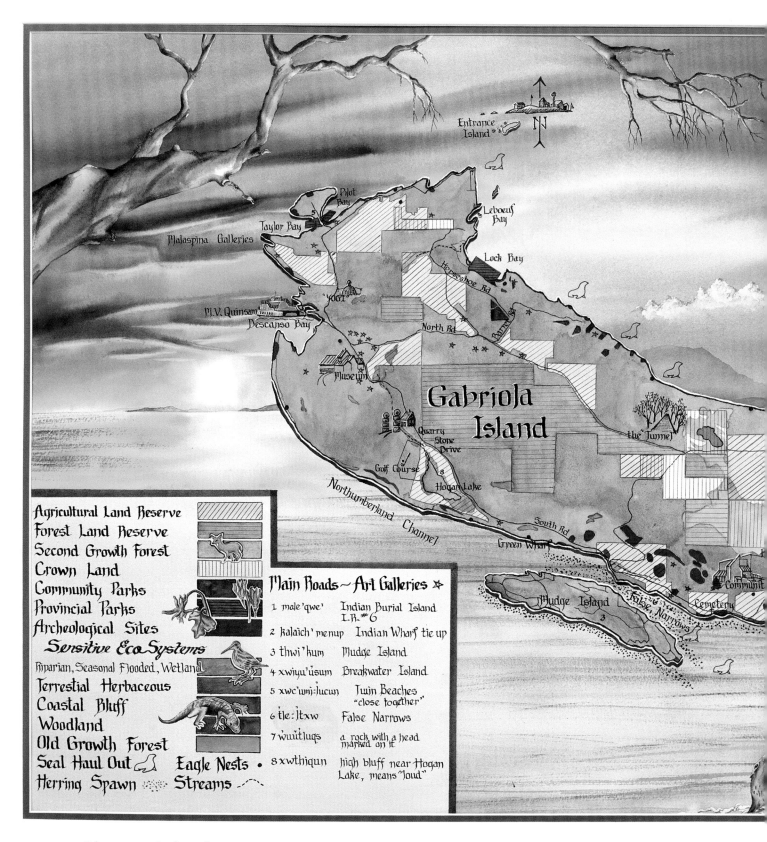

Legend

Agricultural Land Reserve
Forest Land Reserve
Second Growth Forest
Crown Land
Community Parks
Provincial Parks
Archeological Sites
Sensitive Eco Systems
Riparian, Seasonal Flooded, Wetland
Terrestial Herbaceous
Coastal Bluff
Woodland
Old Growth Forest
Seal Haul Out Eagle Nests •
Herring Spawn Streams

Main Roads ~ Art Galleries

1 male'qwe' Indian Burial Island I.R. #6
2 kalaich'menup Indian Wharf tie up
3 thwi'kum Mudge Island
4 xwiyu'usum Breakwater Island
5 xwc'umj:lucun Twin Beaches "close together"
6 tle:ltxw False Narrows
7 wuutluqs a rock with a head marked on it
8 xwthiqun high bluff near Hogan Lake, means "loud"

Map labels: Entrance Island, Pilot Bay, Taylor Bay, Malaspina Galleries, Leboeuf Bay, Loch Bay, Horseshoe Rd, YOGI, M.V. Quinsam, Descanso Bay, North Rd, Paisley Rd, Museum, Gabriola Island, The Tunnel, Quarry Stone Drive, Golf Course, Hogan Lake, Northumberland Channel, South Rd, Green Wharf, Mudge Island, False Narrows, Community Cemetery

Glorious Gabriola

If you meander down Berry Point Road and perch on Sunset Rock, you may observe a glorious sunset in the west while the moon rises in the east. If the day has been fine, Mount Baker will be peeking over your shoulder. The Coast Range, tinged pink with evening's glow, surrounds this beauty.

Eagles soar, sea lions bark from Entrance Island, and a gentle awe settles in the hearts of all who observe. That feeling, bolstered and extended by a great deal of community research on the land and people of Gabriola, was the inspiration for my map.

—Melinda Wilde

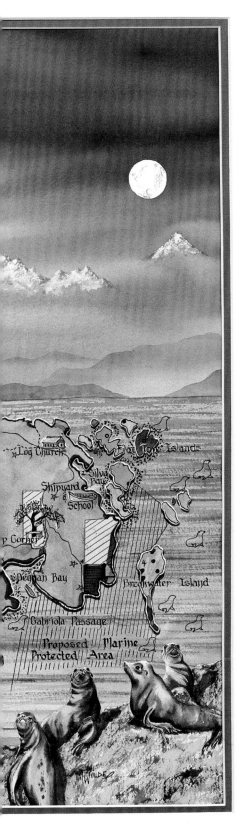

Gossip Corner

Gabriola's first postmaster (appointed in 1935), T.P. Taylor, included Gossip Corner in his delivery route. Not much more than a sharp bend in the road, it boasts a large and beautiful Garry oak tree with a bench beneath it. Neighbours would gather here to pick up their mail from the old rural boxes, and—what else?—exchange gossip.

Gabriola Museum

Half an acre of land was donated in 1993 by Stan and Maxine McRae for Gabriola's museum. Materials and volunteer labour contributed by dozens of Gabriolans, along with government financial support, allowed building to begin in 1994. Its design was at first controversial: except in the workshop it is entirely windowless to protect the exhibits. However, the "feel" of the inner spaces and the "look" of the outer aspects of the building have proved successful. The museum was completed in September 1995, and a community celebration was held to mark its opening.

The Log Church

Gabriola's first church was erected in 1912 through the hard work of Daniel and Bill McConvey, the Crocker family, James Gray and Thomas Degnen. The Silvas donated the land and helped with the building. Although there was still much work to be done on the inside, those in the community who wished to could receive mass from that time forward.

YOGI

In the fall of 1964, while working for the Ministry of Highways, Clyde Coats arranged several round stones (called "concretations") blasted from Taylor Bay Road into the form we know today as YOGI. The following spring, he and a lay minister, Mr. Inkster, brought children from the island together in a group called the Youth of Gabriola Island. Its initials spelled YOGI, which Coats went back and drilled into the little monument. It remains today, a quirky landmark and a tribute to Gabriola's youth.

The Petroglyphs

More than 120 petroglyphs (prehistoric carvings on rock) have been found on Gabriola, cut into the soft sandstone by the ancestors of today's Snuneymuxw First Nation. Nobody knows just how old they are, but estimates range from a few hundred to a few thousand years. Many are weathered to a point of near-invisibility; others are completely covered with moss. Most are hard to locate, or inaccessible on private land. A collection of reproductions can be seen on the grounds of the Gabriola Museum.

GABRIOLA ISLAND AT A GLANCE

POPULATION	SIZE	AREA OF FARMLAND	PROTECTED AREAS	AREA OF GREEN SPACE
2001: 3,522 1991: 2,579	13,706 acres/54.82 sq km	2,399 acres/971 hectares	65.58 hectares/3.15%	3,220 hectares/61%

Faces in the Cliff

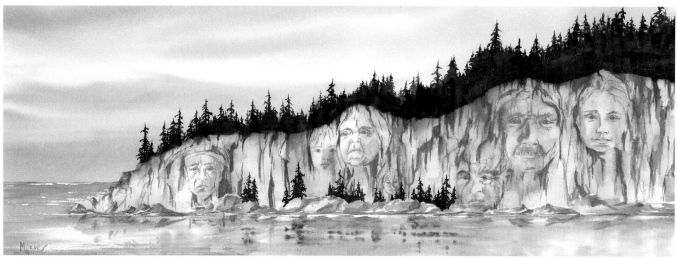

PAINTING BY MELINDA WILDE

From the Gabriola ferry terminal in Nanaimo, the island's sandstone cliffs take on a touchable appearance—like suede. Colours change from earthy ochres and taupes to vibrant blues, mauves and sandpaper yellows, depending on the weather. There is a sculptural quality to the Gabriola cliffs, and with a little imagination one can "see" a multitude of images, suggesting untold stories locked away in the magnificent stones. Artist Melinda Wilde was the recipient of just such a suggestion one day as the ferry MV *Quinsam* was pulling in to Descanso Bay. She "saw" an elder's face in the rocks, a moment of revelation that inspired this painting.

The First Nation whose traditional territories include Gabriola is the Snuneymuxw. They are a Coast Salish people who speak the Hul'qumi'num language. The archaeological evidence shows that they have occupied the eastern shores of south-central Vancouver Island for at least 5,000 years. Although their traditional territory comprises more than 98,000 hectares, the four small reserves assigned to them in the Nanaimo area by the B.C. government more than 100 years ago comprise just 266 hectares. These were, and still are, the smallest reserves per capita in the province.

In 1792, the Spanish observed a large number of people living on Gabriola Island during their stay at Descanso Bay. This corresponds to ethnographic evidence that the Snuneymuxw moved to Gabriola in the spring and summer months to fish, harvest shellfish and hunt deer. In 1853, crew members of the HMS *Virago* under Commander James

Prevost observed a Snuneymuxw village at False Narrows, on the southeast shore of Gabriola. Later maps, drawn by one of the Hudson's Bay Company surveyors, show two villages on the island: one at False Narrows and one at Degnen Bay.

Snuneymuxw elders tell stories about the years of warfare with the Euclataw that took many lives, from young to old. On some evenings, they say, if you walk in certain places just as dusk is falling, you can hear the voices of children laughing. These are the children who were killed by the Euclataw, whose souls have lingered ever after.

The many petroglyphs on Gabriola signal a rich history of First Nations' presence here that people can see and study today. Some of the petroglyphs refer to the four directions, some to religious events and some to hunting and fishing exploits.

The Snuneymuxw are currently involved in a treaty process with the governments of Canada and British Columbia. Much of Gabriola has been identified as part of this First Nation's historic territory but only a few areas on the island have been proposed as part of the treaty settlement. One 393-hectare property has been purchased from a willing seller by the federal government. It will be held for the Snuneymuxw until such time as a treaty is agreed upon.

The day the treaty is signed, there will be great cause for celebration. It will mark the end of a long and sometimes difficult process, and the beginning of a new relationship.

Denman Island

Coordinator Marilyn Jensen
Artist Velda Parsons

Giving Our Island a Voice

ON OUR ISLAND, WE TOOK a unique approach to the mapping project, combining its goals with our wish to have some sort of millennium celebration of Denman. Instead of one map, the local coordinating committee invited everyone who wanted to make a map of Denman to submit a proposal. If accepted—and they all were—the cost of materials would be paid out of project funds. The result was 17 delightfully varied proposals, including three from the local school.

We told those who got involved that "anything can be a map," and they came up with a surprising range of options. Our collection included a video tracing the movement of spring into summer in the gardens of Denman, a sound map that combined a visual representation of the island with a recording of commonly heard bird and animal sounds, as well as two "installations"—a handmade book illustrating a local wetland and a map of salmon streams hung in the open lid of a trunk in which was set a three-dimensional stream full of silvery salmon. Six of the maps now hang permanently in the Conservancy Room of the Old School Centre. These six were also reproduced as cards, which are sold as a fundraiser for the Denman Island Conservancy.

Being part of this project has been a healing experience for Denman. When it began, we were facing rampant logging and other threats. The mapping project helped us remember our past and honour our present. As well, it provided us with some of the hope we need if we are to keep working to preserve and protect this special place.

—Marilyn Jensen

HOW DENMAN CAME TO BE

The last glaciers retreated from the Salish Sea about 10,000 years ago, leaving a climate warm enough for living things to return gradually over centuries. Eventually, people came too. On Denman, three villages of the Pentlatch people observed the arrival of the Spanish explorers in 1792. It was the fate of the Pentlatch to fall ill and die of terrible imported diseases to which they had no immunity. The few who survived were absorbed by the nearby Comox people.

The first European settlers arrived in the 1870s, attracted by government promises of cheap and plentiful farmland. But Denman was thickly forested, and the need to chop down huge trees and burn out the stumps hampered their progress. Settlers struggled to plant gardens and raise livestock, but they fell back on hunting and fishing. By the 1890s, there was an off-island market for the interfering timber, and a small logging industry grew up. Yet, hard as it was, farming continued to attract the majority. By the early 1900s, farm families were doing better, selling their excess produce to the towns on Vancouver Island, and even to Vancouver itself. Milk and cream were important exports, as were vegetables and fruit—especially apples.

In the 1950s, people began to come to Denman not to work, but for recreation. Old farms were carved into dozens of small lots for cabins and summer homes, threatening the rural character of the island. The creation of the Islands Trust in 1974 put in place some limits to growth, but many Denman Islanders continue to feel that their home place is endangered by too much development.

DENMAN ISLAND AT A GLANCE

POPULATION	SIZE	AREA OF FARMLAND	PROTECTED AREAS	AREA OF GREEN SPACE
2001: 1,016 1991: 888	12,881 acres/51.52 sq km	5,903 acres/2,389 hectares	259 hectares/5%	n/a

The Orchards of Denman

This map arose from our appreciation of our agricultural heritage, particularly the apple orchards. Jane Lighthall's work propagating old trees encouraged an exploration of the heritage varieties planted by the first settlers, both those that have been lost (the "ghost trees" of the map) and those that remain. We especially wanted to acknowledge the veteran trees still standing. In good years, these old trees produce bushels of apples for eating, pies, juice and jelly. In bloom, they are a special part of our spring landscape.

We generally used Winnie Isbister's *My Ain Folk* as a reference. As we progressed with our research, we all became aware of the challenge of mapping accurately, and how difficult it is to portray visually information that changes over time. Velda worked long hours to capture many disparate ideas. In the end, we did the best we could with "the facts," and tried as our main goal to convey a feeling for the orchards.

The old and new orchards of Denman are well known to the BC Fruit Testers Association, and the organic fruit grown here is popular at markets in Courtenay and Vancouver. Thanks in part to new apple plantings on Denman since the 1980s, there has been a resurgence of interest in old, unusual and new fruit trees.

At the first meeting of the Denman mapping group in March 2000, Marcus Isbister, long-time islander and mentor to many of us, spoke movingly about the soil of Denman Island and the feel of it in his hands. He did not live to see the map finished, but we think he would have approved.

—Anne de Cosson and Jane Lighthall,
apple-map researchers

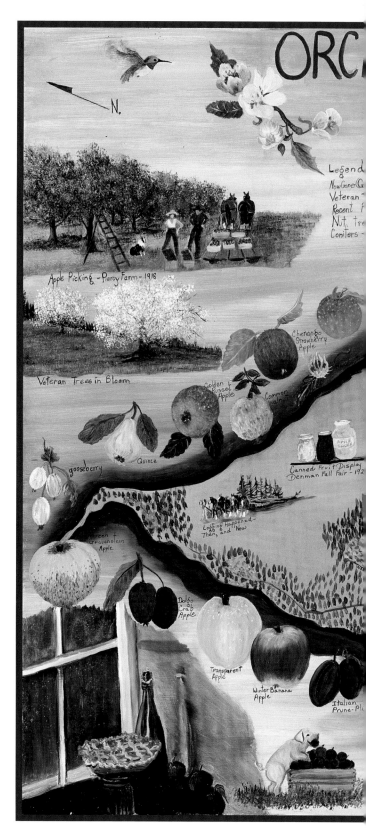

The Early Years

Tom Piercy came to Denman in 1876. It took 25 years of gradual land clearing before he could plant the thousand apple trees of his dreams. He died 14 years later, just as his huge orchard—the biggest on the coast at the time—was coming into prime production. Apples on Denman were known to ripen three weeks earlier than in some competing districts. They were shipped off to nearby Cumberland, where there was a thriving coal-mining community, as well as to Nanaimo, Victoria and Vancouver. Piercy's large orchard continued in production until the 1950s, when competition from the Okanagan became too great, and people no longer appreciated the old varieties, such as Ben Davis and Baldwin, whose flavour requires time in storage to develop.

Bosc
Pear

Bramley
Apple

Wealthy
Apple

mere

Wagener
Apple

Blenheim
Orange
Apples

LAMBERT
CHANNEL

Black
Currant

Grimes
Golden
Apple

AGRICULTURAL SOCIETY
VANCOUVER, BC.
Certificate of Merit.

CERES

To Mr. William Baikie
of Denman Is, B.C.
for Apples
November, 1910

cherry

Suntan
Apple

EAST CIDER ORCHARD

Sour
Cherry

King
Apple

In 1982, Apple Island Orchard Co-op planted
3500 Trees - mostly grafted on Denman
from old varieties from Vancouver Island
and England, all on M26 or M7 (semidwarf)
rootstock.
Of these, two
commercial Organic
orchards remain
in 2000.

Sweet Bough
Apple

Golden
Egg
Plum

APPLE LANE ORCHARD

DENMAN IS.

MAIDEN BLUSH
APPLE

In the early days - around 1900 -
almost every Denman settler
planted some fruit trees, Mostly
the old English favourite varieties.
Some of these veteran trees
are still producing fruit
in 2000.

DAMSON
PLUM

herr
le

Pioneer families: Piercys, McMillans,
Grahams, Lacons, Isbisters, Pikets,
McFarlanes - planted large
orchards. Denman Island
supplied markets in Vancouver
and Victoria, for years —

The Cathryn
Graham
(1954)

Research
and
Cartography

Jane Lighthall

Anne de Cosson

Painting - Velda Parsons - 2000

The Orchards Today

About a hundred years after the first influx of settlers to Denman, a wave of "back to the landers" arrived. Hoping for some farm income, several young families banded together in 1983–84 and started the Apple Island Orchard Co-op. Together they planted some 3,000 apples trees on their separate properties. Although the Co-op itself lasted only four years, most of the trees live on. Islanders have also saved and propagated many heritage fruit varieties. Several people on Denman have small, unique collections. There is a big demand for some of the old favourites now, and their juice is a sought-after treat at local and nearby markets. After many years and much hard work, Denman is once again known in the region for the unusual and wonderful tastes, textures, colours and fragrances of its apples.

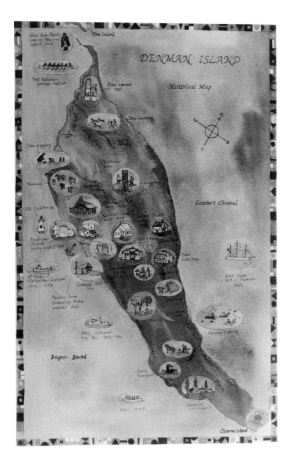

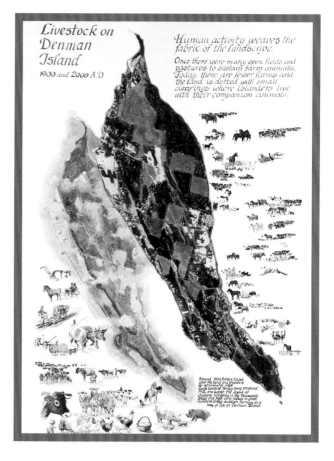

History of Denman by Jane Fawkes

Jane has been fascinated by maps since childhood, when she drew imaginary islands with cliffs and caves and, of course, a cross marking buried treasure. Her map of Denman is designed to give islanders and visitors a sense of how the community evolved. She combed through the local archives, sketched sites that still remain and chose representative places to depict on her map. Some of what once was is now gone, but the community hall, the two churches, the barns and the cemetery remain much as they were when they were built nearly a hundred years ago.

Livestock on Denman by Peter Karsten

Peter's map captures the evolving relationships of humans and domesticated animals on Denman. In 1900, many open fields and pastures had been hacked out of the forest and were being used to sustain farm animals—cattle in particular. In 2000, agriculture was no longer the main industry; fewer farms and smaller clearings pierce the forest, although companion animals remain. Animals are woven into the fabric of Denman life, but their impact on the changing landscape is not as great as it once was.

Morrison Marsh by Cynthia Minden

Approaching "map" as metaphor, Cynthia interpreted the project through an installation built around an artist's book about a much-loved wetland bordering her home. The book features nine photos of the area, turned impressionistic by being transferred onto thin paper she made from kozo fibre, then tinted. Like a raft, the book drifts on a table strewn with plant material gathered from the edges of the marsh. An open drawer overflows with specimens of flora and fauna: twigs, moss, grasses, beaver teeth, bones, a dragonfly chrysalis.

Hornby Island

Coordinators Darlene Gage; Samantha Garstang
Artists Andrew Carmichael; Lynne Carmichael

NOW, YOU NEED TO UNDERSTAND that Hornby is a little different from other Gulf Island communities in that we are not only *visited* by tourists in the summer months, we are *OVERWHELMED* by them. All islands have a big increase of visitors and seasonal residents in the summer, but Hornby's year-round population of about 950 more than quadruples. This may not sound like much compared to urban densities, but we on Hornby are watching this steadily increasing trend take a toll on both the community and the environment. Several of our cherished parks and beaches are suffering ongoing damage and degradation due to over-use and pollution. We can hardly find each other for strangers.

Many people make a living from summer visitors, so there is always a tension between the desire to have people come here and the desire to protect our home place. Not surprisingly, there was some strong local resistance to the idea of "publishing" (via this map) the location of more of our special, hidden or endangered spaces. The fear was that if we show people where those places are, they will all go there and probably damage them. "Loving us to death" is a phrase often heard here.

The challenge was to find a way to create a map of Hornby, showing the important geographic and natural features, in a way that felt comfortable to the community. How could we balance the need for information on the map with the need to protect and even *hide* those special areas that are not yet widely known to the public?

The final product, as you can see, does not look much like the other maps. There is almost nothing marked on the land itself. What we chose to do instead was to identify the special and unique aspects of our natural and human environment in a "web" circling the island, with no indicators as to their location. This may be confusing for the reader, and in fact it was challenging for the organizers. So maybe

ILLUSTRATION BY JANET MORGAN

Non-native opossums were introduced to Hornby by humans in the mid-1980s. With abundant food sources and no native predators except large owls, the population exploded. Opossums will eat almost anything. They have the ability to swim, climb and reach into nesting cavities for food. The larvae of the now locally extinct Edith's checkerspot butterfly have been found in their stomachs. As a control measure, some of the opossums are now being humanely euthanized.

ours is not a conventional map, but it seemed to be the only compromise we could find to ensure that there would not be a community backlash against the project. I hope that at the end of the day, the map does serve to identify those things that make us special. I firmly believe that "if we can map it, we can save it." And Hornby Island has lots of places and people and species and traditions that are very much worth saving.

This project, which was always full of surprises, gave Hornby Islanders a chance to see themselves as a whole: to see how the buildings and history, animals and plants, all fit together to make this such a unique place. It also gave us a chance to see ourselves in the context of the Salish Sea as a whole. And I know that if we can all see how much we are connected to each other, our chance of surviving and thriving will increase a million-fold.

—Darlene Gage

HORNBY ISLAND AT A GLANCE

POPULATION	SIZE	AREA OF FARMLAND	PROTECTED AREAS	AREA OF GREEN SPACE
2001: 966 1991: 924	7,310 acres/29.24 sq km	2,218 acres/898 hectares	755 hectares/25.5%	2,255 hectares/75%

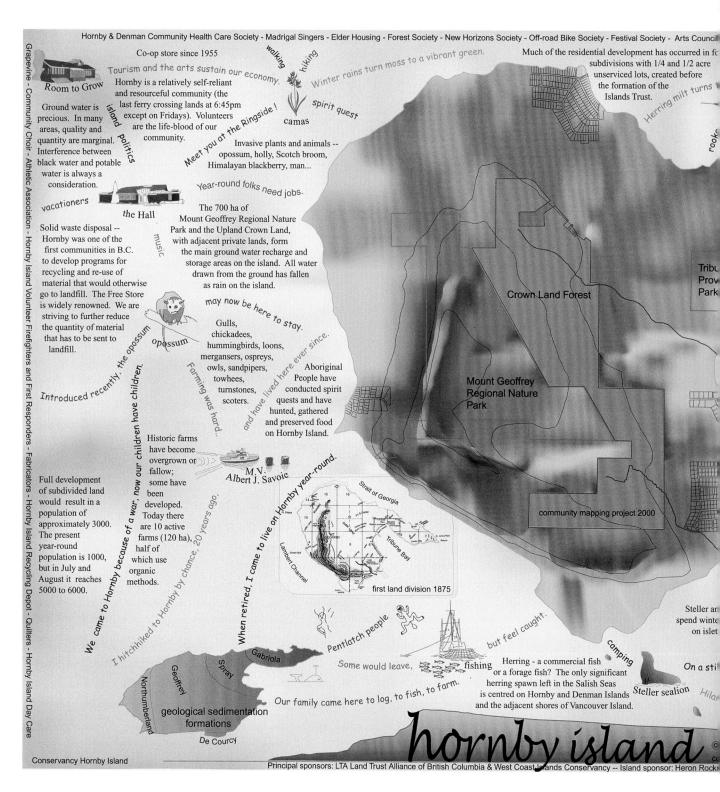

People and Place

Hornby's map is a collaboration between the artists and many of the year-round and seasonal residents of the island. As our map evolved through successive drafts, we gathered comments and reactions from residents. One thing was clear: neither the artists nor other islanders wanted a "tourist map"; there are plenty already. Instead, we wanted to create a map that included both natural and human communities.

Hornby has a unique location, two ferries away from Vancouver Island. It is isolated and it is small, covering about 3,050 hectares with a coastline of just 32 kilometres. Yet it has one of the highest totals of small, subdivided lots, and the most resorts. People and place: what is the critical balance point? What will we, the present inhabitants and visitors, leave for future generations? As the artists, we have articulated these issues through people's personal reflections, memories, impressions of Hornby, reasons for coming here, experiences, emotions and so on.

We have suggested the interconnectivity of natural and human communities through the image of a network. It has two elements: first, its meaning, where each point in the model of a dynamic system is a function of the values of its neighbours; and second, its everyday meaning as an enclosure, where in this case natural and human systems are caught up together.

We are living on Hornby now in what is a blink of

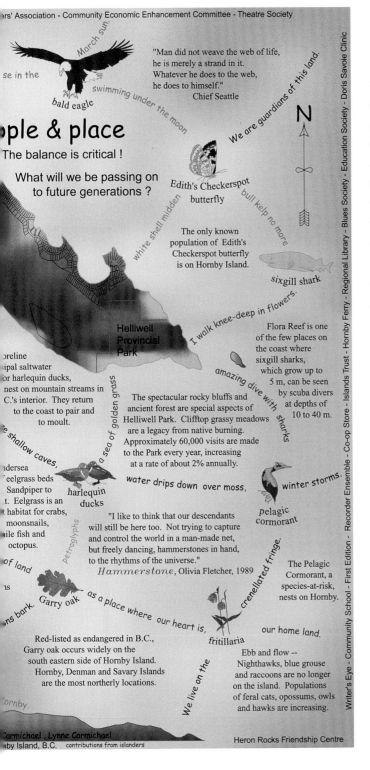

bald eagle

March sun

se in the

swimming under the moon

"Man did not weave the web of life, he is merely a strand in it. Whatever he does to the web, he does to himself."
Chief Seattle

We are guardians of this land.

N

ple & place

The balance is critical !

What will we be passing on to future generations ?

Edith's Checkerspot butterfly

white shell midden

bull kelp no more

The only known population of Edith's Checkerspot butterfly is on Hornby Island.

sixgill shark

Helliwell Provincial Park

I walk knee-deep in flowers.

oreline
ipal saltwater
or harlequin ducks,
nest on mountain streams in
C.'s interior. They return
to the coast to pair and
to moult.

amazing dive with sharks

Flora Reef is one of the few places on the coast where sixgill sharks, which grow up to 5 m, can be seen by scuba divers at depths of 10 to 40 m.

a sea of golden grass

The spectacular rocky bluffs and ancient forest are special aspects of Helliwell Park. Clifftop grassy meadows are a legacy from native burning. Approximately 60,000 visits are made to the Park every year, increasing at a rate of about 2% annually.

e shallow caves,

ndersea
eelgrass beds
Sandpiper to
t. Eelgrass is an
habitat for crabs,
moonsnails,
ile fish and
octopus.

harlequin ducks

water drips down over moss,

winter storms.

pelagic cormorant

petroglyphs

"I like to think that our descendants will still be here too. Not trying to capture and control the world in a man-made net, but freely dancing, hammerstones in hand, to the rhythms of the universe."
Hammerstone, Olivia Fletcher, 1989

crenellated fringe.

The Pelagic Cormorant, a species-at-risk, nests on Hornby.

of land
ns
ns bark.

Garry oak

as a place where our heart is,

We live on the

fritillaria

our home land.

Red-listed as endangered in B.C., Garry oak occurs widely on the south eastern side of Hornby Island. Hornby, Denman and Savary Islands are the most northerly locations.

Ebb and flow -- Nighthawks, blue grouse and raccoons are no longer on the island. Populations of feral cats, opossums, owls and hawks are increasing.

ornby.

armichael , Lynne Carmichael
by Island, B.C. contributions from islanders

Heron Rocks Friendship Centre

SUMMER AND WINTER POPULATION DIFFERENCE

All of the islands in the Salish Sea experience an increase in population in the summer. There have been "summer places" on these islands for half a century. Today they are increasingly a destination for people in cars, boats and float planes. These summer visitors contribute to the economy of the islands, but they also challenge their infrastructure—water, roads—and they change the "feel" of our home places: hiking trails and coffee shops are suddenly crowded; the faces you see at the Co-op are no longer those of your neighbours. Hornby experiences the pressures of this influx in a particularly dramatic way. Accurate figures are hard to come by, but a recent *Quality of Life Report* prepared for the Hornby Island Community Economic Enhancement Committee in 2003 suggests a temporary population explosion in the summer, as shown below.

SUMMER 2002	
Year-round population	966
Summer residents	2,045
Daily ferry arrivals (max.)	1,048
TOTAL	4,059

AN OPTIMISTIC NOTE

In the dark of winter, when the clouds of negativity settle here and there, it is easy to get discouraged and to see our community glass as half empty. I would like to provide a message of hope and to encourage us to see that Hornby's glass is more than half full. For example, 25 percent of Hornby is in protected areas, whereas on some islands the figure is less than 5 percent. On neighbouring Denman, over 300 new lots can be created; only a handful are possible here. Hornby is in the rare position of having a quarter-section of public land designated for community use. Other islands have been assailed by clear-cut logging and increasingly industrialized aquaculture, but Hornby has no large tracts of privately owned forest; our Crown land is protected from extensive logging; and our coast is more exposed and thus less attractive for large-scale aquaculture development.

Perhaps our greatest challenges are these: how to maintain a diverse and healthy community, including young folks; how to create an economy that is not overly dependent upon tourism; how to be better stewards of our water, land and marine environment; how to keep intact the island's special character. These challenges face all of the islands in the Salish Sea.

—Tony Law, Hornby Island Trustee

the eye in geological time. We included the idea of geological evolution by presenting the sedimentation layers visible today on the island. The names of some of these layers correlate with present-day place names.

Hornby's distinctive aerial-view shape is the central image on the map. We also show its profile as seen from the ferry along the bottom. Little interior detail is included: we did not want to show specific locations. The heavy concentration of housing in the three marked subdivisions is indicated by the superimposition of lot plans for these locations. This high density is evidence of insensitive development policy in the past, before the creation of the Islands Trust.

—Andrew Carmichael and Lynne Carmichael

Lasqueti Island

Coordinator and Artist Darlene Olesko

IN 1999, I RESPONDED TO an article in our local island newspaper stating that there was an interesting project under way, involving art and community awareness, other islands and the turn of the millennium. Never figuring largely in local politics, I felt a bit unqualified to get involved in this. However, with encouragement from others in the community, I went to the first workshop on Salt Spring, where I got a lot of ideas about how I could do something in the Islands in the Salish Sea Community Mapping Project. So I took on the challenge of designing a map of Lasqueti that would reflect the landscape, as well as human impact on the place and some history of our little island. I attended that workshop with Sue Wheeler, whose property map is in this section, and whose daughter eventually did another map of Lasqueti, having been inspired by the project's exhibition when it came to our island.

Lasqueti Island is unlike the rest of the developed world, even unlike the other islands in the Salish Sea. One arrives at this observation only after spending some time here. Beyond False Bay, down the gravel road and on to the side trails, there lies a world of deep forests and ominous swamps, houses in the middle of nowhere, ochre-coloured bluffs and high pine ridges where you can wander for hours and days without seeing another soul.

We have one main road that runs down the centre, called Main Road. There are no house numbers here, just people's names, and those you might hear of are invented, which sometimes makes things easier when dealing with stuff from "the other side." Our population of about 415 swells in the summer by another couple hundred, but mostly we are a residential, year-round community consisting of a broad range of hardy individuals. The map shows most of the houses, and since it was made, a few more have been built. Two have been deactivated.

In the last half-century, most of the old-growth forest has been cut and replaced, slowly over time, with second growth. Our once-booming herring fishery and shipyard are in transition. Today our mariculture includes a number of licensed oyster and clam beaches, and a few geoduck beds. We still have lots of feral sheep around, but the big herds of cattle that once free-ranged our roads are long gone. Instead, we haul steer manure over on the ferry in plastic bags that

mostly end up in the dump. A big machine is barged over in summer to shave down the roadside greenery. In the past the cows provided this service, but the herds grew too big, and free-range is now a thing of the past. Today, roadside stands with eggs, baked goods, vegetables and fruit for sale dot the main road—a testament to our faith in the honour system.

We're 10 miles out in the middle of the Salish Sea, so our three-times daily, five-days-a-week passenger-only ferry, limited to 60 people, keeps growth at bay. Patience is a necessary trait if you plan to come for a visit. Our ferry has had almost the same number of runs per week for the past 20 years, and this limited access can be both a restriction and a saviour. Whereas all the fresh water on the island was completely drinkable up to about ten years ago, now a lot of big blue bottles are being shipped over.

We have our dilemmas: welcoming newcomers and their fresh energy and talents, along with the fear of overpopulation and crowding. On an island with no public electricity, where virtually all heat is generated by wood-burning stoves, overpopulation with its resulting deforestation is a real concern.

Because Lasqueti has resisted the installation of public electricity, residents have become crafty and inventive in supplying our own, through water, solar and wind power. Necessity has been the mother of some very creative projects! I'm proud of my community. I'm proud of Lasqueti for being the way it is, a little maverick island holding quiet and steady out here in the south-easterly blown straits.

We're an island, surrounded by salt water and other smaller islands with their own characteristics. The magical Finnertys are almost tropical

in summer; cute little Boho Island has its old-growth trees deep in its centre; pastoral Jedediah Island has a haunting beauty; Bull Island has steep rock walls jutting upward; and lovely Sangster Island is so neatly decked in striates of mauve and yellow wildflowers you'd swear they were planted. Even though these small, outlying islands are offshore of Lasqueti, they feel very connected, like relatives. This salty Salish Sea, which unites all our islands and secludes and protects us, will, we hope, ebb and flow forever. Keeping the rhythm alive ... the rhythm of wave upon pebbles, canoe paddles upon water, great firs in the wind and, somewhere, a hopeful drummer, deep in the cedar grove.

I give thanks for government-issued maps that provided a baseline to start from, to all the people who attended our barefoot-mapping workshop and especially to those people who were inspired enough to make their own maps to complete our island maps exhibit. This project was a real highlight in my life, and I'm so glad that I was lucky enough to be involved. Making the map was a great experience, and even after it was finished, I found myself wanting to make another. I would sometimes wake up in the middle of the night, envisioning maps with new themes and different colours.

—Darlene Olesko

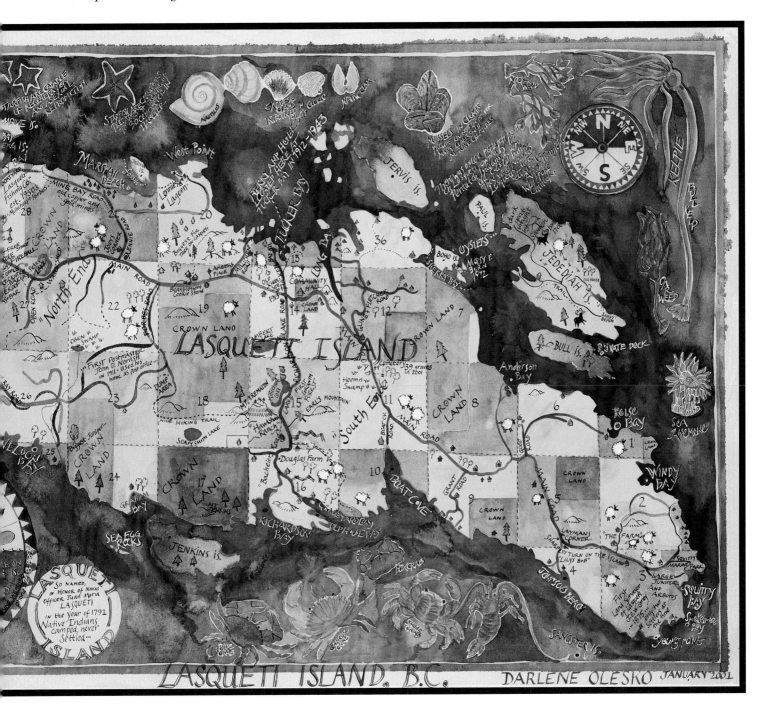

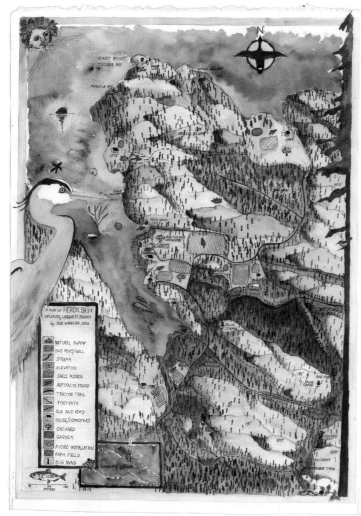

A MAP of HERON BAY &
UPLANDS, LASQUETI ISLAND
by SUE WHEELER, 2002

- NATURAL SWAMP
- DUG POND/WELL
- STREAM
- ELEVATION
- SHELL MIDDEN
- ARTIFACTS FOUND
- TRACTOR TRAIL
- FOOTPATH
- OLD SKID ROAD
- HOUSE/HOMESTEAD
- ORCHARD
- GARDEN
- HYDRO INSTALLATION
- FARM FIELD
- BIG SNAG

Heron Bay Map ARTIST: SUE WHEELER

From an Island to an Individual Home Place

My inspiration for mapping the land I live on came from a notice I saw about a workshop on Barefoot Mapping that Briony Penn was offering on Salt Spring. I took the workshop and spent time over the next four years walking around the land, pacing off distances, sighting things like the osprey nest, or a building, from known points on a base map we had done for forest management. During this time, I was loosely involved with the Islands in the Salish Sea project organizers, which gave me a boost to get moving on my map.

Once I had lines on paper, and piles of ideas, I had to decide what to include, what to leave out and how to render it visually. I spent a day browsing through books of maps and cartography at the University of Victoria libraries, including the map library, getting more ideas.

I got to know the land much better through mapping it. I came to love even more a place that I already loved. I would encourage anyone to do this, no matter how small or large the piece of land involved. When I started, I did not know how to use a compass and had very little practice drawing or painting. If I can do it, anyone can.

—Sue Wheeler

Jedediah Island is one of the many islands nearby, on the east side, that the people on Lasqueti have come to know and love deeply. In 1995 Jedediah was purchased from Mary and Al Palmer, owners of the island since 1949: the Friends of Jedediah, the Marine Parks Forever Society, the Nature Trust of B.C. and many other individuals and groups undertook extensive fundraising activities to buy it. The estate of the late Dan Culver committed $1,100,000 to its preservation.

It is 640 acres of mixed forest, open meadows, sandy beaches, mossy bluffs with rocky coves and deep anchorages. Today it is a very popular provincial marine park, with four registered archaeological sites, including an Aboriginal fish weir. Visitors can camp out, walk the island's trails, view the 95-year-old homestead, wander through old fruit orchards, and maybe catch a glimpse of the sheep and dark Spanish goats that now run wild over the island.

Spanish goat on Jedediah Island PHOTO BY GORDON SCOTT

LASQUETI ISLAND AT A GLANCE

POPULATION	SIZE	AREA OF FARMLAND	PROTECTED AREAS	AREA OF GREEN SPACE
2001: 367 1996: 417	73.56 sq km/18,103 acres	1744 acres/705 hectares	641 hectares/8.6%	4604 hectares/69%

Texada Island

Coordinator Lee Thorpe
Artist Amanda Martinson

THE STORY OF TEXADA ISLAND revolves around its unusual geology. The Sliammon people, from the Powell River area, camped and fished on the island they called Si'ye'yen for thousands of years before the Spanish sailed by. Several middens and the remains of their fish weirs provide evidence of how they lived. But they built no permanent homes there because of a legend with a warning: according to the story, Si'ye'yen rose from the sea in long-ago times and will sink back into it one day—not a good place to stay long.

Skyscape PAINTING BY AMANDA MARTINSON

It's a legend that may well be rooted in geological fact. Texada did rise out of the Salish Sea, at least twice. The last time was about 10,000 years ago, at the end of the most recent Ice Age. The land that was thrust upward contained minerals which subsequent peoples found valuable. Some are still being extracted. At present, about 6 million tonnes of limestone and other aggregate are shipped from Texada each year.

The limestone on Texada took 170 million years to harden up; it began as ocean mud off the coast of Mexico or California and was compressed into rock. The resulting formations travelled north to their present location at about the same rate our fingernails grow. Other minerals mined on Texada over its history—iron, copper, silver and gold—were concentrated into ore bodies by a little-understood geological process called "skarnification," involving great heat and pressure.

The bedrock of Texada is unusual among the Gulf Islands and, as a result, the soils and water bodies are too. The island has rocks (flower rocks), fish (sticklebacks) and certain ferns and flowers (giant chain ferns, elegant camas) found nowhere else in the Georgia Basin.

In some ways, the people here stand apart from other islanders too. For example, it took a while for the project organizers on faraway Salt Spring to find an organization ready and willing to take on local sponsorship of the Islands in the Salish Sea mapping project: the connections just weren't there. But when the Texada Island Community Society heard about it, they couldn't resist such a high-profile, highly participatory project.

In order to get people interested and excited, local coordinator Lee Thorpe made presentations to the community society, the Chamber of Commerce, the Heritage Society and the Texada Trekkers (a hiking group), and spoke at an Old Age Pensioners luncheon and the Sunday Farmers' Market. She also advertised the project in Texada's monthly publication, the *Grapevine* (now the *Express Line*).

Jan Caswell provided systematic research. She interviewed a wide variety of people: farmers, miners, historians, horticulturalists, limnologists, ornithologists. This compilation of oral history gave many people a chance to put what they know about Texada "on the map"—literally.

Local organizers asked several resident artists to submit proposals for the final map, and chose Amanda Martinson. She combined her knowledge of the island's indigenous flora and fauna with research information from several sources to develop a unique image. The map is a lively watercolour, with a variety of current and historical features depicted inside a border of many of the species that inhabit Texada. It is now on permanent display at the Heritage Museum in Blubber Bay.

TEXADA ISLAND AT A GLANCE

POPULATION	SIZE	AREA OF FARMLAND	PROTECTED AREAS	AREA OF GREEN SPACE
2001: 1,129 1996: 1,155	74,495 acres/301.6 sq km	9,208 acres/3,728 hectares	1,118 hectares/3.7%	n/a

When I first came here, I was surprised that Texada, the largest of all the Gulf Islands, was virtually unknown even to people living on the other islands. In contrast to the reputation of those islands as glamorous sanctuaries for artists and hippies, Texada is thought of as a working-man's island (even a "redneck" island) with its three limestone quarries and its long and lively mining history.

In reality, Texada's people and communities are diverse: quarry families, retirees, small-business owners, a few loggers, some farmers, lots of artists and a growing number of urban refugees. It's a place where you know your neighbours. Like extended family, we guard our privacy but are eager to help in times of trouble. It's a tight-knit community that has resisted the assaults of urbanization, including one plan to make the island a dumping ground for big-city garbage and another to build a fish farm.

Artistic licence has granted me access to some incredibly beautiful spots on this island—places of the kind I call "crazy beautiful"—filled with unusual wild things, many of which are featured on the map. I make my case for the forest understory on this map. Tree planting after logging may be a good thing, but what about the replanting of native orchids, shrubs and fungi, the understory of life that is a forest's circulatory system? Once gone, these plants don't come back. Native species are replaced by invasive, naturalized Eurasian weeds.

I also make my case for the swamps, small lakes and marshes on this map. Is it necessary to clear-cut up to the water's edge, destroying the home of sundews and running club moss? Industrial activity tends to wipe out so much. The key to life is genetic diversity.

The Islands of the Salish Sea are like pearls, each a different colour, each having evolved as unique ecosystems for flora, fauna and humans, each a part of a rare and precious necklace. We simply must protect them.

—Amanda Martinson

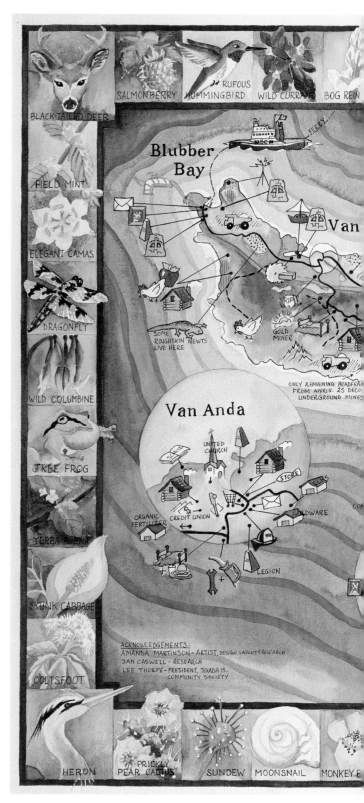

Stickleback species pair. ILLUSTRATION BY MICHAEL HAMES
©1999 PROVINCE OF BRITISH COLUMBIA

DISAPPEARING STICKLEBACKS

Stickleback species pairs are small freshwater fish that, according to B.C. scientists, are found nowhere on Earth but in four of Texada's lakes and one on Vancouver Island. Because of their evolutionary rarity as freshwater fish descended from a marine predecessor, they are a globally important scientific treasure, akin to Darwin's finches on the Galapagos. Their survival depends on protection of their dwindling habitat.

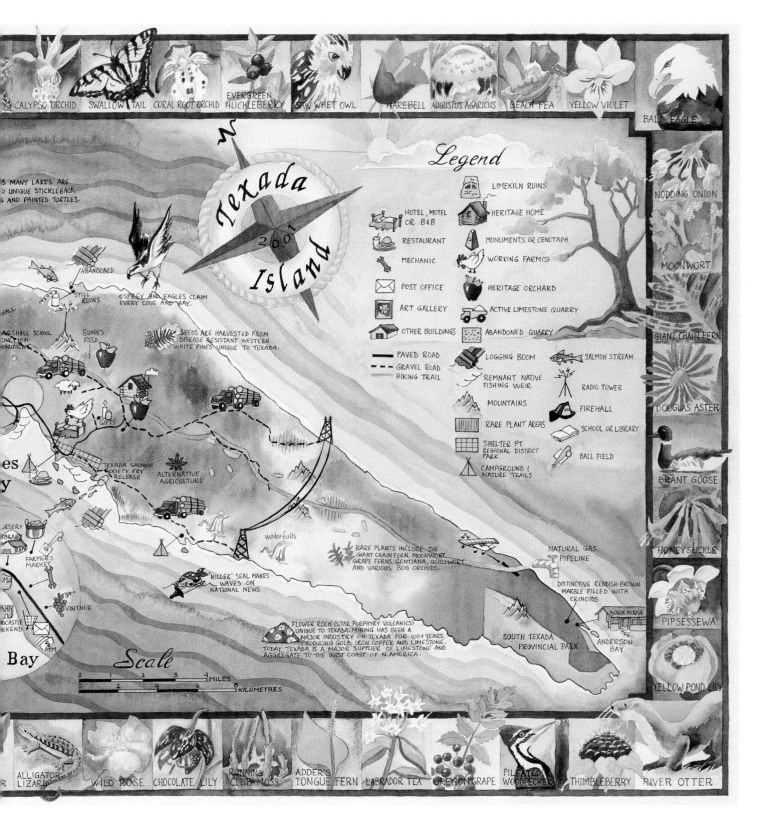

Border specimen labels (top, clockwise)

CALYPSO ORCHID · SWALLOW TAIL · CORAL ROOT ORCHID · EVERGREEN HUCKLEBERRY · SAW WHET OWL · HAREBELL · AUGUSTUS AGARICUS · BEACH PEA · YELLOW VIOLET · BALD EAGLE · NODDING ONION · MOONWORT · GIANT CHAIN FERN · DOUGLAS ASTER · BRANT GOOSE · HONEYSUCKLE · PIPSESSEWA · YELLOW POND LILY · RIVER OTTER · THIMBLEBERRY · PILEATED WOODPECKER · OREGON GRAPE · LABRADOR TEA · ADDER'S TONGUE FERN · RUNNING CLUB MOSS · CHOCOLATE LILY · WILD ROSE · ALLIGATOR LIZARD

Map

Texada Island 2001

Legend

- Hotel, Motel or B&B
- Restaurant
- Mechanic
- Post Office
- Art Gallery
- Other Buildings
- Paved Road
- Gravel Road / Hiking Trail
- Limekiln Ruins
- Heritage Home
- Monuments or Cenotaph
- Working Farm(s)
- Heritage Orchard
- Active Limestone Quarry
- Abandoned Quarry
- Logging Boom
- Remnant Native Fishing Weir
- Mountains
- Rare Plant Areas
- Shelter Pt. Regional District Park
- Campground & Nature Trails
- Salmon Stream
- Radio Tower
- Firehall
- School or Library
- Ball Field

Map annotations

'S MANY LAKES ARE [?] UNIQUE STICKLEBACK, [?] AND PAINTED TURTLES.

OSPREY AND EAGLES CLAIM EVERY COVE AND BAY.

SEEDS ARE HARVESTED FROM DISEASE RESISTANT WESTERN WHITE PINES UNIQUE TO TEXADA.

TEXADA SALMON SOCIETY FRY RELEASE

ALTERNATIVE AGRICULTURE

"KILLER" SEAL MAKES WAVES ON NATIONAL NEWS

waterfalls

RARE PLANTS INCLUDE THE GIANT CHAIN FERN, MOONWORT, GRAPE FERNS, GENTIANA, QUILLWORT, AND VARIOUS BOG ORCHIDS.

NATURAL GAS PIPELINE

DISTINCTIVE REDDISH-BROWN MARBLE FILLED WITH CRINOIDS

SOUTH TEXADA PROVINCIAL PARK

ANDERSON BAY

BUNK HOUSE

FLOWER ROCK (STAR PORPHYRY VOLCANICS) UNIQUE TO TEXADA. MINING HAS BEEN A MAJOR INDUSTRY ON TEXADA FOR 100+ YEARS, PRODUCING GOLD, IRON, COPPER AND LIMESTONE. TODAY, TEXADA IS A MAJOR SUPPLIER OF LIMESTONE AND AGGREGATE TO THE WEST COAST OF N. AMERICA.

ABANDONED · STILL RUINS · MARSHALL SCHOOL JUNCTION MONUMENT · BUNN'S FIELD · GIFTS · VINTNER · FARMER'S MARKET · ...CASTLE ...EKEND · ATM · Bay

Scale
0 1 2 3 4 MILES
0 2 4 6 8 KILOMETRES

DAZZLING FLOWER ROCK

Texada's own jewels, flower rocks, are pieces of black porphyry in which crystalline starbursts of feldspar nestle. Volcanic in origin, they formed several million years ago when the pale feldspar crystals cooled quickly in molten lava and the darker porphyry cooled more slowly around them. Sometimes made into jewellery, they are another example of Texada's unusual geology.

Flower rocks PHOTO BY LEE THORPE

Mining on Texada

Ocean Warlock at Blubber Bay PAINTING BY AMANDA MARTINSON

When you cross Malaspina Strait from Powell River and drive off the ferry at Blubber Bay, you can tell right away that mining is part of the Texada story. The crushing plant, large outdoor conveyor systems and stockpiles of rock from the nearby limestone quarry dominate the scene. No other island in the Salish Sea has experienced anything like it. In 1871, a whaler named Harry Trim discovered iron ore on the northwest shore at Welcome Bay. After this news got around, there was a rush of mineral exploration on Texada. It was well worth a look: beneath the skin of the island were deposits of iron, copper and even some silver and gold.

The first mine opened in 1880, followed quickly by openings on other sites, to which hardbitten men from all over North America came to dig with pick and shovel for the glitter of precious metals. By 1898, the tiny settlement at Van Anda had turned into a classic "boom town," boasting an opera house, three hotels with saloons, a hospital and a thriving business district. We've heard little of these roaring '90s on Texada, perhaps because Van Anda was eclipsed by the even more glamorous Dawson City, Yukon, centre of the Klondike gold rush.

According to the B.C. Ministry of Energy and Mines, in the years between 1896, when record-keeping began, and 1976, when most of the deposits had been mined out, the "varied sink of polymetallic skarns" of Texada produced 10 million tonnes of magnetic iron ore, 35,898 tonnes of copper, 39.6 tonnes of silver and 3.3 tonnes of gold.

Today, three rock quarries remain active on Texada—at Blubber Bay, Gillies Bay and Spratt Bay. They produce over 6 million tonnes per year of limestone and rock aggregates. Not as exciting as silver and gold? Maybe not, but limestone is used in the manufacture of almost everything we touch: paint, paper, glass, plastics, steel and cement. The aggregate is used mainly in road construction.

Not everybody likes the look and the sound of it, but every year the mining industry brings several million dollars into the economy of Texada in the form of high-paying jobs, local purchases of supplies, and taxes.

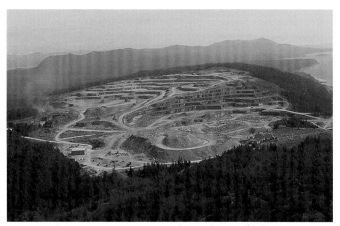

Largest and most active quarry on Texada, northwest of Gillies Bay.
PHOTO BY TEXADA QUARRY LTD.

Savary Island

Coordinator Liz Webster
Artists Kathy Kerbale and Tony Wypkema

"MAP IT AND SAVE IT," she said. "You can do it." Community-mapping proponent Briony Penn told me this on a visit to Savary in the fall of 1999, and she was right. She was visiting the island to give a one-day mapping workshop to some of my students from Malaspina University–College. The workshop involved mapping the first property donated to the Savary Island Land Trust Society (SILT). At the start of the day we were divided into pairs and given a measuring tape, a compass and a map sheet. Once in position, we began the process of "barefoot mapping"—that is, recording the features of the land at close range using just those simple tools. I was amazed by the beautiful and informative map we had created by the end of the day. Even more amazing was the strong connection the students made to the land in such a short time. I knew we needed to do more.

When the opportunity came along to be part of the Islands in the Salish Sea Community Mapping Project, I was keen. As an educator and land trust director, I was looking for a way to share the beauty and astonishing biodiversity of Savary with a wider audience and, at the same time, draw attention to our frightening legacy of subdividing the island into more than 1,700 tiny lots. The offer from the project to help us develop a community map that could be used in a campaign to protect some of our imperilled land came just when we needed it. The first project workshop, held on Salt Spring in January 2000, gave me a chance to hear from other Salish Sea islanders involved in struggles to preserve special places on their islands, and to meet some very valuable resource people. It gave me inspiration and hope.

Early that summer, a small group of us got the project going on Savary. After a period of initial planning, we gathered one day at the Savary Island firehall. Using a base map from the Ministry of Highways, we divided up the island by areas and set out in neighbourhood teams to collect data on each one. We worked at it all through June, July and August. As the summer came to an end, and most of the group returned to their homes on the mainland, they handed in their mini-maps to Norma Flawith and me to be compiled into a grand database for the final map. Next came the phase of sorting the information, debating what would go on the map and discussing how it would be illustrated.

The painstaking work of the artists, Kathy Kerbale and Tony Wypkema, resulted in a wonderful blend of form and function: their map is both an appealing piece of art and a rich source of information. SILT has printed and sold thousands of posters and placemats. The placemats, with the deep blue beauty of the map on one side juxtaposed with the hard reality of Savary's urban-style subdivision on the other, helped us make the case for preserving "the heart of the island."

The people who use the placemat maps to plan adventures while they are here on their summer holidays are learning from it too. Back home in the city in the winter, they trace their favourite paths and bike rides, recalling good times on Savary. Our map is helping them develop attitudes of care that will help preserve the essential character and natural diversity of the island for generations to come.

—Liz Webster

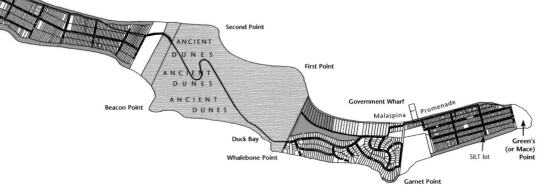

The Geological Underpinnings of Savary

Savary is a narrow, crescent-shaped sliver of glacial outwash sediments, till (glacial debris) and thick deposits of sand, layered on a bed of clay. An ancient granite outcrop at Green's Point, known locally as the "anchor of the island," forms the eastern tip. The surface features are either exposed sections of gravelly till strewn with boulders from the Vachon Drift (see diagram on map), or aeolian sands deposited and sculpted into dunes during the last 10,000 years.

Sand dunes form when steady winds sweep across flat expanses of sand, blowing particles up against a barrier that stops their forward motion. The process is either that of "saltation," in which the wind picks up individual particles and skips or bounces them to the obstacle, or of "surface creep," in which one grain of blowing sand crashes into a larger one, forcing the larger one to roll forward. With the right mix of sand supply and wind conditions, deep drifts will accumulate at the barrier. For the dunes to become permanent they require a barrier of specialized vegetation, able to endure a cycle of growth and burial, regrowth and reburial, until it eventually stabilizes the dunes.

Dune formation is the work of centuries. As long as the wind continues to blow, the sand will continue to shift and reshape the dunes. Typically, they grow higher and higher until they collapse, rolling over and moving inland towards the next obstacle. Between the peaks of the dunes, the wind carves out troughs or valleys, scouring them down until damp sand or bedrock is exposed. Each of these sets of micro-conditions favours a finely adapted group of flora and fauna. The dune ecosystems on Savary are the only ones of their kind in B.C.

Sand formations such as the beaches, cliffs and dunes of Savary erode easily and are highly sensitive to disturbance. They nurture a rare sequence of plant ecosystems extending from the shoreline to the uplands: beach, beach strand, foredune, dune meadow, young dune forest and older forest. The rarity and fragility of the sandy surfaces of Savary point to the need for maximum conservation and protection.

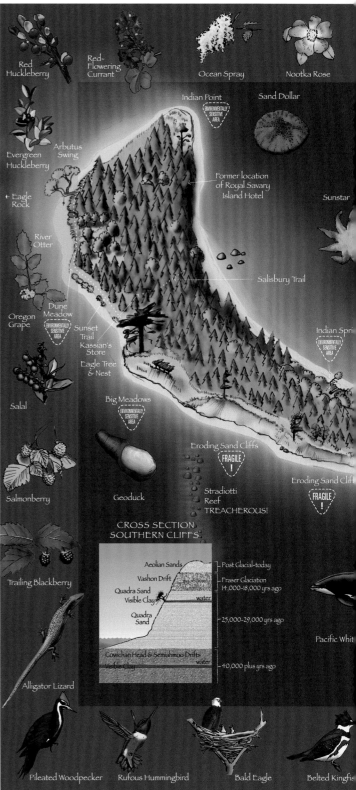

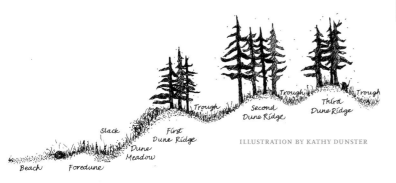

ILLUSTRATION BY KATHY DUNSTER

The problem of erosion:

On Savary both the sand cliffs and the homes built on them are in danger of sliding into the sea. An engineering study in 2003 reported average rates of erosion of .41 metres per year on the south side, and .025 metres per year on the north side.

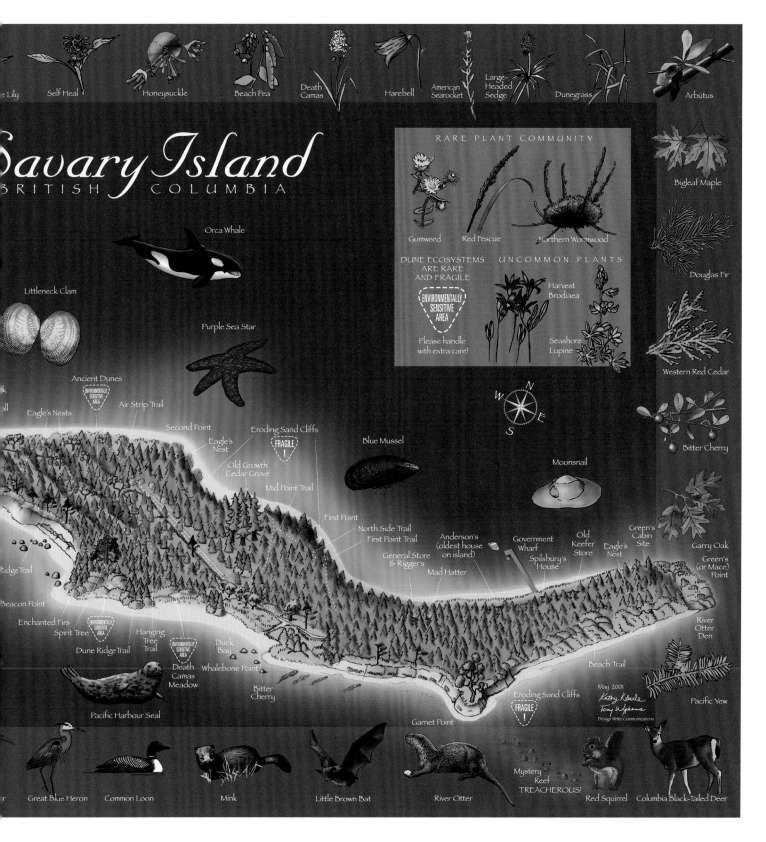

The problem of water:

Water has long been a concern of islanders. To date there has been a lack of data about the quantity of groundwater on Savary. The island has a single main aquifer, three shallow-perched aquifers and four springs. There are no lakes.

Septic systems are widely used. They have been known to be problematic, given the sandy soils, small lots and perched aquifers. Some people, in an effort to safeguard the quality of Savary's groundwater, use composting toilets and alternative technologies such as water-catchment systems.

Ayhus, the Double-headed Serpent

Tiny Savary Island, at the northern end of the Salish Sea, has a singular natural and human history. Only 7.5 km in length and from 0.3 km to 1.0 km in width, it is what is known geologically as a migrating sandbar. Seen from the air, its outline suggests a double-headed serpent or Ayhus, the name given to one site by the Tla'amin First Nation. The island is characterized by steep, unstable sand cliffs that plummet to long sandy beaches, which in turn stretch into the sea to meet treacherous reefs. Its thin skin of soil is just deep enough to permit a tree covering of shallow-rooted fir and cedar, hardy arbutus, yew, big-leaf maple, bitter cherry and a fragile stand of the northernmost population of Garry oak in Canada.

Given the island's extensive beaches and mild climate, it's no wonder that George Ashworth, an enterprising journalist and businessman from Vancouver, decided as long ago as 1910 that Savary had potential as a vacation spot, despite its distance from major centres of population. Ashworth brought several business interests together to form the Savary Island Park Association and contracted surveyors from Vancouver to subdivide three district lots of 643 acres (in total) into 1,401 50-foot, city-sized lots to maximize the potential for profits. By 1913, Ashworth was advertising the island widely as "the Catalina of the North." He invited wealthy customers from Vancouver to travel via Union Steamship to be dropped off on the beach at Green's Point, the eastern end of the undeveloped island—men in suits, ladies with parasols against the sun. The first excursion proved fruitful: more than 50 lots were sold. Over time, the low-bank waterfront lots near the wharf and at Indian Point were sold too, but much of the island remained virtually uninhabited for decades.

Today, with over 1,700 small lots on just 1,111 acres, Savary has the highest lot density of any island in the Salish Sea—nine times greater than Bowen and 20 times greater than Denman. The intensity of subdivision could render Savary a victim of its own appeal. In 1997, planning consultants warned that the island was reaching critical development thresholds. Cliff-edge erosion, diminishing septic capacity and declining water quality are known to be problems. Since then, development has doubled. The year-round population of 60 swells to 3,000 in summer.

It has never been an easy island on which to manage. Until the 1950s, people came by steamer from Vancouver for day trips, for weekends at the Royal Savary Hotel or for the summer. Eventually, the highway connected the city to Lund, where a water taxi is located. There is no car ferry and only a limited system of bumpy roads. Islanders produce their own electricity from the sun, the wind or a generator.

In 2000, when the mapping project began, the last of the five original district lots, DL 1375—329 acres in size and an important groundwater-recharge area—was undivided and undeveloped; it contains one of the best examples of intact coastal dune ecology in Canada. An application from its Washington State owners to subdivide and develop it was under review. Islanders' desire to save this lot, the "heart of the island," had been the catalyst for establishing the Savary Island Land Trust Society in 1997. SILT campaigned for six long years to find a way to protect the land. Using our map to help dramatize the story was one crucial way of doing that.

In 2002, the Nature Trust of B.C., the Province of B.C., the Government of Canada and many private donors made possible the purchase of a 50 percent undivided interest in DL 1375 and title to 13 adjoining parcels. The total area involved is 363 acres, nearly one third of Savary. SILT's dream of protection was not only met; it was exceeded. The Savary map and its powerful message of beauty and diversity at risk played a part in realizing the dream.

SAVARY ISLAND AT A GLANCE

POPULATION	SIZE	AREA OF FARMLAND	PROTECTED AREAS	AREA OF GREEN SPACE
2001: 115 (Summer 3,000, Winter 60)	1,111 acres/4.5 sq km	none	Pending negotiations, 1/3 may be granted some level of protection.	n/a

Cortes Island

Coordinator Sabina Leader Mense
Artist Brigid Weiler

IN JANUARY 2000, I WAS invited to Salt Spring Island to attend an introductory workshop on the Islands in the Salish Sea Community Mapping Project. What a memorable gathering it was, in the old Beaver Point Hall, with representation from 15 of the 17 islands that would come to be involved in the project. Each island representative introduced her or his home island to the group with an overview of island geography, politics, environmental issues and social concerns. Scenarios common to all of us kept coming to the surface and a strong feeling of camaraderie developed in that room of island folk.

That first meeting was the catalyst for our shared undertaking: to identify, record and make maps of what is special, what is loved, what is important and what is threatened on our islands. We were told that this project would "marry the microscope with the mandolin," making it a shared venture in the sciences and the arts.

Cortes Island has a strong history of mapping. This interest comes from an inherent respect for and connection to the place we call home. Eminent conservationist Aldo Leopold has written, "We abuse land because we regard it as a commodity belonging to us. When we see land as a community to which we belong, we may begin to use it with love and respect."[19] With government's increasing divestiture of responsibility for environmental and social issues in outlying rural areas, island communities have had to rally. As part of the process of taking responsibility for what matters to us on our island, Cortes community groups have created maps

The Microscope and the Mandolin
ILLUSTRATION BY DIANNE BERSEA

that span the spectrum from scientifically defensible, ecosystem-based planning maps to heritage place maps based largely on oral history.

Each participating island came to the project as a distinct community. On Cortes, we number fewer than a thousand permanent residents. We do not live anonymous quasi-urban lives, and most of us still feel accountable to one another. We choose rural lifestyles where privacy and respect for our home place are essential qualities of life. Therefore, our challenge in this project lay in the rendering of a map that would marry the microscope with the mandolin—bringing our scientific data together with our artistic sensibilities—in a way that would not dishonour community values.

Our map, *Beginning with a Vision,* accomplishes this by celebrating the place we call home. In his book *A Sense of Place*, artist and environmental activist Alan Gussow defined place as "a part of the whole environment that we claim with feelings."[20] The 18 individual maps of Cortes that fan across the backdrop of sea and sky all document parts of the whole of the island that are "claimed with feelings." Each small image identifies an aspect of the island that is special, loved, important and/or threatened.

Beginning with a Vision is a poignant reminder of the diversity of parts within the whole, and of our relationship to it all, at a crossroads in our history—the turn of the millennium. As a community, our challenge in this new millennium will be to maintain our vision of wholeness for Cortes while honouring the individual parts.

—Sabina Leader Mense

CORTES ISLAND AT A GLANCE

POPULATION	SIZE	AREA OF FARMLAND	PROTECTED AREAS	AREA OF GREEN SPACE
2001: 1,000 1996: 952	31,317 acres/126.74 sq km	2,774 acres/1,123 hectares	1,838 hectares/14.5%	n/a

Beginning with a Vision

When I started this project, I began by asking myself how all the layers of meaning and experience, of nature and community—all that Cortes *is*—could possibly be expressed in one image? The idea of multiple images came absolutely as an inspiration, but the overall design, the greater painting as it were, at first teased my imagination ...

It begins with water. I grew up beside the ocean, to a constant water song that runs so deeply it mostly remains subterranean to the conscious awareness of those of us who are rocked by that vast cradle. An island is created by water and surrounded by water, and is entirely enveloped by a horizon line. It is, for me, defined by its place between the sea and sky. So that's the context, the setting for Cortes. Once this was established in my painting, it provided the background for the 18 individual Cortes maps that make up the two fan-shaped paper collages.

I could have made hundreds of them. As it was, I left out six or seven I'd planned for lack of space. And it was so difficult to be the judge of what should be included, saying, "Thus-and-so is not as important, has less meaning than something else!"

Social history, people, community, the way we live here: those are the themes approached in the upper fan of maps (numbers 1 to 9). First comes Raven, the great transformer and trickster, a major character in many creation myths. The second map shows a petroglyph (rock carving) of a whale; this is a detail of the rich legacy and heritage of First Nations on Cortes that may be seen on the beach at the south end. Next come the trees, so integral to the lives of the island peoples. Then an early homestead, where the trees have been cleared for pasture and built into houses and barns by the first European settlers. The next couple of maps show aspects of modern history on the island: gardens and orchards. The last one in this sequence is a night bird's eye view (heron or owl) of our home lights burning in the night.

The bottom fan of maps (numbers 10 to 18) encompasses elements of natural history. First I've shown the southeast wind—look how it has sculpted the island's beaches: sand in the vulnerable south end and cliffs in the protected north. Next come images of the ocean and intertidal zone, a veritable life-soup. Then the many birds and animals take their place alongside images of the seasons that follow the natural rhythm of a year.

This is Cortes.

This is where we live.

—Brigid Weiler

1. creation myth
2. Aboriginal life
3. forests
4. homesteads
5. gardens
6. orchards
7. flowers
8. cadastral
9. home lights

10. southeast storms
11. fish
12. lower intertidal zone
13. splash zone
14. birds
15. animals
16. migration
17. autumn
18. winter

Cortes Maps What Matters

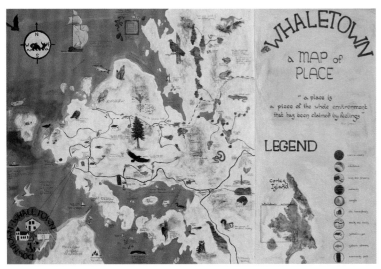

Whaletown map (detail)

In 1999, the Cortes Island Museum and Archives Society featured a display on the history of the Whaletown community, one of three small settlements on the island. Several local artists and storytellers came together to develop a map of the area, which served as an eye-catching focal point for the display.

Ecoforestry map (detail)

In the late 1990s, the Cortes Ecoforestry Society contracted the Silva Forest Foundation of Slocan to produce a series of ecosystem-based planning maps, which provide information on topography, ecological sensitivity to disturbance, forest age and First Nations' cultural-use areas. These maps have been updated several times with community input. They form the foundation for Cortes' application, now pending before the B.C. government, to manage a community forest.

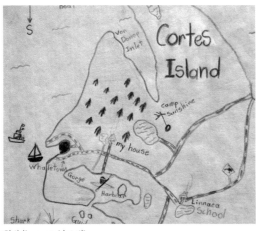

Child's map (detail)

In 2002, the Islands in the Salish Sea Community Mapping Project's completed works travelled to Cortes. Local elementary students prepared for the event by producing their own maps of the island, which covered the walls of the Old Schoolhouse foyer during the exhibition. The basic mapping exercise reinforced their sense of home place, and their visits to the exhibition helped them see themselves in the context of the Salish Sea as a whole.

Eelgrass map (detail)

In 2003, as part of Cortes Island's commitment to the British Columbia Coastal Eelgrass Stewardship Project, the Friends of Cortes Island Society sponsored a two-year project to map and monitor local occurrences of our native eelgrass. Eelgrass and related seagrasses are used worldwide as indicators of nearshore ecosystem health.

Quadra Island

Coordinators Ian Douglas and Terry Phillips
Artists Leanne Hodges; Brian Simmons

THE QUADRA ISLAND MAPPING PROJECT was the local sponsor for the Salish Sea project. This group is made up of one representative each from The Quadra Island Recreation Society, The Quadra Island Conservancy and Stewardship Society, The Quadra Island Salmon Enhancement Society and the Mitlenatch Field Naturalists Society. While each society has its own focus, their shared mission is to establish a central geographic information system (GIS) integrated multiple-resource database that will allow holistic land-use planning decisions to be made for Quadra. So far, we have created an atlas with many layers of information in GIS format for the community's use. We also undertook a project to inventory and map Quadra's coastal resources. Participation in the Islands in the Salish Sea Community Mapping Project was rewarding because it produced artistic maps with more than just information. It also captured some of the heart and feeling of the community and land that is Quadra Island. Both projects have created useful tools for the community to look at when thinking about planning issues, ecosystem and resource values, community interests and the interconnectedness and importance of all.

—Directors, Quadra Island Mapping Project

SOME HISTORICAL BACKGROUND

Quadra Island is the northernmost island in the Salish Sea project, and also the largest in an archipelago known as the Discovery Islands. The narrow southern peninsula was scoured to relative smoothness by glaciers, and this is where the majority of the current population lives. By contrast, the large, northerly portion is inhabited only in small pockets. It is typified by rugged bedrock, mountains, forests and lakes interlaced with a network of well-marked hiking trails, kayaking routes, timber licences and woodlots.

Hudson's Bay Company factor James Douglas wrote about this area and its First Nations people in 1840: "Nature has made a bountiful provision for these people. They have only to cast their nets into the waters and withdraw them full, as the strait appeared after sunset literally to swarm with fish."[21]

Cedar trees provided housing and canoes for the people, who also enjoyed plentiful berry patches and clam beds. Gravelly beaches with crushed clamshell shorelines mark the spots of former villages and food-processing sites, some of which date back over 2,000 years.

The earliest written records of the First Nations here come from the journals of British explorers George Vancouver and Archibald Menzies, who visited a now-abandoned village at Tsa-Kwa-Luten (on the southern tip of the island) in 1792. The villagers welcomed their foreign guests, little anticipating the loss of life and culture that would ensue. Sometime after 1792 the First Nations of the island were all but wiped out by disease and warfare as their culture changed under the influence of adaptation. The few who remained moved to the Comox area, to be replaced on Quadra by their northern neighbours, the We-Wai-Kai, who are related to the Kwakwaka'wakw.

We-Wai-Kai paddlers PHOTO BY PHILIP STONE

In the 1880s, logging contractors and settlers began pre-empting land on the island, responding to government information which promoted the draining of wetlands as arable land. While farming did not provide a viable livelihood, logging and commercial fishing did.

The We-Wai-Kai people continue to use Cape Mudge Village on the southwest shore as their principal settlement. They hold several other reserves on the island, including one next to Rebecca Spit Park, which they operate as a public campground. There are approximately 200 We-Wai-Kai living on Quadra. Fishing, formerly their mainstay, is being replaced by a variety of other livelihoods, including tourism. They own and operate a first-class resort at the former village site of Tsa-Kwa-Luten, overlooking the Strait of Georgia.

—Ian Douglas and Jeanette Taylor

QUADRA ISLAND AT A GLANCE

POPULATION	SIZE	AREA OF FARMLAND	PROTECTED AREAS	AREA OF GREEN SPACE
2001: 2,525 1996: 2,671	300 sq km	n/a	11%	n/a

Quadra Island Shorelines

Artist: Leanne Hodges

In the early 1990s I was shown a copy of *Giving the Land a Voice: Mapping our Home Places*. It spoke to me as a naturalist and artist in an astoundingly direct, clear, evocative manner that was a significant catalyst in my present artistic explorations.

Ten years later, I was approached by the Islands in the Salish Sea Islands Community Mapping Project coordinators to submit a proposal to a multi-island millennium mapping project, based on the very community mapping project I had been enthralled with so long ago. I couldn't believe my luck. Finally, here was a significant opportunity to be both naturalist and artist at once—to portray land-management issues using my creative side, and to expose to a wider audience the critical stewardship issues about one of the most gorgeous, culturally diverse and highly threatened wonders of the world: the Salish Sea. With great conviction and enthusiasm, I accepted the commission.

Rebecca Spit PHOTO BY PHILIP STONE

For over 15 years my son Kai, my partner Chad and I have worked and lived among the islands of the Salish Sea, as contractors aboard MV *Kum-Bah-Yah*, supplying remote camps, working as fisheries technicians and providing eco-interpretation for tourists and coastal explorers. My unique ocean-going lifestyle has shaped my perspective on the diminishing wilderness and encroaching development evident in the Salish Sea today.

For a long time, I have felt that *something* is urgently required to alert residents, government agencies and stakeholders to the coming flashpoint of over-development and over-population facing this region in the 21st century. This project may be it. The goal of the Islands in the Salish Sea project, to combine science with a creative component to dramatize land-management issues in finite areas, is an effective, visionary approach to raising awareness. These spectacular maps will now and for the future establish a significant baseline portrait of a riveting, visually indelible and forever irreplaceable part of the west coast.

The opportunity to create a map for the Islands in the Salish Sea project, and its subsequent purchase for the Quadra community by stewardship matriarch and noted author and illustrator Hilary Stewart, has fulfilled many of my personal goals. I hope the map will be a redefining and critical reminder to my generation. The burden of responsibility lies squarely upon our shoulders to better manage a multitude of 21st-century issues, from First Nations' cultural needs to sensitive marine and land-development strategies.

—Leanne Hodges

The *Shorelines* map was purchased by Hilary Stewart in memory of her sister. It now hangs permanently as a gift in the Quadra Community Centre. The map is 38 by 54 inches, using the Quadra and Discovery Passage marine chart as a base, with recycled pulp, forestry tape, seashells and fishing line ingeniously added as relief in a tactile representation portraying fish, fishermen, bears, sea lions, seals, kelp, boats and a giant octopus at the nearby Octopus Islands.

The following five productive sites, very sensitive to environmental and human impacts, were identified and mapped as part of the Quadra Island Mapping Project. They are coded in the legend and *Shorelines* map as follows:

● P1 – Eelgrass/Shellfish: nursery ground for invertebrates, fish, spawning Herring—RARE

● P2 – Salt Marsh Sedges/Fish Streams: rearing grounds for salmon fry—sensitive to development

● P3 – Shallow Rocky Reef/Kelp Forest: habitat for rockfish, lingcod and invertebrates

● P4 – Tidal Currents: biologically diverse, feeding ground for salmon, orcas, sea lions and seals

● P5 – Marine Mammal Haulouts: also in close proximity to feeding areas and herring grounds

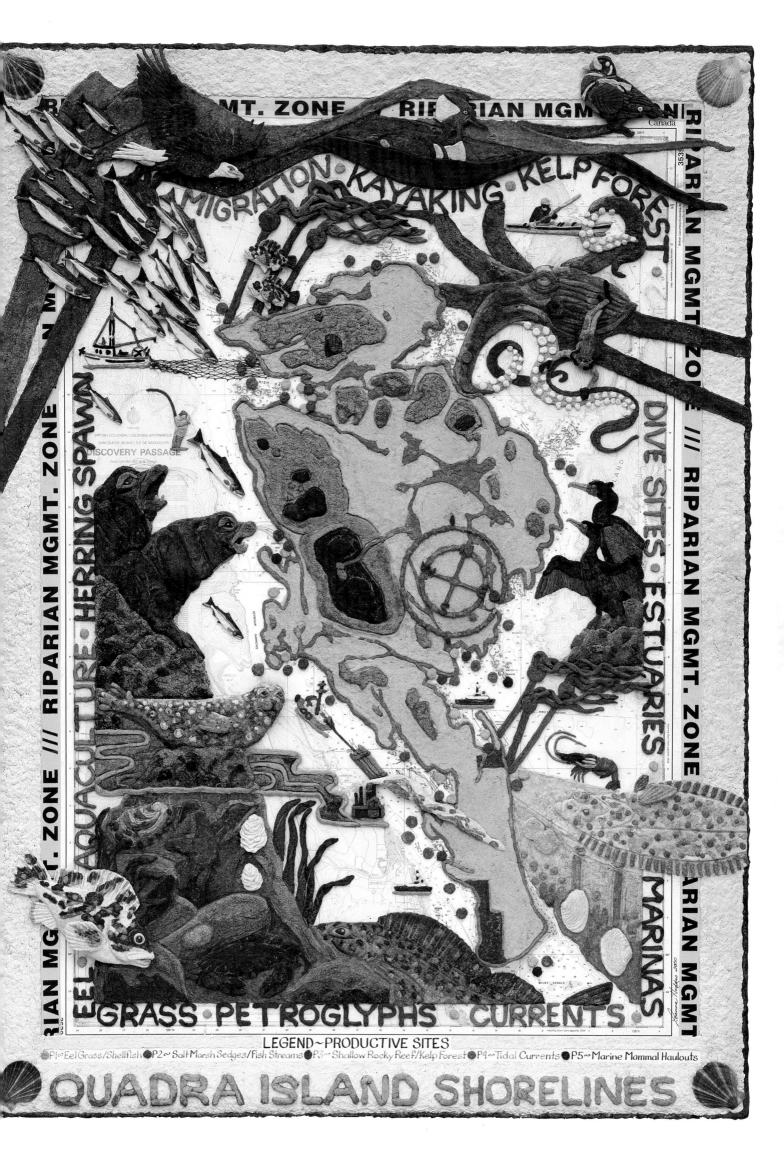

RIPARIAN MGMT. ZONE • RIPARIAN MGMT. ZONE • RIPARIAN MGMT. ZONE

MIGRATION • KAYAKING • KELP FOREST

DISCOVERY PASSAGE

HERRING SPAWN • AQUACULTURE

DIVE SITES • ESTUARIES

MARINAS

EEL GRASS • PETROGLYPHS • CURRENTS

LEGEND~PRODUCTIVE SITES

● P1~ Eel Grass/Shellfish ● P2~ Salt Marsh Sedges/Fish Streams ● P3~ Shallow Rocky Reef/Kelp Forest ● P4~ Tidal Currents ● P5~ Marine Mammal Haulouts

QUADRA ISLAND SHORELINES

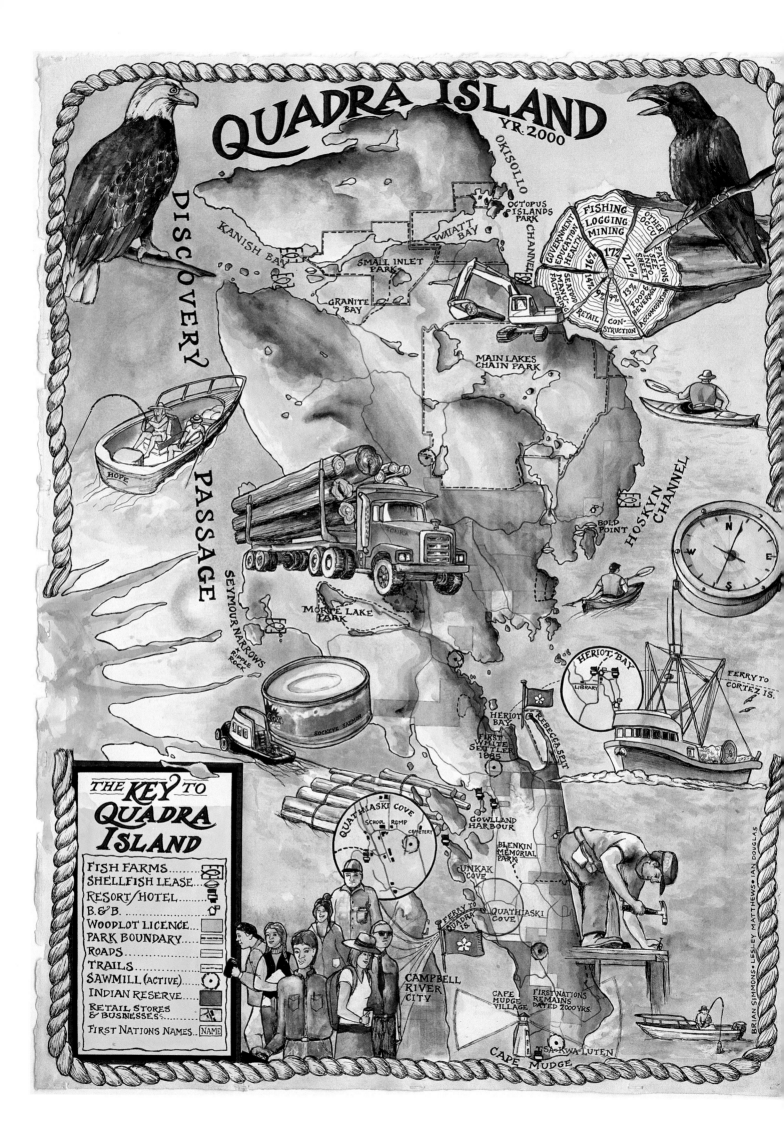

Quadra Island Year 2000, An Economic and Cultural Snapshot

Artist: Brian Simmons

Quadra Island Year 2000 is an economic and cultural snapshot of the island at the millennium. First Nations history goes back thousands of years, with major village sites at Cape Mudge and Kanish Bay, as well as numerous seasonal sites. Non-Native settlers arrived just over a century ago, when Charles Dallas built the first permanent residence on his ranch near Heriot Bay in 1885. Logging, fishing and subsistence farming were the mainstay of settlements around the safe anchorages of Quathiaski Cove, Heriot Bay, Bold Point and Granite Bay.

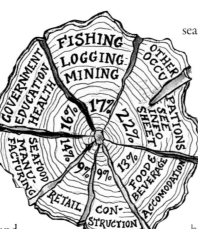

A fish cannery opened in Quathiaski Cove in 1904, providing employment for both fishermen and cannery workers until it burned down in 1941. The Great Granite Development Syndicate Company commenced mining copper, gold and silver from the Lucky Jim Mine near Granite Bay in 1907. The mine reached peak production in 1910, and shut down after the massive forest fire of 1925 swept the island.

In 1951 electricity arrived by cable from Campbell River, and nine years later the first car ferry started operating. Today, Canadian Census employment statistics indicate that logging, fishing and the processing of seafood and woodfibre remain essential elements of the Quadra economy.

The can of sockeye on the map represents an island-based seafood processor that employs 150 islanders. Logging trucks, an excavator, sawmill and woodlot locations indicate that forestry is still a major employer on the island. As island demographics have changed, with more retired couples moving to the island, the construction trades now represent a large component of on-island employment. The ferry commuters represent islanders who work in Campbell River but spend their wages on the island.

Other occupations include agriculture, aquaculture, transport, wholesale trade and business services. Many of Quadra's businesses are family owned and operated. Equally important are the full-time government, education and health positions. Sport fishing and, recently, eco-tourism, notably sea kayaking, represent a significant though seasonal contribution.

Quadra Island has a healthy, well-diversified economy with a strong First Nations community. No wonder the sun shines on Quadra.

—Brian Simmons

GUESTS (A SHORT STORY)

He can't believe the size of some of the potholes. He turns a worried glance towards his waxed car splattered in mud. He greets us, unable to make steady eye contact, and introduces us to his new partner. She smiles an overly huge smile and smells of cosmetics. They walk past our well-stocked woodshed, our freshly turned garden and on up the path to our home, over paving stones and up stairs made of rock we gathered and hauled and placed there ourselves. The entranceway walls are currently made of chic pink insulation. I catch them glancing at each other. They hesitate as they try to decide whether or not to take their shoes off amongst the array of others encrusted with mud from recent hikes or forays through the goat shed.

I welcome them through the antique door we spent hours searching for through used-building-supply stores in Victoria. The man strides across the alder floor we had milled from trees off our land, then cut and laid and finished ourselves. His eyes pass briefly over the tile work under the woodstove that I just put down last week. Then he leans against a post that we dragged off an almost inaccessible beach by rowboat. He lingers over some pictures my home-schooled children painted. I pour him a home brew, pull from the oven a chicken that we raised and butchered ourselves, and cut bread that I'd made that morning. Jars of canned salmon and produce line the shelves when I open the cupboard for butter.

The man, beer in hand, bread and our own goat cheese on the plate in front of him, settles on the couch, leans back against the blanket I wove last fall, the fibres coloured by locally collected natural dyes, and says, "So, what do you do around here?"

—Michelle Buchanan

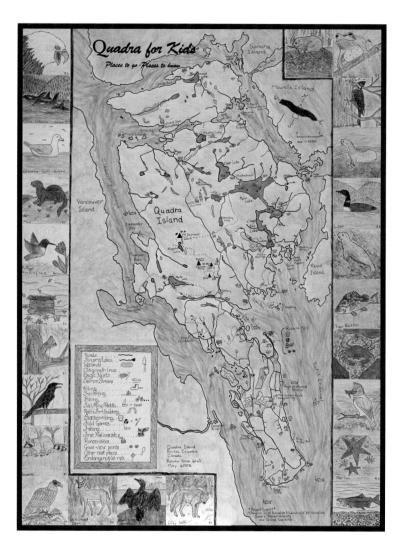

Quadra for Kids

My name is Rowan Kehn and this map is the project I did for the 2002 United Nations International Children's Conference on the Environment in Victoria, B.C. My map, *Quadra for Kids*, includes special places in nature, sensitive and endangered areas, First Nations sites, pioneer sites and places for fun recreational activities. These are all places my family, friends and I visit and enjoy. I live on a beautiful island in a neat community, but it's not as idyllic as it looks from the outside. We have problems just like any place else. I made this map of Quadra especially for kids. It would be healthier for kids and their parents to get to know Quadra better and become more aware of how special and fragile our island is. I think that the more you know about a place, the more you care about it. The more you care about it, the more you will take care of it.

—Rowan Kehn

The Conscience of Quadra

The Heart of the community
The Heart of the forest
Was cut out,
Clear-cut out

A few feeble protests
A few meetings with Raven

An entire forest
Destroyed
All Raven's machines and government machines
And profit machines
Working well
Working overtime
To kill Nature
And eco-tourism
And peace in the forest
And a place for deer to sleep at night

Drive down West Road
Look left, look right
Drive down West Road
Look within
Is not the Heart wounded
Every time?
Is not the conscience wounded
Every time?

Our daily duties
Business as usual,
More important
Than the trees?

Thank the Great Spirit of the Universe
For these letters to the editor
* those few small demonstrations*
It shows we're not dead yet!

Maybe our youngest sons & daughters
Will see the West Road forest
As it once was, as we knew it,
In all its humble majesty

But maybe not

The Raven comes again

Always hungry for food
Always hungry for gold

What will you do next time?

—Steve Moore

The Regional Maps

Wsanec (Saanich)

Coordinator John Elliot
Artist Chris Paul

The Island Relatives

OUR IDENTITY IS TIED TO THE EARTH. We have been here a long time. During that time we lived with the seasons, the elements, the land. Our ancestors continue to teach us through our ancient language, through our presence here.

At the time of creation, XALS (Hy-alx), the Great Spirit, walked the land with our people, the WSANEC (Saanich). Our elders tell us that our people walked hand in hand with the Great Spirit. Our laws, our beliefs and our sacred teachings were given to us by XALS. There was a time when he took some of our people and tossed them out into the ocean, between here, Saanich and the mainland. Each time that he changed another human being into a monument of nature, he spoke to us. As he threw them out there into the ocean, he said, "You will take care of your relatives, the people here." And he turned to the people and said, "And you will take care of your relatives of the deep." From then on, the Saanich people have always respected our Island Relatives. And these Relatives took care of our people, providing shelter, food and a safe place to stay.

The word for "island" in the Saanich languge is TETACES (Tlu-Tla-Chus), meaning "relatives of the deep." Our language is so descriptive in marking the islands. James Island, LELTOS (Klul-toss), means "splashed on the face" because of the sheer bluff on the southeast shore being sprayed by the gales hitting it from that direction.

Some islands still have human or animal names. A mother and daughter who were tossed into the ocean became XODEL (Hwa-tulth), Speiden Island, and XOXDEL (Hwa-hwu-tulth), Mandarte Island. A gray whale holds its name as KENES (Quan-us), Stewart Island.

And still other islands were simply named for the annual activity that took place there, like SDAYES (Sday-us), Pender Island, which means "a happy place to wind and sun dry the salmon." Helen Point, on Mayne Island, is named XIXNESETEN (Heh-nu-shuten), meaning "sacred track." This is a place where XALS sank his foot into the rocky point and drew fresh water from the faraway mountains. This is so the people would have good drinking water on that island.

The plants, the animals, the trees, the fish and even the four winds that blow were once human beings. XALS spoke to our Saanich ancestors in SENCOTEN (Sencho-then) and gave us our sacred teachings, our beliefs and our culture. The Saanich people still follow these very important teachings today to the best of their ability, even with all the restrictions imposed upon them. We must return to a place of mutual respect for all, and we will then have a good life.

This map and these symbols express the connection we have between the land and our culture. Our belief system ties us to these places. This is our way of passing it on.

—John Elliot

Since I was a boy I was told stories of Saanich (my home). I was told we were weak, so the Creator took pity on us. The gifts given were from a place of vision, and this is why we call many things our relatives. The image of the Creator in the middle of the map with hands stretched out depicts a time when the Creator, one at a time, took a person from our community and transformed them into something we needed. The Islands, Salmon, Eagle, Whale, Blue Jay, Raven, Seal, Clam, Camas and much more. This transformation gave us a connection to our home that still exists today.

—Chris Paul

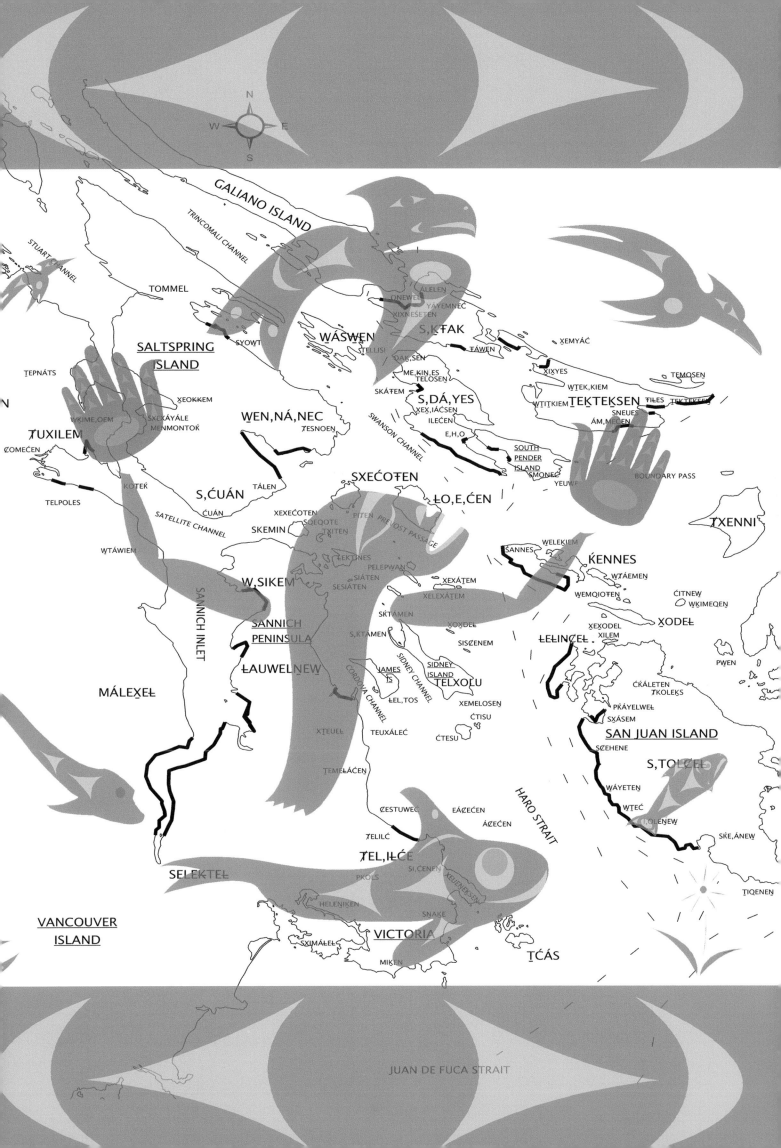

GALIANO ISLAND

TRINCOMALI CHANNEL

STUART CHANNEL

TOMMEL

SALTSPRING
ISLAND

SYOWT

ṮEȽḴIN̵E̵S

ALELEN
ONEWEL
YÁ,EMNEĆ
XIXN̵E̵ŚEṮEN

WÁSWEN

S,ḴṮAḴ

XEMYÁĆ

STELLISI
ṮÁ,EN

ṮÁ,EN

XIXYES

TEMOSEN

TEPNÁTS

X̱EOKKEM

ḌAȽ,SEN
ME,ḴIN̵,ES
ṮELOSEN
SKÁṮEM

WṮEK,KIEM

WṮIṮKIEM

TEKTEKSEN

ṮILES

TEKTEKSEN

XEX̱,IÁĆSEN
ILEĆEN

S,DÁ,YES

SNEUES
ÁM,MEĆEN

TUXILEM

X̱eX̱ÁYÁLE
MENMONTOḴ

TESNOEN

WEN,NÁ,NEC

E,H,O

SOUTH
PENDER
ISLAND
SMONEĆ

ĆOMEĆEN

WḴIME,OEM

YEUWḴ

BOUNDARY PASS

ḴOṮEḴ

TÁLEN

S,ĆUÁN

SXEĆOṮEN

TXENNI

TELPOLES

SATELLITE CHANNEL

ĆUÁN

XEXEĆOṮEN
SQEQOTE
ṮX̱IṮEN

ȽO,E,ĆEN

ṮEḴ,ṮN̵ES

PIṮEN
PREVOST PASSAGE

SÁNNES

WELEḴIEM

ḴENNES

WṮÁ,EMEN

WṮÁWIEM

WEMQIOṮEN

ĆITN̵EW
WḴIMEQEN

W,SIḴEM

PELEPWAN
SIÁṮEN
SESIÁṮEN

XEX̱ÁṮEM
XELEX̱ÁṮEM

XEX̱ODEL

XODEȽ

SANNICH
PENINSULA

SḴ,ṮÁMEN

S,Ḵ,ṮÁMEN

XOX̱DEȽ

ȽEȽINĆEȽ

XILEM

PWEN

SANNICH INLET

ȽAUWELNEW

SISĆENEM

ĆḴÁLEṮEN
ṮḴOLEḴS

PḴÁYELWEȽ

MÁLEX̱EȽ

JAMES
IS

SIDNEY
ISLAND

TELXOȽU

SAN JUAN ISLAND

CORDOVA CHANNEL

ȽEȽ,TOS

XEMELOSEN

SX̱ÁSEM

SĆEHENE

S,TOȽĆEȽ

XṮEUEȽ

TEUX̱ÁLEĆ

ĆTISU

ĆTESU

WÁYEṮEN

WṮEĆ
I,OLEN̵EW

SÉ,ÁNEW

SELEKTEȽ

TEMEȽÁĆEN

ĆESTUWEȽ

EÁĆEĆEN
ÁĆEĆEN

TIQENEN

TELILĆ

ṮEL,IȽĆE

SI,ĆENEN

HARO STRAIT

PROLS

X̱ELEȽ̵EḴSEN

HELEN̵IḴEN

SNAKE

VANCOUVER
ISLAND

SX̱IMÁȽEȽ

VICTORIA

TĆÁS

MIḴEN

JUAN DE FUCA STRAIT

Marine Life in the Salish Sea

Endangered and Vulnerable Species in the Salish Sea

This list is compiled from the offical provincial lists, which incorporate the federal Committee on the Status of Endangered Wildlife in Canada (COSEWIC) list. However, as there are large gaps in our knowledge of the marine environment, it is only a partial list.

The Red List

(species that are threatened, endangered or gone)

MAMMALS: Killer Whale (southern and northern resident populations), Killer Whale (west coast transient population), Humpback Whale, Northern Right Whale

REPTILES: Leatherback Turtle

FISH: Pygmy Longfin Smelt

BIRDS: Brandt's Cormorant, Double-crested Cormorant, Pelagic Cormorant, Western Grebe, Peregrine Falcon, Common Murre, Marbled Murrelet

INVERTEBRATES: Bernard's Shiny White Top Shell, Red Nereid, Fernald's Seaslug, Greenland Cockle, Northern Abalone, Arctic Sand Dollar, Tall Deep Sea Anemone, Polar Lebbeid Shrimp, Vancouver's Okenia Nudibranch

The Blue List

(species that are vulnerable, or particularly sensitive to human activities and natural events)

MAMMALS: Harbour Porpoise, Sea Otter, Gray Whale, Northern Sea Lion, Steller's Sea Lion

FISH: Eulachon, Green Sturgeon, Cutthroat Trout

BIRDS: Great Blue Heron, Green Heron, Surf Scoter, Long-tailed Duck, Dusky Canada Goose, Aleutian Canada Goose, American Bittern, California Gull, Tufted Puffin, Trumpeter Swan, Ancient Murrelet

INVERTEBRATES: Giant Swimming Scaleworm, Olympia Oyster, Glass Skeleton Sponge, Platinum Shiny White Top Shell

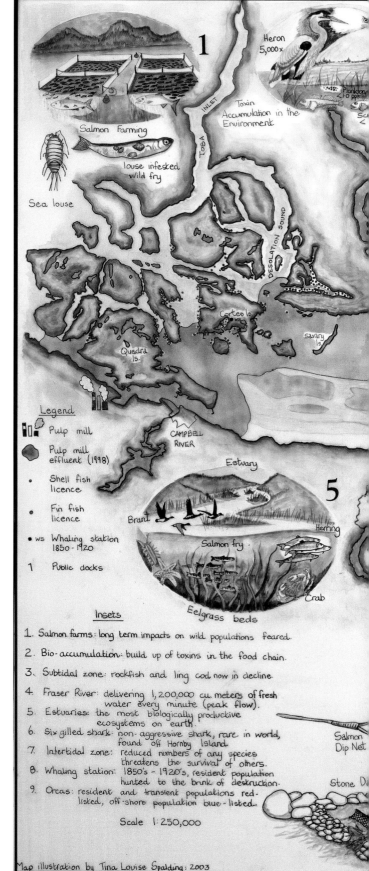

Legend

Pulp mill

Pulp mill effluent (1998)

Shell fish licence

Fin fish licence

ws Whaling station 1850-1920

1 Public docks

Insets

1. Salmon farms: long term impacts on wild populations feared.
2. Bio-accumulation: build up of toxins in the food chain.
3. Subtidal zone: rockfish and ling cod now in decline.
4. Fraser River: delivering 1,200,000 cu. meters of fresh water every minute (peak flow).
5. Estuaries: the most biologically productive ecosystems on earth.
6. Six gilled shark: non-aggressive shark, rare in world, found off Hornby Island
7. Intertidal zone: reduced numbers of any species threatens the survival of others.
8. Whaling station: 1850's - 1920's, resident population hunted to the brink of destruction.
9. Orcas: resident and transient populations red-listed, off-shore population blue-listed.

Scale 1: 250,000

Map illustration by Tina Louise Spalding: 2003

Artist Tina Spalding
Research Catherine Griffiths

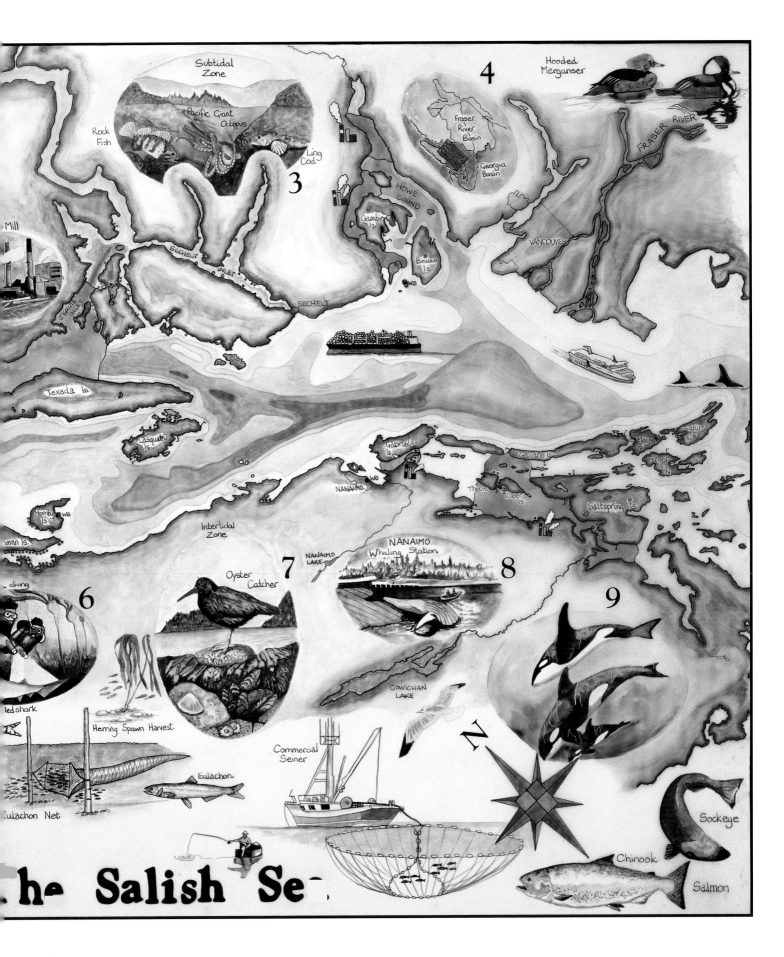

he Salish Se-

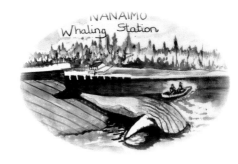

THE SALISH SEA WAS ORIGINALLY thought by European explorers to be an inlet, rather than the unique inland sea, bounded by narrow and shallow passages, that it is. Rich and vibrant, full of life from ocean spray to dark depths, this magnificent water body covers 6,900 square kilometres and has depths up to 400 metres. The Salish Sea is one of the most important marine regions in British Columbia. In 2000 it was estimated that it supported 3,000 species. It is best known for orcas (killer whales), giant pacific octopus, wolf eels, rockfish, lingcod, harbour seals, Steller's sea lions, herring and salmon as well as over 130 species of marine birds. It is also home to many "world giants"—the world's largest octopus, sea urchin, nudibranch, anemone, intertidal clam, sea star, scallop and barnacle.

Estuaries

Estuaries are places where fresh water flows into and mixes with salt water. Salinity levels change both seasonally and with distance from the freshwater source. One of the reasons why the Salish Sea has such a diversity of marine species is that many different habitats are created by the variations in salinity; also, the region contains many small yet vital estuaries. Estuaries make up less than 3 percent of British Columbia's coastline, yet they are essential, at some point in the life cycle, to 80 percent of the wildlife.[22] The increased nutrients in the estuary ecosystems can affect the freshwater source for several kilometres upstream. Estuaries provide important rearing and feeding habitat for juvenile salmon, allowing them to adjust gradually to saltwater conditions. The Salish Sea is a nutrient-rich marine system that can support many species in great abundance and thus its resources were the primary source of food for the First Nations.

With the arrival of Europeans, the sea's bounty was exploited for export. Today, many species are in decline and some are threatened with extinction.

Fisheries

Whaling was a significant industry, continuing on the entire coast until 1972. However, this industry was short-lived in the Salish Sea, with only two intense periods of production: from 1866 to 1875 and again from 1905 to 1908.[23] The pre-exploitation numbers were thought to be between 208 and 596 whales in the Strait of Georgia.[24] The last humpback whale was taken in the Strait of Georgia in 1907. Since 2000, a few sightings have been reported in both Canadian and American Salish Sea waters.

Another species that is under threat is the southern resident population of orcas. These whales are under threat on many fronts. In 2001, the Committee on the Status of Endangered Wildlife in Canada (COSEWIC) upgraded the southern resident population from threatened to endangered. In 2003 COSEWIC listed persistent organochlorines, boat traffic and food source decline (salmon) as reasons for concern. The population declined by 20 percent from 1995 to 2001 to only 78 individuals. According to Environment Canada's Species at Risk website, the level of toxic chemicals found in the southern resident population was three times as high as what is considered harmful to the harbour seal (the marine mammal closest to whales which has been studied for toxic chemicals). The organochlorines readings for the southern resident population were four times as high as the northern resident population. Reduced prey was another area of concern. The southern resident population feeds mainly on salmon (95 percent of their diet) and they seem to prefer chinook (60 percent of the salmon eaten). The chinook salmon stocks are currently depressed and this will compromise the recovery of the orcas. A study by the Department of Fisheries and Oceans shows that PBDES (a new flame retardant) are now being detected in the southern resident population and this could push the whales another step closer to extinction.

Pacific Giant Octopus

Other species that are in decline are rockfish, lingcod, eelgrass, abalone and black oystercatcher. With few historical records, estimating the decline of species is difficult. One groundfish that has records back to the 1980s is the yelloweye (red rock cod). Current estimates state that there are less than 5 percent of the pre-exploitation levels. These fish have a long, slow life cycle; they can live up to 117 years (the marine equivalent of an old-growth forest). The fishery has taken the oldest and largest, leaving younger and smaller fish. The breeding females do not mature until they are 20 years old, an age at which they are taken as a food resource, leaving fewer breeding fish to maintain the stocks. Rock cod are easily caught, and they cannot survive the changes in pressure from the bottom, where they reside among the rich kelp beds once abundant along the coast. Lingcod is also imperilled with an estimate of only 3 percent biomass remaining compared to historical records.

Nearshore Habitats

Oyster Catcher

The nearshore ecosystem is dense and complex, and eelgrass plays a pivotal role. Eelgrass roots help to hold the sea floor in place and buffer wave and tidal action. The plants absorb nutrients from the sea and provide shelter for juvenile salmon before they migrate to the open ocean. A major prey of salmon, herring, also finds shelter in the eelgrass beds. In fact, herring make up between 30 and 70 percent of the chinook salmon's summer diet. Thus the eelgrass is linked to the southern resident population of orcas through the food chain. A study found a "high correlation between estuarine eelgrass biomass and fish diversity, abundance and biomass,"[25] making this a key component in the recovery of many species. The connection of the eelgrass with salmon, herring and orca is only one of the many strands of the nearshore food web; it is an intricately woven tapestry of dependencies.

In the Salish Sea, nearshore habitat is at risk due to coastal development. In British Columbia, it is estimated that 23 percent of the nearshore is urbanized and less than 4 percent of the coastal wetlands and estuaries are protected.[26] The introduction of Japanese oysters and varnish clams and other exotic shellfish has contributed to the decline of the native Olympia oyster, which COSEWIC lists as a Species of Special Concern. According to Shared Waters, a joint B.C. and Washington State research project, habitat loss and degradation is the most urgent problem in the Strait of Georgia and Puget Sound waters; the nearshore is the habitat that has suffered the most from our human-induced impacts.

Human Impacts

Human impacts on the Salish Sea are not restricted to habitat loss in the nearshore. They are felt throughout the region. With approximately 75 percent of British Columbia's population residing in the Georgia Basin, both the nearshore and offshore waters are affected by urbanization and heavy pressure on resources. The main causes of degradation of the marine environment here are dredging, port and harbour development, log storage and pollution. An example of the hidden yet tremendous impact of port development is the "sandpiper squeeze." Described and documented by Environment Canada in 2001, the sandpiper is being squeezed out by the Tsawwassen ferry terminal, the coal terminal and the new container port. The birds are surface feeders, so they ingest the surface oil and fuels from all the ships within this area, reducing their ability to digest and be nourished.

It is not just the industrial ports that affect the environment in the Salish Sea; the volume of boat traffic has increased steadily with the development of the port and the Alaskan-cruise industry. Vancouver had approximately 300 cruise-ship sailings in 2004 and Victoria had 146. Each vessel

carried between 1,000 and 2,500 passengers on each sailing. In fact, each year cruise ships can "generate more waste than a small town the size of Courtenay."[27] According to Ross Klein, a professor at Memorial University, each week-long cruise generates 245,000 gallons of sewage, 2,200,000 gallons of grey water, 37,000 gallons of oily bilge water, 141 gallons of photochemicals, 7 gallons of drycleaning waste and many other waste items. Much of this ends up in the ocean. Canada has only guidelines for releasing ballast, sewage and grey water: there are no laws governing cruise ships in inland waters. On a brighter note, in January 2001 the federal government did prohibit discharge at 10 marine sites in the Strait of Georgia and prohibited the disposal of garbage in the Inside Passage.

The sea is also affected by sewage from the land. The leaching of septic systems, the direct pumping of sewage into creeks and estuaries, and offshore outfalls all lead to contamination of wildlife and habitat, and closures of shellfish harvesting and many popular beaches.

Industries on land also discharge waste into the Salish Sea; pulp and paper mills dot the coastline. Since 1992, the provincial government has required the reduction of dioxins and furans in mill discharge and the mills have managed to reduce their output of these toxic chemicals by 90 percent. The plan for Zero Discharge by 2002 was changed in the summer of that year to allow the current level of discharge to remain. This followed a government review that concluded there was "no evidence to suggest that current reduced levels of AOX [toxic chemicals] discharge present a measurable

risk to the aquatic ambient environment."[28] The long life span of these chemicals and the ongoing investigation into "black liquor" from mills suggest that environmental investigation of mill discharge should not end. According to Reach for Unbleached, a non-governmental research group, kraft black liquor discharge should be minimized "because of the strong evidence that black liquor causes sub-lethal toxicity to aquatic organisms."[29] Even the provincial government states that "black liquor contains the natural chemicals found in wood that has been separated from the wood fibre during the pulp process. When these chemicals are concentrated and released in large quantities to receiving water bodies they can cause chronic toxicity to the aquatic organisms. Chronic or sub-lethal effects may affect an organism's size, growth rate, sexual maturation or ability to reproduce."[30]

The accumulation of toxic chemicals through the food chain is magnified in the higher predators. According to Laurie Wilson, a Canadian Wildlife Service biologist, "At each ascending level, as large predators eat numerous small prey, the contaminants become concentrated in their tissues. Fish-eating birds such as eagles and herons sit at the top of the food chain, so they end up with the highest concentrations."[31]

The potential damage of these persistent chemicals was reported in a study by the Georgia Basin Ecosystem Initiative entitled *Birds Under Stress*. The study used eagles as an environmental indicator. These birds are the top predator of a food web, similar to the orcas in the ocean. The study indicated that the eagles south of the Crofton mill had higher dioxin levels than other eagles in the area, and approximately 75 percent of their nests held no offspring. This is a significant concern, although the eagle population is expanding in other parts of the Georgia Basin.

Solutions

The decline in species is just one indicator of human impacts on the natural ecosystems of the sea. By recognizing the links between species health and our own actions, and by taking an ecosystem approach, we can reduce or eliminate many of these impacts. One first step is to reduce our own personal use of chemicals or other pollutants and our impacts on the shoreline. Another step involves rebuilding and protecting habitat: saving species means saving spaces. We need to create protected marine areas and to preserve the coastline where it has not suffered from irreversible development. There are approximately 100 provincially designated Marine Protected Areas (MPAs) in B.C., but most of these have no species protection and only two are closed to harvesting. Currently, the Strait of Georgia does not contain one national marine protected area, although Gabriola Passage is a candidate as a pilot MPA.

The federal government has recognized the importance of protecting marine areas and has introduced National Marine Conservation Areas (NMCA). According to Parks Canada's website, "National marine conservation areas focus ... on ecologically sustainable use, which means harmonising conservation practices with human activities. ... Human uses such as fishing and shipping, for example, are allowed in national marine conservation areas."[32]

There are many groups focussing on the establishment of protected areas in the Salish Sea. The Georgia Strait Alliance has been instrumental in marine conservation

initiatives throughout the sea. The NMCA Coalition for the Southern Georgia Strait is a group of 16 organizations working hard to establish a set of conservation areas that would create core areas and buffer zones in the Southern Gulf Islands. They are striving to ensure that human activities harmful to the environment are not permitted within the MPAs and to create special management zones that would restrict the type of activities on areas such as eelgrass beds.

Other possible solutions include re-establishing a moratorium on new fish farms, moving fish farms onto land, limiting fishing, treating human waste from cruise ships and prohibiting discharge into the ocean of any chemicals or mill effluents.

It must be understood that all ecosystems are interconnected; human effects on the environment are revealed all too clearly in the decline of the marine life in the Salish Sea. The sooner we make a commitment to change the actions that cause negative impacts, the more confidently we can celebrate the wondrous cycle of life that supports us all.

—Catherine Griffiths

"As long as we return the bones of the salmon to the sea, life will continue."

Economic Map of the Islands

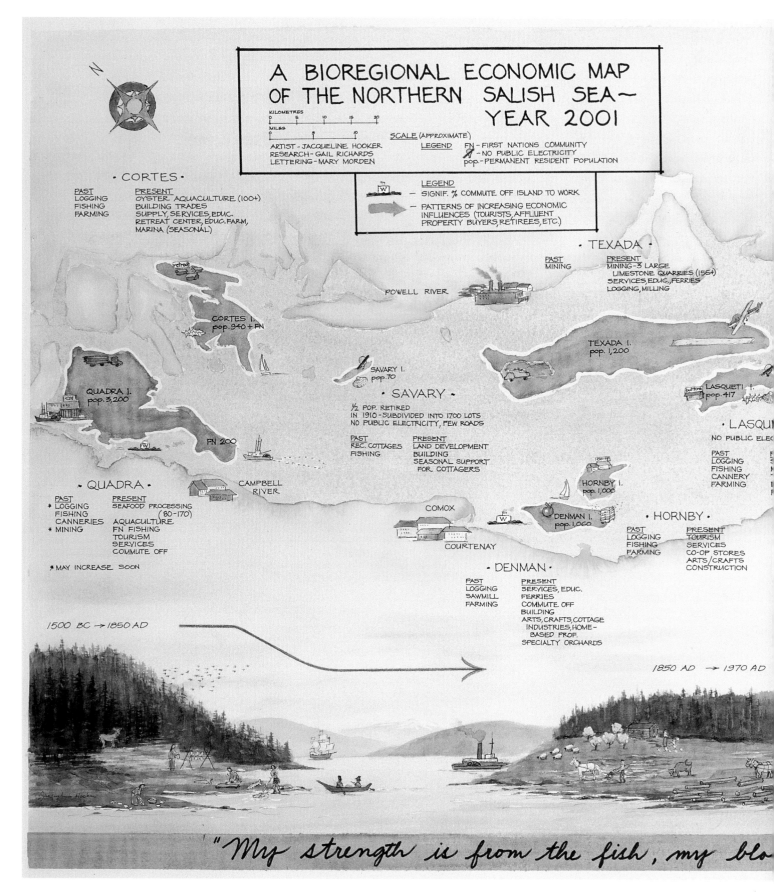

A BIOREGIONAL ECONOMIC MAP OF THE NORTHERN SALISH SEA ~ YEAR 2001

KILOMETRES
0 5 10 15 20

MILES
0 5 10

SCALE (APPROXIMATE)

ARTIST - JACQUELINE HOOKER
RESEARCH - GAIL RICHARDS
LETTERING - MARY MORDEN

LEGEND FN - FIRST NATIONS COMMUNITY
⌀ - NO PUBLIC ELECTRICITY
pop. - PERMANENT RESIDENT POPULATION

LEGEND
— SIGNIF. % COMMUTE OFF ISLAND TO WORK
— PATTERNS OF INCREASING ECONOMIC
INFLUENCES (TOURISTS, AFFLUENT
PROPERTY BUYERS, RETIREES, ETC.)

· CORTES ·

PAST
LOGGING
FISHING
FARMING

PRESENT
OYSTER AQUACULTURE (100+)
BUILDING TRADES
SUPPLY, SERVICES, EDUC.
RETREAT CENTER, EDUC. FARM,
MARINA (SEASONAL)

· TEXADA ·

PAST
MINING

PRESENT
MINING - 3 LARGE
LIMESTONE QUARRIES (155+)
SERVICES, EDUC., FERRIES
LOGGING, MILLING

POWELL RIVER

CORTES I.
pop. 940 + FN

TEXADA I.
pop. 1,200

QUADRA I.
pop. 3,200

SAVARY I.
pop. 70

· SAVARY ·

½ POP. RETIRED
IN 1910 - SUBDIVIDED INTO 1700 LOTS
NO PUBLIC ELECTRICITY, FEW ROADS

PAST
REC. COTTAGES
FISHING

PRESENT
LAND DEVELOPMENT
BUILDING
SEASONAL SUPPORT
FOR COTTAGERS

LASQUETI I.
pop. 417

· LASQUETI ·

NO PUBLIC ELEC

PAST
LOGGING
FISHING
CANNERY
FARMING

FN 200

CAMPBELL RIVER

HORNBY I.
pop. 1,000

· QUADRA ·

PAST
* LOGGING
FISHING
CANNERIES
* MINING

PRESENT
SEAFOOD PROCESSING
(80-170)
AQUACULTURE
FN FISHING
TOURISM
SERVICES
COMMUTE OFF

* MAY INCREASE SOON

COMOX

DENMAN I.
pop. 1,060

· HORNBY ·

PAST
LOGGING
FISHING
FARMING

PRESENT
TOURISM
SERVICES
CO-OP STORES
ARTS/CRAFTS
CONSTRUCTION

COURTENAY

· DENMAN ·

PAST
LOGGING
SAWMILL
FARMING

PRESENT
SERVICES, EDUC.
FERRIES
COMMUTE OFF
BUILDING
ARTS, CRAFTS, COTTAGE
INDUSTRIES, HOME-
BASED PROF.
SPECIALTY ORCHARDS

1500 BC → 1850 AD

1850 AD → 1970 AD

"My strength is from the fish, my bloo

138

Coordinator Gail Richards
Artist Jacqueline Hooker
Calligrapher Mary Morden

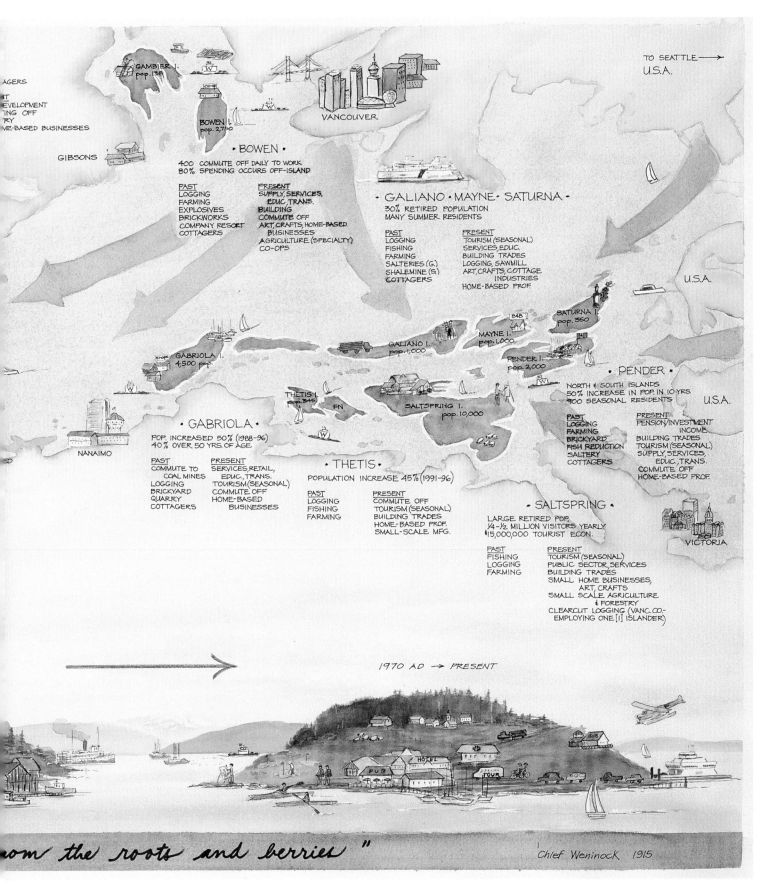

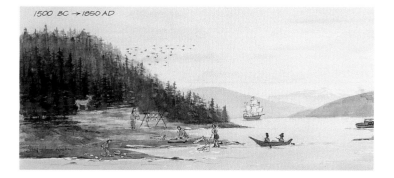

1500 BC → 1850 AD

Long Ago

These islands were the hunting and gathering lands and waters of the Salish people. A large number of middens attest to thousands of years of seasonal occupation for fishing, hunting, gathering and preserving the bounty that nature provided. They say the "ground was purple with camas" and the "skies were dark with ducks," and "you could walk from one island to another on the backs of the fish." The necessities of life were understood to be gifts of The Great Nature, and the work required to harvest these gifts was the life of the community for many months of the year. Each individual had the responsibility of helping to acquire and preserve the essentials that would sustain life for the entire community until the next harvest season. A person was respected and honoured for his or her part in this significant process; their work contributed to the survival and flourishing of the entire community.

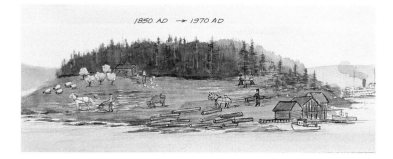

1850 AD → 1970 AD

Settlement Period

When European settlers arrived on these islands, they did what most pioneers in newly discovered places did. They cleared the land, plowed the new fields, hunted, fished and began to create an economic base for themselves. While they had their individual properties, they shared some of the big jobs of setting up a community. Their subsistence economy was elaborate and strong. People worked hard and grew to know each other in the camaraderie of work. Once established, the settlers began to look for areas of commerce through which they could earn an income.

There were vast resources when the settlers arrived: the islands were thick with trees of a size never encountered by Europeans, and the land and water were filled with game, birds and fish. Logging gradually increased, commercial fishing fleets grew in size and efficiency, and a few good-sized agricultural enterprises were established.

After World War II

After World War II, new methods and techniques allowed for rapid resource extraction by large, distant companies as well as islanders. With the arrival of steamships, travel and the moving of goods on and off the islands became far easier, leading to an increase in people who came to the islands as well as the number of businesses an island could support. When a regular ferry service was created for the islands, many cottagers came to establish permanent residences; older folks retired to their favourite islands; and businesses that provided services for islanders began to flourish.

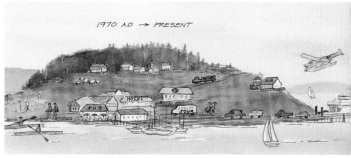

1970 AD → PRESENT

Where We Are Now

The islands in the Salish Sea have all been greatly affected by rapid population growth in the surrounding urban areas (Vancouver, Victoria and Seattle) and the technological advances in resource-extraction methods in industries such as logging and fishing. Within the last couple of decades the populations on these islands have so increased, and the natural resources so decreased, that the lifestyle, economics and evolving character of the islands have been significantly affected. Many of the islands have a large retired population. These older, often affluent folk have come to the islands because they desire the rural lifestyle, no longer need to work and can sometimes get more for their housing money on the islands than in the urban centres. They contribute pension and investment income to their communities and create certain types of employment (support services, health care, recreation, etc.) Owing to computers and modern communications, a number of urban professionals have moved to the islands and are able to continue to work. Finally, the lower

Canadian dollar and the desirable location have prompted a considerable influx of Americans to purchase property on the islands. These factors have contributed to a shortage of housing, high property values and a dearth of well-paying work.

When a significant number of islanders do not derive their income from economic activities occurring on the island, a lessening of community attachment and resistance to activities that do promote local economic development can result. With the change in demographics—from younger couples with children to an aging and retired population with few young families—the tone of the islands, as well as the range of work available, is changing too.

Islanders are no longer able to depend upon the extraction of natural resources as the basis for their economy. While there is still considerable mining on Texada and a large commercial shellfish industry on Cortes, islanders have had to diversify into different areas of work in order to stay in their home places. Creativity and innovation have resulted in Jacks- and Jills-of-all-trades, and an upsurge in art, crafts, cottage industries, specialty agriculture and eco-forestry. The land development taking place everywhere supports more work in the building trades. Jobs in the service sector, especially in retail, are rapidly increasing as the island population comes to depend more on goods from off the island than those produced locally. Tourism is now the leading economic activity on most of these islands; concerns about managing its impact occupy considerable community time and produce many heated opinions.

In summary, the most significant factors now affecting local economies in the region are:
- a decrease in natural resources suitable for commercial extraction (e.g. timber, fish);
- a demographic shift from young families to an ageing and retired population;
- a shift from wealth generated on the islands (e.g. farming, fishing, forestry) to wealth brought to the islands (e.g. pensions, investment income, tourism);
- income disparity between workers on the islands and many affluent new arrivals;
- wage disparity between men and women.

—Gail Richards

"Only with local prosperity do the people have power and the land a voice."

—Wendell Berry

FACTS AT A GLANCE

In 1996, there were more people in the Islands Trust Area with lower incomes and fewer with moderately high incomes than in 1991. By 2000, there was a decrease in people with lower incomes and an increase in people with moderately high incomes. The average income of area residents was $26,895. The provincial average was $29,613.

In 2001 the sources of income in the Trust Area were 55.8 percent from employment, 17.5 percent from government transfer payments and 26.6 percent from other sources such as pensions and investments; 40.9 percent of residents were self-

Commonly seen on the islands now are recreational boats that were converted from fishboats. PHOTO BY PHILIP STONE

employed, compared to 14.5 percent across B.C.. Economic dependence on primary industry was lower than the provincial average, with 6 percent in the Trust Area, compared to 20 percent provincially. The average unemployment rate in the Trust Area decreased from 8.7 percent in 1996 to 7.8 percent in 2001, compared to 7 percent for all British Columbians.

In 2001, 24.4 percent of households in the Trust Area were paying more than 30 percent of their income on housing, compared to 28.6 percent of households in B.C. Families without affordable housing ranged from 16.1 percent on Mayne Island to 39 percent on Galiano Island.

The population of the Trust Area has increased from 20,215 in 1991 to 23,009 in 2001. This represents 12.1 percent growth over the 10-year period. In 2001, the population included a smaller percentage of people under 34 years of age and a larger percentage of people over 45 than in the province as a whole. On some islands, there were large gaps in some age groups. For example, some of the smaller island communities have almost no children or adolescents.

(Selected data from 1996 and 2001 census for the Islands Trust Area, excluding Cortes, Quadra, Savary and Texada.)

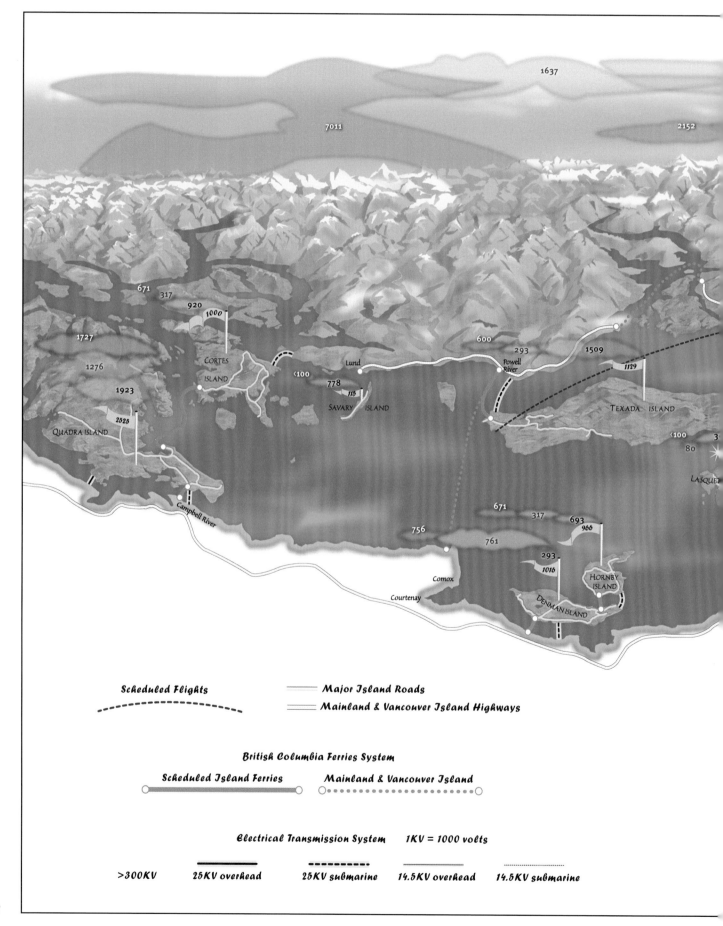

Scheduled Flights

Major Island Roads

Mainland & Vancouver Island Highways

British Columbia Ferries System

Scheduled Island Ferries

Mainland & Vancouver Island

Electrical Transmission System 1KV = 1000 volts

>300KV 25KV overhead 25KV submarine 14.5KV overhead 14.5KV submarine

Coordinator and Artist Eckhard Zeidler
Researcher Tina Symko

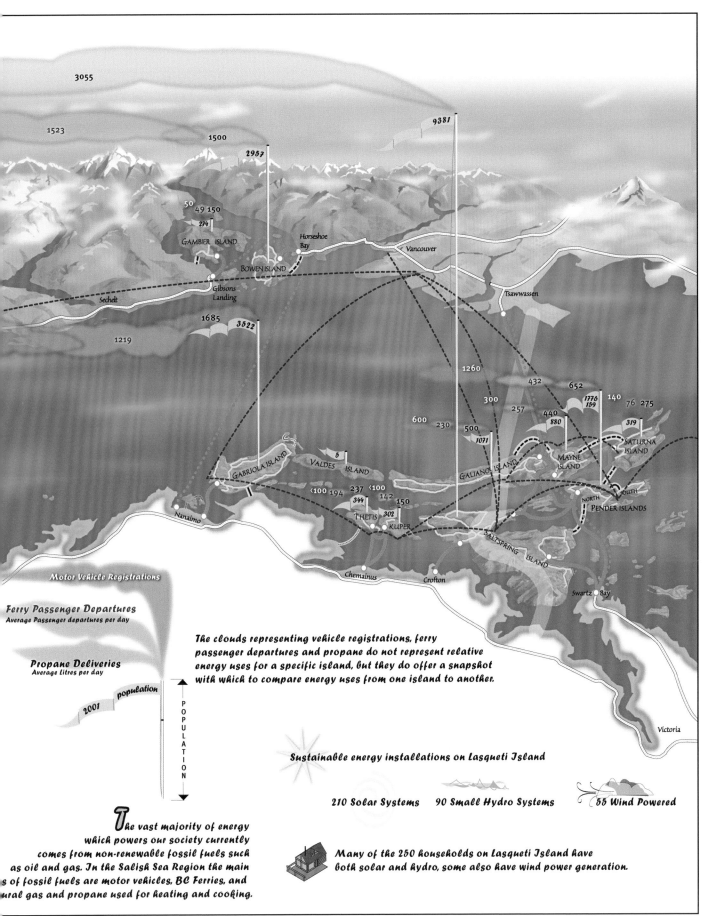

WE SHARE WITH OUR ANCESTORS a need for abundant and readily available energy. Whether we are cooking, heating a home, travelling to visit relatives, moving to another city or trading goods, we are burning wood, coal, propane, gas or oil; our dominant energy supply has always been ancient sunlight—energy from the sun that is stored in plant material through photosynthesis. We combine the carbon and hydrocarbons stored in this plant material with oxygen, apply a little heat, and the energy of the sunlight that built these plants is released for our use. Perhaps this solar energy reached the Earth only last year before the tree was felled and dried, or perhaps it came a million years ago only to reappear in a refined state in our gas tank. When we burn this ancient sunlight, the carbon that was stored is now combined with oxygen and released into the atmosphere as carbon dioxide (CO_2), the dominant greenhouse gas.

Quadra Island lighthouse PHOTO BY PHILIP STONE

The sun powers the Earth and our society, but our choices of how and in what form we use this sunlight play a major role in determining whether human society will sustain itself or become a minor footnote in the history of the Earth.

The *Major Energy and Transportation Systems* map offers a baseline view of the region at the turn of the millennium. We see a region that is not much different from the rest of the world in its use of primarily fossil fuels and electricity to meet transportation and energy needs. Hydroelectric power affects the land both where it is originally channelled and dammed and also where the huge electromagnetic transmitters and hydro lines run.

Current provincial plans call for increased electrical generation based on fossil fuels: coal- and natural-gas-fired generation plants. These are massive, mega-corporate energy systems which require increasing dependence on limited resources and cause increasing impacts on the air, climate and land. There are, however, examples of sunlight being used in a more sustainable way on a few of these islands. For example, small-scale solar, hydro and wind systems—generally at reduced load levels—are used on Lasqueti, Savary and, to a limited extent, on other islands. These systems are an early glimpse into a future of sustainable-energy production, as our current unsustainable fossil-fuel system inevitably declines.

The economies of the islands in the Salish Sea have been undergoing a major transition over past decades from resource-based industries to a predominantly tourism-based economy. This transition brings visitors from all over the world. They arrive in their own motor vehicles on the ferry system or in cars they have rented at the airport after stepping off a jet. This tourism-based economy is expanding rapidly. Tourism is often considered a sustainable industry because it *seems* to have little effect on the environment, but ever-increasing numbers of visitors cause impacts in a context far larger than just this region. Increased greenhouse-gas emissions on the islands are only part of the picture. The energy expended by visitors to get here includes their transportation choices from their own front doors, whether their homes are in Victoria or halfway around the world. Sustainability must be considered in a global context, as must the impacts of a growing tourism economy.

Sustainable Tourism Solutions

In much of the western world, use of material and energy continues to rise (per capita energy and material demand has increased 30 percent since 1975). Local residents and businesses on the islands could demonstrate a commitment to more sustainable energy-use practices by supporting:

• improved on-island passenger shuttle services;
• rental of bikes and storage lockers;
• rental of battery powered or other "smart" cars;
• "carbon neutral" airline travel whereby passengers can pay a small premium to offset the carbon expended in their journey through the planting of carbon-storing trees.

If visitors could, in the future, take the memory and inspiration of a visit to the "Sustainable Islands in the Salish Sea" back home and put that into practice in their own communities, households, schools and businesses, then we would have made a real contribution to a more sustainable society.

Transmission lines between Vancouver Island and Salt Spring, above endangered Garry oak woodlands. PHOTO BY KAREN HUDSON

This map is only a snapshot—a moment in time. Not long ago the impact of humanity's transportation and energy systems was negligible; what those impacts are in the future will be a result of our decisions now. Sustainable choices will not only benefit our region directly, but our example can contribute to the knowledge of people in other parts of the world. Otherwise, all we can say is that we have the nicest and most sustainable deck chair on the *Titanic*.

—Eckhard Zeidler

AIR QUALITY

The Characterization of the Georgia Basin/Puget Sound Airshed study was undertaken to assess the air quality within the area. The following information is excerpted from that study, done by a team of Canadian and American scientists.

Overall, the report states that rapid growth in population, transportation demands and energy consumption in the airshed is stressing the region's environment and public health; population in the region is projected to increase by as much as 50 percent by 2020.

The concentration of ambient air pollution is linked to social and economic trends including increasing population, transportation demands, energy consumption and shifts in industry. Although emissions of pollutants from the on-road vehicle sector are projected to decrease over the next decade, emissions from the marine sector are increasing, as are emissions from agricultural practices.

• Health impacts from airborne pollutants range from eye, nose and throat irritation to decreased lung function and cancer.
• Contaminants in the air can damage farmland and vegetation, reducing yields of economically important crops.

Increasing concentrations of heat-trapping gases are contributing to climate change, with far-reaching and unpredictable environmental, social and economic consequences.

CANADIAN ENERGY POLL

According to a national poll released by Oraclepoll Research, on behalf of Pollution Probe, 87 percent of Canadian voters support the use of green power (i.e., wind, solar, small hydro, geothermal) as a source of electricity.
• Canadians are willing to pay extra for Green Power to improve air quality, with 48 percent prepared to pay more than $5 per month and 60 percent prepared to pay more than $2 per month.
• Green power is the preferred electricity supply source for 60 percent of Canadians, followed by large hydro projects (20 percent) and natural-gas-fired power plants (15 percent).
• Three-quarters of Canadians believe that it is very important for the federal and provincial governments to work together to develop Green Power in Canada over the next 20 years.
• Nuclear power is the preferred power source of only 5 percent of respondents. At the bottom of the list is coal-fired power, which is preferred by only 1 percent of Canadians.

Islands Trust Protected Sites

This map celebrates the lands and wildlife protected by the Islands Trust Fund as of February 2002. It illustrates 125 species of animals and plants found in the Trust Area, many of which are rare and endangered. Superimposed on each protected property is an icon of a bird, mammal or amphibian that identifies the property and depicts one of the species found in that area. The small green salal leaves represent conservation covenants.

I tried to convey the notion of amazement and great joy that touches us when we look into a treasure chest filled with precious jewels. I hope that the artwork will inspire many more islanders to set land aside for nature conservation.

—Peter Karsten

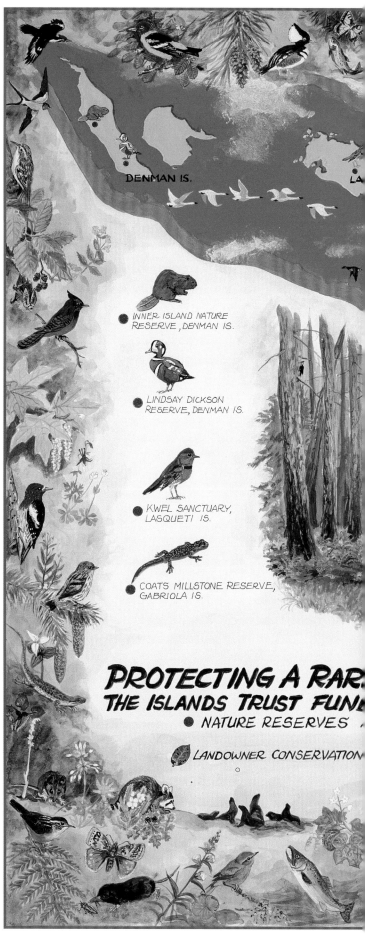

DENMAN IS.

LA

INNER ISLAND NATURE RESERVE, DENMAN IS.

LINDSAY DICKSON RESERVE, DENMAN IS.

KWEL SANCTUARY, LASQUETI IS.

COATS MILLSTONE RESERVE, GABRIOLA IS.

PROTECTING A RAR
THE ISLANDS TRUST FUN
● NATURE RESERVES

LANDOWNER CONSERVATION

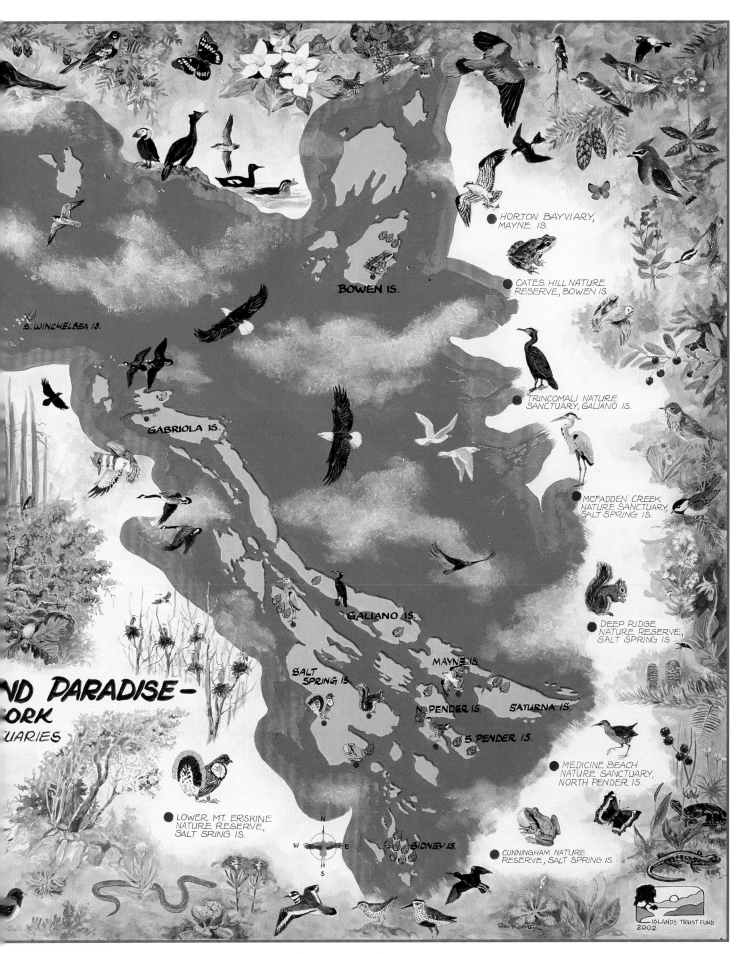

Coordinator Carolyn Stewart
Artist Peter Karsten

HORTON BAY VIARY, MAYNE IS.

CATES HILL NATURE RESERVE, BOWEN IS.

TRINCOMALI NATURE SANCTUARY, GALIANO IS.

McFADDEN CREEK NATURE SANCTUARY, SALT SPRING IS.

DEEP RIDGE NATURE RESERVE, SALT SPRING IS.

MEDICINE BEACH NATURE SANCTUARY, NORTH PENDER IS.

LOWER MT. ERSKINE NATURE RESERVE, SALT SPRING IS.

CUNNINGHAM NATURE RESERVE, SALT SPRING IS.

BOWEN IS.

S. WINCHELSEA IS.

GABRIOLA IS.

GALIANO IS.

SALT SPRING IS.

MAYNE IS.

N. PENDER IS.

SATURNA IS.

S. PENDER IS.

SIDNEY IS.

ND PARADISE— ORK UARIES

ISLANDS TRUST FUND 2002

The Story of the Islands Trust Fund

During the 1960s and early '70s the government of British Columbia became increasingly aware that the islands between Vancouver Island and the mainland comprised a special place where the distinctive beauty, rural character and diverse ecosystems should be protected. This realization led to the Islands Trust Act, which was adopted in 1974. The legislation established the Islands Trust as a unique form of local government with a mandate "to preserve and protect the trust area and its unique amenities and environment for the benefit of the residents of the trust area and of British Columbia."

In 1990, the Islands Trust Act was amended to establish a board to set up and oversee a conservation land trust to be called the Islands Trust Fund. The vision of the Islands Trust Fund is to create a legacy of special places in the Trust Area, protecting both natural and cultural features in perpetuity. This area covers all the islands included in this atlas with the exceptions of Texada, Savary, Quadra and Cortes.

The Islands Trust Fund works with island communities, partner land trusts and other agencies to protect significant areas by encouraging, undertaking and assisting in voluntary conservation initiatives.

Coats Millstone Nature Reserve, Gabriola Island

The Coats Millstone Nature Reserve is a 0.25-hectare property on Gabriola Island with an intriguing cultural history. Sandstone blocks quarried from the site in the 1920s and '30s were used in the construction of several notable buildings, including the Victoria Post Office, the Carnegie Centre in Vancouver and the San Francisco Mint. Millstones were also cut on the site and used in pulp mills across British Columbia and as far away as Finland and France. Today the millstone holes, more than a metre in diameter and often water-filled, are surrounded by lush green moss. Along with a nearby young forest, they provide valuable habitat for a variety of birds and animals.

In 1994 the Coats family donated this site to the Islands Trust Fund. The land is further protected by a conservation covenant held jointly by the Gabriola Historical and Museum Society and the Nanaimo and Area Land Trust. The short-term objective of the Islands Trust Fund is to work cooperatively with the museum society to erect an interpretative sign on the site.

Medicine Beach Nature Sanctuary, North Pender Island

Wetlands are rare in the dry climate of the Gulf Islands, and brackish marshes, which contain both salt and fresh water, are particularly special. The brackish marsh at Medicine Beach on North Pender Island boasts a great diversity of plant species and is home to several uncommon bird species. Due to a human-made berm, the back of the marsh is freshwater inflow, supporting cattails and other freshwater marsh species. As the water approaches the beach and becomes salty, the plant communities change. Medicine Beach gets its name from traditional Aboriginal use of plants in the marsh area for medicinal purposes, and the area is a registered archaeological site. Today the land is an eight-hectare nature sanctuary that includes a forest of mostly second-growth trees with some older forest, the marsh and coastal bluffs. Near the bluffs there are areas of meadow where camas lilies bloom in the springtime. As in the past, the area is considered healing, inspirational and beautiful.

Previously owned by the Atkins family, the property was the first major acquisition project of the Pender Island

Conservancy. As professional printers, the Atkins contributed fundraising and other educational material and, towards the end of the project, generously donated some of the land. With help from the Islands Trust Fund, the community worked tirelessly to raise the funds needed to purchase the land. The Islands Trust Fund now owns the property, and the Conservancy takes a management role.

Ruby Alton Nature Reserve, Salt Spring Island

Ruby Alton's family settled on Salt Spring Island at the start of the Depression. Ruby grew up digging clams, fishing and raising sheep and vegetables on the family farm. Although she worked in northern British Columbia as a nurse for a few years, she returned to Salt Spring Island, married and lived near her family home, continuing the island life she had known as a girl.

Ruby showed a strong concern for the environment and was described as one of Salt Spring's early pioneers in the conservation movement. It was well known that she wanted to preserve her property, which consisted of 1.6 hectares on the water side of Isabella Point Road and 13.4 hectares on the uphill side.

When Ruby died in 1998, she left the 1.6-hectare portion of her land to the Islands Trust Fund. This piece, now a nature reserve, includes the original homesite, as well as beach, forest, gardens, heritage orchard and pasture. The 13.4-hectare portion of her property was left to the Nature Conservancy of Canada. Ruby was particularly eager to safeguard the creek running through her land, and her primary motivation for this donation was to help protect the watershed. This larger piece is now further protected by a conservation covenant held jointly by The Land Conservancy of B.C. and the Salt Spring Island Conservancy. Ruby also left an endowment fund for maintaining the land. Through this bequest, her generous spirit lives on.

CONSERVATION OPTIONS

People who own a special property, such as a site with a wetland, an old-growth forest or other ecologically, historically or culturally significant feature, sometimes want to protect the land in perpetuity. These far-sighted landowners can leave a legacy for their community by working with a land trust.

There are several ways in which landowners can protect important features on a property. They can donate all or part of the property to a land trust while they are alive or through their will, sell the property at a reduced value, place a conservation covenant on the property or work with a land trust to explore other options. Tax benefits may be available to donors in certain situations.

In some instances, a community raises the money to buy a piece of land and preserve it for the long term. Where the land is of particular ecological importance, one or more regional, provincial or national land trusts may assist in fundraising, thus becoming partners in the acquisition. Usually, the partners decide at the outset which land trust is best suited to look after the property being purchased.

By choosing a land trust to hold the land, donors are assured that it will be conserved in perpetuity. When a land trust acquires land, a management plan is developed specifically for that property and is regularly monitored to ensure that the special features continue to be protected.

PROTECTING SITES THROUGH CONSERVATION COVENANTS

A conservation covenant is a written legal agreement between a landowner and a designated body, most commonly a land trust, whereby the landowner promises to protect land in specified ways. A conservation covenant can cover all or part of the landowner's property. It is registered on the title of the land, and it is intended to provide protection forever. Landowners continue to own and enjoy their land, and future owners of the land are bound by the terms of the covenant. Landowners have various reasons for considering conservation covenants: they may wish to ensure that the ecosystems on their property are not damaged after they move or die, or they may wish to restrict the kinds or level of development that can take place on the property.

Prior to 1994 only government bodies held covenants. Since then, this legal tool has also been available to non-government bodies. Other provinces have similar legal agreements, commonly referred to as easements. Covenants have the particular advantage of protecting land without requiring that it be purchased or donated outright. The covenanting body, usually a land trust, holds the covenant in perpetuity, undertaking a long-term commitment to monitor the site. If the terms of the covenant are broken, the land trust will take steps to see that the damages are rectified. In rare cases, legal action may be required to enforce the covenant.

Endangered Ecosystems

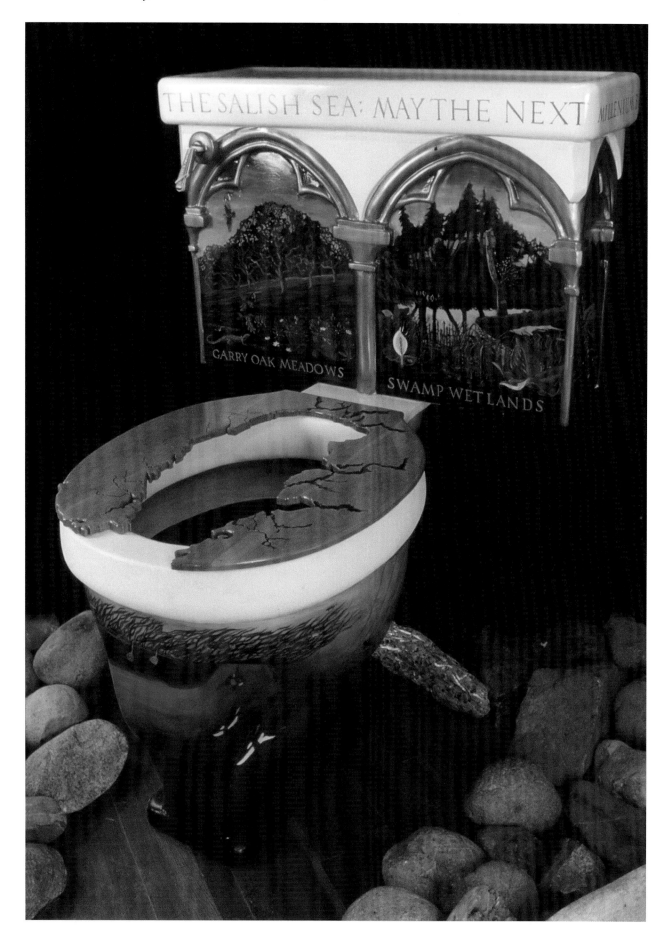

Coordinator and artist Briony Penn with
assistance from Michelle McDonald

THE BIGGEST THREATS FACING THE islands in the Salish Sea are the increasing human pressures around and within the islands. Few people realize that it is an inland sea with slow circulation, and that their individual actions have an effect upon life forms in and around this sea. From leaking septic tanks to clearing of forests for views or pulp, people are killing the Salish Sea.

What I hoped to do with this installation was create a bold symbol of the threats that urbanization poses to the sensitive ecosystems of the Salish Sea—a toilet. The indoor toilet is also a symbol of our separation from our waste and other impacts on the environment. Waste can be flushed down a drain and simply disappear from view and from thought.

This idea was inspired by a 15th-century Flemish masterpiece by Hans Memling called *The Voyage of Saint Ursula's Relics*. In the same shape as a water tank, Memling's piece depicts the sacred relics of Saint Ursula with scenes of her sainthood painted around it. In our piece, by putting artistic importance on relics of species and ecosystems rather than saints, we are highlighting the essential sanctity of the biological diversity of the region. We (as artists) are asking this question: have we, as people, lost our sense of sanctity for the natural world, and is that the problem? Do we put cleanliness, convenience—even ocean views—before life itself?

The departure from a traditional map came about for a variety of reasons. In the other maps in the collection, threats are only hinted at as artists and local project coordinators on each island sought to celebrate what is still left—beauty, diversity and character. What I felt I could contribute was an integrating vision of the threats to this archipelago, and a humorous but strong message about our role in destroying this beauty or maintaining it.

—Briony Penn

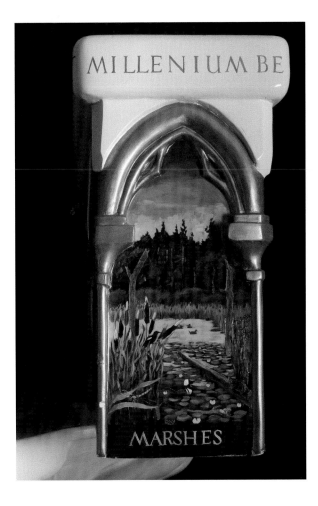

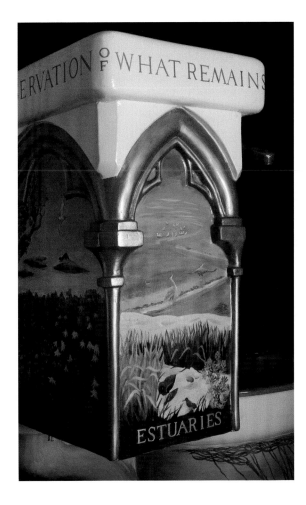

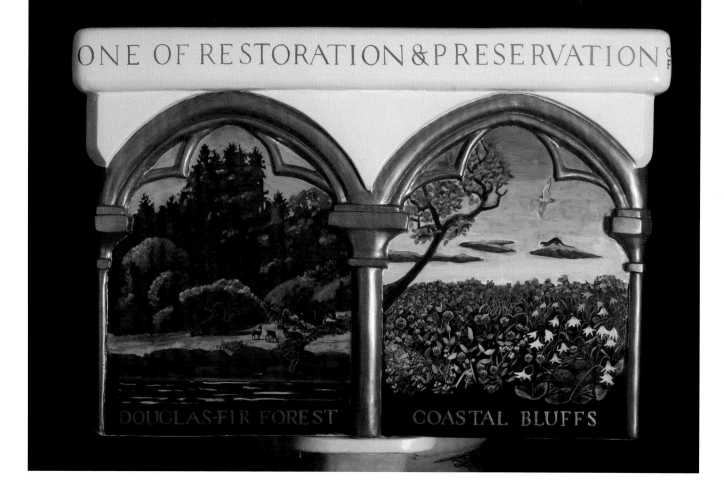

ONE OF RESTORATION & PRESERVATION

DOUGLAS-FIR FOREST COASTAL BLUFFS

We're Losing It

Areas of sensitive ecosystems left in all the Gulf Islands as surveyed between 1984 and 1990 by the Conservation Data Centre:

1. Coastal bluffs 611.2 hectares and rocky outcrops 683 hectares
2. Older Douglas-fir forest 2,263 hectares
3. Swamp wetlands 102 hectares
4. Garry oak meadows (and arbutus/trembling aspen stands) 900 hectares
5. Marshes and bogs 389 hectares
6. Estuaries 36 hectares and dunes 136 hectares

The total area of sensitive ecosystems left in the Gulf Islands in 1990 was 5,150 hectares or 7.8 percent of the total land area. When the toilet was finished in 2001, an update report by the Conservation Data Centre[33] estimated that 11 percent of this area has already been altered or destroyed by development in the last 10 years; that puts the area left at approximately 4,405 hectares. Just for comparison, 4,405 hectares is *half* the land currently set aside for the new airport in Toronto.

None of these endangered places have any type of protection placed on them, unless they have been acquired as protected areas. Currently 13 percent of the Gulf Islands overall are in protected areas, but a lot of this is not in the biodiversity hotspots.

The minimum area that should be protected under the Biodiversity Convention that Canada signed is 12 percent of each type of ecosystem. We don't even have 12 percent of each type left to save if we wanted to.

Seven Salish Sea Salvations

1. Love the Salish Sea and teach your children to love it.
2. Listen to the voices of other species and take action.
3. Understand the genius of the place in which you have chosen to live.*
4. Give more to your island than you take from it.
5. Treat water as a gift from heaven.
6. Strive for simplicity and slow down.
7. Think native and seven generations from now in everything you do.

*A tribute to Alexander Pope, an English essayist

Understanding the Toilet

The Salish Sea has a very low natural rate of flushing, which makes sewage discharge, storm water runoff and boat discharge all the more damaging.

The islands look tiny and vulnerable in the toilet bowl, as indeed they are. They are exposed pieces of rock rising out of a shallow seabed, with fluctuating ocean levels. We are one biological region, all islands experiencing the same issues.

Rare and endangered ecosystems and species are painted on the sides of the water tank (terrestrial) and bowl (marine); these are our sacred places. They are also our watersheds: they store water and purify it. I think of it as holy water.

When you look at these tiny islands, consider that the remnants of these ecosystems are in some instances less than 1 percent of their original size. They are now merely "islands" within islands, an unstable state to be in since the smaller the island, the greater the risk of habitat loss and species reduction or extinction.

Vancouver Island and the edge of the mainland are cut into the toilet seat profile, with the Strait of Juan de Fuca left as a slit in the seat. We chose Douglas-fir as the material for the seat, to profile the dominant forest type of the region.

On the lid of the toilet is the title, *Slow Islands*, a concept that embodies island ideas that can help solve the crisis: conservation covenants, organic farming, hydrogen fuel cells, wind power, native plant gardening, voluntary simplicity, buying local, slow food, marine and terrestrial protected areas. These ideas will reduce our ecological footprint, and "put the lid" on further loss.

—Briony Penn

Endangered Terrestrial Ecosystems
ON THE TANK
DOUGLAS-FIR

GARRY OAK MEADOWS

SWAMP WETLANDS

ESTUARIES

MARSHES AND BOGS

COASTAL BLUFFS

Endangered Marine Ecosystems
ON THE BOWL
KELP FOREST

EELGRASS

SPONGE GARDENS

> *Sculpting of toilet with bathymetric and topographic representation of Salish Sea in bowl and fabricated wood toilet seat by Michelle McDonald. Concept and painting by Briony Penn, with the guidance of Sue Pratt.*

Endnotes

1 Alan Morantz, *Where Is Here? Canada's Maps and the Stories They Tell*, Toronto: Penguin Books, 2002, p. 179.

2 United Nations Board of Directors, *Living beyond Our Means: Natural Assets and Human Well-being, Measuring Our Progress, A Millennium Assessment,* March 2005.

3 Roger Deakin, *from place to PLACE*, edited by Sue Clifford and Angela King, London: Common Ground, 1996, p. 27.

4 Alan Morantz, *Where Is Here?*, p. 13.

5 Sue Clifford, *from place to PLACE*, p. 4.

6 Initially described by Barbara Bender, *from place to PLACE*.

7 Dave Elliot Sr., *Saltwater People*.

8 Stan Rowe, *Home Place: Essays on Ecology*, pp. 5-6.

9 Officially, the Islands Trust encompasses 470 islands and islets. Thirteen are considered to have enough residents to elect trustees to the Trust Council: Bowen, Denman, Gabriola, Galiano, Gambier, Hornby, Lasqueti, Mayne, North Pender, Salt Spring, Saturna, South Pender and Thetis.

10 Chamberlain, 2003, p. 1.

11 United Nations, 1996-2000, Part III, Article 14.

12 Mackie, 1995, p. xi.

13 Province of British Columbia, 1973.

14 UNESCO, *Island Agenda: An Overview of UNESCO's Work on Island Environments, Territories and Societies*, Paris, 1994, p. 3.

15 *Islands Trust Policy Statement*, April 2003, p. 9.

16 Elliott, *Mayne Island and the Outer Gulf Islands, A History*, p. 69.

17 Miller, *Shingwauk's Vision: A History of Native Residential Schools*.

18 Chatwin et al., "Changes in Pelagic and Double-crested Cormorant Nesting Populations in the Strait of Georgia."

19 Leopold, *A Sand County Almanac*, p. xviii.

20 Gussow, *A Sense of Place*, p. 17.

21 Taylor and Douglas, *Exploring Quadra Island*, p. 26.

22 According to a report released by the Georgia Strait Alliance, 2002.

23 Merilees, cited in Wallace, Symington and Glavin, *State of the Strait*, 2002.

24 Winship, cited in Wallace, Symington and Glavin, *State of the Strait*, 2002.

25 Hunter-Thomson, Hughes and Williams, "Estuarine-open-water comparison of fish community structure in eelgrass (*Zostera marina L.*) habitats of Cape Cod," in *The Biological Bulletin* 203, October 2002, pp. 247–248.

26 Nowlan and Kwan, "Cruise Control—Regulating Cruise Ship Pollution," 2001, p. 2.

27 British Columbia Nearshore Habitat Loss Working Group, "A Strategy to Prevent Coastal Habitat Loss and Degradation in the Georgia Basin," 2001.

28 British Columbia, Ministry of Water, Land and Parks, "Are Measures to Reduce Pulp and Paper Effluent Effective?" in *Pulp and Paper Mill Effluent—Environmental Trends in British Columbia*, 2002.

29 Reach for Unbleached, "BC'S Zero AOX Pulp Pollution Regulation at Risk," in *MillWatch* 36, April 2002.

30 British Columbia, Ministry of Water, Land and Parks, "State of Environment Reporting," 2002.

31 Canada, Environment Canada, "Birds Under Stress: Chemical Contamination Threatens Marine Fish-Eating Birds in the Georgia Basin," in *Georgia Basin Action Plan*.

32 Canada, Parks Canada, *National Marine Conservation Areas of Canada,* Introduction.

33 Ward, et al., *Sensitive Ecosystems Inventory: East Vancouver Island and Gulf Islands, 1993–97*.

* **Sources of data for Island at a Glance information as follows.** Population: Canada Census.
Size: Regional districts and Islands Trust ("Measuring our Progress: Sustaining the Islands Program," Draft Report on Levels 1, 2 and 3 Indicators Victoria: Islands Trust, 2002.
Green space: Landsat imagery from July 30, 2000, analyzed using the *ArcView Image Analyst* and a recognized technique described by J.W. Rouse, R.H. Haas, J.A. Schell and D.W. Deering in 1973 in *Monitoring Vegetation Systems in the Great Plains with ERTS*, Proceedings, Third ERTS Symposium, Vol. 1, pp.48–62. Areas were classified as vegetated if the (Near-Infrared - Red)/(Near-Infrared + Red) value was greater than 0.35.
Farmland refers only to Agricultural Reserve Lands.
Protected areas are government parks, eco-reserves, Trust Fund Board and Conservancy-owned lands as well as any covenants known by the Islands Trust.

Bibliography and Resources of Interest

BIOREGIONALISM AND CONSERVATION

Andruss, V., C. Plant, J. Plant and E. Wright (Eds.). *Home! A Bioregional Reader*. Gabriola Island: New Society Publishers, 1990.

Berg, Peter. *Discovering Your Life-Place: A First Bioregional Workbook*. (San Francisco: Planet Drum Books, 1995).

Bernard, R. and J. Young. *The Ecology of Hope: Communities Collaborate for Sustainability*. Gabriola Island: New Society Publishers, 1997.

Butala, S. *The Perfection of the Morning*. Toronto: HarperCollins Canada, 1994.

Curry, Janel M. and Steven Mcguire. *Community on Land — Community, Ecology and the Public Interest*. Lanham, Maryland: Rowman and Littlefield, 2002.

Durning, A.T. *This Place on Earth: Home and the Practice of Permanence.* Seattle, WA: Sasquatch Books, 1996.

Emmings, Kate and Keith Erickson. *Galiano Island Landscape Classification and UP-CLOSE Workshop Series Final Report.* Galiano Conservancy Association: 2004.

findlay, Barbara and A. Hillyer. *Here Today, Here Tomorrow: Legal Tools for the Voluntary Protection of Private Land in British Columbia.* Vancouver: West Coast Environmental Law Research Foundation, 1994.

Gussow, Allan. *A Sense of Place: the Artist and the American Land.* Friends of the Earth and Seabury Press, 1972.

Hillyer, Ann and J. Atkins. *Giving It Away: Tax Implications of Gifts to Protect Private Land.* Vancouver: West Coast Environmental Law Research Foundation, 2000.

Hillyer, Ann and J. Atkins. *Greening Your Title: A Guide to Best Practices for Conservation Covenants,* revised edition. Vancouver: West Coast Environmental Law Research Foundation, 2004.

Jackson, W. *Becoming Native to This Place.* Lexington, Kentucky: The University Press of Kentucky, 1994.

Leopold, Aldo. *A Sand County Almanac: With Essays on Conservation from Round River.* New York: Ballantine Books, 1970.

Leopold, Aldo. *For the Health of the Land.* Washington, DC: Island Press, 1999.

Meyer, Christine and F. Moosang. *Living with the Land—Communities Restoring the Earth.* Gabriola Island: New Society Publishers, 1992.

Plant, C. and J. Plant (Eds.). *Turtle Talk: Voices for a Sustainable Future.* Gabriola Island: New Society Publishers, 1990.

Rowe, J.S. *Home Place: Essays on Ecology.* Edmonton: NeWest Publishers, 1990.

Sale, K. *Dwellers in the Land: The Bioregional Vision.* Gabriola Island: New Society Publishers, 1985.

United Nations. "Living Beyond Our Means: Natural Assets and Human Well-being," *The Millennium Ecosystem Assessment Synthesis Report.* Malaysia, 2004.

Van Newkirk, Allen. "Bioregions: Towards A Bioregional Strategy for Human Cultures." *Environmental Conservation* 2, 1975.

ECOLOGY

Agee, J. *Fire Ecology of Pacific Northwest Forests.* Washington, DC: Island Press, 1993.

Beach, S.A., N.O. Booth and O.M. Taylor. *The Apples of New York,* Volume I and II, Report of the New York Agricultural Experiment Station for the Year 1903. Albany NY: J.B. Lyon Company Printers, 1905.

British Columbia Ministry of Environment, Lands and Parks. *Stickleback Species Pairs: Species at Risk in British Columbia.* Victoria, 1999

British Columbia Ministry of Water, Land and Air Protection. "Are Measures to Reduce Pulp and Paper Effluent Effective?" *State of the Environment Report, Environmental Trends in British Columbia.* Victoria, 2002.

British Columbia Nearshore Habitat Loss Working Group. *A Strategy to Prevent Coastal Habitat Loss and Degradation in the Georgia Basin.* Victoria: British Columbia Ministry of Water, Land and Air Protection, 2001.

Butler, R.W. *The Great Blue Heron.* Vancouver: University of British Columbia Press, 1997.

Cannings, Richard and S. Cannings. *British Columbia: A Natural History.* Vancouver: Greystone Books, 1996, 2004.

Chatwin, Trudy A., Monica H. Mather and Tanya D. Giesbrecht. "Changes in Pelagic and Double-Crested Cormorant Nesting Populations in the Strait of Georgia," *Northwestern Naturalist,* 83, 2002.

Clague, J.J. *Quadra Sand: A Study of the Late Pleistocene Geology and Geomorphic History of Coastal Southwest British Columbia.* Report 77-17 Geological Survey of Canada, 1977.

Committee on the Status of Endangered Wildlife in Canada (COSEWIC) 2003 Species Database. (www.cosewic.gc.ca/_eng/sct1/indix_e.cfm)

Dunster, Katherine. *Sand Dune Ecosystems on Savary Island, B.C.* Bowen Island: Dunster & Associates, 2000.

Environment Canada. "Birds Under Stress: Chemical Contamination Threatens Marine Fish-Eating Birds in the Georgia Basin," *Georgia Basin Action Plan,* 2004.

Environment Canada. "Sandpipers Feeling Squeeze in Strait," *Science and The Environment Bulletin,* March/April 2001.

Georgia Strait Alliance. *Georgia Strait Coastal Waters.* (www.georgiastrait.org/whogeorgia.php).

Glavin, T. *The Last Great Sea: A Voyage Through the Human and Natural History of the North Pacific Ocean.* Vancouver: Douglas & McIntyre, 2003.

Green, R.N. and K. Klinka. *A Field Guide to Site Identification and Interpretation for the Vancouver Forest Region.* Victoria: Ministry of Forests Research Branch, 1994.

Katnick, D.C. and P.S. Mustard. *Geology of Denman and Hornby Islands, British Columbia.* Geoscience Map 2001-3. B.C. Geological Survey Branch, 2001.

Lamb, A. and P. Edgell. *Coastal Fishes of the Pacific Northwest.* Madeira Park, BC: Harbour Publishing, 1986.

Lange, O.S. *Living with weather along the British Columbia coast: The veil of chaos.* Vancouver: Environment Canada, 2003.

Layberry, R.A., P.W. Hall and J.D. Lafontaine. *The Butterflies of Canada.* Toronto: University of Toronto Press and National Research Council, 1998.

Ludvigsen, Rolf and G. Beard. *West Coast Fossils: A Guide to the Ancient Life of Vancouver Island.* Vancouver: Whitecap Books. 1980.

McGillivray, Brett. *Geography of British Columbia: People and Landscapes in Transition.* Vancouver: University of British Columbia Press, 2000.

McPhee, M., L. Wolfe, N. Page, K. Dunster, P. Ward, N. Dawe and I. Nykwist. *Sensitive Ecosystems Inventory: East Vancouver Island and Gulf Islands 1993–1997.* Volume 2: Conservation Manual. Technical Report Series No. 345. Canadian Wildlife Service, Pacific and Yukon Region, British Columbia, 2000.

Martell, S. and S.S. Wallace, 1998, cited in Scott Wallace (Ed.), *State of the Strait: The History and Future Outlook of the Strait of Georgia Marine Fisheries: An Interim Report.* Sierra Club, 2002.

Merilees, B., cited in Scott Wallace (Ed.), *State of the Strait: The History and Future Outlook of the Strait of Georgia Marine Fisheries: An Interim Report.* Sierra Club, 2002.

Muller, J.E. *Geology of Vancouver Island and Gulf Islands.* Geological Survey of Canada, Open File 463, 1977.

Muller, J.E. *Geology, Victoria Map Area, Vancouver Island and Gulf Islands.* Geological Survey of Canada, Open File 701, 1980.

Nagorsen, D.W. and R.M. Brigham. *Bats of British Columbia. Volume 1: The Mammals of British Columbia.* Vancouver: University of British Columbia Press and Royal British Columbia Museum, 1993.

Niesen, Thomas M. *Beachcomber's Guide to Marine Life of the Pacific Northwest.* Houston, TX: Gulf Publishing, 1997.

Penn, Briony (with Jennifer Hoffman). *Canada's Rainforest: From Maps to Murrelets, An Introduction to Life Science 8, Social Studies 10 and 11, Geography 12, Forests 11, First Nations 12, Biology 11.* Victoria: Sierra Club of British Columbia, 1998.

Pielou, E.C. *After the Ice Age: The Return of Life to Glaciated North America.* Chicago: University of Chicago Press, 1991.

Pojar, J. and A. MacKinnon. *Plants of Coastal British Columbia.* Vancouver: Lone Pine, 1994.

Reach for Unbleached. "BC's Zero AOX Pulp Pollution Regulation at Risk," *MillWatch,* 36 (April 2002), www.rfu.org/_archives?MillWatch/Misswtch36.htm

Transboundary Georgia Basin-Puget Sound Environmental Indicators Working Group. *Georgia Basin-Puget Sound Ecosystem Indicators Report.* Georgia Basin Ecosystem Initiative Publications and Washington State Department of Ecology, 2002.

Stewart, H. *Cedar.* Vancouver: Douglas & McIntyre, 1995.

Ward, P., G. Radcliffe, J. Kirkby, J. Illingworth and C. Cadrin. *Sensitive Ecosystems Inventory: East Vancouver Island and Gulf Islands, 1993–1997.* Volume 1: Methodology, Ecological Descriptions and Results. Technical Report Series No. 320. Canadian Wildlife Service, Pacific and Yukon Region, British Columbia, 1998.

Winship, A., cited in Scott Wallace (Ed.), *State of the Strait: The History and Future Outlook of the Strait of Georgia Marine Fisheries: An Interim Report.* Sierra Club, 2002.

FIRST NATIONS

Arnett, Chris. *The Terror of the Coast.* Burnaby: Talonbooks, 1999.

Brody, Hugh. *Maps and Dreams: Indians and the British Columbia Frontier.* Vancouver: Douglas & McIntyre, 1981.

Carlson, Roy L. and Hobler, P.M. "The Pender Island Canal Excavations and the Development of Coast Salish Culture," *BC Studies,* Volume 99, 1993.

Chamberlain, J. Edward. *If This Is Your Land, Where Are Your Stories?* Toronto: Knopf Canada, 2003.

Claxton, Earl Sr. and John Elliot Sr. *Reef Net Technology of the Saltwater People.* Brentwood Bay: Saanich Indian School Board, 1994.

Duff, Wilson. *The Indian History of British Columbia: The Impact of the White Man.* Victoria: Royal British Columbia Museum, 1997.

Elliot, David Sr. *Saltwater People.* Janet Poth (Ed.). Saanich: School District No. 63, 1990.

Elliot, Gordon (Ed.). *Memories of the Chemainus Valley: A History of People.* Chemainus Valley Historical Society, 1978.

Fisher, Robin. *Contact and Conflict: Indian-European Relations in British Columbia, 1774–1890.* Vancouver: University of British Columbia Press, 1977.

McKay, Kathryn. "Recycling the Soul: Death and the Continuity of life in Coast Salish Burial Practices." MA Thesis (History), University of Victoria, 2002.

Miller, James Roger. *Shingwauk's Vision: A History of Native Residential Schools.* Toronto: University of Toronto Press, 1996.

Stewart, H. *Indian Fishing.* Vancouver: Douglas & McIntyre, 1996.

Suttles, Wayne. *Coast Salish Essays.* Vancouver: Talonbooks, 1987.

Thom, B.D. "The Dead and the Living: Burial Mounds & Cairns and the Development of Social Classes in the Gulf of Georgia Region." MA Thesis (Anthropology and Sociology), University of British Columbia, 1992.

Turner, N.J. *Food Plants of British Columbia Indians.* Victoria: B.C. Provincial Museum, 1975.

Turner, N.J. *Plants in British Columbia Indian Technology.* Victoria: B.C. Provincial Museum, 1979.

Turner, N.J. "Time to burn: traditional use of fire to enhance resource production by Aboriginal peoples in British Columbia," in R. Boyd (Ed.), *Indians, Fire and the Land in the Pacific Northwest.* Corvallis: Oregon State University Press, 1999.

Union of BC Indian Chiefs. *Researching the Indian land question in B.C: An introduction to research strategies & archival research for band researchers.* Vancouver: University of British Columbia Press, 1998.

United Nations. *Draft United Nations Declaration on the Rights of Indigenous Peoples.* Geneva, Switzerland: Office of the United Nations High Commissioner for Human Rights, 1996–2000.

Young, T.A. *Researching the History of Aboriginal Peoples in British Columbia. A Guide to Resources at the BC Archives and Records Service and BC Lands*. Victoria: Queen's Printer, 1992.

GENERAL HISTORY

Akrigg, G.P. V. and H.B. Akrigg. *British Columbia Place Names*, third edition. Vancouver: University of British Columbia Press, 1997.

Barman, J. *The West Beyond the West: A History of British Columbia*, revised edition. Toronto: University of Toronto Press, 1996.

Begg, A. *History of British Columbia from Its Earliest Discovery to the Present Time*. Toronto: W. Briggs, 1894.

Broadfoot, B. *Years of Sorrow, Years of Shame: The Story of the Japanese Canadians in World War II*. Toronto: Doubleday, 1977.

Hayes, D. *Historical Atlas of British Columbia and the Pacific Northwest*. Vancouver: Cavendish Books, 2000.

Howay, F.W. *British Columbia: The Making of a Province*. Toronto: Ryerson Press, 1928.

Koppel, T. *Kanaka: The Untold Story of Hawaiian Pioneers in British Columbia and the Pacific Northwest*. Vancouver: Whitecap Books, 1995.

Lowenthal, David. *The Past is a Foreign Country*. Cambridge: Cambridge University Press, 1985.

Mayne, R.C. *Four Years in British Columbia and Vancouver Island*. London, 1862.

Ormsby, M.A. *British Columbia: A History*. Vancouver: The Macmillans in Canada, 1958.

Province of British Columbia. *Official Report of Debates of the Legislative Assembly*. Legislative Session: 3rd Session, 30th Parliament. Tuesday, September 25, 1973, Afternoon Sitting.

Walbran, J.T. *British Columbia Coast Names 1592–1906*. Ottawa: Geographic Board of Canada, 1909. Vancouver: J.J. Douglas reprint, 1971.

Yates, Steve. *Orcas, Eagles and King: A Popular Natural History of Georgia Strait and Puget Sound*. Seattle, WA: Primavera Press, 1992.

LOCAL HISTORY AND CONTEMPORARY STUDIES

Aitken, N. *Island Time: Gabriola: 1874–1879*. Gabriola: Reflections, 1993.

Barman, J. *Maria Mahoi of the Islands*. Transmontanus Number 13. Vancouver: New Star Books, 2004.

Barman, J. *The Remarkable Adventures of Portuguese Joe Silvey*. Madeira Park, BC: Harbour Publishing, 2004.

B.C. Historical Federation. *More Tales from the Outer Gulf Islands*. Pender Island: Gulf Islands Branch, B.C. Historical Federation, 1993.

Bond, B. *Looking Back on James Island*. Sidney: Porthole Press, 1991.

Elliott, M.A. "History of Mayne Island." MA Thesis (History), University of Victoria, 1982.

Elliott, M. *Mayne Island and the Outer Gulf Islands, A History*. Mayne Island: Gulf Islands Press, 1984.

Elliott, M. *Winifred Grey, A Gentlewoman's Remembrances of Life in England and the Gulf Islands of British Columbia, 1871–1910*. Victoria: Gulf Islands Press, 1994.

Fletcher, O. *Hammerstone. A Biography of Hornby Island*. Edmonton: NeWest Publishers, 2001.

Flucke, A.F. "Early Days on Saltspring Island," *British Columbia Historical Quarterly*. Volume 15, 1951.

Freeman, B.J.S. (Ed.). *A Gulf Islands Patchwork: Some Early Events on the Islands of Galiano, Mayne, Saturna, North and South Pender*. Gulf Islands Branch, B.C. Historical Association, 1961.

Garner, J. *Never Fly Over an Eagle's Nest*. Nanaimo: Cinnabar Press, 1980.

Garner, J. *Never Chop Your Rope*. Nanaimo: Cinnabar Press, 1988.

Gustafson, L. *Memories of the Chemainus Valley*. Chemainus: Chemainus Historical Society, 1978.

Hanen, E.A., J. Kearney and B. Murray. *Bowen Island Reflections*. Bowen Island: Bowen Island Historians, 2004.

Harker, D. (Ed.). *More Tales from the Outer Gulf Islands: An Anthology of Memories and Anecdotes*. Pender Island: B.C. Historical Federation, Gulf Islands Branch, 1993.

Hill, B., S. Mouat, M. Cunningham and L. Horsdal. *Times Past: Salt Spring Houses and History Before the Turn of the Century*. Salt Spring: Gulf Islands Community Arts Council, 1983.

Hornby Island Community Economic Enhancement Committee. *Quality of Life Report*. 2003.

Howard, I. *Bowen Island 1872–1972*. Bowen Island: Bowen Island Historians, 1973.

Isbister, W.H. *My Ain Folk: Denman Island 1875–1975*. 1976.

Islands Trust. *Islands Trust Policy Statement*. Victoria: Islands Trust, 2003.

Kahn, C. *Salt Spring: The Story of an Island*. Madeira Park, BC: Harbour Publishing, 1998.

Keller, B.C. and R.M. Leslie. *Bright Seas, Pioneer Spirits: The Sunshine Coast*. Victoria: Horsdal & Schubart, 1996.

Kelsey, Sheila. *The Lives Behind the Headstones*. 1993.

Kennedy, I. *Sunny Sandy Savary: A History of Savary Island 1792–1992*. Vancouver: Kennell Publishing, 1992.

Lewis-Harrison, J. *The People of Gabriola: A History of Our Pioneers*. Gabriola Island: June Lewis-Harrison, 1982.

Mackie, Richard S. *The Wilderness Profound: Victorian Life on the Gulf of Georgia*. Victoria: Sono Nis Press, 1995.

Mason, E.C. *Lasqueti Island History & Memory*. Victoria: Morriss Printing, 1976.

Merilees, Bill. *Newcastle Island: A Place of Discovery*. Surrey: Heritage House, 1998.

Murray, P. *Homesteads and Snug Harbours: The Gulf Islands*. Ganges: Horsdal & Schubart, 1991.

Nowlan, Linda and Ines Kwan. *Cruise Control—Regulating Cruise Ship Pollution on the Pacific Coast of Canada.* www.wcel.org/wcelpub/2001/13536.pdf.

Ovanin, T. K. *Island Heritage Buildings. A Selection of Heritage Buildings in the Islands Trust Area.* Victoria: Queen's Printer, 1984.

Parks Canada. *Gulf Islands National Park Reserve of Canada: Parks Management Planning Newsletter #1.* Sidney, Fall 2004.

Pender Islands Museum Society. *A Self-Guided Historic Tour of the Pender Islands.* 2002.

Penn, B. *A Year on the Wild Side.* Victoria: Horsdal & Schubart, 1999.

Pilton, J.W. "Negro Settlement in British Columbia 1858–1871." MA Thesis (History), University of British Columbia, 1951.

Pratt, Derek. *Savary Island Draft Official Community Plan.* Planistics Consulting, 1997.

Reimer, D. (Ed.). *The Gulf Islanders.* Sound Heritage, Volume V (14). Victoria: Provincial Archives of British Columbia, 1976.

Rushton, G. *Whistle Up the Inlet: The Union Steamship Story.* Vancouver: J.J. Douglas, 1974.

Sandwell, R.W. "Reading the Land: Rural Discourse and the Practice of Settlement, Salt Spring Island, 1859–1891." Ph.D. Thesis, Simon Fraser University, 1997.

Schermbrucker, B. *The Campbells of Saturna: Interviews with Jim and Lorraine Campbell.* Saturna: Saturna Community Club, 2005.

Skolrood, A.H. *Piers Island: A Brief History of the Island and Its People, 1886–1993.* Lethbridge: Paramount Printers, 1995.

Smith, E. and D. Gerow. *Hornby Island: The Ebb and Flow.* Campbell River: Ptarmigan Press, 1988.

Spillsbury, Jim. *Spillsbury's Album.* Madeira Park, BC: Harbour Publishing, 1990.

Steward, Elizabeth. *Galiano Houses and People: Looking Back to 1930.* DoMo Communications, 1994.

Stewart, H. *On Island Time.* Vancouver: Douglas & McIntyre, 1998.

Strix Environmental Consulting. *Savary Island Dune and Shoreline Study: Ecological Component Final Report.* 2003.

Sweet, Arthur F. *Islands in Trust.* Lantzville: Oolichan Books, 1988.

Taylor, Jeanette and I. Douglas. *Exploring Quadra Island Heritage Sites and Hiking Trails.* Quathiaski Cove: Fernbank, 2001.

Thurber Engineering Ltd. *Savary Island Dune and Shoreline Study.* 2003.

Toynbee, Richard M. *Snapshots of Salt Spring Island and Other Favoured Islands.* Ganges, BC: Mouat's Trading Company, 1978.

Trettin, H.P. *Geology of Cortes Island and Environs.* 2002.

Turner, R.D. *The Pacific Princesses.* Victoria: Sono Nis Press, 1977.

Yates, Steve. *Marine Wildlife of Puget Sound, The San Juans, and the Strait of Georgia.* Globe Pequot Press, 1988.

Yorath, Chris. *A Measure of Value: The Story of the D'Arcy Island Leper Colony.* Victoria: TouchWood Editions, 2000.

MAPPING

Aberley, Doug (Ed.). *Boundaries of Home: Mapping for Local Empowerment.* Gabriola Island: New Society Publishers, 1993.

Arendt, Randall G. *Conservation Design for Subdivisions.* Washington, DC: Island Press, 1996.

Clifford, Sue and Angela King (Eds.). *From Place to PLACE: Maps and Parish Maps.* London, UK: Common Ground, 1996.

Dunster, K. "Acting Locally: Mapping and Counter-mapping Towards a Grassroots Feminist Cartography," in M. Hessing, R. Raglon and C. Sandilands (Eds.), *This Elusive Land: Women and the Canadian Environment.* Vancouver: University of British Columbia Press, 2005.

Flavelle, Alix. *Mapping Our Land: A guide to making maps of our own communities & traditional lands.* Edmonton: Lone Pine, 2002.

Gould, P. and R. White. *Mental Maps.* Harmondsworth, Middlesex: Penguin Books, 1974.

Harmon, Katharine. *You Are Here: Personal Geographies and Other Maps of the Imagination.* New York: Princeton Architectural Press, 2004.

Harrington, S. (Ed.). *Giving the Land a Voice: Mapping Our Home Places,* revised edition. Salt Spring Island: Land Trust Alliance of British Columbia, 1999.

Jackson, J.B. *Discovering the Vernacular Landscape.* New Haven: Yale University Press, 1984.

Kellogg, E. (Ed.). *The Rain Forests of Home: An Atlas of People and Place.* Portland: Ecotrust, Pacific GIS and Conservation International, 1995.

McHarg, I. *Design with Nature.* Garden City, NY: Doubleday, 1971.

Monmonier, M. *How to Lie with Maps.* Chicago: University of Chicago Press, 1991.

Morantz, Alan. *Where Is Here? Canada's Maps and the Stories They Tell.* Toronto: Penguin Books, 2002.

Panzarasa, Stefano (Ed.). *La Terra Racconta Il Bioregionalalismo e L'arte Di Disengnare Le Pamme Locali.* Via Bosco: rete Bioregionale Italiana, 1997.

Robinson, M., T. Garvin and G. Hodgson. *Mapping How We Use Our Land: Using Participatory Action Research,* third edition. Calgary: Arctic Institute of North America, 1994.

Watts, M.T. *Reading the Landscape of America.* New York: Macmillan, 1975.

Winchester, Simon. *The Map That Changed the World.* New York: HarperCollins, 2001.

Wood, D. and J. Fels. *The Power of Maps.* New York: Guilford Press, 1992.

Stark, C. and B. Cestero. *Landscapes, Wildlife & People: A Community Workshop for Habitat Conservation.* Tucson: The Sonoran Institute, 2001.

Acknowledgments and Thanks

In addition to the host organizations, coordinators and artists for each island and regional map, we thank the following for their many, varied and special contributions to the project:

BOWEN: Sue Ballou, Lisa Barrett, Betty Dhont, Sarah Haxby, Bill Hoopes, Andrea McKay, Suzanne McNeil, Wendy Merkley, Jude Neale, Cynthia Nicolson, Sheilagh Sparks, Baiba Thomson, Bowen Island Arts Council, Bowen Island Community School, Bowen Island Conservancy, Bowen Island Forest and Water Management Society, Bowen Island Public Library, Island Pacific School

CORTES: Dianne Bersea, Norberto Rodriguez de la Vega, Richard Trueman

DENMAN: Jenny Balke, Louise Bell, Graham Brazier, Anne de Cosson, Jane Fawkes, Patrick Fawkes, Dennis Forsyth, Marcus Isbister, Peter Karsten, Jane Lighthall, Denise MacKean, Denman Community School students

GABRIOLA: Bob Andrew, Clyde Coats, Nick Doe, Phyllis Fafard, Paul Grignon, Larry Holbrook, Geraldine Mansen, Margret Taylor, Christy Wilson

GALIANO: Chris Donnelly, Al Elliot, Keith Erickson, Bara Follows, Alan Forget, Pam Freir, Geoff Gaylor, Tara Gill and Thistledown, Catherine Holahan, Val Kirkland, Dianne Laronde, Louise Lemoine, Andrew Loveridge, Line-Marie, Steve Nemtin, David and Gwynneth New, Lony Rockafella, Alistair Ross, Annette Shaw, Keo Trueit, Eva Wilson, The Galiano Conservancy, The Galiano Museum

GAMBIER: John Calder, Joyce Clegg, Sherry and Rick Cooper, Karsten Kehler, Lois Kennedy, Dorothy Pohl, Richard Potter, Mike and Kate-Louise Stamford, Wolf Wiedemann

HORNBY: Jan Bevan, Josi Fletcher, Olivia Fletcher, Stevi Kittleson, Tom Knott, Tony Law, Janet Morgan

KUPER: Susan Rankin, Ellen White

LASQUETI: Barry Churchill, Chris Ferris, Doug Hopwood, Eric O'Higgins and Tom Weinerth, Sue Wheeler, Briony Penn

MAYNE: Alan Cheek, Michael Dunn, Terry Glavin, Jennifer Iredale and the Iredale family, Helen and John O'Brian, George Scott, David Spalding, Bill Wheaton

NORTH AND SOUTH PENDER: Peter and Elizabeth Campbell, Shirley and Dick Fyles, Derek Holzapfel, Jill Ilsley, Elaine Jacobsen, Julie Johnson, Jan Kirkby, Angus McMonnies, David Nicoli, Paul Petrie, Isabel Roberts, Mary Roddick, Tom Rutherford, Andrea and David Spalding, Jim Stafford, Jill Taylor, Susan Taylor, Marti Tilley, Tim Underhill, Ellen and Rob Willingham

QUADRA: Michelle Buchanan, Annik Dumouchel, Caroline Heim (Carolla Consulting), the directors, past and present, of the Quadra Island Mapping Project (Alvin Tye, Ian Douglas, Don McEachern, Dr. Dirk Van Der Minne, Joyce Overness, Terry Phillips, Dr. G. Barabas), Steve Moore, Philip Stone, Jeanette Taylor

SALT SPRING: Bob Akerman, Fiona Flook, Rachel Grant, Charles Kahn, Dan Lee, Felix Markevicius, Usha Rautenbech, Ann Richardson, Ramona Scott, Tony Threlfall, Nancy Turner, Tom Wright

SATURNA: Jim and Jody Bavis, Walter Bavis, Jim and Lorraine Campbell, Barry Crooks, Bill Douglass, John and Melanie Gaines, Bakhshish Gill, Pam and Harvey Janszen, Mary Gaines Jones, Rick Jones, Gloria Manzano, John Money, Karen Muntean, Erle Nelson, Jack Rush, Rick and Judy Tipple

SAVARY: Lise Butler, Paula Butler, Carmen Cadrin, Karen and Tony De Lorenzo, Daryl Duke, Rachel Ermellini, Norma Flawith, Anne-Marie Harvey, Christopher Harvey, Sherwood Inglis, Rod Kirkham, Paul Leighton, Ben Lightburn, Tom Lightburn, Anna Linsley, the Hartland MacDougall family, Joan and John Treen, Norma Wood, Wynn Woodward

TEXADA: John Dove, Todd Hatfield, Catherine Johnson

THETIS: Jeannine Caldbeck, Gail O'Hara, Sheri Pepin, Ian Ralston, Ruth Rebain

ECONOMIC MAP: B.C. Ferries

ADDITIONAL SIGNIFICANT ASSISTANCE: Eric McLay, Jean Gelwicks and Peter Lamb, Donna Martin and Michael Hogan

ADDITIONAL RESEARCH AND REVIEWS: Bill Austin, Kathy Dunster, Jan Kirkby, Maureen Milburn, Peter Ronald, Andy Telfer

THE ISLAND HOST ORGANIZATIONS:

Bowen Island Heritage Preservation Association

Friends of Cortes Island Society

Denman Island Conservancy Association

Heartlands Conservancy Society (Gabriola Island)

The Galiano Club

Gambier Island Conservancy

Heron Rocks Friendship Centre Society (Hornby Island)

Lasqueti Island Community Arts Council

Mayne Island Agricultural Society

Pender Island Conservancy Association

Quadra Island Mapping Project

Salt Spring Island Conservancy

Saturna Island Community Club

Savary Island Land Trust Society

Texada Island Community Society

Thetis Island History and Land Conservancy Group

REGION-WIDE SPONSORING ORGANIZATIONS:

The Land Trust Alliance of British Columbia (LTABC)

West Coast Islands Conservancy Association

All of us involved in the Islands in the Salish Sea Community Mapping Project thank the following contributors for their generous support. Their donations provided funds for mapping, framing and exhibiting the maps, and preparing atlas text. Many other individuals not named in this book donated to the project. Thank you, one and all!

BIRGIT AND ROBERT BATEMAN

ALAN CHEEK